Bollywood Horrors

Also Available from Bloomsbury

Martin Scorsese's Divine Comedy, Catherine O'Brien
Practical Spiritualities in a Media Age, edited by Curtis Coats and Monica M. Emerich
Religious Humor in Evangelical Christian and Mormon Culture, Elisha McIntyre

Bollywood Horrors

Religion, Violence and Cinematic Fears in India

Edited by Ellen Goldberg, Aditi Sen, and Brian Collins

BLOOMSBURY ACADEMIC
LONDON • NEW YORK • OXFORD • NEW DELHI • SYDNEY

BLOOMSBURY ACADEMIC
Bloomsbury Publishing Plc
50 Bedford Square, London, WC1B 3DP, UK
1385 Broadway, New York, NY 10018, USA
29 Earlsfort Terrace, Dublin 2, Ireland

BLOOMSBURY, BLOOMSBURY ACADEMIC and the Diana logo are trademarks of
Bloomsbury Publishing Plc

First published in Great Britain 2021
This paperback edition published in 2022

Copyright © Ellen Goldberg, Aditi Sen, and Brian Collins, 2021

Ellen Goldberg, Aditi Sen, and Brian Collins have asserted their right under the Copyright,
Designs and Patents Act, 1988, to be identified as Editors of this work.

Cover design: Tjaša Krivec
Cover image: *Kabrastan* movie poster (1988) (© MKB FILMS COMBINE)

All rights reserved. No part of this publication may be reproduced or transmitted
in any form or by any means, electronic or mechanical, including photocopying,
recording, or any information storage or retrieval system, without prior permission
in writing from the publishers.

Bloomsbury Publishing Plc does not have any control over, or responsibility for, any
third-party websites referred to or in this book. All internet addresses given in this
book were correct at the time of going to press. The author and publisher regret any
inconvenience caused if addresses have changed or sites have ceased to
exist, but can accept no responsibility for any such changes.

A catalogue record for this book is available from the British Library.

A catalog record for this book is available from the Library of Congress.
Library of Congress Control Number: 2020945417

ISBN: HB: 978-1-3501-4315-9
PB: 978-1-3501-9175-4
ePDF: 978-1-3501-4316-6
eBook: 978-1-3501-4317-3

Typeset by RefineCatch Limited, Bungay, Suffolk

To find out more about our authors and books visit www.bloomsbury.com
and sign up for our newsletters

*Dedicated to the memory of
Kathleen M. Erndl
January 21, 1954–February 19, 2017*

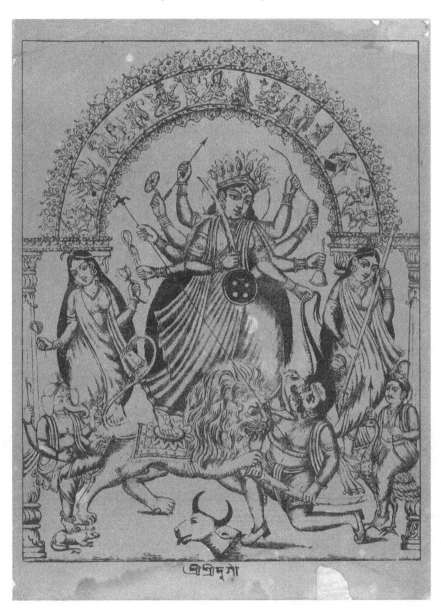

Contents

List of Plates	viii
Notes on Contributors	ix
Preface *Brian Collins*	xii
Introduction *Brian Collins, Aditi Sen, and Ellen Goldberg*	1

Part One Material Cultures and Prehistories of Horror in South Asia

1. Monsters, *Masala*, and Materiality: Close Encounters with Hindi Horror Movie Ephemera *Brian Collins* — 21

2. Vampire Man Varma: The Untold Story of the "Hindu Mystic" Who Decolonized Dracula *Brian Collins* — 44

Part Two Cinematic Horror, Iconography, and Aesthetics

3. Divine Horror and the Avenging Goddess in Bollywood *Kathleen M. Erndl* — 69

4. Horrifying and Sinister *Tāntriks* *Hugh B. Urban* — 78

5. Do You Want to Know the *Raaz*? Sāvitri, Satyavān, and the Other Woman *Aditi Sen* — 94

Part Three Cultural Horror

6. Cultural Horror in *Dev*: Man Is the Cruelest Animal *Ellen Goldberg* — 115

7. *Bandit Queen*, Rape Revenge, and Cultural Horror *Morgan Oddie* — 140

8. *Mardaani*: The Secular Horror of Child Trafficking and the Modern Masculine Woman *Beth Watkins* — 161

Notes	185
Bibliography	220
Index	238

Plates

We are grateful for permission to reproduce these images in this book. We have made every effort to secure the permission of relevant parties, but if we have inadvertently missed any relevant permissions or have been unable to find any parties, then we will move to rectify this at the earliest opportunity.

1. Poster for *Darawani Haveli* (The Frightful Mansion, 1997, dir. Rakesh Sinha)
2. Front cover of song booklet for *Khatarnak Raat* (Dangerous Night, 2003, dir. Muneer Khan)
3. Back cover of song booklet for *Khatarnak Raat* (Dangerous Night, 2003, dir. Muneer Khan)
4. Song booklet for *Lady Killer* (1995, dir. S.A. Chandramohan)
5. Poster for *Andheri Raat* (Dark Night, 1995, dir. V. Prabhakar)
6. Song booklet for *Daayan* (1998, dir. D.S. Azad)
7. Poster for *Khooni Murda* (The Bloody Dead, 1989, dir. Mohan Bhakri)
8. Poster for *Haiwan* (The Beast, 1977, dir. Ram and Rono Mukherjee)
9. Poster for *Cheekh* (Scream, 1985, dir. Mohan Bhakri)
10. Entrance to the Hanumān temple in Jhandewalan Felhi in Delhi
11. Poster for *Jaani Dushman* (Bitter Enemy, 1979, dir. Rajkumar Kohli)
12. Photo taken in the United Arab Republic in 1958 or 1959
13. Program for Dalhousie's 1973 "Transylvania Weekend"
14. Varma as Macbeth in Syria, the United Arab Republic in 1959
15. Varma contemplating a Nepalese mask, *c.* 1970s
16. Varma at Dalhousie University in Nova Scotia, *c.* 1980s

Contributors

Ellen Goldberg received her PhD from the University of Toronto, and is Associate Professor of South Asian studies in the School of Religion at Queen's University, Canada, as well as cross-listed to Gender Studies and Cultural Studies. She is the author of *The Lord Who Is Half Woman: Ardhanārīśvara in Indian and Feminist Perspective* (2002), and *Gurus of Modern Yoga* (co-edited with Mark Singleton, 2014). She has written extensively on Indian iconography, and the intersection between yoga and cognitive science. She serves on the editorial board of two journals, *Journal of the American Academy of Religion* (*JAAR*) and *Literary Discourses: International Journal of Art and Literature* (Indira Kala Sangeet University, India).

Aditi Sen gained her PhD in Ancient Indian culture and history from Deccan College, Pune, India. Her research interests include witchcraft in South Asia, Hindi horror films, and Bollywood cinema. She is a regular contributor to *Livemint* and *The Hindu*, and has published several articles on Bollywood in academic journals and in popular press. She is currently Assistant Professor in the Department of History and the School of Religion, Queen's University, Canada.

Brian Collins holds a PhD in the History of Religions from the University of Chicago Divinity School. Currently, he is the Drs. Ram and Sushila Gawande Chair in Indian Religion and Philosophy and Associate Professor of World Religions at Ohio University. A specialist in Hindu epics with a deep interest in comparison, he is the author of *The Head Beneath the Altar: Hindu Mythology and the Critique of Sacrifice* (2014) and articles on comparative religion for *Jewish Quarterly Review*, *Religious Studies Review*, and *Journal of Vaishnava Studies*. He has also published essays on the films *Black Swan* (2010) and *The Wrestler* (2008) as well as the *Saw* franchise. Most recently, he has written an afterword for a new Italian translation of the 1951 book *Man into Wolf: An Anthropological Interpretation of Sadism, Masochism, and Lycanthropy* by Robert Eisler (2019) and a second monograph on Indian religion, *The Other Rāma: Matricide and Genocide in the Mythology of Paraśurāma* (2020).

Kathleen M. Erndl was Professor in the Department of Religion at Florida State University, and affiliated with the Department of Religion at the University of Florida's Center for the Study of Hindu Tradition. She obtained her PhD in South Asian language and literature from the University of Wisconsin-Madison. Her publications include *Victory to the Mother: The Hindu Goddess of Northwest India in Myth, Ritual, and Symbol* (1993), the co-edited volume *Is the Goddess a Feminist? The Politics of South Asian Goddesses* (2000), and numerous articles on Śakta traditions, spirit possession, gender, and Bollywood. During her career, she received fellowships from the American Institute of Indian Studies, the National Endowment for the Humanities, the John Simon Guggenheim Memorial Foundation, and the Fulbright-Hays program. She was also co-chair of the Religion in South Asia section of the American Academy of Religion, and was completing a book titled *The Play of the Mother: Women, Goddess, Possession, and Power in Hinduism* at the time of her death.

Morgan Oddie is a doctoral candidate in the Cultural Studies Program at Queen's University (Canada). She is working on feminist ethnographic research on the embodiment of consensual pain with women who participate in Bondage/Discipline/Dominance/Submission/Sadism/Masochism (BDSM).

Hugh B. Urban received his PhD from the University of Chicago in the History of Religions. He is Professor of religious studies at Ohio State University. He is the author of eight books and numerous articles, including *Secrecy: The Adornment of Silence, the Vestment of Power. Comparative Studies in Esoteric Religions* (in progress); *The Power of Tantra: Religion, Sexuality and the Politics of South Asian Studies* (2009); *Magia Sexualis: Sex, Magic, and Liberation in Modern Western Esotericism* (2006); *Tantra: Sex, Secrecy, Politics and Power in the Study of Religion* (2003); and, *The Economics of Ecstasy: Tantra, Secrecy and Power in Colonial Bengal* (2001).

Beth Watkins is a freelance journalist. Her pieces on Bollywood have been published in *Filmfare, The Times of India, The Indian Express, Business Standard,* and *The Globe and Mail* (Canada). She also has written for Indian publications such as *Film Companion, The Big Indian Picture, The Indian Express, The Hindu, Hindustan Time Brunch,* and *Tehelka* and contributed to pieces in international media such as BBC radio, *Time Out London,* and CBC television, as well as in a weekly column in *The Wall Street Journal*'s "India Real Time."

She is the education, exhibit development, and publications coordinator at the Spurlock Museum of World Cultures at the University of Illinois at Urbana-Champaign. She holds Masters' degrees in Museum Studies from the University of Toronto and Library and Information Science from the University of Illinois at Urbana-Champaign.

Preface

Until recently, Hindi horror cinema has been the province of niche collectors and B-movie aficionados who treated it as a curiosity. But this has begun to change with recent work by Meraj Ahmed Mubarki, Meheli Sen, and others. How does *Bollywood Horrors* fit into this ongoing conversation? Taking a broader view of "horrors" than other books, this volume will look at the generic conventions of the horror film, cinematic portrayals of real-life horror, and the affective response to both.

All three meanings are contained in the English word "horror" already. We can define horror as a set of generic conventions (as in, "she loves horror novels"), as a real act of violence (as in, "we all know the horrors of the Spanish Inquisition"), or as affective response (as in, "she reacted with horror"). Since all three of the editors and two more of the contributors work in the field of religious studies, we decided to give religion a prominent place in our analysis, something that has not yet been done in what scholarship there is on Hindi horror films. I will now briefly explain how a religious studies book on Indian horror films came into existence.

This project comes out of a panel session called "Theorizing Horror in Bollywood" hosted by the Hinduism Group at the 2016 Annual Meeting of the American Academy of Religion in San Antonio, Texas with Aditi Sen, Ellen Goldberg, Diana Dimitrova, Kathleen M. Erndl, and myself. With the conference taking place just a few weeks after the US presidential election in 2016, many of us were preoccupied, still dealing with the shock and uncertainty we all felt after watching a man who had called for a ban on all Muslims entering the United States be elected to the presidency. Although I hesitate to use the phrase "good time" in connection with this traumatic moment, it was nonetheless a good time to think about the work that horror films do, allowing us to visualize our deepest fears and confront them on the screen, to traumatize ourselves as a form of inoculation, and to participate in a community of fandom marked by gallows humor, ironic enjoyment, and a celebration of the macabre.

Thinking about these aspects of horror film appreciation in the Indian context naturally lead to discussions of *rasa*, the classical Sanskrit philosophy of aesthetics. Centuries before Freud's "death drive," Kristeva's concept of "abjection,"

Bakhtin's "grotesque body," or Becker's "terror management theory," Sanskrit philosophers had already developed in *rasa* a classification scheme that accounted for the role of the terrifying (*bhayānaka*) and the horrifying/repulsive (*bībhatsa*) in art and religion. *Rasa* was an innovation of the classical era, first appearing in Bhārata's 300 CE *Treatise on Drama* (*Nāṭyaśāstra*). But, we recognized, the tradition of horror in India stretches back beyond the classical era to the ancient Vedas (See *Ṛg Veda* 10.85, "The Marriage of Sūryā") and, through folklore and mythology, up to the present cultural moment when it has taken new forms in movies and in television shows like *Darr Sabko Lagta Hai* (Everyone Feels Fear, 2015–16) and *Kaun Hai?* (Who Is It?, 2018).

Of the four papers given during the session (my "Whistling Past the *Kabrastan*: Aesthetics, Demonology, and Politics in Hindi Horror Film Posters and Ephemera;" Erndl's "Divine Horror in Bollywood: Avenging Goddesses in Hindi Cinema;" Goldberg's "In *Dev* Man Is the Cruelest Animal;" and Sen's "Do You Want to Know the *Raaz*? Sāvitrī, Satyavān, and the Other Woman"), all of which are included in some form in this volume, three dealt with the ways in which the gods and demons of Indian religion influenced Bollywood's horror tradition. I will note here, with sadness, that Kathleen M. Erndl passed away suddenly on February 19, 2017, just about three months after the paper session. Discussing the matter with her partner, we decided to honor her original contribution to the panel by including the written version of the paper she gave in San Antonio in this volume. It has not been edited except to correct a few minor inaccuracies.

Hugh Urban's "Horrifying and Sinister *Tāntriks*," the first essay we included in this volume that did not come from the panel, was chosen because it fits squarely into our existing framework for picking out what is unique about the horror genre in India. It went along with the essays based on our papers that Sen and I contributed to this volume: "Do you want to know the *Raaz*?: Tropes of Madness and Immorality in Bollywood Horror" and "Monsters, *Masala*, and Materiality: Close Encounters with Hindi Horror Movie Posters and Song Booklets," respectively.

The fourth paper on that original panel, that of Ellen Goldberg, looked at the representation of communal violence in a particular film, Govind Nihalani's *Dev* (2004), which appears here as "Cultural Horror in *Dev*: 'Man Is the Cruelest Animal.'" Goldberg's paper provided a point of departure out of our narrowly focused discussion on the films that we all agreed belong in the "horror" category. In the discussions we conducted over email in the months after the panel, we recognized that communal violence and other real-life horrors are the background against which Hindi horror films from the 1980s onward should be

properly understood. So when we considered how to move forward with a book of essays based on the session, we decided to include not only horror as a film genre, but also horror as a subject matter, the latter approach leading us to solicit some additional essays about the cinematic portrayal of sexual violence (Oddie's "*Bandit Queen*, Rape-Revenge and Cultural Horror") and human trafficking (Watkins' "*Mardaani* and the Trafficking of Women in India").

This project, three years in the making, would not have been possible without the invaluable assistance provided by our colleagues. We would especially like to thank Aseem Chandaver for his own insights into Hindi horror; David Colagiovanni, director of the Athens Center for Film and Video, for his help in archiving some rare and delicate posters and arranging for them to be photographed; Andrew Musil of Ohio University's College of Fine Arts for photographing and color-correcting twenty-five posters; Anand Tharaney for helping track down permissions to reproduce the booklets and posters in this book; a grant from Ohio University's Research Council that made it possible to print in color; and Robin Varma for sharing his grandfather's archive and his thoughtful and detailed email responses to my endless questions. Thanks are also due to Yakini Kemp, Lee Seigel, Ziad Abu Rish, Simon Brodbeck, Berkeley Franz, Mark Franz, Natasha Madoff, Herman Varma, Judy Varma, Tami Varma, Melissa Haviland, Jennifer Collins, Asko Parpola, Jayson Beaster-Jones, David Carrasco, Molly Raspberry, Jai Arjun Singh, Jeremy Bessoff, Namrata Jain, Rajesh Devraj, Shyam Dasgupta, K. M. Bhakri, David Blamey, Deepak Ramsay, and Subbir Mukherjee.

Finally, a note on transliteration. On this point, we have striven for clarity rather than consistency. For Sanskrit, we have used the International Alphabet of Sanskrit Transliteration scheme (IAST). For Hindi, we have used both the IAST as adapted for Hindi words (e.g., *ḍāyan*) and the Indian Languages Transliteration scheme (ITRANS), which is frequently used in Indian film titles (e.g., *daayan*).

<div style="text-align: right;">
Brian Collins

Athens, Ohio

September 2020
</div>

Introduction

Brian Collins, Aditi Sen, and Ellen Goldberg

A Short History of Indian Horror Films

Ideally, a book on Hindi horror films should begin by presenting a brief introduction to the subject, including its historical development. That said, it is notoriously difficult to be certain exactly what the first Hindi horror film was. One possible candidate, simply titled *Haunted House* (1932), was unfortunately lost in a studio fire, and is purported to have been more comedy than horror besides. Many scholars begin with Kamal Amrohi's *Mahal* (Mansion, 1949) and consider it to be the first example of Hindi Gothic cinema. Whether it was first or not, it certainly served as a stylistic model and, a little more than a decade later, it was followed by a spate of successful films imitating *Mahal*'s Gothic trappings, including *Woh Kaun Thi* (Who Was She? 1964, dir. Raj Khosla), *Bees Saal Baad* (Twenty Years Later, 1962, dir. Biren Nag), *Bhoot Bungla* (Haunted Bungalow, 1965, dir. Mehmood), and *Kohraa* (Mist, 1964, dir. Biren Nag).

In the 1970s, the massive box office success of Rajkumar Kohli's monster movie *Jaani Dushman* (Sworn Enemy, 1979) proved that the creature feature could find an audience in India, but it was the seven sons of F.U. Ramsay—Kumar, Tulsi, Shyam, Keshu, Kiran, Ganguly, and Arjun, known collectively as the Ramsay brothers—who took the genre to the mainstream. While they were not the first horror filmmakers, the Ramsays laid the foundation for the basic framework of horror cinema from the early 1970s to the late 1980s with commercially successful films like *Do Gaz Zameen ke Neeche* (Six Feet Under, 1972) *Aur Kaun* (Who Else? 1979), *Purana Mandir* (The Old Temple, 1984), and *Veerana* (Desolate, 1988).

The Ramsay formula built on the simplistic good-versus-evil plot that was already present in earlier Gothic films with the addition of a grotesque and often sexually predatory monster as the antagonist. The premise in a Ramsay film was

simple: There is a monster lurking in a haunted or cursed place that the villagers never disturb. Then a group of young, attractive, Western-educated urban protagonists who are ignorant of the local folklore come in and foolishly let loose the monster. In the end, the monster is defeated by a jeweled *Oṃ* symbol, Śiva's trident, or some other piece of religious iconography. In a Ramsay film, the dichotomy between good and evil tends to be clearly laid out with little space for ambiguity.

After their successes, other aspiring horror filmmakers soon jumped on the Ramsay bandwagon and started producing similar films. Two such Ramsay-inspired directors were Vinod Talwar and Mohan Bhakri. Between 1987 and 1991, Talwar made half a dozen movies with memorable titles like *Wohi Bhayanak Raat* (That Terrifying Night, 1989) and *Khooni Panja* (The Bloody Claw, 1991). Bhakri was even more prolific, directing a slew of low budget movies that included *Cheekh* (Scream, 1985), *Kabrastan* (Graveyard, 1988), and *Khooni Murdaa* (The Bloody Dead, 1989).[1]

It was the lackluster box office performance of the Ramsays' *Bandh Darwaza* (Closed Door, 1990) that marked the end of the Ramsay era. *Bandh Darwaza* had flopped even though it had all the Ramsay staples, including India's favourite monster, "Samri," and was a well-made film with a rather engaging story to boot. By the early 1990s, the genre was out of steam and the Ramsays moved to television, where they had some success producing the anthology series *Zee Horror Show* for the 9:30 Friday night-time slot from 1993–7 and its successor show, *Anhonee* (Omen), from 1997–2000.

But with the fading of Ramsay-style films came the subsequent rise of a new type of very low-budget horror film. Many filmmakers had joined the Ramsay bandwagon primarily because low-budget horror cinema was a lucrative business in the 1980s. And to cut costs and maximize profits, creative filmmakers developed an arsenal of tricks and techniques. For example, Joginder Shelly took Kamal Hasan's existing Tamil film *Behroopiya* (Shapeshifter, 1984), dubbed it in Hindi, edited in some shots of himself as the monster, and released it as a Hindi film called *Pyasaa Shaitan* (Lusty Demon, 1985). Movies like these often lacked a coherent plot, since the main attraction were the monster (frequently, a man in mask) and the promise of sex scenes. One practice that began in the late 1980s and continued into the 2000s was the use of "cut-pieces," a term for sexual content surreptitiously spliced into the film. Cut-pieces could either be a few minutes of random pornographic imagery temporarily inserted into the reel, or a scene of sex or nudity taken out of the original cut of the movie and then re-inserted (again, temporarily) after the movie had passed the censor board.[2]

Needless to say, these low-budget and salacious films were very far from mainstream, and it is only because of fan interest in cult cinema, often shared over social media, that they have had some academic and mainstream recognition today.

Hindi horror cinema began to make a comeback when it took a more sophisticated approach like the one exemplified in *Talaash: The Answer Lies Within* (2012, dir. Reema Kagti), which boasted major stars Rani Mukherjee, Kareena Kapoor, and Aamir Khan and had a very good opening at the box office. The main theme of the film is coping with the grief of a child's death, and it explores the fuzzy realms of mental illness and the supernatural. Similarly, although it was not a commercial success, *Ek Thi Daayan* (There Was Once a Witch, 2013, dir. Kannan Iyer) used folk beliefs about witches to spin a story about deep-seated psychological traumas. Both films were evidence not only that established stars were now willing to do this new type of horror film, but that the genre itself was finally incorporating different styles and ideas.

Current horror films are increasingly socially and politically conscious and many of them want to make a statement. Horror has always been a tool of subversion and the current Indian political climate is therefore particularly conducive to that aim.[3] For example, *Kaal* (Time, 2005, dir. Soham Shah) is a horror film that delivers a timely message about protecting the forests and the environment. *Aatma* (2013, dir. Suparn Verma) deals with the theme of domestic violence. *Raagini MMS* (2011, dir. Pawan Kripalani), inspired by the American found footage blockbuster *Paranormal Activity* (2007, dir. Oren Peli) as well as real events that took place in Delhi, is about both the clandestine internet sex tape market and the phenomenon of witchcraft accusations. And even the zombie horror comedy *Go Goa Gone* (2013, dirs. Raj and D.K.) is set against the backdrop of the epidemic of drug abuse and the Russian mafia presence in Goa. Horror is not just jump scares and scary monsters anymore. It does not allow the audience the comfort of being spooked without feeling uncomfortable. In fact, it demands that the audience feel revulsion, distaste, anger, pain, and resentment.

The year 2018 was significant as two horror films witnessed both critical and commercial success. Set during the Raj in the early twentieth century, the period piece *Tumbbad* (dir. Rahi Anil Barve) is an example of modern mythological Gothic horror, centering on an ancient evil god called Hastar, who resembles the Hindu god of wealth (and death) Kubera very closely and instills insatiable greed in anyone who comes into contact with him.[4] The horror comedy *Stree* (Woman, dir. Amar Kaushik Woman) expands upon a local urban legend that was popular in the Kannada-speaking region of South India in the 1980s. According to the

legend, once a year, for the length of a four-day *pūjā*, a witch known as Stree takes human form and abducts unsuspecting men at night, stealing their bodies and souls and leaving only their clothing behind. The only men who are safe from her are those from households that write the phrase "*O Stree Kal Aana*" ("Oh Woman, come tomorrow") on their walls. In the film, men who have ignored the custom begin to disappear, prompting other men to dress in women's clothing in an attempt to hide from the witch. Given these elements of cross-dressing and the fact the hero who tames the witch is the son of a prostitute, the movie raises questions about gender roles and sexual morality.

This year also saw the streaming giant Netflix release *Ghoul*, their first Indian horror series. *Ghoul* is set in a detention center and produced by Blumhouse, the American production company behind the socially conscious horror blockbuster *Get Out* (2017, dir. Jordan Peele). *Tumbbad*, *Stree*, and *Ghoul* represent the extended journey of the horror genre in India, drawing elements from campfire ghost stories, mythology, Hindi horror comics, international cinema, and folklore. Their successes were notable because the horror genre was and is routinely dismissed by Indian cinema critics. But their popularity with filmgoers is indicative of how the Indian audience has grown more sophisticated and changed the way it consumes and comprehends horror.

Looking for Horror in Bollywood

Until recently, Indian horror cinema has been the province of niche collectors and B-movie aficionados who treated it as a curiosity.[5] But this has begun to change, and there are now several recent academic books that have provided a context for understanding Hindi horror cinema and performed some thoughtful analysis of its themes, conventions, and historical development. Journalist Shamya Dasgupta's *Don't Disturb the Dead: The Story of the Ramsay Brothers* does a thorough job of documenting the history of Ramsay Productions, the family-led film dynasty responsible for the horror boom of the 1980s and 1990s.

Meheli Sen's *Haunting Bollywood: Gender, Genre and the Supernatural in Hindi Commercial Cinema* discusses the role of the supernatural in Bollywood movies and analyzes the ways in which it manifests in different film genres through the lenses of literary criticism, postcolonial studies, and queer theory. Meraj Ahmed Mubarki's *Hindi Cinema: Ghosts and Ideologies* uses psychoanalysis and critical theory to locate and analyze commercial Hindi cinema while

Mithuraaj Dhusiya's *Indian Horror Cinema: (En)gendering the Monstrous* goes beyond Bollywood and also includes a discussion of regional horror cinemas.

Taking a broader view of "horrors" than other books have done, this volume will look at three related categories of horror as they pertain to Bollywood films: (1) horror as a genre, (2) cinematic portrayals of real-life horror, and (3) the affective response to both. As both Dhusiya and Mubarki do in their respective works, we also find it necessary to delve into the central definitional problem of what kind of Indian films qualify as what Noël Carroll has called "art-horror" in his influential writings on the philosophy of horror. With the term "art-horror," Carroll is referring to horror as a cinematic and literary genre with distinctive characteristics, not to be confused with "natural horror." For Carroll, the term "natural horror" is properly used when a horrifying or repulsive event happens in a non-horror movie, such as the gruesome deaths that stuntman Cliff Booth (Brad Pitt) deals out to the Manson Family-esque home invaders in the climax of Quentin Tarantino's *Once Upon a Time in Hollywood* (2019). While it certainly features blood and gore, *Once Upon a Time in Hollywood* would never be classified as a horror movie.

Gore and violence do not a horror movie make. And neither, necessarily, do monsters. Carroll explains:

> What appears to distinguish the horror story from mere stories with monsters, such as fairy tales, is the attitude of characters in the story to the monsters they chance upon. In works of horror, the humans regard the monsters that they encounter as abnormal, as disturbances of the natural order.[6]

It is clear that, while the cult TV show *Buffy the Vampire Slayer* (1997–2003) and the *Twilight* series of books and movies are populated by werewolves and vampires, neither can be considered "art-horror" because the monsters encountered by the characters function no differently in the action than any human antagonist would. They are not "disturbances of the natural order." Turning to India, the eleventh century *Vetālapañcaviṃśati* (Twenty-five Tales of the Vetāla, translated by Sir Francis Burton in 1870 as *Vikram and the Vampire*) is a series of stories within a frame story narrated by a talking corpse, but the stories themselves are no more or less "frightening" than any other Sanskrit story collection of the period. We cannot call this art-horror either.

We can extend Carroll's logic about the generic conventions of art-horror to make a different but related point. When dealing with realistic movies (as opposed to movies that take place in other realities, as is often the case in science fiction and fantasy), the distinction between art-horror and natural horror

revolves around the question of whether the feared antagonist is a particularly terrifying part of the movie's natural world (like a serial killer or a rabid dog) or a *thing that should not be* (like an evil protean clown or a haunted house). In the first case, the characters may fear for their lives, but they tend to react with a kind of pulse-pounding, adrenaline-fueled fight-or-flight response. But in art-horror, Carroll observes, "we often see the character shudder in disbelief, responding to this violation of nature."[7]

The violation of nature as a prerequisite for art-horror also conditions the way audiences relate to the film. As an example, when the characters in *Jaws* (1975, dir. Steven Spielberg) encounter the (often assumed to be titular) killer shark, they experience both terror and horror. But they do not experience the trauma of being forced to give up their entire previously held worldview. On the other hand, in *The Omen* (1976, dir. Richard Donner), the main characters simultaneously come face to face with an actual Hell-spawned demon *and* the mind-shattering revelation that their rationalist assumptions about the world, by which demons cannot exist, were wrong. Typical American audiences can realistically imagine themselves living in the universe of *Jaws* (albeit with some reservations about the improbably large size of the shark). But they cannot imagine themselves living in the universe of *The Omen* because they have no reason to accept the existence of demons who can possess and control human beings. *The Omen* is therefore a horror movie. *Jaws* is not.

It is not clear that we can easily make the same kind of distinction as the one made above between *The Omen* (art-horror) and *Jaws* (not art-horror) when dealing with Bollywood horror movies. This realm of ambiguity is where the religious studies focus of this volume comes into play. Since all three of the editor-contributors and two more of the other contributors work in the field of religious studies, religion takes a prominent place in our analysis in a way that not yet been done in scholarship on Hindi horror films. And, in focusing on religion, the essays in this volume are engaging the question of what it means to be a horror movie in India in a new way.

Having established some parameters for what Carroll calls art-horror, we will now turn to the three distinct but related understandings of horror that inform this book and unpack them one by one, explaining the theoretical framework we will be using to interpret them: religious studies frameworks for understanding the iconography of horror, classical Sanskrit theories of aesthetics for understanding horror as affect, and scholarship from critical theory of various types to understand the presentation of real-life horror through the medium of film.

Horror as a Genre: Conventions of Bollywood Horror Through the Lens of Religious Studies

For over three decades, Hindi horror cinema has used monsters (often derived from Indic demonology), jump-scares, Gothic-inspired settings, and other reliable horror tropes to deliver fright to the audience. But unlike most other horror movies from around the world, Bollywood horror movies of the 1980s and 1990s prominently feature the song and dance numbers typical of Indian popular cinema. Somewhat less frequently, they also include martial arts scenes imitating Kung Fu and *wuxia* films from Hong Kong, pitting the heroes against a gang of *tāntrika*s or *goonda*s.[8] Partly as a result of these obligatory sequences, Bollywood horror movies also run about an hour longer than British, European or American horror films of the same time period.

But what is useful about Carroll's notion of art-horror is that it allows us to think about the generic conventions of horror apart from these cultural differences (all of which serve to meet the Indian audience's expectations). Following Carroll's definitional logic, if the antagonist confronted by the heroes in a film appears as a "violation of nature," the film is art-horror no matter how much singing and martial arts it contains. A film can have characteristics that American audiences would not recognize and still be art-horror, but it can also lack characteristics that some audiences might see as essential and still do the same. Contrary to some expectations, art-horror does not necessarily require the jump scares and special effects common in American films.

For example, so-called "cosmic horror"—usually associated with H.P. Lovecraft (1890–1937) and those who draw inspiration from his work—frequently eschews the element of suspense but is none the less an unalloyed form of art-horror because it focuses on piercing the façade that is reality and revealing the unknowable, incomprehensible void behind it. One popular work that could be classified as cosmic horror is the Stephen King novel *Revival* (2014), in which a minister who has lost his Christian faith upon the deaths of his wife and child looks beyond the veil into the afterlife and sees a monstrous nightmare in which an endless procession of human souls suffers eternal slavery in a realm of black chaos.

What matters most for art-horror is not whether there are choreographed dances or jump-scares or not, but to what extent a film leaves its audience's worldview intact. This means that understanding an audience's worldview is essential to understanding their idea of horror. Given the connection between the plots of Bollywood horror films and the religious context in which they play

out—a connection has all sorts of connotations for understanding horror as a genre in India—we think that a religious studies approach can yield some new and useful insights. To demonstrate, we will consider the Ramsay brothers' *Veerana*, in which a *tāntrika* uses his powers to place the spirit of a dead witch into the body of the local landlord's daughter. The film begins with this disclaimer:

> This movie is a work of imagination, a concocted story written with influence from ancient folklore and mythological stories. In this film there is mention of ghosts and goblins (*bhoot-pret*), witches (*chudail*) and black magic (*kaala jadoo*) such as nefarious powers (*naapak shaktiyon*), which do not exist in today's reality. Viewers are requested to watch it purely for entertainment as the film has no connection to reality.[9]

If we take the disclaimer at face value, it informs the audience that the witches and black magic in the movie are make-believe. The reason for making what might seem such an obvious claim is the fact that the witch and the black magic in the film are inseparable from the black-robed *tāntrika* who summons one and wields the other, respectively. The significance of this inseparability is that the viewer knows that *tāntrikas* are real without a doubt, so it is therefore unclear whether the witch who possesses the heroine through black magic in *Veerana* is meant to inhabit the same realm as the viewers do.

Notably, while it is more common among some groups than others, many Hindus accept spirit possession as part of the natural order. Is the possession by a goddess part of the natural world while possession by a witch is not? More to the point, if the audience disbelieves in the witch, must it also then disbelieve in the god Śiva, whose *murti* destroys her with its power? Surely not, as Hindus pray in front of *murti*s on a daily basis because they have such power.[10] It is also worth noting that in 1982, six years before the release of *Veerana*, there were twelve witchcraft-related murders in the Malda district of West Bengal and there were about sixty in the state of Jharkhand in the 1990s.[11]

This is not to say that all Hindus hold to a particular theology or that there is not significant opposition to these beliefs. Indeed, the speedy passage of the wordily titled Maharashtra Prevention and Eradication of Human Sacrifice and other Inhuman, Evil and Aghori Practices and Black Magic Act in 2013 precisely exemplifies a thoroughly rationalist-materialist form of such opposition.[12] We certainly do not endorse any generalizations about Indian culture being inherently "superstitious." We only point out that demonology is intimately connected with other aspects of the spirit world, including the goddesses who possess their devotees on a regular basis at temples and festivals. While possession

practices may be more or less unusual given the part of the country one lives in, few in India would call them "abnormal." It is not the case that every member of the audience in an Indian movie would believe in possession, but it is certainly the case that the supernatural elements and demonology in Bollywood horror movies tend to exist alongside things like prayers answered by gods and the power of religious iconography that are part of the "natural" world.

With some exceptions, like Narendra Nath Bhattacharyya's *Indian Demonology: The Inverted Pantheon*, the rich demonological lore of South Asia has not been systematically studied in recent works. This is regrettable because demonology has clearly been a large part of the spread of Sanskritic culture, as David Gordon White has demonstrated in pointing out the important role played by malevolent supernatural entities, many of whose names are associated with screaming and howling, in tracing the transmission of Tantric traditions into South and Central Asia.[13] More recently, Benedict Anderson and Erik Davis have written about the popularity of Southeast Asia's ghost festivals and hell-themed monastic parks featuring Buddhist demons derived from Indic mythology.[14]

The witches, evil spirits, black magicians, and curses that populate Bollywood horror are drawn from a tradition that, by the early modern period, had already spread far and wide and come into contact with Buddhist, Islamic, Manichean, Christian, and Zoroastrian cosmologies. And as Natasha Mikles and Joseph P. Laycock have demonstrated, a handful of Indo-Tibetan demonological ideas have spread very far west indeed as they were picked up and heavily modified by Theosophists in the nineteenth century.[15] The idea of the *tulpa* or "thought-form," understood as an entity that feeds on the fear or belief of humans, is a staple in Western horror, from Freddy Krueger in the *Nightmare on Elm Street* series to the internet-based mythology of Slenderman. A related bit of cultural borrowing occurs in Stephen King's 1986 novel *It*—as well as the 2019 blockbuster movie it inspired—in which the heroes perform a ritual named after and (very) loosely inspired by the Tibetan rite of *chöd* in order to defeat the demonic clown-creature Pennywise (who also bears some resemblance to a Western *tulpa*).

We think it is therefore useful when attempting to understand the broader cultural context of Bollywood horror films to pay attention to the religious elements in them. Accordingly, throughout these essays, we will draw attention to Indian myths, rituals, iconographic elements, and religious attitudes when they are relevant to our analyses. And, along with looking *at* elements of Indian thought, we also think it is sometimes useful to look *through* elements of Indian thought, specifically the Sanskrit aesthetic philosophy of *rasa*, in order to better

illuminate the sources of indigenous South Asian horror traditions and give readers a new perspective on horror in general.

Horror as Affective Response: Reading Bollywood Horror with *Rasa* Aesthetics

The shudders and other visceral responses of the horror movie heroines (or "Scream Queens," to use a genre-specific term) to which Carroll directs our attention are more than just convention. They may also tell us something about the nature of horror. Carroll explains:

> The reports of characters' internal reactions to monsters—whether from a first person, second person ... or authorial point of view—in horror stories correspond to the more behavioral reactions one can observe in theater and cinema. Their faces contort. They freeze in a moment of recoil, transfixed, sometimes paralyzed. They start. Their hands are drawn toward their bodies in an act of protection but also of revulsion and disgust. Along with the fear of severe physical harm, there is an evident aversion to making physical contact with the monster. Both fear and disgust are etched on the characters' features. Within the context of the horror narrative, the monsters are identified as impure and unclean. They are putrid or mouldering things, or they hail from oozing places, or they are made of dead or rotting flesh, or chemical waste, or are associated with vermin, disease, or crawling things. They are not only lethal but they make one's skin creep. Characters regard them not only with fear but also with loathing, with a combination of terror and disgust.[16]

We think that these aspects of horror film appreciation can be illuminated by discussing them in terms of *rasa*, the classical Sanskrit philosophy of aesthetics. Centuries before Freud's "death drive," Kristeva's concept of "abjection," Bakhtin's "grotesque body," or Becker's "terror management theory," Sanskritic philosophers had already developed in *rasa* a classification scheme that accounted for the role of the terrifying (*bhayānaka*) and the horrifying/repulsive (*bībhatsa*) in art and religion.

In his 300 CE *Treatise on Drama* (*Nāṭyaśāstra*), Bhārata elucidates the eight *rasa*s, or aesthetic modes. Along with *bhayānaka* and *bībhatsa*, they are the erotic (*śṛngāra*), the comic (*hāsya*), the violent (*raudra*), the pathetic (*kāruṇya*), the heroic (*vīra*), and the marvelous (*adbhutam*). Further, he clarifies that of the eight *rasa*s, four are generative and the other four are generated as their correlates:

From the erotic arises the comic, from the violent the tragic, from the heroic the fantastic, and from the macabre the fearful. The comic may be described as an imitation of the erotic, and the tragic *rasa* may be understood as an effect of the violent. The fantastic is declared to be an effect of the heroic, and the fearful should be understood to come about at the sight of the macabre.[17]

The *bhayānaka rasa* (translated above as "fearful") comes from the Sanskrit root √*bhī* ("to fear"), and its generated correlate, the *bībhatsa* (translated above as "macabre"), despite its resemblance to √*bhī*, is actually a desiderative formed from the root √*bādh* ("to oppose") and means something like "repulsive" or "repellant." Bhārata elucidates and distinguishes the two *rasa*s, writing that the *bhayānaka* "can be simulated, or stem from a criminal act, or be anything a timid person finds frightening" while the *bībhatsa* "can be pure or impure: the former is disturbing, and is brought about by the sight of blood and the like; the latter is disgusting, and is brought about by the sight of excrement, maggots, and so on."[18]

When focusing on the horror genre specifically, which offers chills as well as thrills and promises to make the audience shudder as well as scream, there are good reasons to translate *bhayānaka* as "terror" and *bībhatsa* as "horror." This follows the useful taxonomy that Charles Darwin lays out in *The Expression of the Emotions in Man and Animals*, listing some of the same associated psychophysical responses that Bhārata had delineated in 300 BCE for each emotional state.[19] It also speaks to the tension between high-brow and low-brow conceptions of scary entertainment found in India and elsewhere. For instance, in an effort to distance himself from the more unsavory aspects of his genre, the horror icon Boris Karloff insisted in his 1962 interview with *Psycho* author Robert Bloch that he made "terror" movies and not "horror" movies, complaining, "I wish the movies had never found that ["horror"] label ... There's nothing pleasant, nothing appealing, about the word. It doesn't promise entertainment."[20]

Perhaps more germane to the discussion at hand is the formulation put forward by pioneering British Indian-born Gothic scholar Devendra Varma: "The difference between Terror and Horror is the difference between awful apprehension and sickening realization: between the smell of death and stumbling against a corpse."[21] Or, to put it in operational terms, there is Stephen King's self-aware admission: "I recognize terror as the finest emotion ... and so I will try to terrorize the reader. But if I find I cannot terrify him/her, I will try to horrify; and if I find I cannot horrify, I'll go for the gross-out. I'm not proud."[22]

The "gross-out" King is talking about partakes of horror, to be sure, but it often also mixes with the comic, as it does in the "splatter" horror-comedies of Peter Jackson and Sam Raimi as well as the ironic enjoyment of low-budget Bollywood

B- and C-movies. In his seminal study *Laughing Screaming: Modern Hollywood Horror and Comedy*, William Paul argues that the political and social upheavals taking place in America in the 1970s and 1980s "enabled [Americans] to reestablish ties to a repressed tradition of vulgar art," leading to the popularity of slasher movies like *Friday the 13th* (1980, dir. Sean S. Cunningham) as well as teen sex comedies like *Porky's* (1981, dir. Bob Clark).[23]

Turning to classical Indian aesthetics, David Gitomer observes that this connection between revulsion and laughter is encoded not just in theory but in performance. He writes:

> The great Odissi dancer Sanjukta Panigrahi, for example, in one portion of her act represents in succession the nine *rasa*s. Not only is *bībhatsa* alone presented with narrative content (finding a worm in the food—she merely strikes a pose for each of the other eight)—but the shrinking grimaces are clearly meant to evoke laughter on the part of the audience, not revulsion.[24]

There is also some gross-out humor in the bizarre bazaar held in a cremation ground in the *Śitalā-maṅgala* of Dvija Nityānanda, an eighteenth-century Bengali poem connected to the cult of the smallpox goddess Śitalā:

> The ears of corpses were sold in the market as *pān* [betel leaf], and the pupils of their eyes as *śali*-rice. Female ghouls bought bags of brains as lime, and rotten melting corpses as perfume. Pairs of ears were sold as incense, finger and toe nails as husked rice, and the penises of boys [as] enticing dates. Palates were sold as ripe cantaloupe and human heads as vegetables. Vomited blood is the best-loved drink of ghouls; human blood is sugarcane juice for them. Demons bought and ate the breasts of dead women as if they were custard-apples or pomegranates, with great delight . . .[25]

Between the seventh and ninth centuries, the Sanskrit dramatists Bhāvabhūti and Ārya Kṣemīśvara cultivated horror and terror as transcendent aesthetic experiences, prompting the questions one still hears today about the aesthetic paradoxes of horror enjoyment ("What is so fun about being scared?"). They also juxtaposed terror and horror with other *rasa*s to heighten the effect. In one memorable passage of what we might call "gore-rotica," Bhāvabhūti's *Mālatīmādhava* combines horror and eroticism, portraying a scene in which "with guts for bracelets, and elegant flower chains of hearts, and women's *lac*-painted hands for red lotuses at their ears with thick blood for makeup, the demon women join their lovers and drink in skull goblets the marrow wine."[26]

Thinking of *rasa* in this way leads us back to religious studies scholarship. Taking up images of death, decay, and the grotesque, Bengal scholar Edward Dimock has noted the place of the repulsive in the concept of *āndolan* or "oscillation," the nature of reality as it appears in the partial view granted to human beings as opposed to the all-encompassing powers of perception attributed to the goddess:

> As all forms of the divine are possible, there is no difference, except to limited human sight, between what is beautiful and what is repulsive. In the divine realm of the goddess, in her *avatāras* and in the texts that describe them, these opposites do not exist ... The repulsive, horrifying form, as it seems to our eyes, is latent in good times; or perhaps it would be better described as repressed, for, poor weak creatures that we are, we cannot see that the distinction is false, and could not stand it if we did ... [What] is grotesque is what is exaggerated, and in the divine realm the concept "grotesque" cannot exist.[27]

The title of the essay from which the above words are quoted, "A Theology of the Repulsive," could well serve as watchwords for our study and we will keep them in our sights. But alongside horror as affect and horror as genre, we must also consider the real-life horrors of human cruelty and desperation that are all too present in our world and take specific forms in contemporary India.

Horror as Representation: The Portrayal of Real-life Terror

The now-defunct Indian Horror Tales blog proclaims (presumably regarding the same *bhoots*, *prets*, and *chudails* disavowed by the Ramsays in their disclaimer at the beginning of *Veerana*):

> Since centuries they have been dwelling in this land, migrating to places & forms, awaiting reincarnation. From the dark forests to the crowded bazaars—from abandoned forts to lonely village roads—they are still there, everywhere. Urbanization may simply camouflage them but their reflections can be sensed by those open to their vibes.[28]

Comparing *Veerana*'s relegation of demonology to the realm of the unreal and the Indian Horror Tales blog's insistence that demons never die, but only change form, we can boil down these two opposing viewpoints into an either-or proposition: Either Indian horror films are purely for entertainment, or they relate in some substantive way to today's reality, with its own attendant horrors

(e.g., Prime Minister Narendra Modi's sudden and complete transformation of Kashmir into a virtual prison camp for seven million people in August of 2019 or the mob violence committed against JNU (Jawaharlal Nehru University) students and those protesting the Citizenship Amendment Act in December and January of 2020).

We titled this book "Bollywood Horrors" out of recognition that horror is both a genre and a subject matter and that, although cinematic treatments of the two do not always overlap, they relate to each other in important ways. The uneasy proximity of real-life atrocities, supernatural beliefs, and the titillations of cinematic terror is not unique to Bollywood. Pier Paolo Pasolini's *Salò, or the 120 Days of Sodom* (1975), a study—set in Fascist Italy—of sexual sadism and a dark political satire based on Sade's famous unfinished work, portrays the corrosive power of authoritarian rule in terms of Sadean excess. While it would not qualify as art-horror, *Salò* was listed by the Chicago Film Critics Association among the top 100 scariest films ever made, despite the lack of any monsters or jump-scares.[29]

If horror films are pure entertainment, providing nothing more than safely unrealistic monsters to induce cathartic chills and thrills in their audiences, then it would be bad taste to analyze them alongside films dealing with real-life horrors like communal violence and sex trafficking. If they are something more, then such a comparison might be very useful, even if it is still not in good taste. But then, good taste is not something of which horror films have been very often accused, so perhaps it is the wrong standard to apply.

Two examples from recent Indian scholarship, both of which connect the idea of horror to the social and political forces in Indian society, will illustrate the point. The first comes from an essay by Arindim Chakrabarti titled "Refining the Repulsive: Toward an Indian Aesthetics of the Ugly and the Disgusting." Tying together the subjective aesthetic experience of horror with political commentary, Chakrabarti describes his affective response to a scene from an Urdu story by Sadaat Hasan Manto in which a child comes upon the body of an ice vendor stabbed to death during the communal riots that accompanied partition in 1947 and mistakes his congealed blood on the road for jelly:

> I am repulsed even to imagine clots of human blood mixed with melting ice looking like edible jelly to a child. It suggests cannibalism. The clear hint that the blood is from an innocent victim of mass ethnic violence adds moral nausea to my gut-disgust. I take no masochistic delight in painful revulsion or abomination. Yet I *like* the story as a work of art. I would even say that it is a beautiful story. Why?[30]

To set alongside this reflection on the appreciation of horror, we can take Shakuntala Banaji's observation about contemporary audiences' enjoyment of Hindi horror films:

> In Bollywood, horror is professional women who undermine men, families who abandon their elderly, those who disrespect the gods; but it is also the rape and murder of vulnerable persons; the absence of regulation in mental healthcare in the global south; the desolate silence in the abandoned courtyard; the bloodthirsty rage of the unavenged; the inexplicable "other" who refuses to die, to change, or to submit. Unlike their romantic counterparts, Hindi horror films do not excise any of these issues: they wallow in them. They probe the effects both of apparently indigenous traditions and of unevenly experienced modernity. They do so in ways that are ideologically structured and ribald, open to carnivalesque enjoyment and disgust.[31]

As these quotes from Chakrabarti and Banaji suggest, and as the essays in the volume will demonstrate, horror in the Indian context is as much about the fear of human violence and unwelcome social changes as about supernatural and the uncanny.

The Structure of this Book

The eight chapters of this book explore the contributions that individuals, films, and aspects of material culture have made to the discourses on violence, religion, and cinematic fears in Bollywood. While our treatment is not intended to be exhaustive (and necessarily excludes some important issues and films), our hope is that the wide-ranging perspectives we have addressed will shed light on the multi-faceted subject of horror in Indian cinema.

The book is divided into three sections. The first section, "Material Cultures and Prehistories of Horror in South Asia," begins with Brian Collins's chapter titled "Monsters, *Masala*, and Materiality: Close Encounters with Hindi Horror Movie Ephemera." In this chapter, Collins is interested specifically in the materiality of Hindi horror movie posters and song booklets, which he argues constitute a type of advertising unique to Indian cinema. As a long-time collector himself, Collins uses extensive (and often exclusive) archival visual materials to discuss a diverse range of subjects including possession, colonialism, tantra, *rasa* aesthetics and the idea of the wet *sari*. Collins's chapter also contains ten color reproductions of movie posters and song booklets.

The other chapter in this section, also by Collins, is titled "Vampire Man Varma: The Untold Story of the 'Hindu Mystic' Who Decolonized Dracula." In it he argues that although conventional wisdom holds that the haunted house and other Gothic tropes found in Hindi horror movies are simply borrowed from the West, this does not tell the whole story. In an attempt to do just that, Collins explores the remarkable life and work of Sir Devendra Prasad Varma, a former Gurkha paratrooper and lifelong friend of Jawaharlal Nehru, who was one of the most significant writers of the second generation of Gothic fiction scholars. Collins recounts how Varma sought out lost Gothic works as an archivist and oversaw their republication, performed Shakespeare for Gamal Abdel Nasser in Damascus, hosted "Transylvania Weekends" at Dalhousie College, befriended horror movie icons Vincent Price and Christopher Lee, was inducted into the Dracula Society in Hollywood, and published an essay tracing all vampire legends back to Tibet. Collins maintains that without a treatment of Varma and his works (presented in this chapter using exclusive archival photos from Varma's estate), no account of the adoption of Gothic conventions in Indian cinema is complete.

The second section, "Cinematic Horror, Iconography, and Aesthetics," opens with Kathleen M. Erndl's "Divine Horror and the Avenging Goddess in Bollywood." In her essay, Erndl maintains that classical Indian aesthetic theory speaks of successful drama as an ideal mix of dominant and subordinate *rasa*s that evoke in the audience appropriate, elevated moods that are central to the aesthetic experience. The category of "horror" most closely corresponds to the *bhayānaka* or "terrifying" *rasa*, though it also includes at least a taste of *bībhatsa* or "disgusting" *rasa*. Echoing and transforming themes in the *Rāmāyaṇa*, *Mahābhārata*, and oral traditions of India, Bollywood has a pervasive fascination with what Erndl calls the "Avenging Goddess" motif, where a woman, subject to violent oppression, transforms into a horrific Durgā or Kālī-like goddess to exact revenge upon the demonic forces and re-establish justice. Erndl shows how the social, political, and economic oppression of women is homologized with the cosmic struggle between *devas* and *asuras* (gods and demons), and *dharma* and *adharma* (righteousness and unrighteousness). An ordinary woman killing a rapist becomes Durgā slaying the Buffalo Demon. Using a cluster of films starting with *Pratighat* (Retribution, 1987, dir. N. Chandra), Erndl explores how through visual, aural, and lyrical means, "Avenging Goddess" films evoke the *rasa*s of terror and disgust to create "Divine Horror."

Next comes Hugh Urban's "Horrifying and Sinister *Tāntriks*," the first essay we included in this volume that did not come from the 2016 panel. It was chosen because it fit squarely into our existing framework for picking out what is unique

about the horror genre in India. In his essay, Urban explores the portrayal of sinister *tāntrikas, sadhus,* and black magicians in a variety of films including *Gehrayee* (Depth, 1980, dirs. Aruna Raje and Vikas Desai), *Jadugar* (Magician, 1989, dir. Prakash Mehra), and *Sangarsh* (Struggle, 1999, dir. Tanuja Chandra). Urban argues that these modern Bollywood productions draw upon the image of the "sinister *yogī*," which David Gordon White has shown is a recurring trope throughout medieval Sanskrit and vernacular Indian literature. Like the medieval sinister *yogīs,* Urban claims Bollywood villains are associated with all manner of terrifying and transgressive activities, ranging from black magic, sorcery and exorcism to sexual perversion and child sacrifice. Urban also provides a brief history of tantra in South Asian literature as background for understanding a variety of Tantric images and themes in Bollywood film.

In the third and final essay of section two, "Do You Want to Know the *Raaz*?: Sāvitri, Satyavān, and the Other Woman," Aditi Sen argues that *Raaz* (Secret, dir. Vikram Bhatt), a major box office success in 2002, retells the myth of Sāvitri and Satyavān and thus opens up space for discussion about the boundaries of *strīdharma* (rules of conduct governing women), the sanctity of marriage, mainstream religion versus folk religion, the limits of sexual morality, and madness. Sen identifies how *Raaz* blends the polarizing ideas of the holiness of traditional marriage and the lure of illicit sexual relationships. She also shows how the romantic journey of the central couple in *Raaz* provides the perfect backdrop to analyze many complex subjects including divorce, evil spirits, possession, ghosts and madness—elements that throughout the film attempt to subvert the patriarchal order of married life.

The third section, "Cultural Horror," begins with Ellen Goldberg's "Cultural Horror in *Dev*: Man Is the Cruelest Animal." Goldberg argues that horror can be construed in various way, and while *Dev* (2004) is not strictly considered among the standardized Hindi formula horror genre films, it is director Govind Nihalani's extremely bold and graphic attempt to capture the real-life horror of recurring Hindu-Muslim communal violence. Goldberg looks at the haunting effects of social trauma in the 2002 pogrom in Gujarat as a way to interrogate and unravel *Dev's* complex narrative. She applies insights from Hannah Arendt on the politics of evil, Frantz Fanon's work on understanding colonialism, and Sigmund Freud's theories of repression. Goldberg also looks at Indian film scholar Bhaskar Sarkar's work on trauma and cinematic mourning and situates his scholarship on Partition films within a framework that she calls "cultural horror" to reiterate how the memories and ghosts of Partition continue to haunt the Indian nation.

The next essay is "*Bandit Queen*, Rape-Revenge, and Cultural Horror," by Morgan Oddie. In it, Oddie discusses the controversial subject of graphic rape and violence depicted in Shekar Kapur's 1994 biopic of outlaw folk hero-turned-MP Phoolan Devi. Kapur's portrayal of gender-based violence illustrates a cultural horror grounded in reality, while at the time of its release, Devi's banditry and crimes against higher caste men were still fresh in the national consciousness. Oddie argues that Kapur's representation results in the over-signification of a subaltern, low-caste woman and reads similarly to a rape-revenge movie, in that it focuses on the violence to a woman's body to justify the violence she later enacts as revenge. Oddie claims that this diminishes the subversive qualities of Phoolan Devi's story, by emphasizing the horror she endured without adequate recognition of her agency as a dacoit or a survivor of the horrors of rape.

The last essay in the third section, focused on the 2014 film *Mardaani* (dir. Pradeep Sarkar), is titled "*Mardaani*: The Secular Horror of Child Trafficking and the Modern Masculine Woman." Author Beth Watkins argues that because *Mardaani*'s protagonist, Inspector Shivani Roy (Rani Mukerji), is a "masculine" woman, both the heroine and the villain represent (perceived) societal evils. The villain abducts children, typically young girls, and sells them into sex slavery; the hero subverts expectations of women to thrive in the domain of the home and to serve family and/or God. *Mardaani*, as Watkins shows, moves the avenging figure away from the spiritual and familial and into the professional, anonymous, public-serving world that derives its power from human-made law. In the mundane world, individuals remain largely unconnected to one another and innocent children are not protected by community, justice, or the supernatural. Although Roy restores the moral order, she ignores most societal conventions to do so. Her violence is not on behalf of God but for public good and personal catharsis. What Watkins identifies are two very different images of woman: the formidable image of woman as *śakti* and the cultural horror of the image of woman as chattel. Thus, the issues raised in this chapter are complex and multi-layered.

Part One

Material Cultures and Prehistories of Horror in South Asia

1

Monsters, *Masala*, and Materiality: Close Encounters with Hindi Horror Movie Ephemera

Brian Collins

Introduction: Posters, Song Booklets, and "Methodological Fetishism"

Scholars generally agree that the first promotional material of any kind for an Indian film appeared in the form of a newspaper advertisement for the 1913 "mythological" film *Raja Harishchandra* (King Harishchandra, dir. Dadasaheb Phalke).[1] However, no evidence exists for an actual poster until *Kalyan Khajina* (The Treasures of Kalyan, dir. Baburao Painter) in 1924.[2] And it was not until after the success of the publicity campaign for 1948's *Chandralekha* (dir. S. S. Vasan) that posters became widespread marketing tools.[3]

Typically, Indian movie posters advertise the title of a film and provide relevant information like stars, director, and songwriter. They also give an idea of the film's genre: mythological, social, family, or *masala* ("spicy"). When used to describe a film, *masala* refers to a something-for-everyone approach, with thrills and chills, dance and romance, as well as humor. As the director Manmohan Desai puts it, *masala* films should have "an item in every reel."[4] Given the amount of film contained in one reel, this amounts to a dance number, a fight scene, a jump scare, a romantic duet, or some slapstick comedy about every eleven minutes.

But when someone describes the style of a poster as *masala*, they mean something more like "[an] item in every square inch," often utilizing a bright color palette. Devraj and Bouman explain:

> An elementary color code marks the characters as positive or negative, with pink-faced heroines flinching from villains painted angry red or base green ...

The diverse elements are at times unified by some device like a spiral pattern or a background of flames. The title treatment is often monumentally three-dimensional and may wield its own pictorial elements, symbols representing the theme of the film like a rose, a chain, a pair of handcuffs, or a bloody dagger.[5]

As the art form of the Hindi movie poster developed, illustrators began to employ an established color scheme to advertise each movie's genre, using blue, purple, and dark green paint for action-oriented films and yellow, pink, and light green paint for family films. And even as posters incorporated more and more photographic elements and stopped relying on painting, this color scheme remained in use. "There is probably no [śilpa-śāstra] for this colour code," writes Stephen Haggard in an oft-cited article, "but the evidence of the posters suggests that it is known to artists and perceived by the public."[6] He continues:

> These systems of colour reference can also be found in the West, but a comparison of Hollywood and Bombay publicity shows a far less naturalistic, more symbolic use of colour in the Indian case. For example, the use of dark blue in poster representations of Amitabh Bachchan and Darmendra, the two rival heart-throbs of the late 1970s, is surely significant ... In the film *Mera Gaon, Mera Desh*, Dharmendra hides in a tree and secretly watches the village girls bathing in the river. This reference to Krishna is obvious, and there can be no doubt that similar associations are achieved by colouring a major male star blue in a poster.[7]

The *masala* style of poster design is rooted in Indian techniques of storytelling, art, and imagination. But it also rooted in another hallmark of Indian culture—bureaucracy. India is divided into eleven film distribution zones derived from an old Raj-era system: Bombay, Delhi, Nizam, East Punjab, Eastern, Central Provinces and Berar, Central India, Rajasthan, Mysore, Tamil Nadu, and Andhra. Purchasers of distribution rights must operate within these geographical confines, leading to large-scale and flashy advertising efforts to maximize their profits. Additionally, in each distribution zone there is an "A circuit" for the wide release of Bollywood blockbusters, a "B circuit" for re-releases of classic Bollywood films and new low-budget genre films, and a "C circuit" for "sexy horror" and soft-core pornography.[8] The posters that concern us here (if it needs to be said) come from the B and C circuits.

Song Booklets

When the tradition of printing promotional booklets for upcoming movies first arose in the 1920s, the booklets that were distributed contained stills, plot

synopses, and reviews, and were only intended for distributors and theater owners. But the arrival of sound in the 1930s and the subsequent popularity of film songs saw the addition of lyrics to the booklets, which began to be distributed to theatergoers in advance of a film's showing.[9]

A typical modern song booklet is 7in. × 10in., printed on magazine paper stock coated with kaolin to give it a slick feel, and is either one-fold with two inside panels or two-fold with three inside panels. In some cases, there is an additional page of cheaper newsprint paper glued or stapled inside like a magazine. The booklets also contain poster-style artwork for the film along with the title, credits, and a synopsis (*kathaasaar*). Usually, but not always, they also include the lyrics of one or more songs in Hindi, English, and sometimes Urdu. We should note here that, while Indian movie posters may have their own distinctive style, they are nonetheless recognizable as a type of promotional material found all over the world. The song booklet, on the other hand, is a form of advertising unique to India. As such, they share certain design characteristics with other products produced, circulated, and used within South Asia.

This brings us to another influence on the stylistic development of movie posters and song booklets that has been underappreciated: South Asian industrial design of the kind documented by design historians Catherine Geel and Catherine Lévy in *100% India*, their photography book featuring everyday objects ranging from bicycle reflectors to stamp pads.[10] In the introduction, Geel characterizes this design aesthetic:

> Indian objects are witty and spirited in every sense of the words. They are filled with sparkling details and possess a unique sensibility that refashions them again and again, in thousands of copies. What inspires workers and craftspeople to take the time to engrave little flowers on the most ordinary of glasses, to adorn radio-cassette players with flashing lights and LEDs? Rather than succumbing to the inevitable and reflexive appeal to a cultural habit that embellishes and elaborates everything (from frescoes to temple walls, from a taste for kitsch to precious textiles) I like to believe it to be the expression of a subconscious refusal to be subsumed by the market, like the stubborn recalcitrance turned against the British occupation in its day.[11]

Building on Geel's intuition, I will argue that the most useful way of interpreting these posters and song booklets requires us to see them as drawing from a deep well of cultural knowledge and forms, but also shaping and being shaped by the economies in which they circulate.

Market Forces and Methodology

"No social analysis of things," writes anthropologist of globalization Arjun Appadurai, "can avoid a minimum level of what might be called methodological fetishism."[12] By "methodological fetishism," Appadurai means that, in order to counterbalance what has historically been an overemphasis on human intention and cognition in the study of artifacts, a scholar must "fetishize," or imagine some inherent power in, whatever object she is studying. To carry out this recommendation, I will continually reframe and refocus my analyses of these posters and song booklets in this essay by returning to them as the *things* that they are—things that, when interpreted in their overlapping contexts, can tell us much about the intersecting currents of human activity in which they are caught.

As the objects of an enthusiast's desire—traveling along a current that flows from manufacturer's shop to reseller's stall to collector's collection—they are brittle, age-worn artifacts, dwindling in number; cheap to produce but expensive to purchase, and originally designed to do nothing more than serve as advertisements for a few weeks and then dissolve into pulp in the unforgiving Indian elements.[13] On the other hand, as Indian products of manufacturing, these song booklets and posters have a kind of fragile durability that provides an explanation for their longevity that has nothing to do with the collector's market. It derives instead from traits they share with a wide array of other Indian products.

Referring mostly to the electronic and mechanical items that reasonably skilled technicians (often either informally or self-taught) can keep in working order through the ready availability of standardized components, Geel writes:

> The incredible fragility that radiates from shop windows in India ... seems to go together with the industrial production of the most densely populated country in the world. For Westerners, this quality makes them unusual objects, filled with happiness and the symbolic value of transgression. The captions to the photographs in [*100% India*] regularly mention the relative efficiency of these objects; nonetheless, the products do not at all seem to have been designed for a limited period. There are no preconceived ideas about the life of an object. Such ideas wouldn't be Indian. Godrej refrigerators or Penjaj scooters easily give twenty or thirty years of loyal service. But Indian objects do in fact look fragile, and they often are.[14]

Posters are not like motorcycles that can be repaired and put back on the road by a self-taught mechanic. But the skills of the *bricoleur* do come in handy when it comes to storing and shipping such delicate and unwieldy paper items. To illustrate: After I had spent my research money on a large stack of movie posters,

I began to wonder (belatedly) how I was going to get them safely out of the bazaar, much less back to Ohio. I had already established that there were no enclosed cardboard mailing tubes to be purchased in the area. When I asked the shopkeeper what I should do, he told me not to worry. He called over his assistant, who then created a remarkably sturdy tube out of nothing but newspaper and masking tape that lasted through a wild scooter ride, a taxi, three airplanes, and a car and even proved difficult to open with a razor blade when I got home. I have seen other posters shipped using the ingenious method of rolling them up and putting them in a piece of PVC pipe.

The preservation of old movie posters for resale and/or reuse is thus overdetermined both by the skills and habits of recycling and repairing acquired during the decades of economic protectionism and by the desire of collectors (from India, Europe, Australia, South Africa, and the United States) to acquire rare and remarkable objects. But these objects do not exist in a context defined only by human attitudes and activity. Just as plastic debris collects in ocean currents with other objects of like density and buoyancy, these posters and song booklets tend to travel on the same currents as other related materials and collect in the same places (we can think of these groupings as "collections without a collector"). The proximity of all these objects to each other in these "collections without a collector" then creates a new, properly material context against which to interpret them.

Material Intertextuality

Along with the materiality of these posters and song booklets, I am also interested in the total collection of elements (visual, textual, technological, religious, and cultural) that form the background against which they take on meaning: in a word, context. The context of the Hindi horror poster or song booklet includes non-material, conceptual things like pornography, spirit possession, colonialism, Tantra, economic liberalism, *rasa* aesthetics, the idea of the wet sari, American horror movies, the *Mālatīmādhava* of Bhavabhūti, the online communities that frequent blogs like *I Love Trashy Hindi Movies*, Indian village folklore, and the Gothic novel. Individually and in concert, these elements provide a kind of interpretive frame by dint of their conceptual relationship to the artifacts in question.

But what about the context created by material things in a different kind of relationship to these objects, namely, one of physical proximity? To analyze a poster as a particular thing rather than an infinitely reproducible image, we have

to consider its provenance and *mise-en-scène*, the context created by the other things that surround it in physical space, viewed apart from any human network. Appadurai writes:

> Even if our own approach to things is conditioned necessarily by the view that things have no meanings apart from those that human transactions, attributions, and motivations endow them with, the anthropological problem is that this formal truth does not illuminate the concrete, historical circulation of things. For that we have to follow the things themselves, for their meanings are inscribed in their forms, their uses, their trajectories. It is only through the analysis of these trajectories that we can interpret the human transactions and calculations that enliven things. Thus, even though from a *theoretical* point of view human actors encode things with significance, from a *methodological* point of view it is the things-in-motion that illuminate their human and social context.[15]

When I began to incorporate Appadurai's ideas into this essay, it became clear very quickly that, considered as "things-in-motion," posters and song booklets do indeed tell us something about their human and social contexts. But, since I tend to look at myths (my usual subject of study) not only in terms of their human and social contexts, but also in terms of how they illuminate and are illuminated by other narratives, I wondered if there was anything like this kind of intertextuality in the study of objects. It is not possible to talk about the myth of Paraśurāma's annihilation of twenty-one generations of warriors in the *Mahābhārata* epic without mentioning that two variants of the story are used to frame the epic's narration of the great climactic battle at Kurukṣetra that also wipes out an entire generation of warriors.[16] How then, I wondered, can I offer more than a surface impression of the poster for *Darawani Haveli* (The Frightful Mansion, 1997, dir. Rakesh Sinha) without acknowledging that it was found next to a stack of smaller posters that contained an extremely faded and pulpy 8in. x 10in. publicity still from *Friday the 13th* (1980, dir. Sean S. Cunningham) showing Jeannine Taylor and Laurie Bartram chatting aimlessly on a dock? The answer is that I cannot. A full picture of the context of a poster or song booklet must include the various things that surround it. They surround it, after all, because they too have been swept up and carried in the same currents that brought that poster or song booklet into the here and now.

Following the principles outlined above, in the rest of this essay I will present a detailed analysis of a poster advertising the film *Darawani Haveli*, focusing on the poster as a material object that communicates meaning against the backgrounds of its Indian cultural context, the intercultural/subcultural context of global horror fandom, and its physical context as a purchased commodity

encountered in Mumbai's Chor Bazaar. Next, I will examine the use of synoptic narrative, Vedic demonology, and repurposed Hollywood horror imagery in the song booklets for *Haveli* (Mansion, 1985, dir. Keshu Ramsay), *Khatarnak Raat* (Dangerous Night, 2003, dir. Muneer Khan), *Ek Aur Khoon* (One More Drop of Blood, 1985, dir. Ramesh Bedi), *Lady Killer* (1995, dir. S.A. Chandramohan), and *Daayan* (1998, dir. D.S. Azad). Finally, I will attempt a psychoanalytic exploration of what I call, following Richard Kearney's analysis of the Song of Songs, the "theo-erotics" of the devouring mouth as recurring image in horror posters in order to expand my analysis to the more general subjects of sex and violence.[17]

Text and Violence in *Darawani Haveli*

The poster for *Darawani Haveli* (see Plate 1) is in the *masala* style and contains the key credits for director, music, and lyrics. No stars' names are given, because the stars (such as they are) are not going to sell *Darawani Haveli* to audiences. Instead, we have a collection of publicity photos from the movie in which images of sex, violence, and the supernatural are on display. They are incorporated into a painted background with a splashy, stylized title that is part of the overall poster design and (as is only rarely the case) is written only in Devanāgarī script with no romanization or Nastaʿlīq in sight.

In the mixed media tradition described by Haggard, this poster would have been made by hand painting the background on a canvas, then pasting on the title, credits, and publicity stills from the movie. Evidence of the cut and paste process is visible in the title, set against a black background. A cursory examination reveals that the poster artist chose not to trim away the black background from the right of the word *darawani* in the way that it was trimmed away on the left to make room for the umbilical staircase. The cutting and pasting are still more obvious with the credits—printed in blue type on thin strips of white paper. The visible painted elements are the monster's face and clawed hand in the top third of the poster; the blue-sleeved arm (painted from the shoulder) of the evil magician or *tāntrik* and the *haveli* with the woman in its doorway in the middle third; and in the lower third, the umbilical staircase that acts as a vertical line to separate the poster's two erotic elements, both of them photographs.

The photograph on the left is the familiar image of a screaming woman in a bathtub, the Western convention of a woman's bare breasts barely concealed by suds becoming a more modest bathing top obscured by suds in India. On the

right is a couple with no visible clothing in a clearly sexual, but also puzzling, position. Both are facing down, with the man's head behind the woman's, suggesting that he is penetrating her from the rear (or is preparing to) while she lies flat on her stomach. The expression on her face as she stares up and to the right of the viewer looks like one of resignation. The man's eyes are unfocused and his mouth is open to make a sound or maybe to kiss the woman's shoulders, and the downward hang of his necklace suggests that he is not lying flat on her back, but slightly above her. Neither the man nor the woman is obviously portrayed as hero or villain, but it would be unheard of for a poster to portray a hero engaged in a sex act like this. More than anything, they seem to advertise (accurately or not) that the movie contains a fairly explicit sex scene.

The poster's only obvious hero, representing the *vīra rasa*, what Sanskrit aesthetic philosophers called the experience of being thrilled by the valor of a brave warrior, is the green-shirted man in the top third of the poster. The object he is brandishing is a *triśūl*, the divine weapon of Śiva often used to defeat monsters in these films. The blood coming from his mouth would typically signify a devourer of flesh or a drinker of blood. In this context, however, and in concert with the blood on his shoulder, it signifies instead that he has been hurt in battle but is undaunted and not about to give up the fight.

The most likely candidate for the human villain on this poster is the *tāntrik*, who appears twice. The larger of the two images (in which his robes appear blue) shows some kind of an energy flare shooting, whip-like, out of his fist. This large image works as the major horizontal element of the poster, stretching all the way across the middle third. The smaller image (in which his robes appear a more traditional black) shows him standing behind a skull with his eyes closed and his arms stiffly pointed down, as if concentrating.

Probably, though, he is only a secondary villain, since in these movies the *tāntrik* or *pujari ki shaitan* ("priest of the devil") is usually only the one who summons the monster, and that monster is actually the primary villain. And indeed, the biggest image of the *tāntrik* is still not as big as the smaller of the two images of the female monster positioned above him. Aside from the size difference, anyone who has seen a few Hindi horror movies would be familiar with the common plot device of a black magician summoning an evil supernatural being. In the actual film, though, the female monster appears rarely and the *tāntrik* is equally scarce.

Now we come to the appearance of this female monster, which may be a *ḍāyan*, a creature whose name is derived from the *ḍākinī* of Sanskrit myth and Tantric ritual, and generally refers to a vengeful female ghost.[18] Global horror

enthusiast and popularizer Pete Tombs has made the pronouncement that "India, unlike Japan or China, has no literary tradition of horror outside ... old folk tales and *puranas*."[19] This is a bit like saying that Victorian Britain had no literary tradition of horror outside of ghost stories and "penny dreadfuls." In other words, there is no good reason to disqualify these old folk tales and *purāṇas* as sources of the horror tradition. We should note though, that in Indian cinema, depictions of the *ḍāyan* and other beings like it, such as the *cuṛail* (usually the ghost of a woman who has died in childbirth or during menses), frequently ignore or play down the distinctive traits of their descriptions from folklore, such as backwards-facing feet, in favor of a more generic monster look.[20] In contrast, Indonesian cinema has embraced the very unusual and distinctive form of its own female demon, the *leák*, which flies through the air at night as a woman's head trailing its stomach and entrails, as seen in the cult classic *Leák* AKA *Mystics in Bali* (1981, dir. H. Tjut Djalil).

B- and C-grade Indian horror cinema has no real special effects budget, much less the benefit of special effects auteurs like Rick Baker or Tom Savini, so there is typically only one way to make a monster. Consequently, many of them do, in the memorable words of Tombs, look like they have a "three-day old pizza" stuck to their faces.[21] But the *ḍāyan* on this poster has a distinguishing characteristic in her misshapen right eye, which looks dead in the photograph but full of malevolent life in the painting.

In the film itself, the creature appears only in dizzyingly quick zoom shots and the part that features most prominently is her clawed hand, which is reflected in the hand's prominent placement on the poster. There may be a budgetary reason for this, since many of the attack scenes were shot from a first-person point-of-view and therefore all that was required to play the monster was someone wearing a glove and standing slightly behind the camera, out of frame except for the forearm. Horror fan and former poster collector Aseem Chandaver argues that the source of many of the monsters in these films is the village folklore imported by the rural low-caste laborers brought to work on the movie sets.[22] It is possible, then, that the *ḍāyan*'s prominent eye and clawed hand represent an independent folklore tradition that matched what was available in the make-up department at the time of the film's production.

The two representations on the poster of both the *tāntrik* and the *ḍāyan* exemplify the "synoptic mode" of narrative art. Describing the representation of the Buddha's birth as a monkey on a *stūpa* at Sanchi, Vidya Dehejia describes the synoptic mode as one in which "multiple episodes from a story are depicted within a single frame, but their temporal sequence is not

communicated, and there is no consistent or formal order of representation with regard to either causality or temporality."[23] In the poster, we see the *tāntrik* engaged in two actions, "invoking" in the smaller image and "spell-casting" in the larger image, if we take the yellow streak coming out of his fist as some kind of an *astra* or magic missile weapon. Likewise, we see the *ḍāyan* brandishing her right claw in the upper image and stabbing downward with a curved and already bloodied blade in the lower image, keeping her claw hand above the frame and out of sight.

Typically, a still image on a poster functions as a synchronic distillation of some part of the diachronic narrative that is the film. But the *masala* style poster offers "a condensed narrative of the film, and more besides."[24] But, in this case, the "more besides" is an unrelated narrative that almost displaces the plot of the film being advertised. Widening the gap between the story that the poster suggests and the plot of the film itself is the fact that in the actual movie, two bumbling Abbot-and-Costello-type detectives and a comic actor in drag (none of whom figure in the poster) have roughly five times more screen time than the *tāntrik* and the *ḍāyan* combined. Without a synopsis to provide narrative sequence (unlike the song booklets that we will look at below), and without the context provided by the narrative of the film itself—which the poster's original intended viewer has not yet seen, presumably—this poster tells its own story.

The poster also creates its own context through allusion and suggestion, a process that plays out when we look closely at the appearance of the title. Expressive typography like the kind in which this title is set began to be popular in Indian film poster design in the 1970s with box office hits like *Bobby* (1973, dir. Raj Kapoor) and *Sholay* (1975, dir. Ramesh Sippy).[25] It is especially popular in horror films, where it has been used to great effect. But *Darawani Haveli* does not use familiar elements like words dripping with blood or letters pointed to look like fangs. Instead, we see the shattered glass effect that was made iconic by Tony Palladino's title design for *Psycho* (1960, dir. Alfred Hitchcock).

The effect is only on the noun in the title, *haveli*, which is twice as big as the modifier *darawani* and is red with a yellow outline in a direct inversion of the color scheme used for the adjective. *Haveli*, we should note, is a common word in horror titles. Examples include *Purana Haveli* (The Old Mansion, 1989, dir. Shyam and Tulsi Ramsay), *Maut ki Haveli* (Mansion of Death, 2001, dir. A. Raja), and *Haveli ke Peeche* (Behind the Mansion, 1999, dir. Vijay Chauhan). Meheli Sen notes that the *haveli* "often stands in for feudal excesses and for crimes, misdemeanors, and exploitative practices nurtured within the feudal dispensation."[26]

The subtle reference to *Psycho* is strengthened by the manner in which the actual *haveli* is presented above and to the left of the title. The house or castle is

painted and, like the famous womb-like manse in *Psycho*, has an umbilical staircase, in this case, connecting the thing directly to its name. The *haveli* itself calls *Psycho* to mind again with its figure of a white-haired woman (à la Norman Bates's white-wigged "mother" alter ego) stepping out of the doorway and preparing to run down the steps with arms outstretched.

But how much of this alleged allusion to *Psycho* is confined to the mind of the present author? Here, the material context of the object helps us to interpret the image it bears. The particular *Darawani Haveli* poster reproduced here was not found in the state in which it was originally intended to end up (i.e., stuck with wheat-paste to a wall from which it could never be removed without destroying it). Instead I found it, like most of the others I will discuss in the essay, stacked up with dozens of other never-hung posters on a concrete floor in a stall on Mutton Street in Mumbai's Chor Bazaar. I purchased it there from the father and son vendors Shahid and Wahid Mansoori, who make part of their living selling posters, song booklets, and other Bollywood movie memorabilia to tourists and collectors at a significant markup. And I was both a tourist and a collector.

This seems a good place to state my own position *vis-à-vis* the cultures of collecting and cult fandom, so I ask the reader for a bit of indulgence as I take an autobiographical detour. When I was in high school, I wanted to be a filmmaker. I worshipped Alfred Hitchcock, Orson Welles, Stanley Kubrick, David Lynch, Francis Ford Coppola, and Martin Scorsese, but also maintained my childhood love of things like the Universal Studios monsters, Vincent Price movies and *The Creature from the Black Lagoon* (1954, dir. Jack Arnold), which I watched on television with 3-D glasses purchased at a convenience store. Growing up in the 1980s, I was well also aware of—but never allowed to watch—the explosion of slasher movies from that period, so that Jason Voorhees, Michael Myers, and Freddy Krueger were figures of children's folklore to me long before I ever actually got to watch their movies (which I did as soon as I was able).

In middle school, I spent a good amount of time at the local video store renting "cult" movies like those of Ed Wood Jr. and collecting posters whenever I could. Two of my prize acquisitions from this period were from the horror-comedy *Zombie High* (1987, dir. Ron Link) and the low-budget drive-in film *Gator Bait* (1974, dir. Beverly and Ferd Sebastian). I also read biographies of B-movie director Roger Corman, B-movie producer Samuel Z. Arkoff, and zombie movie pioneer George A. Romero, and subscribed to the magazines *Film Threat* and *Psychotronic Video*. The latter, through its classified section advertising rare VHS tapes and posters, introduced me to the various subgenres of "exploitation movies," most of which were completely unknown to me.

Through the VHS tape trading culture, I discovered Alejandro Jodorowsky's *The Holy Mountain* (1973) and the short films of Kenneth Anger as well as John Waters' *Pink Flamingos* (1972), and Richard Elfman's *The Forbidden Zone* (1982). I was also exposed to newer underground fare like the gritty experimental shorts of New York filmmakers Lydia Lunch, Nick Zedd, and Richard Kern. I even spent the summer of 1993 studying filmmaking at a camp for high schoolers at the University of the Arts in Philadelphia, where everyone was talking about more sophisticated (and contemporary) work like Spike Lee's *Do the Right Thing* (1989), Quentin Tarantino's *Reservoir Dogs* (1992), and James Foley's *Glengarry Glen Ross* (1992). Even as I developed a serious interest in film, I never really lost my interest in cinematic "trash" and transgression. Ultimately, after the embarrassing experience of falling asleep watching Sergei Eisentein's undisputed masterpiece *Battleship Potemkin* (1925) in my first college film class, I abandoned my plans to study cinema—and college altogether.

Years later, when I was in Chicago pursuing what I (naïvely) thought was a much safer bet by earning my PhD in History of Religions, I discovered that I had previously only scratched the surface of cult film fandom. Taking advantage of the city as best as I could, I attended the Chicago Underground Film Festival, joined the University of Chicago's legendary Doc Films society and regularly attended midnight movies (as well the annual twenty-four-hour horror marathon) at the Music Box Theater in Wrigleyville. It was the 2000s by then and Netflix's rent-by-mail service had become available, which gave me a chance to see movies I had previously only read about in books (like those of Pete Tombs). Renting them three at a time and watching one every night, I made my way through a fair number of Italian cannibal, zombie, and *giallo* films; the French vampire films of Jean Rollin; and a smattering of ghost films from South Korea, Hong Kong, and Japan.

By the time I was getting ready to travel to Pune for an American Institute of Indian Studies Sanskrit summer program in 2003, I was steeped in cult fandom but only vaguely aware that Bollywood horror existed. It was after the program was over and I was in Mumbai wandering through the Chor Bazaar with a friend that I first came across the Mansooris' stall, "Bollywood Bazaar." I was fascinated by what I saw, but was low on cash, so only purchased a few color continuity photographs (misplaced as of this writing) from some Ramsay brothers films. I also discovered what was then still a thriving trade in VCDs (video compact discs) on the streets of Mumbai and Delhi. Displayed in wooden carts and sold out of plastic trash bags, practically any Bollywood or Tollywood movie could be found there, along with a good selection of pirated American and European

titles from the action, horror, and erotic thriller genres, as well as various "hot movies."

On later trips to India, I tried to figure out how to get those remarkable movie posters off the walls where they were wheat-pasted, but that proved impossible. On one occasion in Tamil Nadu I thought I had adequately explained to a taxi driver that I wanted to go to the place where they were showing the film advertised in a poster we passed by on the road. My lack of Tamil got in the way though, because an hour later we arrived at our destination: a shop that sold film for 35mm cameras. Finally, on a trip to Delhi I managed to convince an inebriated theater manager in Paharganj to let me look in the closet where he stored his posters and, after some haggling, to sell three of them to me. It was years later when I returned to the Chor Bazaar as a tenure-track professor that I finally had the chance to start looking for posters and song booklets in earnest and figure out what I wanted to write about them.

Scholars of cult fandom of the kind described in autobiographical detail above have described it as "oppositional taste," meaning that fans of cult movies define the movies they like in opposition to whatever they consider to be the mainstream. This often includes movies from their own part of the world that are dismissed and forgotten along with movies from other parts of the world that are mostly unknown in the fan's own culture. The introduction to an influential collection of essays on the topic explains it this way:

> [Many] cult movies are films that have been transplanted from one specific cultural terrain and consumed within another quite different one. However, not only are these products celebrated in this new context for their supposed difference from the "mainstream" (although they may in fact be the mainstream of their own culture) but this often involves an exoticization of other cultures. In other words, cult movie fandom often relies on a celebration of the "weird and wonderful" of world cinema, but does so in a way that has no interest in the meaning of these films within the contexts of their own production . . .[27]

These concerns about cultural appropriation of world cinemas seem to be of far more relevance to scholars than to the people who stand to make money off of them. For instance, no employee of Toho in Japan is likely to have worried about whether audiences were decontextualizing the Kaiju movies that were being dubbed in English and shown in American theaters as long as they kept buying tickets. It is, however, worth looking at the Indian merchants who mediate between foreign collectors (most of whom, I should note, collect memorabilia from mainstream, even prestigious Bollywood films) and the originally intended

audience for these films and posters. What might they think about the international popularity of films that are generally poorly regarded in India and how do they see themselves situated in relation to foreign collectors and Indian audiences? When asked in an interview about why they though that C-circuit posters like *Darawani Haveli* appealed to their customers, Shahid Mansoori replied that they "go for high prices because they look quirky and add zing to the room."[28]

But this is the pitch of a salesman, not the aesthetic judgement of a horror aficionado, and as such, it somewhat overstates the broad appeal of these objects and takes them out of their material context in the Chor Bazaar. Those willing to pay the comparatively steep asking price for Hindi horror posters, bearing as they do images that are grotesque and lurid to varying degrees, are not likely to be merely looking to bring some color to their living room walls. They are far more likely to be fans of horror in general. And fans of horror in general (depending upon their age), will probably have some familiarity with Tony Palladino's iconic *Psycho* design, insofar as *Psycho* is one of the precursors of the perennially popular 1980s "slasher" genre, of which *Friday the 13th*—the same film whose publicity still I found in the same stack as the poster—is a paradigmatic example. Thus, whether or not the shatter effect used in *Darawani Haveli*'s title design is directly inspired by Palladino's, the connection arises in the reflexive interpretive act of the horror fan/collector unfolding, laying out, and considering the poster as a member of the set of noteworthy horror posters—a connection that is reinforced by the presence of a nearby object representing a classic slasher movie.

Close examination reveals that the poster spent a good deal of time neatly folded into a square: the horizontal creases dividing it into thirds were still visible before it spent several months spread out in the "flat file" in which it I stored it, and damage to the brittle left edge of the poster shows where it has been handled repeatedly and subjected to tearing.[29] Newsprint, the material on which the poster is printed, is a mechanically pulped paper, a process that produces short cellulose fibers that are prone to rapid deterioration, further exacerbated by the acid in the paper (left over from the hydrochloric acid solution used to remove the polysaccharides from the lignin) and by its absorption of Mumbai's pervasive air pollution.[30]

This poster was not meant to outlast the run of the film. It survives at all only because it never fulfilled its intended purpose; it was never pasted on a wall, which is the sole reason it was printed in the first place. Shahid Mansoori recounted to me his early years in the business when he ran after the hangers to

buy some of their posters before they were pasted up and became irretrievable. Since its acquisition (by Mansoori or one of his agents) for non-advertising purposes, this poster has been given an exchange value far above its use value and has been preserved, with the regular spray of pesticides and chemical preservatives, to sell to collectors.[31]

Every element of the poster takes on still more nuance and meaning in light of the other objects that surround it, having all been washed up at the same place on their own tides of desire and neglect: an antique rickshaw meter; an Indian men's magazine from the 1980s misleadingly titled *Gayboy* and made up of photocopied pictorials of topless "Page 3" women from British newspapers and sex advice articles from *Cosmopolitan*; and a proffered cup of chai that had cooled (because none of the Muslim shopkeepers would drink before sundown in the holy month of Ramzan) and was therefore no longer at a sufficient temperature to kill the flagellated parasite *Giardia lamblia* that had found its way inside it. Further context is supplied in the mind of the Indian horror fan, where the shattered glass effect on the title reflects the iconic image of *Psycho*, the black magician conjures up sensationalistic fantasies of Tantra, the figure of the *ḍāyan* summons the trope of the vengeful female spirit, and the position of male and female bodies implies regnant notions of sexual desire and gender roles.

Sex, Blood, and Copyright Infringement in Song Booklets

As we have seen above, the narrative suggested by the imagery on a movie poster can often be a significant departure from the film. This is not the case in song booklets, which usually contain a synopsis of the film, presented in a way to titillate and entice potential moviegoers. The typical English synopsis in a Hindi horror movie song booklet ends with a riot of breathless questions whose nonstandard spelling and idiosyncratic (seemingly random) capitalization make them seem all the more pitched. The song booklet for *Haveli* (Mansion, 1985, dir. Keshu Ramsay) asks: "Who is the killer? Why is he killing? Who is going to die Now? Who's turn is it now? To Find out all this you also have to face a night full of Horror in Haveli."

The booklets also abound with conventional images denoting terror and horror—like bats, blood, and spider webs—as well as sexual imagery. There is also a good deal of visual content borrowed from other sources, since the booklets have multiple panels to fill up and often too few original images with

which to do it. The borrowed images help to advertise the terrifying and erotic elements of a film that may actually devote precious little of its running time to either, despite the claims made in its synopsis.[32] The most blatant instances of image borrowing, often from non-Indian movies, may also be an attempt to appeal to the same horror fans who might purchase black market VCDs of foreign horror films in addition to visiting the cinema.

One panel for the song booklet advertising 2003's *Khatarnak Raat* lifts the iconic three-quarter view of a skull with staring eyeballs from the poster for Sam Raimi's *Evil Dead II* (1987) and superimposes a digital drawing of a black widow spider in the center of a web (see Plate 2). Another panel prominently features a still of an ape-like monster carrying an obviously white woman from monster movie maven Jack Arnold's 1958 film *Monster on the Campus* (see Plate 3). The song booklet for *Ek Aur Khoon* (One More Drop of Blood, 1985, dir. Ramesh Bedi) makes a similar campy reference with its copying of the Vincent Price horror spoof *The Abominable Dr. Phibes* (1971, dir. Robert Fuest).

The simple, one-fold song booklet for *Lady Killer* (1995) provides an interesting mix of visual and textual elements. The front cover carries the English title in a stylized typeface and is awash in digitally added blood-red color, especially on the two figures it features: a man brandishing a chainsaw and an angry-looking woman pointing directly at the reader. At the top we see the cut-and-pasted questioning tagline, "WHO WILL BE THE VICTIM TONIGHT[?]" The back cover gives the title transliterated in Devanāgarī and Nastaʿlīq along with a woman's screaming face and a partial image of a sinister, bloody visage and clutching hand. This same image (with more of the face visible) appears in the movie poster for V. Prabhakar's film made the same year, *Andheri Raat Tu Mere Saath* (Dark Night with You) AKA *Andheri Raat* (Dark Night), which is probably the original source.

Inside the booklet, there are the lyrics for four untitled songs and a synopsis in Hindi with a much shorter and not very accurate English version beside it. The English version (with spelling and syntax mostly corrected) reads:

> BOBY (Heroine ABHILASHA) is trapped by CHERAN RAJ by making her [pregnant] and with a false promise to marry her. One day [Charan] Raj fixes the marriage spot and calls Bobby at a Horror place that is DEVGARH but Charan Raj did not turn-up as promised and [in turn she] falls into the [clutches] of DEVIL who kills her in order for a Re-birth to become Lady killer. Now this LADY-KILLER (TARA) kills numerously under the command of the said DEVIL and she also traps Hero (RAJIV) and [Comedian] Raghu. Rest see in the film. How this DEVIL drama concludes?

But the Hindi version explains that the actual villain of the movie is a blood-drinking possessed tree (*shaitani ped*) that gets its power from the infants that it commands women to offer to it so that it can absorb their lifeforce into its trunk. Once the reader understands that *Lady Killer* is about neither a lady who is a killer nor a killer of ladies, but an evil tree, the tree trunk on the front cover and the tree roots on the back cover suddenly make sense, and the man brandishing the bloody chainsaw becomes the hero about to slay the monster rather than a murderer about to dismember a victim.[33] The line drawing at the bottom of the page of a skeletal hand stabbing a knife into a naked reclining woman's torso does not seem to relate to the rest of the booklet at all (see Plates 4 and 5).

Turning to the song booklet for *Daayan* (1998), the Hindi plot synopsis begins, "This is the story of a *ḍāyan*." But in the English version this sentence is rendered, "This is the story of a wicked woman." The actual vengeful spirit that she summons is identified with the Arabic/Urdu word *rūh*, or "soul," which is one of the two references to Islam (the other being the confusing description of the "devil" singing a *qawwali* or Sufi devotional song). Below is the English-language text with the words used in the Hindi-Urdu version placed next to their equivalents in square brackets.

> This is the story of a wicked woman [*ḍāyan*]. She uses a devilish manner to fulfill her desires and she is helped by the spirit [*rūh*] of a beautiful girl Lily (Jyoti Rana). Actually Lily was Tony's (Rajkiran) wife. Tony had been unfaithful to Lily and had tortured her to death. Lily has come back as a spirit to haunt him and his family and to take revenge. Her first victim is David who is also killed by the devil [*shaitan*]. David's brother Peter has the ability to see and fight with spirits. David's spirit comes and tells Lily's secret to Peter who goes to Tony's house where Tony is getting married to Nancy (Afreen Khan) for the third time. The devil (Shakti Kapoor) comes there and sings a qawali, Peter confronts him but just at that time Inspector Harry (Kizar Khan) and his assistant (Rajesh Puri) intervene and thus the devil and Lily escape with Tony's younger brother, Johny. They take him to a Graveyard and kill him there. Inspector Harry holds Peter responsible for this murder. Inspector Harry is in love with Daisy (Monika) who is Peter's sister. He and his wife (Sanchi Shrestha) suspect Peter of all the killings in the city. Harry wants to catch Peter red-handed whereas Peter is trying to save Tony's family and to bring an end to the wicked witch who is doing all this. Then:—Does Peter succeed?—Does Harry catch Peter?—Do Harry and Daisy get married?—What happens to Tony and his family?—What happens to Lily and the wicked witch? ... who is she really? To find the answers to all these thrilling chilling questions—See "**Daayan**" on the silver screen!

Other than being evil and female and witchy, what exactly a *ḍāyan* might be is unclear in the synopsis.[34] But in terms of visual content, the women wearing bloody white sheets on the front and the back cover—and especially the woman on the front cover with bloody clawed hands—look more like the description of the Vedic demoness called the *kṛtyā* than anything else. Described in Ṛg Veda 10.85, "The Marriage of Sūryā" (*mantra*s from which are still recited at traditional Hindu weddings today), the *kṛtyā* is born from the sheet stained with blood on a consummated wedding night.

In verse 28, "the purple and red appears, a *kṛtyā*; the stain is imprinted [on the gown]." In the next verse, "[the stained gown] becomes a *kṛtyā* walking on two feet and like the wife, it draws close to the husband." In verse 30, the hymn warns against the husband having sex with the *kṛtyā*, suggesting that she has the quality of a succubus: "the [husband's] body becomes ugly and pale if the husband covers his penis with his wife's robe out of his evil desire." Finally, verse 34 gives a description of the gown-turned-*kṛtyā*, saying that it "burns, it bites, and it has claws, [and is] as dangerous as poison to eat."

One final point of interest on the *Daayan* song booklet is the image on the back cover of pooled blood reflecting the images of three women without visible clothing. The woman in the middle actually appears to be topless with only her hands covering her breasts. On the question of nudity in general, Rachel Dwyer has made a convincing case that "the Indian cinema has a specific erotics of clothing, whereas nakedness is seen as a source of shame and fear."[35] While these films typically follow the pattern Dwyer identifies, as in the poster for *Bungalow No. 666* (1990, dir. P. Chander Kumar), *Daayan* seems to present a picture of the "gore-otica" variety, mixing sex, nudity, and horror in one image and eschewing the "erotics of clothing" (see Plate 6).

In these song booklets, images—including visual references to Vedic and village demonology and a liberal borrowing of non-Indian elements—are used to frame a text whose frenetic style approximates the *masala* aesthetic of both posters and movies. But unlike posters, which were meant to be pasted to a wall and attract the attention of passersby and only became commodities through the demand created by horror fans' desire to collect memorabilia, song booklets were distributed to moviegoers and had intrinsic use-value. They provided audiences with the lyrics to film songs and with still images from the movie that could be viewed at any time. And with the addition of multiple panels, some of which were hidden behind the fold, there was room for more lurid imagery and cultural references.

And what physical objects do we find in proximity to these song booklets? There are faded and beaten up lobby cards for English-language movies like the

erotic thriller *Scream for Help* (1984, dir. Michael Winner) and the women-in-prison exploitation film *Chained Heat II* (1993, dir. Lloyd A. Simandl), the latter having been laminated in attempt to preserve it and fitted with a metal grommet in each corner, presumably so that it could be hung on a wall without having to damage the paper with tacks or tape.[36] But in the same stack there is also an equally well-used lobby card for the 1987 Indian release of the English version of *King Kong Vs. Godzilla* (1962, dirs. Ishirō Honda and Thomas Montgomery).

Their proximity to the *Chained Heat II* and *Scream for Help* lobby cards (whose misogynistic taglines read, respectively, "Used for the pleasure ... with the hope of freedom" and "Every man's fantasy becomes one woman's nightmare") suggests that these song booklets belong to a class of items that appeal to the prurient interest of male audience members. But the second lobby card, advertising a 1960s monster movie with special effects that are laughable by today's standards, complicates the picture: are these booklets meant to be used as material for violent sexual fantasy or objects of ironic appreciation for their tackiness? Interpreted *in situ*, these song booklets (whose images are tame compared to what any Indian can see on his or her mobile phone) seem to appeal to a more sophisticated viewer with an ability to ironically appreciate "trash culture." They also presume an awareness of the Indian demonological traditions that lie behind the *curail* and *ḍāyan* of Hindi horror movies.

Adding even more complexity to the reception of these objects is the fact that equally lurid images of sex and violence can be found carved in temples and depicted in Tantric texts (and even the Veda itself) because transgression is recognized by many as a path to transcendence, if a difficult and dangerous one. It was this very observation that led one twentieth-century Indian-born scholar to trace the origin of the European vampire mythology that informed American and British horror films back to the fierce, fanged deities of his native Himalayas (see the next essay in this volume for more about this fascinating man). In the next and final section of this essay, I will dig deeper into the Indian religious context and provide some new possibilities for reading the images of eroticized violence we see in these posters and song booklets.

A Psychoanalytic Examination of the Theo-erotics of the Devouring Mouth

In movie posters and song booklets of the non-*masala* variety (i.e., featuring a single tableau or image), there are some images that have the visual power to

stand alone. One of these is the devouring mouth, often closing around an eroticized female body. This visual trope is by no means unique to India, as evidenced by the iconic poster for *Jaws* (1975, dir. Steven Spielberg) designed by Roger Kastel.[37] In the Indian context, it recalls the devouring mouths of demons like Aghāsura, whom the child Kṛṣṇa defeats in the *Bhagavata Purāṇa*, but also Kṛṣṇa's own terrible gaping maw of death in *Bhagavad Gītā* 11.29–30, in which Arjuna sees a vision of all the heroes of the epic "hastening into [his] numerous mouths, which are spiky with tusks and horrifying [*bhayānaka*]" and in which "there are some who are dangling between [his] teeth, their heads already crushed to bits."[38] The posters for *Khooni Murdaa* (The Bloody Dead, 1989, dir. Mohan Bhakri), *Cheekh* (Scream, 1985, dir. Mohan Bhakri), and *Haiwan* (The Beast, 1977, dir. Ram and Rono Mukherjee), and the entrance to the Hanumān temple in Jhandewalan Felhi in Delhi all feature some version of a devouring mouth (see Plates 7–10).

The mouths of the temple entrance (a demon killed by Hanumān) and the demonic Aghāsura, whom Kṛṣṇa slays by walking right into his mouth, both devour in a bloodless, almost passive, fashion, like a baleen whale getting a mouthful of krill. But the mouths on the movie posters are much closer to the theologically-charged *bhayānaka* gore of the *Bhagavad Gītā*, with the important difference that the bodies being masticated in the posters are not those of warriors as in the epic, but women. In the epic, the great devourer is Time and the world proceeds inexorably into its open mouth. But in the *Haiwan* and *Khooni Murdaa* posters, the women have not just fallen into a mouth. Instead, they appear to have been hunted and snatched up in a pair of jaws. This is not out of the ordinary, since violence against women occurs with regularity in Hindi horror posters and song booklets, and tropes of hunting and eating women are common in horror cinema the world over.

The sexual aspect of this violence is foregrounded in *Haiwan*, where the victim's sheer negligee has slipped off to reveal one of her breasts. In the context of a cat's well-known propensity to play with its prey before killing it, the viewer could well imagine that the woman is still alive and that her unconscious form is helplessly awaiting whatever comes next. It also brings to mind the Hindi proverb, "*Billee ko cheechdon ke khvaab*" ("The cat dreams of the choice meats"). *Cheekh* also plays up the erotic elements, giving the viewer a look up the woman's nightgown and setting the open mouth in which her body lies in a sweating, clearly female face. The title tells us that we should read this mouth as screaming, not devouring, but the eroticized image of a woman's body placed in a mouth cannot easily be seen as something else.

Entrenched misogyny provides a clear and simple answer to the question of what these images are doing, but that is really only a redescription of the phenomenon and not an explanation of its nature. There are desires and fears at work in the minds of those who view and interact with the image of the devouring mouth and they may have something to do with the theological edifice built on the *Gītā*. In the devotional theology of *Kṛṣṇa-bhakti*, identification with Kṛṣṇa's beloved cowherd maiden Rādhā is a valid attitude of worship for male devotees. Indeed, the erotic mode of devotion to the male deity is considered the most sublime in Vaiṣṇava Sahajiyā theology, whether the devotees are women or men.[39]

In the nineteenth century, rumors spread among British colonial officials that worshippers of Kṛṣṇa were killed in large numbers when they threw themselves under the wheels of the chariot carrying his image during the Jagganath festival in Puri.[40] Like many British rumors about India, this one tells us more about the colonials' taste for sensationalism and their superior attitude toward the natives than anything else. But while Kṛṣṇa worship never involves blood sacrifice, the worship of the great goddess Devī in India frequently does, and also incorporates a kind of imagined self-sacrifice and passive eroticism.

In one ancient myth from the *Aitareya Brāhmaṇa* (c. 800–500 BCE) the goddess of sacred speech, Vāc, is identified as the "Great Naked Woman" who couples with the all-important Vedic sacrifice itself.[41] Vāc is also identified as the lion-mounted war goddess who decapitates her enemy the Buffalo Demon. In later texts, this role is taken over by the figure of Durgā. Looking at developmental psychology in the Indian context, the psychoanalyst Stanley M. Kurtz identifies what he calls the "Durgā complex," which finds expression in ritual and myth as "an identification between the demon decapitated by the goddess and the devotee himself."[42] This same identification exists in South Indian myths of Pōttu Rāja-Pōrmannan, the "Buffalo King," whose complex story cycles revolve around his identity as the Buffalo Demon slain by Devī, resurrected and converted into one of her devotees.[43]

I have suggested elsewhere that the Vedic story of the *kṛtyā*, which seems to be a source for the imagery on the *Daayan* song booklet I analyzed in the previous section, bears a resemblance to the paradigmatic Devī myth (not recorded until fifteen or twenty centuries later) in which the male gods temporarily cede their power to a "tame" form of Devī like Pārvatī so that she can take the fearsome form of Kālī in order to kill a powerful demon.[44] In this myth, the gods quickly come to regret their decision after she turns on them in her indiscriminate bloodlust. The only way to tame the goddess is to have Śiva lie

down in her path so that when she steps on him she is brought back to her senses by a sudden awareness of the shameful act of placing her feet on the god.

In its orthodox interpretation, the Kālī myth is about the danger of female power uncontained by the obligations of female propriety. In the popular so-called Dakṣiṇakālī image in which the goddess is standing on a supine Śiva, the long tongue that typically protrudes from Kālī's mouth is seen as an expression of *lajjā* ("shame"), albeit one that no other goddess or woman seemingly ever exhibits in any other narrative. But the Tantric interpretation put forward by Devī worshippers is that the protruding tongue is an expression of anger, unabated by her awareness that she is walking on the body of Śiva, who has succumbed to Kālī's power.[45]

The Vedic story of the *kṛtyā* is a precursor to the story of Kālī's transformation in that the demonic being seems to be a dangerous shadow form of the benevolent solar goddess Sūryā just as the rampaging Kālī, who can dominate men and gods with her power, is a shadow of the maternal and well-behaved forms of Devī. Verses 28 to 30 of the Vedic hymn describe the victory of the *kṛtyā* and the husband's surrendering of his lordship to her:

> The bride's garment becomes dark red. She becomes witchcraft, a noose. She is smeared with blood. Her relatives are elated; her husband is bound in bonds. Hand over the stained garment; to the brahmins parcel out the goods. She herself has become walking witchcraft: the wife enters her husband. His body loses its splendor—glistening in that evil way—when the husband is about to put on his own member the "garment" of the bride.[46]

The text seems to worry that, without the intervention of a Brahmin priest to purify the bloodstained sheet of the marriage bed, the husband will enter the *kṛtyā*'s bonds willingly; that he will be so enthralled by this unmediated form of female sexuality that he will try to eat it and instead be eaten by it, try to penetrate it and instead be penetrated by it. It is not too hard to imagine that the fantasy of passive, feminized sexuality could spring from this mythology.

Along with the well-established religious attitudes regarding males identifying as females and offering themselves up to a terrifying goddess in India, there is also some evidence that something similar may be happening in men's enjoyment of horror films. Consider Carol Clover's argument that the primary identification in American slasher films is with the female victim rather than the male aggressor:

> [Just] as attacker and attacked are expressions of the same self in nightmares, so they are expressions of the same viewer in horror film. Our primary and acknowledged identification may be with the victim, the adumbration of our

infantile fears and desires, our memory sense of ourselves as tiny and vulnerable in the face of the enormous Other . . .[47]

In a bit of analysis that has since been incorporated into the highly self-referential horror genre, Clover notes that while nubile women are often killed in slasher movies, the male audience also roots for and ultimately identifies with a "final girl" who will triumph over the (usually male) killer.[48]

In India, the deep structures that underlie the myth of Devī's destruction of the Buffalo Demon and the practice of male devotees of Kṛṣṇa identifying with desiring females may also encourage male viewers to see "her body, himself" in these images of women being devoured in giant mouths. With these arguments and examples, I am not ruling out the effects of violence against women in a country whose struggles with that issue have played out so horrifically in the public sphere over the last decades. Rather, I am leaving open the possibility that some male viewers of these materials may, on some level, identify with the eaten rather than the eater.

Conclusion

Why have we been looking at posters and song booklets instead of the movies themselves? By looking at Hindi horror posters and song booklets instead of Hindi horror movies, we are able to speak in the language of things and thereby get beyond questions only of narrative or image, which can lead to broad, often unwarranted, assumptions about life and thought in India. The materials we have been examining can never be mistaken for expressions of some timeless essence of Indian culture. They are subject to decay; they bear the marks of their human manufacture and of their circulation as "things-in-motion," to use Appadurai's terminology. They are only meaningful or even legible to the extent we can see them in context that is both cultural and material.

I have attempted to situate these materials on what Catherine Geel calls the "fluctuating, decorated surface" of Indian culture,[49] and put forward my counterintuitive intuition about the possible meaning of the arresting image of the devouring mouth with recourse to psychoanalysis and Hindu *bhakti* theology. Ultimately, my hope is that I have gone some way towards demonstrating the wonderful insights that ephemera like posters and song booklets can give us into the tradition of the Hindi horror film before we have even watched a single frame.

2

Vampire Man Varma: The Untold Story of the "Hindu Mystic" Who Decolonized Dracula

Brian Collins

We men are all in a fever of excitement, except Harker, who is calm; his hands are as cold as ice and an hour ago I found him whetting the edge of the great Ghoorka knife which he now always carries with him. It will be a bad look out for the Count if the edge of that Kukri ever touches his throat, driven by that stern ice cold hand!

Dracula, Bram Stoker

Introduction

In June of 2017, when I was researching the tropes of Gothic literature in service of my other essay for this collection ("Monsters, *Masala*, and Materiality") I came upon a book with the rather extravagant title, *The Gothic Flame: Being a History of the Gothic Novel in England; Its Origins, Efflorescence, Disintegration, and Residuary Influences*. It was written in 1957 by an author whom I had never heard of named Devendra Prasad Varma. I was intrigued both by the book itself (a study of Western horror traditions by an Indian scholar) and by the dedication it bore to Jawaharlal Nehru, accompanied by a frontispiece depicting India's first prime minister in a three-piece suit and fedora, taken, according to the caption, "on a trip to Ottawa in 1957, when *The Gothic Flame* was first published."[1]

Curious enough to do a little internet research on the author, I soon found an article online about Varma's two adult grandchildren, Robin "Rob" Varma and his sister Tami. Five months earlier they had won a contest sponsored by the online hospitality brokerage company Airbnb to spend Halloween night sleeping in coffins in Transylvania's Bran Castle (commonly referred to as "Dracula's Castle" despite having no historical connection to either Vlad Țepeș or Bram

Stoker). Naturally, I assumed at first that having the grandchildren of "Vampire Man Varma" win the contest was a publicity stunt. It was not. By happenstance or *kismet*, their 500-word entry was selected from 88,000 contestants. Tami and Rob were then given thirty-six hours to be on a flight to Romania. Rob did not hold a passport, but Tami's event-planning skills apparently saw the day through.[2]

I had no idea what any of this had to do with my original topic of Hindi horror movie posters, but I was unable to move on from it. Tami, an event planner in Ottawa, was easy to contact online, and she directed me to her brother, who graciously provided me with a treasure trove of scans of his late grandfather's correspondence, papers, photographs, and notes, along with a healthy dose of family lore. For reasons that I hope will soon become clear, I quickly became quite fascinated with the author of *The Gothic Flame* and equally convinced that any discussion of horror in India was impoverished to the extent that it ignored his remarkable life and work.

Fascination aside, how exactly does Varma's story help us to understand the development of horror in Bollywood? Let us begin to answer this by looking at the poster for Indian director Rajkumar Kohli's 1979 Hindi film *Jaani Dushman* (Bitter Enemy, see Plate 11). Anyone who has seen the extremely similar poster for British director Terrence Fisher's *Horror of Dracula* (1958) would rightly conclude that *Jaani Dushman* simply copies the iconic design of the earlier poster without bothering to hide the fact (despite the fact that the monster that actually appears in *Jaani Dushman* looks more like Lon Chaney Jr.'s Wolfman than Christopher Lee's Dracula). The implication of this obvious borrowing is that influential Western horror films like *Horror of Dracula* provided a set of conventions, loaded with Christian and Eurocentric imagery, that were then appropriated in India and deployed in subsequent Hindi movies. There is no denying that, as Valentina Vitali notes, "the 'vampires and stakes' of Hindi horror were inspired largely by Christian ritual, unashamedly borrowed from British Hammer films."[3]

But the real story is more complex, because those conventions themselves were already intimately connected to India *before* they were imported by Bollywood. To describe this kind of "cross-cultural form of intertextuality," in the case of how reincarnation is represented in the plots of two Hollywood films (*The Reincarnation of Peter Proud* and *Chances Are*) and two Bollywood films (*Madhumati* and *Karz*), Wendy Doniger borrows a term originated by Agehananda Bharati (1970) and calls it the "pizza effect:"

> *Madhumati* (1958) anticipates, and hence may have been a source of, much of the plot of *The Reincarnation of Peter Proud* (1975). *Karz* (1980) in turn shows

the influence of both *Madhumati* and American films about reincarnation, particularly *Peter Proud*, and may in its turn have contributed to *Chances Are* (1989).[4]

The complicated process of exchange and appropriation at work in the development of Hindi horror films is even more so when we take into account the significant role played by a former Gurkha paratrooper, Shakespearian actor, and Indian diplomat named Devendra Varma. *Horror of Dracula* is (of course) an adaptation of the famous 1897 novel *Dracula* by Bram Stoker, whose brother Thomas served in the Bengali Civil Service from 1872 to 1899. And in Stoker's book, Dracula is not killed by a Hollywood-style stake but by a Bowie knife and a *kukri*, the latter being the favored weapon of the Indian Gurkha soldier, as the passage from *Dracula* quoted in the beginning of this chapter illustrates.

And the film itself, in which the Count is played by Varma's friend and admirer Christopher Lee, was part of a wave of movies inspired in part by the popularization of Gothic literature in which Varma played no small role. British vampire films like *Horror of Dracula* were already using Indian-inspired source material recently popularized by an Indian scholar before they went on to influence the Indian cinematic vampires found in *Bhayaanak* (Frightening, 1979, dir. S.U. Syed), *Veerana* (Wilderness, 1988, dir. Shyam and Tulsi Ramsay), and *Bandh Darwaza* (The Closed Door, 1990, dir. Shyam and Tulsi Ramsay).[5] For his part, Varma pushed the starting point of this process of exchange and appropriation back even farther, observing, "Westerners have viewed vampire lore as a fascinating but unsolved enigma, but the origins of this myth lie in the mystery cults of Oriental civilizations."[6]

A View of Everest

Devendra Varma's is a biography that strains credulity. Who would guess that one man would have known horror icons Vincent Price and Christopher Lee as well as the founder of modern India, Jawaharlal Nehru (a cousin of his, no less); that this man would also have corresponded with Egyptian president Gamal Abdel Nasser and *Psycho* author Robert Bloch; that he would have fought for the British during "Operation Dracula" in 1945 and been honored by the Count Dracula Society in Los Angeles in 1968? Nevertheless, all of this is true of a man who was also, at least in the last phase of his career, a true-life example of the kind of bow tie-wearing, globe-trotting, ghost-hunting antiquarian that

populates M.R. James-inspired horror fiction.[7] His biography serves as a kind of missing link, or better yet, a missing Gordian (Gauḍīyan?) knot, connecting colonial history, the Indian independence movement, the Gothic revival of the 1960s and 1970s, South Asian folklore, British and American horror cinema, and Bollywood.

Born in 1923 to a high-caste family in Darbangha in present-day Bihar, Varma was raised with wealth and education. He married Eileen Florence Sircar, a woman from a Baptist family who was a lifelong intimate of Indira Gandhi. Varma received his BA in English from Patna University in 1942 and his MA two years later, after which he joined a Gurkha Battalion of the Indian 50th Parachute Brigade. In March 1944, the brigade found itself in heavy fighting at the Battle of Sangshak on the India-Burma border where 652 soldiers lost their lives. Varma and ninety-nine others were taken prisoner by the Japanese and held in a prisoner-of-war camp. The brutality of the treatment he endured there, which he always refused to discuss with his family, marked him for the rest of his life.

In 1946, Varma was back in India and teaching English when he made a visit to Birla Cottage, Gandhi's summer headquarters. In an essay written nearly forty years later, Varma described his audience with Gandhi ("a strangely sane old man in a world going mad") in this way:

> "So you are scattering ignorance all around and corrupting the morals of youth, my dear lecturer in English," thus the Mahatma greeted me at Birla Cottage in Mussoorie during the summer of 1946. "I have often seen you at prayer meetings in the far distant corner of the tennis court in your shark-skin suit and flashing red-tie ... thought that you are a deputy magistrate of some sort."[8]

At the end of their meeting, Gandhi looked suspiciously at the homespun *khadi* clothing that Varma and his companion were wearing (claiming to have adopted it long ago). He picked out some telltale coarse threads that indicated a recent purchase and remarked wryly, "Whenever you wear new clothes do take care to have them first washed and laundered!"[9] The sartorial commentary in this anecdote is perhaps not surprising given the significance of Indian-made clothing to Gandhi's movement, but it also speaks to what we will see as a deeper current in Varma's life: his penchant for "dressing the part," whether as a Gandhian, a high-flying diplomat, a Shakespearean villain, or an aspiring horror movie producer.

From 1947 to 1953 Varma held the post of assistant professor at the Universities of Patna and Bihar. He subsequently did two post-graduate stints in

Great Britain, where he was introduced to the English Gothic novel by his mentor, Bonamy Dobrée. It was during this period that Varma did the research that would soon yield his most well-known work, *The Gothic Flame*. In 1957, the year it was published, Varma was sent to teach English literature at Tribhuvan University in Kathmandu as part of the Colombo Plan, a development scheme in which seven Commonwealth Nations (Australia, Britain, Canada, Ceylon, India, New Zealand, and Pakistan), with significant help from the United States, would attempt to combat the growth of communism in Asia by investing in infrastructure, agriculture, and a campaign aimed at improving the image of democracy and capitalism.[10] Describing the origins of the plan, Daniel Oakman writes: "Equal to these anti-communist ambitions was a more secretive agenda to use aid to 'modify any resentment arising from differences between Australian and Asian living standards' and 'strengthen or develop amicable political relations' by using economic and social instruments to assert political and cultural pressure on Asian people and their leaders."[11]

In Kathmandu, Varma staged a production of *Othello* in which he played Iago and which was attended by King Mahendra Bir Bikram Shah Dev.[12] Meanwhile, *The Gothic Flame* was widely reviewed at home and abroad. In India, *The Sunday Searchlight Magazine* held up his work as evidence of "the renewed vitality of modern research in English by Indians," and *The Illustrated Weekly of India* took umbrage on Varma's behalf at the "awkward introduction" in which the publishers describe him as "an Indian and a youngish man at that!"[13]

After Nepal, Varma was sent to Damascus, following that humiliating last gasp of the British Empire known as the Suez Crisis.[14] He arrived in September 1958, eight months after the founding of the United Arab Republic (UAR), a political union of Syria and Egypt under Nasser (see Plate 12). Per the Colombo Plan's *raison d'être*, it seems likely that Varma was there to keep an eye on political developments. This would explain his friendship with the former director of Syrian military intelligence and current vice-president of the UAR, Colonel Abdel Hamid al-Sarraj, whose biography he was writing, according to press reports.

A letter of recommendation from Dr. Hikmat Hashim, rector of the University of Damascus, paints a picture of Varma's time in Syria:

> Dr. Varma's elevated artistic interests made him a much sought-after person in Damascus social circles. He proved to be very popular, and always remained a generous host ... What endeared him most to us was his sense of loyalty and devotion to the Arab cause, and his subtle understanding and interpretation of the Syrian way of life.[15]

In 1959, he mounted and played the lead in a production of *Macbeth,* the first foreign-language play ever performed in Syria.[16] The following season, he put on *Othello* and sent an invitation to Nasser. Not only did Nasser attend (along with Anwar Sadat), he returned the following season for *The Merchant of Venice* and gave a short address in which he pronounced himself "greatly affected by the speech of Dr. Varma" and proclaimed, "I know that Dr. Varma is an Indian professor. We like India; we love India. We have great respect for India and for the Prime Minister of India Mr. Nehru." A photograph from the time shows Varma as Shylock, decked out in his customary white stage makeup and a cloak emblazoned with a Star of David, pulling Nasser onto the stage to take a bow.[17]

Varma's three years in Damascus more or less coincided with the entirety of Syria's participation in the UAR, which began to collapse after a military coup on September 28, 1961, in which Varma's friend al-Sarraj was imprisoned. Because of his known connections with al-Sarraj and Nasser, along with "certain indiscreet statements" and "professional jealousies," Varma was abruptly expelled from Syria in November of 1961 and returned to Delhi.[18] Samar Attar, a Syrian graduate student whom Varma cast as Desdemona (with the condition that she dye her hair blonde), recalls that "the Syrian military authorities expelled Dr. Varma from Syria for his association with Nasser during the production of *Othello.*"[19] Shortly thereafter, in the fall of 1962, Varma traveled to Cairo at Nasser's request, where he taught for one semester at the University of Ain Shams.[20]

After the semester break Varma went to Canada, where he took a position at Dalhousie University in Halifax, Nova Scotia. He later wrote that he owed the university's president a debt of gratitude "for salvaging me from my Syrian nightmare in the explosive Middle East" (1968: ix). At Dalhousie, Varma took on a persona quite different from the urbane and dapper Shakespearian scholar and actor who had moved about in the most rarefied social and political circles in Syria and Egypt. Instead, while he retained his customary well-dressed elegance and air of cultivation, Varma reinvented himself as a literary sleuth, taking as his first case the seven "horrid novels" described in Jane Austen's *Northanger Abbey.* The novels are: *Castle of Wolfenbach* and *The Mysterious Warning* by Eliza Parsons, *Clermont* by Regina Maria Roche, *The Necromancer* by Ludwig Flammenberg, *The Midnight Bell* by Francis Lathom, *The Orphan of the Rhine* by Eleanor Sleath, and *Horrid Mysteries* by the Marquis de Grosse. The conversation in *Northanger Abbey* goes as follows:

> "But, my dearest Catherine, what have you been doing with yourself all this morning? Have you gone on with Udolpho?"

"Yes, I have been reading it ever since I woke; and I am got to the black veil."

"Are you, indeed? How delightful! Oh! I would not tell you what is behind the black veil for the world! Are not you wild to know?"

"Oh! Yes, quite; what can it be? But do not tell me—I would not be told upon any account. I know it must be a skeleton, I am sure it is Laurentina's skeleton. Oh! I am delighted with the book! I should like to spend my whole life in reading it. I assure you, if it had not been to meet you, I would not have come away from it for all the world."

"Dear creature! How much I am obliged to you; and when you have finished Udolpho, we will read the Italian together; and I have made out a list of ten or twelve more of the same kind for you."

"Have you, indeed! How glad I am! What are they all?"

"I will read you their names directly; here they are, in my pocketbook. Castle of Wolfenbach, Clermont, Mysterious Warnings, Necromancer of the Black Forest, Midnight Bell, Orphan of the Rhine, and Horrid Mysteries. Those will last us some time."

"Yes, pretty well; but are they all horrid, are you sure they are all horrid?"

"Yes, quite sure..."[21]

The novels had been long lost and were, in fact, widely assumed to have been invented by Austen herself before the Gothic scholar Michael Sadleir had proved their existence in 1927. After their discovery, the other great Gothic scholar of the period, Montague Summers, set out to oversee the republication of the novels, but the series was discontinued after two volumes.

In the 1960s, Varma's revived republication of the novels was widely covered in the press and made him into something of a celebrity, cementing his reputation as a Gothic expert and a literary detective. He went on to publish deluxe critically edited editions of the works of Gothic novelists Horace Walpole, Anne Radcliffe, Matthew Lewis, and dozens more "rare Gothics," including *Varney the Vampire* and Sheridan Le Fanu's *Carmilla*, both of which are widely regarded as two of the most significant precursors to modern vampire fiction.[22]

In the period surrounding the publication of *The Gothic Flame* and the republication of the seven horrid novels, a "Gothic revival" was in full swing in the popular culture of the English-speaking world. In Hollywood, Vincent Price appeared in a slew of films directed by Roger Corman based on the work of Edgar Allan Poe. In Britain, Christopher Lee was starring in blood-spattered Hammer horror vehicles like *The Curse of Frankenstein* (1957, dir. Terence Fisher) and *Horror of Dracula* (1958, dir. Terence Fisher).[23]

Significantly, Varma's work did not go unnoticed by the major players in this Gothic revival. Donald A. Reed, the founder and president of Los Angeles's Count Dracula Society, had purchased the first edition of *The Gothic Flame* in 1957 and in 1968 the Society honored Varma with the "Ms. Ann Radcliffe Award."[24] Subsequently, Reed became a close friend of his and introduced Varma to a crowd that included Robert Bloch (who had been the youngest disciple of American cosmic horror master H.P. Lovecraft), science fiction pioneer Ray Bradbury, and *Famous Monsters of Filmland* editor Forrest J. Ackerman. Ackerman even hosted a reception for Varma at the "Ackermansion," the house where he lived and displayed his massive collection of horror memorabilia. A 1968 letter from science fiction author A.E. van Vogt describes a plan for promoting Varma's work with the help of fellow Count Dracula Society members, "since a great success for the Horrid Novels might stimulate a further Gothic revival."[25]

Varma also visited the campus of the University of Southern California and was probably attempting to negotiate a position for himself there, closer to Hollywood ("For the last five years, like a bad coin I have got stuck in Nova Scotia!" he complained in a letter to Reed in 1968). Varma's trips to Los Angeles exemplified the combination of show business and scholarship that would come to define the "third act" of his career. The talk he gave at the Count Dracula Society in 1968 bore the tellingly aspirational title, "On Possibilities of Gothic Romances on the Silver Screen."

The question of the extent to which Varma was involved in any actual filmmaking is difficult to answer conclusively. Sometime in the 1970s, Varma was in talks to produce a screenplay based on Ann Radcliffe's *The Mysteries of Udolpho* in which Vincent Price would play the lead.[26] In later interviews, he mentioned that he was working on a film of Matthew Lewis's *The Monk*, and in a 1986 profile piece he told a reporter that he planned "to turn to publishing and making his own films when he [retired] from teaching in two years."[27] A 1987 press release for *Voices from the Vaults*, a collection of short horror fiction and real-life accounts of the supernatural that he edited and wrote an introduction for, lists three movie credits for Varma: The Robert Bloch-penned horror anthology *The House that Dripped Blood* (1971, dir. Peter Duffell) and two Vincent Price movies, *Theater of Blood* (1973, dir. Douglas Hickox) and *The Fall of the House of Usher* (1960, dir. Roger Corman), the last of which seems highly unlikely given that Varma was in Syria at the time of the movie's production and release.

Varma was indeed carrying on a friendly correspondence with Bloch during the time the latter was writing the screenplay for *The House that Dripped Blood*, but when Bloch mentions the film in his letters he makes no reference to Varma's

involvement. Likewise, Varma was in contact with Price during the time in which *Theater of Blood* was filmed, but none of Price's letters suggest they worked on it together in any way. It seems likely that Varma considered this correspondence itself and his providing Bloch and Price with copies of his books to constitute a form of participation in the film-making process, and that he then capitalized on that self-acknowledged collaboration to publicize *Voices from the Vaults*, a book that was clearly aimed at modern horror fans rather than an academic audience that would know his reputation as a scholar.[28]

An essay that Varma sent sometime in the late 1970s or early 1980s to Sue Bradbury, the editor-in-chief of the London Folio Society, contains paeans to his friends Christopher Lee and Vincent Price, and this not-so-subtle suggestion on the last page:

> So far only two strains of the Gothic, the vampire and the monster, in sequels of Dracula and Frankenstein, have been fully exploited by the cinema industry, while the rich repository of Gothic classics has been left virtually untouched. The producers and directors of horror films are not expected to be scholars of Gothic Romance, but they have still to experiment with that rare kind of suspense and mystery which is locked in The Monk and The Mysteries of Udolpho. They have to be initiated into the arcana of these sealed treasuries.[29]

There is little doubt about who Varma thought would be most qualified to do the initiating.[30]

Even apart from Hollywood, Varma was a showman in all things, hosting "Transylvania Weekends" at Dalhousie in 1973 and 1986 (see Plate 13) and personally conducting "vigils" at such sites as Dracula's Castle (where his grandchildren would spend a night in coffins courtesy of Airbnb thirty years later) and Castle Lauenstein in Thuringia. A profile of Varma (whose "background is as exotic as his beliefs") appeared in *The Queen's Journal* on Halloween 1986, illustrated with a drawing of the "Bleeding Nun" who is said to haunt Castle Lauenstein. Varma also appeared on Canadian television and radio. His television work usually consisted of appearances around Halloween on morning talk shows, where he was asked about things like Dracula and witchcraft. But he also participated in the Ontario children's variety show *The Hilarious House of Frightenstein* (1971–2), co-hosted by comedian Billy Van along with a late-career Vincent Price. It may have been around this time that Varma's son discovered the horror icon "sleeping one off" on the family couch.

While he was helping along the Gothic revival in Hollywood, Varma's friendship with Rashtrakari ("National Poet") Ramdhari Singh Dinkar (one of

whose Hindi operatic works he staged) also gave him some influence in Bollywood. He reportedly talked Dinkar out of censoring Johnny Walker's "*Sar Jo Tera Chakraye*" ("If You Have a Headache") from the 1957 classic *Pyaasa* (Thirst, dir. Guru Dutt). And when Varma died in 1994 while on a speaking tour in New York, none other than the most famous Bollywood star of them all, Amitabh Bacchan, called to offer the family condolences.

The most important thing about Varma that this brief look at his life reveals is that the theatrical side that he cultivated as an actor was strategically important to negotiating the shifting sands of the post-colonial, post-war world.[31] Whether he was donning *khadi* for Gandhi, a tailored sharkskin suit for photo opportunities with world leaders, or a tuxedo for gala dinners with movie industry people at the Knickerbocker Hotel in Hollywood, Varma always looked the part, just as he did for his performances as Shylock and Iago.

In Varma's archive, I found three images that speak eloquently to how central performance and self-presentation were to his identity. The first shows Varma the thespian wearing white make-up as he portrays Macbeth in Damascus (see Plate 14). In the next photo, taken on a visit by royal invitation to Sikkim, he sits in contemplation of a Nepalese mask, wearing a silk *daura-suruwal* with a Dhaka *topi* on his head (see Plate 15). In the last, we see the professor in his well-appointed library, decked out in tweed and a bow tie, staring intently past the camera as he gesticulates to make a point about Walpole or Byron (see Plate 16).

The scholar of Romanticism Mario Praz once described Varma as a "blend of Marco Polo, Lawrence of Arabia, and [Melmoth] the Wanderer."[32] The first two names refer to historical figures who became larger-than-life examples of the archetypal adventurer and "stranger in a strange land," both of whom eventually returned home full of tales about the Mysterious East. The last, Melmoth the Wanderer, Varma would have known well as the title character in Charles Maturin's 1820 Gothic novel of the same name. Loosely based on the medieval legend of the Wandering Jew, Melmoth is a man who sells his soul for a preternaturally long life.[33] Repenting of the bargain, he then spends 150 years traveling the earth attempting to find someone he can tempt into damnation in his stead.

Although a European academic like Praz may well have seen the diasporic populations of the decolonized world as rootless wanderers like Melmoth, everything I have read by or about Varma suggests that this story would not have matched his self-image. Even so, in the letter to Donald Reed where he reproduces the quote, Varma writes that he "felt highly flattered" upon hearing it and raises

it in the context of feeling stuck in Nova Scotia and frustrated with his unsuccessful attempts to relocate to Los Angeles. One can detect here a possible unacknowledged desire for Melmoth's peripatetic life at this moment when Varma's previously episodic existence had slowed its pace. The anticipated next transition, from literary sleuth to movie-maker, was proving difficult and Varma was facing the fact that his current identity as half-showman, half-scholar was likely to become his final one.

We should note here that *Melmoth the Wanderer* also has a place in the Indian construction of the Other within.[34] The novel's opening shipwreck scene inspired the frame story of the 1955 Hindi film *Udan Khatola* (The Flying Machine, dir. S.U. Sunny), in which a pilot named Kashi (Dilip Kumar) crashes in an unknown land whose natives are suspicious of outsiders, worship a fire-breathing idol, and forbid their women from talking to strange men. In a typical colonial romance, the outsider Kashi quickly finds himself in a love triangle with a priest's daughter, Soni (Nimmi), and the jealous queen (Surya Kumari). In the end, Soni, the woman Kashi truly loves, throws herself into the ocean, only to come back in an ethereal form when he is an old man to take his spirit to the other side in her titular flying chariot.

Throughout Hindi horror films, we find wicked priests, black magicians, *tāntrik*s, and other stereotypes who come from the rural laboring population and use their sorcery to torment the hereditary land-owning Thakurs. Often these rural sorcerers curse the Thakur's family for multiple generations, since their monopoly on land ownership also carries on from one generation to the next. In the films of the Ramsays, "the trope of the monstrous often crystallizes around [a] fantasy of feudal excess."[35] In *Veerana*, for instance, the witch Nakita and her servants are associated with the forests surrounding the well-appointed bungalow of the Thakur protagonist. Here, the filmmakers not only appropriate the Gothic castles and curses that Varma popularized in the West, but they also borrow the colonizer's fear of sleeping while surrounded by subalterns, translated into a feudal idiom.

Films like *Udan Khatola* and *Veerana*, which also contain elements common to Victorian adventure-romance novels like *She* (1887), present an example of Indian internal colonialism, by which I mean the attitude of the ethnic and linguistic majority group towards the indigenous peoples (*adivāsi*) of South Asia, including the Gond, Great Andamanese, and Munda tribes. Traces of this internal colonialism are frequently present in Bollywood horror films in the images of savage *jangli* cults with primitive rites and alluringly beautiful women. The discourse of internal colonialism has a tendency to paint rural and tribal

populations as superstitious, eroticized, and prone to despotism and corruption. This is also a tendency to which Varma himself sometimes succumbed. Other times, it was used by critics to marginalize Varma's scholarly contributions. We will now look at some instances of both.

"A Hindu Mystic": The Post-colonial Gothic and the Politics of Gothic Criticism

In their introduction to an issue of *Gothic Studies* devoted to the "post-colonial Gothic," William Hughes and Andrew Smith write:

> Gothic, it is now evident, may not simply be found in the slavery conscious narratives of the Romantic era and in the immigration- and degeneration-obsessed novels of the Victorian fin de siècle, but also in the experience of writers writing out of colonised countries, and those who attempt to rationalise the confused and competing power structures and identities that may follow the departure of the absolutist-colonialist.[36]

In a similar vein, Phillip Holden contends that if Gothic literature serves to "excavate Victorian insecurities regarding Empire only to ultimately contain them, postcolonial texts in these new readings display the Gothic's other face, subverting and calling into question narratives, patterns of thought, and modes of representation that have their origin in colonialism and imperialism."[37] The post-colonial Gothic, which refers both to a practice of critically reading classic Gothic texts and a subsequent genre of fiction that includes works by Toni Morrison and Margaret Atwood (who also corresponded with Varma, incidentally), uses the trope of being haunted by the past in order to explore the unsettled present and future.

Dealing with the question of the Gothic in India specifically, Rachel Dwyer writes, "One may detect links between the Gothic and the problems of Indian modernity, rooted in the Enlightenment, which has often been presented as India's only possible modernity . . ."[38] Meheli Sen makes the nuanced argument that although "Bombay Cinema's romance with the Gothic is . . . an appropriation and restructuring of an inherited colonial form . . . contemporary reviews of the Hindi Gothic film suggest that the Gothic arrives in Indian cinema through a slightly more circuitous route."[39]

Both the general idea of the post-colonial Gothic and the application of its logic to understand the Indian case rest on the presupposition that the European

Gothic developed as a reaction against the context that originally produced it. Smith and Hughes describe this presupposition as an implicit analogy between the eighteenth and nineteenth century Gothic's repudiation of Enlightenment humanism and the postcolonial era's critique of that same Enlightenment humanism as the rationale of the colonial project.[40]

To view the Gothic in this way, as a kind of antithesis produced by the thesis of the Enlightenment, is to conclude that its general characteristics are shaped by an endemic antithetical spirit. That is to say that the primary driving force for the sense of the uncanny in Gothic literature, expressed in themes of haunting and the like, is a discomfort with the new regime of Enlightenment humanism. By this logic, another kind of discomfort, similarly antithetical, but to a different status quo (e.g., colonized people's reaction to colonial rule) could also inhabit the Gothic and keep its general shape, while modifying its specific features to fit the context. One example of this phenomenon is Sen's observation that in Indian horror films Gothic conventions like haunted houses and curses are often overlaid with Indic themes of reincarnation.[41] "In the Indian gothic," likewise argues Vijay Mishra, "reincarnation is an uncanny confrontation with one's past history structured, as in the English literary gothic, through the discourses of melodrama and sentimentality."[42]

Reincarnation is indeed a recurrent theme in Hindi Gothic and horror cinema, playing an important role in films like *Bees Saal Baad* (Twenty Years Later, 1962, dir. Biren Nag), *Neel Kamal* (The Blue Lotus, 1968, dir. Ram Maheshwari), *Mehbooba* (Heroine, 1976, dir. Shakti Samanta), and *Kudrat* (Nature, 1981, dir. Chetan Anand). But it is already present in the Gothic long before it gets to India. In 1832, Poe published "Metzengerstein: A Tale in Imitation of the German," in which a murdered man's spirit comes back to earth as a horse to take revenge on the aristocratic family that wronged him. The story is so ostentatiously Gothic that some critics have thought it a parody of Gothic literature.[43] "Metzengerstein" also seems to have been a primary influence on Kipling's 1888 story "The Phantom Rickshaw," set in Shimla. If Indian filmmakers overlaid themes of reincarnation onto Gothic conventions, we must conclude, they were laying it on top of a nearly identical, well-established theme already present in the European, American, and British colonial Gothic.

Recent critics have rejected the idea of an inherent nostalgic and anti-Enlightenment bent in Gothic literature (the entire basis of its postcolonial appropriation) as ahistorical and invented. In their essay, "Gothic Criticism," Chris Baldick and Robert Mighall take aim at what they see as the regnant notions that have poisoned the well of the study of Gothic literature:

> In our view, Gothic Criticism has abandoned any credible historical grasp upon its object, which it has tended to reinvent in the image of its own projected intellectual goals of psychological "depth" and political "subversion." It has erased fundamental distinctions between Gothic suspicion of the past and romantic nostalgia, mistakenly presenting Gothic literature as a kind of "revolt" against bourgeois rationality, modernity, or Enlightenment.[44]

Baldick and Mighall lay what they see as the insidious misrepresentation of the Gothic as an anti-rational revolt against the Enlightenment directly at the feet of both Varma and his eccentric predecessor Montague Summers, under whose "giant [shadow]" Varma declared himself to be working:[45]

> The assimilation of Gothic fiction into romantic and pre-romantic nostalgia for the Middle Ages is one of the cardinal errors of Gothic Criticism. [This] notion of the Gothic as a "Revival" of medieval spirituality overlooks both the fact that most Gothic novels . . . have nothing to do with the Middle Ages as such, and the more important tendency of Gothic writers to display a thoroughly modern distrust of past centuries as ages of superstition and tyranny. Summers and Varma both seem to have had religious motives for suppressing these awkward features of Gothic: the former was an ardent Roman Catholic convert, the latter a Hindu mystic.[46]

Baldick and Mighall, having dismissed Varma as a "Hindu mystic," go on to argue that a properly critical reading of the Gothic novels reveals in them a "self-consciously Protestant approach to historical representation."[47]

The infamous "Protestant presuppositions" exposed in the study of Buddhism by the scholarship of Gregory Schopen (1991) and, more recently, in the study of Hinduism by Michael Altman (2017), are on full display in Baldick and Mighall's implication, whether intended or not, that Roman Catholicism and Hindu mysticism share a kind of latent irrational "medievalism." Baldick and Mighall were likely unaware that Varma was, according to his grandson, someone who "took his spirituality seriously, though he was also something of a jokester in the temple" and considered himself a Buddhist rather than a Hindu at the time of his death. His wife Eileen was from a prominent Indian Baptist family and later became a Catholic, but also attended the local Hindu temple with her husband. When the Varmas arrived at Dalhousie from Cairo in 1963, there was no real South Asian community, and so they became central to the one that eventually developed as immigrant families moved in. As in many South Asian diasporic populations, the temple's social and economic functions were at least as important as its spiritual ones, making attendance at the temple a rather poor measure of

personal religiosity, let alone "mysticism." But for Baldick and Mighall there are no such distinctions to be made, and the phrase "Hindu mystic" even appears to be redundant.

Varma himself was by no means free from the Protestant notion of "God-obsessed India" and writes in his essay on meeting Gandhi that "[adoration] or idolatry is an inherent [part of the] Indian psyche, an exotic impulse to discover the fountain head of spiritual-mystical wisdom."[48] However, taken in context, what appears at first to be the familiar uncritical attribution of excessive religiosity to India as a whole is undermined by his subsequent description of that meeting with Gandhi. It is of no little consequence that Varma, the devoted scholar of English literature, describes that memorable day with the words, "it still lingers fresh in my memory *for I fancied myself to have sat like Conway at the feet of the High Lama*."[49] The "Conway" to whom Varma refers is Hugh Conway, the hero of the 1933 novel *Lost Horizon*. In the story, Conway is a British diplomat brought by magical means to the inaccessible, luxurious, and utopian Tibetan monastery of Shangri-La, whose inhabitants have eternal youth as long as they stay on the premises. The centuries-old lama, himself a European (a former Catholic monk from Luxembourg, to be precise) informs Conway that he is destined to take over the monastery after the lama's death.

With the deployment of the influential Orientalist fantasy contained in *Lost Horizon* as the lens through which he views his visit with Gandhi, Varma gives us a glimpse into his complex attitude toward religion. If Varma is imagining himself as Conway, a Westerner brought to Shangri-La only to learn that he was always destined to be there, and indeed, to rule over it, wherein lies this "exotic impulse to discover the fountain head of spiritual-mystical wisdom" that he describes? Is it in the psyche of the Indian? Is it in the psyche of the colonialist? Is it the psyche of a colonialist who discovers himself to have been an Indian all along? To complicate matters further, while equating Conway with himself, Varma has equated the white European High Lama in *Lost Horizon* with Gandhi, the English-educated Indian destined to force the British out! There is much ambiguity here.

Baldick and Mighall are not alone, however, in arguing that Varma, as J.M.S. Thompkins puts it in his introduction to *The Gothic Flame*, "sees the Gothic writers as restoring the sense of the numinous to a literature cramped by rationalism and bleached by exposure to unvarying daylight ... [and] renewing its contact with the fertile depths of mystery and primitive emotion."[50] David Richter describes this aspect of Varma's work in especially harsh terms, scoffing at "the numinous" ("a term of, shall we say, elusive meaning") and concluding

that it was "[despite], or perhaps because of, the vacuousness of his critical contribution, [that] Varma became the key Gothic scholar of his generation...."[51]

Along with his show business friends like Robert Bloch and Vincent Price, Varma had friends who did not see the supernatural as pure entertainment. He was close to the Catholic demonologists Ed and Lorraine Warren and invited them to speak at Dalhousie in 1986. While there, the Warrens had a run-in with former president of the British Occult Society Harry Price, who had come "for the gathering," despite having died in 1947.[52] He was also in contact with real-life vampire hunter "Bishop" Seán Manchester (a direct descendant of Lord Byron, which must have thrilled Varma) in 1970, during the latter's search for what he believed was "a King Vampire of the Undead" stalking London's Highgate Cemetery.[53]

According to an obituary written by Manchester, "Varma subscribed unreservedly to a belief in the existence of vampires, the supernatural variety, as defined in every dictionary and chronicled in ancient tradition."[54] But Varma himself was always ambiguous about this. Writing of his trip to "Dracula's Castle," Varma does recount hearing unexplained footfalls and sensing an "unseen, ever-watchful presence."[55] But he also describes "demoniac vampire figures" as "nightmarish projections of a dream world" and refers to "the vampire concept" and "the vampire legend."[56] However, he once quipped, "[you] don't need to believe in a thing to be bitten by that thing."[57]

Dracula Decolonized: Knocking on *Bandh Darwaza*

With a better understanding of Varma's background and the place of his work in the history of Gothic criticism, we can now turn to his ideas. While it is inaccurate to suggest that Varma's "mysticism" drove him to simply project his own worldview onto the literature of the Gothic and the macabre, it is equally inaccurate to deny that his particular ideas about religion and the sacred, rooted in the traditions of the Himalayas, were inextricable in his approach. For Varma, terror and horror were something akin to Rudolf Otto's notion of the *mysterium tremendum*. To illustrate, he cites two scriptures. The first is Job 4.13–16 from the King James Bible:

> In thoughts from the visions of the night, when deep sleep falleth on men, Fear came upon me, and trembling, which made all my bones to shake. Then a spirit passed before my face; the hair of my flesh stood up: It stood still, but I could not

discern the form thereof: an image was before mine eyes, there was silence, and I heard a voice...

The second is *Bhagavād Gītā* 1.29–30, taken (without citation) from Sarvepalli Radhakrishnan's 1948 translation, in which Arjuna says, upon seeing Kṛṣṇa's universal form, "My limbs quail, my mouth goes dry, my body shakes and my hair stands on end."[58]

In one of his rhapsodic meditations, seemingly more indebted to the work of his beloved Romantic and Persian poets than any historical scholarship, Varma uses the language of the Hindu *trimūrti* (Brahmā the Creator, Viṣṇu the Preserver, and Śiva the Destroyer) to describe the vampire as both "the Destroyer and the Preserver, for the passive vampires of life turn into active ones after death."[59] And of the fanged Tantric deities of Tibet, Nepal, and Mongolia, he writes:

> They were meant to inspire terror—an emotion which, for a time, thrusts an individual beyond the self... These terrifying Gods and awesome figures of Tantric Buddhism were manifestations of a great faith. Their timelessly transcending images and paintings in remote mountain shrines, looming terrifyingly in their demonic forms, stimulated the mystics to comprehend that a man can arrive in heaven only if he has the daring and perseverance to wade right through Hell.[60]

We should recall here that Varma identified the ultimate source of the vampire "in the mystery cults of Oriental civilizations," and more specifically in the cultures of the Himalayas, writing:

> During my own visits to the monasteries in the Trans-Himalayas, and wanderings into the empire of the vampire from Tibet to Transylvania, gleaning and tracing sources of lost legends and lore, I gathered fantastic samples of vampire motifs and murals that may open up possibilities of a fascinating study of antique art forms and the process of their dissemination into European culture and literature, and their bearing upon the concept of Hell in medieval paintings and in the Italian Renaissance. Those glaring demoniac vampire figures, nightmarish projections of a dream world, had surely been inspired by antique pristine faiths and were creations of some prehistoric, unknown Oriental Michelangelo or Leonardo da Vinci of ages long ago.[61]

We should recognize that Varma's imagined Himalayan origins of the vampire are part of a larger discourse about Tibet and environs represented in works like the aforementioned *Lost Horizon* and Alexandra David-Néel's influential *Magic and Mystery in Tibet*.[62] Likewise, his description of Tantra as "a disastrous

parasitical disease" and "a cloak to the worst forms of devil worship"[63] parrots a party line that goes back to the nineteenth century reform movements of Rammohan Roy and others.[64]

But unlike figures such as David-Néel on the one hand or Roy on the other, Varma was neither a Western *sahib* nor a social reformer. He was more of an Occidentalist than an Orientalist, studying English literature from the outside, as is made clear in newspaper headlines like "Indian Found Secret Britons Had Missed"[65] and in the title of the (lost, sadly) paper he gave in Delhi in 1982, "Romance of Research in English: Viewpoint of an Alien Indian." As one reviewer remarked:

> It is interesting that the authority on this aspect of our heritage should be an Oriental. The writer remembers meeting a Burmese scholar in a small village in Wiltshire not far from Foothill. The latter talked much about Beckford and the gothick novel and said how he had read *Vathek* as a young man years before in Burma.[66]

In his introduction to *The Necromancer*, Varma writes that the "[black] magic and diablerie" of German *Schauerromantik* ("dark romanticism") "were native to the soil of Germany, and the transplantation of these exotics into England pleased English readers."[67] Finding the exotic and bizarre in Germany and indulging in a gleeful shudder at its delicious depravity would seem to reverse the direction of the "Indo-Germanic" axis that positions Germany as the spiritual heir of India's now-decadent culture.[68]

The Himalayas were not just some abstraction for Varma, or a mere projection of Orientalist fantasy. He seems to have remained close to Nepal his entire life, joining the Association of Nepalis in America, serving as a consultant for acquisition of Vajrayāna Buddhist artifacts for the Nepali Cultural Centre, and corresponding with the Nepalese ambassador in China about the role of India in the country's future global interests in the early 1980s.

A 1969 newspaper article reports that he "had obtained images which support his theory that Hindus knew of the Vampire legends long before their occidental and Gothic brothers."[69] In September of 1970 he traveled to Sikkim on the border at the invitation of its Queen Consort, Gyalmo Hope Nyagmal (formerly blue-blooded New York socialite Hope Cooke, a freshman majoring in Asian studies at Sarah Lawrence when she met the Crown Prince), to examine paintings of wrathful deities at the Sinon monastery.

"Anti-Tantricism," the attitude of combined revulsion and fascination toward Tantra that Varma appears to share with people like Roy and David-Néel, is no

more homogeneous or monolithic than Tantra itself. For Varma, it seems to come out of a showman's sense of titillating the reader, performing the duties of an enthusiastic tour guide of the grotesque, playing up to stereotypes when it serves his purposes. "Dr. Varma's rich voice, thickly accented with the mystic tones of his native India, enunciates each word," recalls an interviewer, "while dramatically savoring the unworldly implications of his beliefs. For Dr. Varma, it is 'Dwaacullaa,' not a wimpy 'Dracula.'"[70]

His deployment of Orientalist fantasies about Tantra have to be understood as originating in the same impulse that led him to republish in gilt-paged deluxe editions the "horrid" novels of Jane Austen *because they were horrid*. Despite (or maybe as a result of) his prior participation in establishing Western hegemony in post-colonial Africa and Asia as part of the Colombo Plan, in his incarnation as the eccentric but worldly "Vampire Man Varma," ("the best PR man [vampires] ever had")[71] he seemed uninterested in imposing any cultural taxonomies, only in using Orientalism as yet another disguise. He became the "jokester in the temple" who brings everyone in on the joke by playing with Orientalist tropes out in the open. I argue that with this ludic sensibility, he renders these tropes "inoperative," a term I am borrowing here from Giorgio Agamben, who envisions (following Walter Benjamin) a post-messianic order in which "humanity will play with the law as children play with disused objects, not in order to restore them to their canonical use but to free them from it for good."[72]

But, we may now ask, how does Varma's influential re-imagining of the Gothic play a role in Indian filmmaking? His filmmaking ambitions having been thwarted (though not for lack of trying), Varma never had a chance to directly inspire any Indian cinematic knock-offs or remakes of his own films. However, the influence of scholarship like Varma's on horror cinema is well documented. We can observe how the folklorist Jan Harold Brunvand's popularization of the "urban legend" has inspired genre films like the *Urban Legend* and *Candyman* franchises.[73] Likewise, the medievalist Carol Clover's theory of viewer identification with the "final girl" in slasher films[74] has informed self-conscious genre exercises like the *Scream* franchise and the even more explicitly referential *Final Girl* (2015, dir. Tyler Shields).

We can see the influence of (or at least some resonance with) Varma's theory that Tantra and vampirism spring from a common source in a film like *Bandh Darwaza*. *Bandh Darwaza* was the Ramsay brothers' last theatrical hit, and it rehashed many plot and stylistic elements from their earlier successes, especially *Purana Mandir* (1984, dir. Shyam and Tulsi Ramsay) and *Veerana*. Known for saturating their Gothic landscapes in vivid colors and playing up the blood and

sex, the style of what Meheli Sen describes as the Ramsays' "Emergency Cinema" (a product of the political turbulence of India under Indira Gandhi) looks very much like what Varma described in the cinema of postwar Britain:

> Colour turned more crimson with blotched victims, scarred disfigurements, and stakes thrust into the hearts of voluptuous maidens resting in coffins spurting rich blood. The public luxuriated in blood-bath and blood-fantasy, and inevitable ritual of experience for an audience that had already gorged off real-life horrors.[75]

While the satin-cape-wearing, widow's-peaked appearance of the glowering villain of the film, Nevla (Anirudh Agarwal) is obviously based on the Western cinematic vampire originated by Bela Lugosi, the plot more resembles a classic Gothic curse movie like Mario Bava's *Black Sunday* (1960), in which a witch returns from being buried alive to torment the descendants of her killers.[76] In the film, a rich landowner's wife Laajo (Beena) is unable to conceive and so her maid (Aruna Irani), a devotee of Nevla, takes her to the master's cave, where he ritually impregnates her on the condition that Laajo will bring the child to him if it is a girl. When the girl is born, the maid poisons Laajo and brings the baby, Kaamya, to Nevla, prompting Laajo's husband Thakur (Vijayendra Ghatge) to rescue his daughter and stab Nevla in the heart. Twenty years later, Nevla has been resurrected and uses his magic to lure the grown-up Kaamya (Kunika) to him, where he seduces and murders her. Finally, Thakur corners Nevla in his lair and destroys him for good by setting fire to the giant bat-idol in which his power lies.

Usha Iyer identifies the bat idol in *Bandh Darwaza* as non-Hindu, indeed, part of "a concerted effort to not associate any Hindu deity with the 'horrifying' Tantric practices in the film."[77] But to my eyes, the image closely resembles an amalgam of a vampire bat, clearly borrowed from Western lore, and the Tantric goddess Revatī-Jātahāriṇī, said in the eighth century *Kaśyapa Saṃhitā* to be have folded wings and fangs and be prone to attacking pregnant women and killing their unborn children, an identification that resonates with the film's plot.[78]

Iyer identifies Nevla himself as the result of a "semiotic osmosis that interweaves the Western folkloric figure of the vampire and African traditions of voodoo with indigenous horror traditions of possession and the occult."[79] But he is also the Lord of the Black Mountain, attended by his devotees and surrounded by the trappings of *pūjā*. And his bargain with Laajo is not so different from the one that Varuṇa makes with Hariścandra in the famous story of Śunaḥśepa, where the god grants the king a son on the condition that the son would then be sacrificed to him.[80] In fact, Nevla's offer is better than Varuṇa's because he at least gives the child a roughly 51 percent chance of escaping by being born male.

Varma's entire project to recover the numinous Gothic appears as a kind of inside-out version of the attraction-repulsion toward the exotic/*jangli* that we see expressed in works like *Lost Horizon, Bandh Darwaza, Udan Khatola*, and *Veerana*. The difference between Varma's discourse and the pure colonial discourse is the ambivalence lent to it by the cultivated ambiguity of Varma's self-presentation and the profound entanglement of his own life with the end of colonialism.

Apart from these thematic connections between Varma's theory of the vampire and Bollywood horror, there is a (probably unintentional) parody of Varma in the 2014 Ramsay brothers' film *Parosi* AKA *Neighbours: They Are Vampires*, a remake of the American *Fright Night* (1985, dir. Tom Holland). It was bizarrely advertised as the first Indian vampire movie, despite being at least the third Indian remake of *Fright Night*, following the Tamil *Amavasai Iravil* (Mother's Night, 1989, dir. P. Chandrakumar) and the Hindi *Wohi Bhayakar Raat* (That Terrifying Night, 1989, dir. Vinod Talwar).[81] The possible Varma reference in the film is the horror-loving heroine's favorite author of books on vampires, the track-suit-wearing professor named Indernath Malhotra. Played by comic actor Shatki Kapoor, the "Professor Malhotra" character replaces Peter Vincent (Roddy McDowall) in the original film, himself an amalgam and sendup of B-movie actors and TV horror hosts from the Gothic revival of the 1960s that Varma helped to inspire.

Conclusion

The epigraph that sits atop the editor's preface to *The Northanger Set of Jane Austen Horrid Novels* is a Sanskrit quatrain that Varma attributes (incorrectly) to the *Pañcatantra*, and translates:

> *Vedas* and *Smritis* differ in their views;
> There is no single philosopher whose opinion is binding on all;
> The secret of *Dharma* lies concealed in a mysterious cavern;
> The path trodden by the great ones is the only way.[82]

Despite what Baldick and Mighall suggest, Devendra Varma was not a "Hindu mystic" meditating in a mysterious cave, even though that may well be where the secret of *dharma* lies concealed. He was instead a wanderer, like Melmoth, following "the path trodden by the great ones."

Along with Melmoth, Marco Polo, Lawrence of Arabia, and Hugh Conway, there is one last historical alter ego that sheds some light on Varma's self-image.

The Hungarian Orientalist Arminius Vámbéry (1832–1913), himself a consummate "wanderer," was a "small, curious, limping eccentric figure—with a fund of strange stories to tell," and "a wonderfully clever man, who had travelled all over the East and gone in disguise through hair-breadth escapes in Bokhara, Samarkand, and Afghanistan."[83] Vámbéry was a "free thinker" born into a Jewish family who sometimes identified as a Christian but also had great sympathy for Islam and disguised himself as a Sunni holy man to spy for the British during the "Great Game," in which he sided with the them against the Russians. In England, he met with Disraeli, Lord Curzon, and Queen Victoria. He also knew Bram Stoker, and Varma argued that he provided the inspiration for Stoker's creation, the archetypal vampire hunter Abraham Van Helsing. It is hard to imagine that Varma did not see something of himself in Vámbéry, who also died suddenly of a heart attack in New York.

Above all else, Varma was able to be who and what he needed to be for any occasion, a skill he developed to survive the brutality of a Japanese POW camp, the high-stakes pressure of a diplomatic crisis, or the difficulties of managing one's career as an Indian-born academic teaching English literature at a Canadian university. Ironically, it is his protean personality that served him so well in life, along with the attending complexities of his biography, that seem to have so far kept him out of the intersecting histories of India and horror in contemporary scholarship. Hopefully, that will not be the case any longer.

ns/Part Two

Cinematic Horror, Iconography, and Aesthetics

3

Divine Horror and the Avenging Goddess in Bollywood

Kathleen M. Erndl

Editor's Note

Ellen Goldberg and Aditi Sen organized a panel at the 2016 American Academy of Religion meeting in San Antonio, Texas titled "Theorizing Horror in Bollywood." Panelists included Ellen Goldberg, Aditi Sen, Brian Collins, and Kathleen M. Erndl, with Diana Dimitrova as presider. After the panel, all the participants met for dinner to discuss the idea of turning the presented papers into a book. We agreed unanimously that this was an excellent idea and that we would each submit a first draft of our papers early in the new year. However, on February 19, 2017, less than three months following the AAR meeting, Kathleen died suddenly at the age of sixty-three. We were shocked and deeply saddened. We have included her paper here, in its original form, in memory to Kathleen's scholarly legacy and her love of Bollywood.

Horror is not found only in genre horror films; it plays a significant role as an element in mainstream Hindi films, films that may be primarily romances, comedies, historical dramas, social critiques, and so on. In the film *Om Shanti Om* (2009, dir. Farah Khan), a meta-commentary on the Hindi film in general that reprises well-worn tropes from earlier films of retribution in the next generation through reincarnating characters, the ghost of murder victim Shantipriya appears in the final scene, adding a touch of the macabre. One could multiply examples. If one accepts Vijay Mishra's argument, at least as a general observation if not as an absolute rule, that Bollywood films are in one way or another retellings or re-creations of the *Rāmāyaṇa* and the *Mahābhārata*, then the reason for horror as a minor element in many Bollywood films is not hard to find.

Horror appears sporadically, and in some cases extensively, as in battlefield carnage passages in the epics, as well as in Sanskrit drama and story literature and in folk dramas and oral tales throughout South Asia. Classical Indian aesthetic theory speaks of successful drama as an ideal mix of dominant and subordinate *rasas*, "tastes" or "flavors," that evoke in the audience appropriate elevated moods that are central to the aesthetic experience. These *rasas* are the refined results of corresponding *stāyibhāvas*, or "stable moods," which have numerous variations and subtypes (see Table 3.1, on *rasas*, below).

Several scholars have suggested that popular Hindi (and other Indian language) films, with their inclusion of music, dance, and "frontality" are driven more by *rasa* than by "realism," plot consistency, or adherence to a single genre. This is not to say that Indian filmmakers are experts on *rasa* theory or apply it in a handbook sort of way. As Philip Lutgendorf has stated, "although modern filmgoers seldom specialize in classical aesthetic theory, the vocabulary of *bhāva* and *rasa* remains in use in Indian vernaculars, and the broad cultural consensus is that a satisfying entertainment ought to consist of a range and succession of sharply-delineated emotional moods."[1] Bollywood films are often referred to, sometime dismissively, sometimes appreciatively, as *masala*. *Masala* means "spice," or more accurately, a "mixture of spices." The *masala* film is a not really a genre, but rather a megagenre encompassing comedy, drama, action, and song-and-dance sequences, often in exotic locales. It is intended to entertain and appeal to all audiences, to have "something for everybody." I suggest that *masala* is a vernacular version of *rasa*, with a similar semantic range, though earthier and more populist. It does not have the extensive technical vocabulary associated with *rasa* theory, and of course includes modes absorbed from Persian, Arabic, and Western sources.

Table 3.1 Chart Outlining Various Moods and Flavors (*rasas*)

Sthāyibhāva	Rasa
Rati (Love)	**Śṛṅgāra** (Erotic Love)
Hāsya (Merriment)	**Hāsya** (Humorous)
Soka (Sorrow)	**Kāruṇa** (Pathetic)
Krodha (Anger)	**Raudra** (Furious)
Utsāha (Enthusiasm)	**Vīra** (Valorous)
Bhaya (Terror)	**Bhayānaka** (Horrific)
Jugupsā (Disgust)	**Bībhatsa** (Repugnant)
Vismaya (Astonishment)	**Adbhuta** (Wondrous)
Śama (Placidity)	**Śānta** (Blissful)

Rasa and *Masala*

There is no *rasa* or *bhāva* that corresponds exactly to horror, as we find in genre horror films, either Western or Indian. The category of "horror" most closely corresponds to the *bhayānaka* or "terrifying" *rasa* though, as I will demonstrate through the following examples, it also includes at least a taste of the *bībhatsa* or "disgusting" *rasa*. Echoing and transforming themes in the *Rāmāyaṇa*, *Mahābhārata*, *purāṇas*, and oral traditions of India, Hindi cinema has a pervasive fascination with what I call the "Avenging Goddess" motif. Several scholars have called this motif "Avenging Woman," which is (also) accurate, but which fails to give sufficient attention (or maybe considers it too obvious to mention) how through sound, music, and iconic imagery a woman "becomes" a goddess.

How does a woman become a goddess? This is accomplished through what in aesthetic theory (see Anandavardhana, Abhinavagupta) is called *dhvani*, or "suggestion." First, there is the pervasive idea, found in such texts as *Devī-Mahātmya* and popularly, that women embody *śakti*, the feminine power or energy that can, under certain circumstances, become manifested as a Devī, or goddess. Such commonplaces as a wife as "Lakṣmī of the house" or a virtuous woman being a veritable Sītā attest to this. But a woman can also manifest the fierce aspects of the goddess when pushed to the limit and redressing injustice. A woman, subject to violent oppression, transforms into a horrific Durgā or Kālī-like goddess to exact revenge upon the demonic forces and re-establish justice. This she does with bloodshot eyes and wild hair, wielding a sword, axe, or sickle, or even tearing at the flesh of the miscreant with her teeth. Severed heads are often involved. Social, political, and economic oppression of women are homologized with the cosmic struggle between *devas and asuras* (gods and demons), and *dharma* and *adharma* (righteousness and unrighteousness).

An ordinary woman killing a rapist becomes Durgā slaying the buffalo demon. This is shown in various degrees in different films, sometimes minimally. For example, the 2014 film *Mardaani* (dir. by Pradeep Sarkar), a police drama starring Rani Mukerji who hunts down a child slavery ringleader, has little religious imagery (see Chapter 8 in this volume). But when she, along with a gang of young women, corner the culprit, the women collectively attack him, while a non-diegetic voice in the background chants: *ya devi sarvabhiuesu sakti rupena samsthita*. The film ironically is called *Mardaani* (Manliness), while the *dhvani* clearly establishes the female power.

Using examples from films like *Pratighat* (Retribution, 1987, dir. N. Chandra) and *Anjaam* (Outcome, 1994, dir. Rahul Rawail) this paper explores how through

visual, aural, and lyrical means, "Avenging Goddess" films evoke the *rasas* of terror and disgust to create "Divine Horror."

The *Devī-Mahātmya*

In the Hindu sacred text *Devī-Mahātmya* (Greatness of the Goddess), in times of crisis when the cosmic moral order (*dharma*) has been usurped by demons, the Goddess Durgā appears in order to destroy evil or disorder (*adharma*) and re-establish justice or harmony (*dharma*).[2] The text consists of three stories relating the exploits of Durgā, interspersed with hymns that extol her powers and qualities. Throughout the text, she is called by various epithets, the most common being Ambikā (Mother) and Chaṇḍikā (Fierce One). The most well-known in iconography and oral tradition is the second story, that of the Goddess Durgā killing Mahiṣa, the buffalo demon. Mahiṣa has usurped the power of the gods, so that they are no longer able to receive their proper shares of the offerings of sacrifice, thus throwing the whole cosmos into disorder. As the gods are unable to defeat Mahiṣa themselves, they concentrate their powerful energies which fuse together as a heap of brilliance that becomes a beautiful woman who rides on a lion. Each god gives her a weapon or quality, whereupon she proceeds to demolish Mahiṣa's army, while her lion devours the dead bodies. Finally, facing Mahiṣa himself, battling his various shape-shifting forms, she places her foot on the buffalo demon's neck and pierces it with her trident. As the demon in "humanoid" form tries to emerge from the buffalo's mouth, she cuts off his head with a flourish. After gods praise her with hymns, she promises to return whenever they call on her again. In folk versions of this story, Mahiṣa tries to capture and marry Durgā against her will. This theme is found in the Sanskrit *Devī-Mahātmya* in the third episode, where the demon brothers Śumbha and Niśumbha try to force her to marry one of them.

> Carnage on the Battlefield in the *Devī-Mahātmya*
> Then the Goddess with her trident, club, and showers of spears,
> With sword and the like slew the great Asuras by the hundreds.
> And she felled others who were deluded by the sound of her bell.
> And having bound some Asuras on the ground with her noose, as she dragged them along.
> Others were cut in two sharp blows from her sword.
> Still others, crushed by the fall of her club, lay on the ground,
> And some, much smitten by her mace, vomited blood.

> ... The arms of some were broken, and others had broken necks.
> The heads of some fell to the ground, others were pierced in the middle,
> And other great Asuras, with their legs cut off, fell to the earth.
> Others were cut in half by the Goddess, having in each part a single arm, eye, and leg.
> Some, when their heads were cut off, fell and rose again.
> Headless trunks, still grasping the best of weapons, fought with Goddess,
> And others danced in battle, keeping time to the sound of the drums
> Headless trunks, with broken heads, with sword, spear, and double-edged sword still in hand.
> Other Great Asuras cried out, "Stop! Stop!" to the Goddess.
> The earth became impassable ...
> Great rivers with torrents of blood from the elephants, Asuras, and horses
> Flowed there in the midst of the Asura Army. (*Devī-Mahātmya* 2.54–65)

While the theme of attempted rape or forced marriage is certainly relevant to women's experience in the human realm, the text itself says little about actual women. The action of the three episodes is all in the divine realm. In the frame story of the text, a male sage narrates the three episodes to two human males, a deposed king and an ousted merchant, both of whom worship the Goddess after hearing her stories and, as a result, receive boons from her. Nevertheless, adaptations of the text in oral tradition frequently identify human women with the Goddess in one or more of her many forms.

In folk and regional traditions throughout India, an ordinary woman subjected to oppression, takes on the power of her divine counterpart, transforming into a fierce Goddess to avenge the injustice done to her or her community. While the goddess of the Sanskrit text *Devī-Mahātmya* is a transcendent mythic figure, the vernacular and folk traditions abound with divine figures that had prior lives as human women and, after suffering a devastating injustice, are transformed and worshipped as goddesses. This theme of feminine (divine/human) retribution, repackaged in modern political and social contexts, has emerged in popular Indian cinema over the last several decades, presenting an image of women that complicates that of the docile, obedient daughter or wife, as well as that of sex object.

Fierce Goddesses and the Male Gaze in Indian Film

The *locus classicus* in modern Indian film for "woman" as fierce goddess is the iconic *Mother India* (1957, dir. Mehboob Khan), in which the character Rādhā,

overcoming the adversity of flood, poverty, abandonment by her injured husband, and constant financial and attempted sexual exploitation by the village moneylender, symbolizes India as an emerging nation. The film opens with her being honored as the "mother of the village" and asked to bless the new irrigation system. Her life story unfolds as a flashback, culminating in her killing her favorite son, Birju, as he is about to dishonor the moneylender's daughter. This sacrifice, terrible as it is, is necessary to uphold *dharma* and requires Rādhā to assume the form of the goddess Durgā.

In the 1980s, a spate of films, most notably *Pratighaat* (Retribution, 1987, dir. N. Chandra), centered on themes of rape and revenge, largely in response to growing feminist activism in India in the 1970s centering around high profile rape cases and resulting in on-going changes to rape laws.[3] In *Pratighaat*, the female protagonist, Lakṣmī, files a criminal suit against a corrupt politician, whose name ironically is Kālī, the name of a fierce Hindu goddess. Kālī had committed numerous violent crimes, including the gang rape of Lakṣmī's friend Durgā and the fatal torture of Durgā's husband. He retaliates against Lakṣmī by publicly disrobing her, a scene reminiscent of Draupadī's attempted disrobing by the Kauravas in the *Mahābhārata*. In the climax of the film, Lakṣmi garlands and anoints Kālī publicly on the stage of a political rally, then kills him by striking him with an axe, the symbol of his political party. The theme of women becoming fierce goddesses to redress injustice is more explicitly linked to feminist analysis of patriarchy in "independent" films of the so-called parallel cinema. Examples of these include *Mrityudand* (Death Sentence, 1997), directed by Prakash Jha, known for his socio-political themes, and *Daman* (Oppression, 2001) and *Chingaari* (Spark, 2006), both directed by Kalpana Lajmi, known for her feminist, woman-centered themes. *Daman*, subtitled *A Victim of Marital Violence*, was distributed by the Government of India in order to raise awareness of domestic abuse and promote women's education and independence.

When a Woman Becomes Chaṇḍīka
(Nari Bane Jab Chaṇḍīka)

Shivani has been victimized not just by a psychopathic male, but also by the State, which is all too willing to condemn a woman for even the suspicion of sexual infidelity. In prison, Shivani bonds with fellow inmate Nisha, convicted for the death of her mother-in-law who had attempted to murder her over the

wedding dowry. Shivani suffers the wrath of the short-haired, cigarette-smoking, liquor-drinking (Bollywood film codes for immoral) female warden who uses the inmates to provide sexual services to government officials. Thus, the police, judicial system, prison administrators, and government officials are shown to be corrupt, to be the agents of *adharma*, rather than the protectors of *dharma* that uphold Mother India.

Shivani escapes being pimped out to a politician because of her pregnancy, but her friend Nisha is sent instead. Soon, Shivani finds out that her daughter and sister have been killed, after the brother-in-law has thrown them out of the house, by a car Vijay was driving. Shivani has only her unborn child to live for, but then the warden severely beats her in retaliation for reporting to the authorities the warden's pimping activities, causing her to miscarry. When her friend Nisha tries to comfort her, she says: "Don't cry Nisha ... You won't see a single tear in my eyes. Like dried-up blood, every tear in my eyes has dried up. Wipe these tears that weaken a woman. Do you know why a woman is terrorized? Because she endures it. A woman's endurance is like the earth. She bears everything, but at the limit of her endurance, a volcano erupts, and she annihilates everything. The world has seen a woman as a mother, a sister, and a daughter, but it has not seen a woman in the form of Chaṇḍī!" Chaṇḍī or Chaṇḍikā is the fierce, demon-slaying Goddess, who now has finally made an explicit appearance in the film and remains until the end.

The next scene shows the warden explaining to the prison guards that the women have requested to hold a *jagrata*,[4] an all-night songfest honoring the Goddess, and that these sinful women now want to atone for their sins. She tells the guards that permission must be granted, since the ceremony is a matter of religion, but that the guards should watch the women carefully. For non-Hindi speaking viewers, the reference to the *jagrata* could be easily missed, for it is not translated in the DVD's English subtitles.[5] The *mise-en-scène* highlights the irony of the dialogue; behind the warden is a map of India, reminding viewers that nationalist images and discourse are always the backdrop of Indian cinema. Mother India is pure and sacred, while the warden as a representative of the State is a victimizer of Mother India, who is here represented by Shivani.

As the women begin their prayers in front of a garlanded portrait of the lion-riding Goddess Durgā, a guard summons Shivani to the warden's office to meet some "special guests." At that moment, Nisha, with the portrait of the Goddess behind her, wipes her own forehead with blood-red vermillion, turns and, looking straight at Shivani, intones the following chant:

O Goddess Riding a Lion, your eternal victory!
O Flame Goddess, your eternal victory!
O Fiery Goddess, your eternal victory!

The other inmates join Nisha in this chant, as Shivani enters the warden's office. Shivani declares that the warden has brought on her own death by killing Shivani's unborn child and says, "You flesh trader! This uniform of law doesn't become a woman like you." The camera cuts back and forth between shots of the women prisoners blowing a conch, playing musical instruments, and chanting praises of the Goddess, on the one hand, and Shivani beating and executing the warden, on the other hand. As Shivani chases the warden down a passageway to the gallows, her friend Nisha chants these words:

> The fire of revenge has ignited
> Now that she is poised for vengeance
> The fire of revenge rages
> Now that she is poised for vengeance
> Now that she slays her foes, she vanquishes evil
> When a woman becomes Chaṇḍīkā
> Justice will prevail
> There will be no sin
> Sinners will not be spared
> This vow she will not break
> Law and Justice have done enough atrocity
> She's no longer afraid of the outcome (*anjaam*),
> Now that she slays her foes,
> She vanquishes evil
> When a woman becomes Chaṇḍīkā.

The last line, "when a woman becomes Chaṇḍīkā," is the most important phrase not only in the song, but also in the film as a whole, as it signals Shivani's transformation from a virtuous woman who simply plays by the rules to one who reaches deep into herself to pull out that *śakti*, that divine feminine power, to destroy the force of evil. This chant, sung along with instrumentation, the blowing of a conch shell, and the beating of drums, repeats non-diegetically throughout the remainder of the film, every time Shivani kills one of her oppressors.

After her release from prison, Shivani first extracts revenge on her brother-in-law, who was responsible for the deaths of her sister and daughter. Next is the police inspector Arjun Singh who, bribed by Vijay, was responsible for her incarceration and who also informed the prison warden about Shivani's report,

leading to the murder of Shivani's unborn child. Arjun Singh confronts Shivani at her daughter's grave,[6] knowing that she would go there and that she must have been the one responsible for the brother-in-law's murder. He had already figured out that she killed the warden, but was not able to prove it, since the women all swore that she was at the *jagrata*. Shooting at Shivani and cornering her in a nearby barn, Arjun Singh plans to rape her but she pulls out a sword from under her shawl and kills him, leaving him to burn in the barn. After another story arc, Shivani does finally kill Vijay, after nursing him back to health from a catatonic state, taking on the guise of Durgā killing the buffalo demon. Incidentally, she kills off the lesser demons first, like in the *Devī-Mahātmya*, before saving the greatest demon for last.

Ironically, the brother-in-law has finally picked a winning horse and won the jackpot. Shivani, dressed in black like the Goddess Kālī, attacks him, bites a chunk of flesh from his arm, and with blood streaming from her mouth, kills him by stuffing the rupee notes down his throat. As I have already explained, Shivani's actions are an instance of divine retribution, horror in the service of *dharma*. So, this is not demonization, but it certainly is a novel form of demonetization.

4

Horrifying and Sinister *Tāntriks*

Hugh B. Urban

They are frauds, those who call themselves God. They are so base they are not worthy of being called criminals. If God is an ocean, they are not even a millionth drop of that ocean ... There is only one God. But these men are Satans who pose as God. Satans!

Jaadugar (1989)[1]

Among the many horrifying tropes in Bollywood film, one of the most persistent and popular is the figure of the sinister *tāntrik*—that is, the dangerous *yogī* who uses his knowledge and power to deceive, manipulate, exploit, and/or destroy those around him. As the embodiment of spiritual power that has been perverted into a dark and malevolent force, the sinister *tāntrik* is a favorite villain throughout Indian cinema, sometimes portrayed in cartoonishly simple stereotypes and sometimes with remarkable depth and nuance. In this sense, the image of the sinister *tāntrik* is a contemporary reflection of the complex history of Tantra and its various representations in South Asian narrative more broadly.[2]

A complex tradition that spread widely throughout the Hindu, Buddhist, and Jain traditions of South Asia from roughly the fifth or sixth century CE, Tantra has long had a controversial reputation in both Indian and Western imaginations.[3] From the first mention of texts called *tantras* in Sanskrit literature, the *tāntrik* has often been portrayed as a purveyor of spells and magic, sometimes ridiculous, sometimes awesomely powerful, and sometimes terrifyingly evil.[4] As such, the figure of the malevolent *tāntrik* is a particularly acute example of what David Gordon White has called the "sinister *yogī*," or the widespread image of the *yogī* as not so much a pristine ascetic meditating on a snow-peaked mountain top but rather an ambivalent character endowed with tremendous but dangerous and sometimes destructive power.[5]

This association between Tantra and black magic was greatly amplified during the British colonial period, as Orientalist scholars and colonial administrators began to recount the evils of Tantra in elaborate and often wildly exaggerated detail.[6] Hindu reformers and nationalists would in turn add their own condemnations of Tantra as an evil perversion of true Hinduism, thus solidifying the stereotype of the evil *tāntrik* permanently in the modern imagination. Ironically, however, while North American and European popular audiences almost universally associate Tantra primarily with *sex* and *optimal orgasm*, Indian audiences associate it largely with *black magic and occult power*.[7] In sum, what became "the art of sexual ecstasy" in the Western imagination became "the art of dark magical power" in the Indian imagination.

The sinister *tāntrik* appears in hundreds of films released in Hindi, Bangla, Assamese, Telugu, Tamil, and other languages, ranging from extremely low budget productions such as *Shaitan Tantrik* (Tantric Devil, 1999, dir. Wajid Sheikh) or *Khooni Tantrik* (Bloody Tantrika, 2001, dir. Teerat Singh) as well as high-end action films such as *Naan Kadavul* AKA *Himalayan Aghori* (I Am God, 2017 dir. Bala).[8] However, for the sake of this chapter, I will focus primarily on three well-known Hindi films—*Gehrayee* (Depth, 1980, dirs. Vikas Desai and Aruna Raje), *Jaadugar* (The Magician, 1989, dir. Prakash Mehra), and *Sangarsh* (Help, 1999, dir. Tanuja Chandra)—and one Telugu film—*Ammoru* (1995, dir. Kodi Ramakrishna)—that each draw heavily upon the traditional image of the "sinister *yogī*," while also re-articulating it in a modern Indian context.[9] Like the medieval *yogīs*, these Bollywood *tāntriks* are deeply ambivalent characters, possessing tremendous powers but also engaged in acts of sorcery, exorcism, and human sacrifice. However, these films also re-articulate the image of the sinister *yogī* through a variety of contemporary idioms, for example, by referencing American horror films or mixing in non-Indian black magic tropes, such as Haitian Vodou. The sinister *tāntrik*, we will see, is also recast in contemporary scripts drawn from modern Indian debates over caste politics, land disputes, fake gurus and their Western disciples, psychiatry and mental illness.

To conclude, I will make some broader theoretical comments, drawing upon but also critically rethinking some contemporary approaches to horror, such as those of Julia Kristeva and Judith Butler.[10] The sinister *tāntrik* is in many ways the embodiment of the "abject" in Kristeva's sense of the "cast off," particularly the horror of death, perversion, transgression, and taboo that is rejected by the social body. If Vijay Mishra is correct that much of Bollywood cinema is aimed at projecting the image of a national community and a pan-Indian popular culture,[11] then the sinister *tāntrik* is precisely what does not fit into and must be

cast out of that national community and pan-Indian culture.[12] In Bollywood, this abjection is always conquered in the end: the sinister *tāntrik* is ultimately defeated, usually by a "good" *yogī* or by a deity representative of pure, normative, non-*tāntrik* Hinduism.

From Sinister *Yogīs* to Bollywood *Tāntriks*: A Brief History of Tantra in South Asian Narrative

The sinister *tāntrik* is by no means a trope that is new to Bollywood film. On the contrary, the image of the *tāntrik* as either a charlatan or a dangerous figure working with the dark side of power dates to the very first mention of texts called *tantras* in Sanskrit literature. Most scholars today agree that Tantra is not a monolithic or homogenous category but rather an umbrella term that covers a vast array of traditions that spread through the Hindu, Buddhist, and Jain traditions over the last 1,500 years.[13] Some of these developed into incredibly sophisticated philosophical traditions, such as the Kashmir Śaivites, and into powerful, *brāhmaṇic* ritual traditions, such as the Śākta lineages of Bengal and Assam.[14] Although Tantra is notoriously difficult to define, one of the more useful attempts is David White's suggestion that Tantra centers primarily on the divine energy or power (*śakti*) that flows through the entire cosmos and human body, seeking to harness that power for both material benefits and spiritual liberation: "Tantra is that Asian body of beliefs and practices which, working from the principle that the universe we experience is nothing other than the concrete manifestation of the divine energy of the godhead that creates and maintains the universe, seeks to ritually appropriate and channel that energy ... in creative and emancipatory ways."[15]

In its more extreme "left-hand" (*vāmācāra*) forms,[16] Tantric ritual often involves substances and practices that are normally considered extremely impure and polluting, such as consumption of meat, wine, and sexual fluids, and meditation upon corpses in cremation grounds.[17] The point of such explicitly transgressive practices, however, is not mere hedonism or self-indulgence. Rather, it is a radical attempt to shatter all sense of duality—including the duality between pure and impure, clean and unclean, high and low class, self and other—in order to experience the all-pervasive unity of the Ultimate Reality. As Alexis Sanderson puts it in his classic essay on the Kashmir Śaivite Tantric tradition, "This inhibition, which preserves the path of purity and barred his entrance into the path of power, was to be obliterated through the experience of a violent,

duality-devouring expansion of consciousness beyond the narrow confines of orthodox control into the domain of excluded possibilities, by gratifying with wine, meat and through caste-free intercourse, with orgasm and its products."[18]

From the earliest reference to Tantra in Sanskrit drama and narrative, however, the tradition was also often associated with black magic, sorcery, and trickery by other non-*tāntrik* authors. The first known mention of texts called *tantras* is Bāṇabhaṭṭa's classic fantasy tale, *Kādambarī* (seventh century), which describes a rather demented, power-hungry, and comical old *sādhu* from South India: "he had collected information about jugglery, mystical formulas and spells [*tantras* and *mantras*] ... He had the madness of belief in alchemy. He was obsessed with a yearning to enter the world of the demons."[19] Later Sanskrit literature often focuses on the infamous Kāpālikas or "skull bearers," an early *tāntrik* lineage devoted to Śiva in his terrible form that may have been carried over into modern sects such as the infamous Aghorīs ("those without fear," who also carry human skulls as their begging bowls; see Lorenzen 1972). Thus, the eleventh century author Kṛṣṇamiśra includes a detailed satire of a Kāpālika in his drama, *Prabhodacandrodaya*. Inhabiting cremation grounds, drinking wine from skulls, and offering human sacrifices, the Kāpālika is portrayed here as the epitome of the most frightening powers of impurity, violence, and transgression:

> I who am adorned with a garland of human bones, who live in the cremation ground and who eat out of a human skull, with an eye purified by the instrument of yoga, see the world having differences within itself but being non-different from God ... We who offer oblations in the fire in the form of human flesh, brains, entails and marrow break our fast with alcohol help in the skull of a *brāhmaṇa*. Mahābhairava [*Śiva* in his terrible form] has to be worshipped with human offerings, lustrous streams of blood flowing from the stiff throat which is freshly cut.[20]

The figure of the perverse and cruel *tāntrik* Kāpālika reappears throughout modern Indian fiction, for example in the works of nineteenth century Bengali authors such as Bankimcandra Caṭṭopādhyāy (1838–94). Born into a *brāhmaṇ* family and working as a deputy collector for the British government, Bankimcandra was part of a broader movement in the colonial period that sought to reform and re-imagine "Hinduism" for the modern era, while also cleansing it of its more embarrassing elements, such as Tantra. As Wilhelm Halbfass summarizes Bankimcandra's reformed ideal of Hinduism (or "neo-Hinduism"): "The 'truly' religious elements of Hinduism had to be ... separated from the multifarious forms of superstition, from local popular cults. Such a purified Hinduism ... could be placed above Islam

and Christianity."[21] Thus Bankimcandra's most famous work, *Kapālakuṇḍalā*, continues the stereotype of the sinister skull-bearer, here performing the infamous *tāntrik* rite of *śava sādhana*, or worship with and upon a human corpse. The character Nabakumār describes him:

> The form with matted hair was seated on a putrid corpse. With even greater fear he saw that a human skull lay before him, and inside it was some red liquid. On all sides, bones were strewn ... He knew that this person was must be a terrible Kāpālika.[22]

The cruel Kāpālika then traps Nabakumār and plans to offer him as a human sacrifice to the fearsome goddess of time and death, Māhā Kālī—a trope that later reappears throughout Bollywood (and American) horror films.

In short, the image of the *tāntrik* as a dangerous, power-hungry, and corrupting figure was clearly in place as a widespread trope in Indian literature by the end of the nineteenth century. However, it would also soon be taken up, amplified, and often wildly exaggerated by British novelists of the early twentieth century, where the sinister *tāntrik* became the ultimate embodiment of everything they thought was wrong or corrupt with modern India. As we see in works such as F.E.F. Penny's *The Swami's Curse* (1929), Flora Annie Steel's *The Law of the Threshold* (1924), or Elizabeth Sharpe's *Secrets of the Kaula Circle* (1936), the *tāntrik* had become equated with not just black magic but also sexual perversion and even subversive political activities. As we read in Penny's novel, "The follower of the Tantric cult professes no austerities. He seeks to kill desire by an unlimited indulgence which bring satiety and extinction of emotion. The indulgence is enjoined by his so-called religion; and his depravity is commended as a great virtue."[23] Thus, by the mid-twentieth century, the image of the sinister *tāntrik* had become more or less solidified in both Indian and Western imaginations as a figure of ultimate danger and transgressive power, embodying the potential subversion of not simply the individual self but of society and the body politic.[24]

The Varieties of *Tāntrik* Experience: Fraudulent, Sinister, and Pure *Māntriks* in Gehrayee

Vikas Desai and Aruna Raje's 1980 film, *Gehrayee*, is a particularly interesting variation on the sinister *tāntrik* theme. Centered on a mysterious case of spirit possession involving a young girl in a wealthy Bangalore family, the film presents three different versions of the *tāntrik* character—one, a charlatan; one a

power-hungry fiend; and one a pure, selfless devotee of Lord Gaṇeśa. As such, it covers the spectrum of imaginative representations of the *yogī* in Indian popular culture, from the ridiculous purveyor of mumbo-jumbo, to the sinister black magician, to the true knower of powerful esoteric knowledge. As the same time, however, the film also asserts the triumph of the pure, truly "Hindu" *yogī* as devotee of Gaṇeśa over the wicked *tāntrik*.

The father in the film, Chennabasappa, is a successful manager and a hard-nosed rationalist who initially has little patience for things supernatural. When he needs money to build a new home in Bangalore, he decides to sell his plantation in his ancestral village to a soap company. The plantation's caretaker, Baswa, becomes deeply agitated, viewing the selling of one's ancestral lands as analogous to the rape of one's own mother. Meanwhile, the young daughter Uma begins to behave strangely, going into trance states and uttering cryptic revelations about the past. The most terrible of these revelations is that Chennabasappa had once seduced and impregnated Baswa's wife, who later committed suicide.

After trying every possible medication to no avail, the family decides to bring in a *māntrik* ("knower of *mantras*," a term often used interchangeably with *tāntrik*) to try to exorcise whatever spirit, ghost, or other entity that has possessed the girl. Here we should note that spirit possession and exorcism have a long history both in traditional South Asian Tantra and in popular representations of *tāntrik* magic. As Frederick Smith has shown in his comprehensive study of possession in South Asia, the ability to possess or dis-possess bodies has long been part of Tantric literature, and it clearly survives as a trope in the Indian popular imagination.[25]

Unfortunately, the first *māntrik* they call upon turns out to be a ridiculous charlatan, a buffoon who embodies the stereotype of the *tāntrik* as mere fraud. Performing his *pūjā* with absurd and pompous display, he invokes the goddess Māhā Kālī while chanting *mantras*, slapping the girl across the face, smashing coconuts, and of course collecting a large fee. Disgusted with this huckster, the son suggests another, more powerful *māntrik* named Puttachari. This one appears to possess more genuine abilities, but also seems suspiciously concerned with knowing whether or not Uma is a virgin. After learning that she is indeed, he abducts her and takes her to perform a secret *tāntrik* ritual in a cemetery, hoping to use her virginal potentiality in order to awaken the power of the goddess. As he chants and waives his *āratī* lamp before a fire, the girl sits naked in a trance, surrounded by *mantras, yantras*, and various offerings. The *tāntrik* is performing his *pūjā* before a stone image and a *yoni* (female sexual organ, symbol of the goddess), invoking the deity, "*darśanaṃ kuru, darśanaṃ kuru!*"

When the brother interrupts the ritual to save the girl, the *tāntrik* cries out, warning that they will incur the goddess's wrath and be cursed forever:

> Stay back! You cannot interrupt the worship of the goddess! You will be ruined. The goddess will never forgive you ... She cannot be freed now. And you cannot take her away ... I have waited for this moment for fifteen years ... Your daughter has all the right qualities, because of which the goddess has agreed to come. You have angered the goddess. You will be ruined![26]

Finally, after rescuing the girl, the family decides to consult one last *yogī* to exorcize the spirit—this time, the sincere, powerful, yet humble Shastri. Immediately upon visiting the house, Shastri discovers two cursed objects that have been hidden around the grounds, a lemon and a small voodoo doll with pins in it. He burns the evil objects and then confronts the spirit inside the girl. Sitting before an altar bearing the image of Lord Gaṇeśa, Shastri forces the spirit to confess that it had been trapped through black magic by another *māntrik*, who had been hired by none other than the disgruntled caretaker, Baswa. All of this was Baswa's vengeance against the family for selling the ancestral plantation.

When the family thanks the Shastri and offers to pay him for his efforts, he refuses any compensation, humbly attributing his abilities not to himself but rather to Lord Gaṇeśa, whose grace alone can bind or free such spirits:

> No, please don't bow your head to me. All this is the grace of Lord Gaṇeśa. Bow to him. I am a human just like you ... You don't need to give me any charity or anything. I don't do all this to earn wealth. It is all the grace of Lord Gaṇeśa. He is the one who does all this.[27]

Here we see the ultimate contrast with the sinister *tāntrik*: instead of a mere charlatan or a power-hungry sorcerer who harnesses dark forces for material gain, Shastri embodies the ideal of the pure *yogī* who is devoted only to God in in the loving and generally quite *non-tāntrik* form. While the power-hungry *tāntrik* performs his secret rituals in the cemetery before the goddess *yoni*, the selfless Shastri performs his healing *pūjā* before the flowered-covered image of Gaṇeśa. As such, the film also portrays the triumph of a kind of mainstream, normative Hinduism over the dangerous path of the *tāntrik*.

Magic—Real, Fake, and Really Fake in *Jaadugar*

Prakash Mehra's 1989 film *Jaadugar* continues the theme of the malicious and fraudulent *tāntrik*, though with an interesting twist of its own. Here the villainous

tāntrik is conquered, not by a more powerful genuine *yogī*, but rather by a kind of "genuine fake"—the flamboyant *jādugar* ("magician") named Goga.

The story opens when Shankar Narayan returns from America to discover that his father—formerly a businessman and convict—has set up shop as a miracle-working *guru* with a large and lucrative *ashram*. Bearing an elaborate handlebar mustache, shaven head and pony-tail, Mahaprabhu performs a variety of cheap stage tricks, such materializing small objects and manifesting sacred ash (*vibhūti*) from his hands, in order to dupe his gullible devotees. His followers include not only Indian disciples but a large number of wealthy white foreigners who are pouring millions in cash, gifts, gold and jewelry into his coffers. Thus, Shankar overhears the *guru*'s Indian disciples gambling at night, with several white female devotees hanging on the side: "He lost today's earnings," one jokes, "but it doesn't matter. He'll trap ten more rich foreigners tomorrow."[28] Here we should note that the film is surely parodying some of the hugely prosperous Hindu mega-gurus of the 1980s, such as Sathya Sai Baba—also famous for materializing small objects and sacred ash—and Bhagwan Shree Rajneesh—who was quite infamous for both his large following of Western white hippies and his outrageous wealth and conspicuous consumption.[29] The cheating guru offers Shankar the massive riches from his treasury, but the son refuses with disgust and leaves and the *ashram*.

Hoping to unmask his father, Shankar decides to call upon a famous and flamboyant stage magician name Goga (played by Amitabh Bachchan). The plan is for Goga to confront the charlatan Mahaprabhu, reveal his cheap tricks for what they are, and so dethrone him once and for all. This Goga easily does, but then he too is seduced by the power of guru-ship and takes over the god-man role himself, assuming the title of "Gogeshwar" or Lord Goga. Still determined to retake his *ashram*, the fallen Mahaprabhu tries to unmask and/or kill Goga in various ways, first attempting to poison him and then sending in his minions to attack the magician. This leads to a farcical fight scene in which Goga demonstrates a mixture of martial arts, stage magic, and seemingly genuine *tāntrik* powers— sometimes tricking opponents with magic handkerchiefs, sometimes turning guns into bananas, and sometimes magically removing his foes' clothing. Indeed, the fight scene is one of several telling moments in which the film plays upon the boundary between stage magic and real spiritual power, hinting that Goga may possess more of the latter than we first assume.

Finally, another of Mahaprabhu's minions is sent with an axe to chop off Goga's hands and so prevent him from working his magic. In response, Goga freely offers up his hands to the butcher and then delivers an impassioned speech

about the difference between true and false religion. "Stop dancing to the tune of frauds," he tells the axman, "They are frauds, those who call themselves God. They are so base, they are not worthy of being called criminals. If God is an ocean, they are not even a millionth drop of that ocean. There's only one God, whether they call him Bhagwan Allah, Karim, or God. There is only one God. But these men are Satans who pose as God. Satans!"[30] Deeply impressed, the axman finally accepts the truth that his *guru* is a fraud who has been deceiving and exploiting his followers with his lame magic tricks: "Mahaprabhu Jagatsagar Chintamani is not God but an ordinary mortal, a cheap magician who is selling God's name in every home and misleading people." Instead of taking Goga's hands, he returns to his former master and chops off Mahaprabhu's hands instead, thus depriving the charlatan of his means of deception.

In the end, Goga completely exposes Mahaprabhu in front of everyone and then also reveals himself to be, not a god, but simply an ordinary man who has merely played the role of "Gogeshwar" in order to expose the fraud. "Then where is God's true form?" the people ask him. "Look inside yourself!" Goga sternly replies, launching into another impassioned speech about the difference between true religion and the chicanery of these false *gurus*:

> God exists in every being. Man cannot become God by displaying fake miracles. If anyone can do a real miracle, it is the Supreme Lord, whom we call Allah, Jesus, Bhagwan ... Have faith in yourself, but don't have blind faith ... Worship whatever God you like, but don't have blind faith ... Or you will come across many Mahaprabhus on every street corner, who will continue to loot you.[31]

In this closing oratory, we can clearly see that Goga is articulating a kind of "feel good pluralist 'secularism'" expressed in other classic Bollywood films, most notably *Amar Akbar Anthony*, which likewise celebrates the validity of diverse religious faiths.[32] At the same time, he is also articulating a very modern, neo-Hindu or neo-Vedāntic universalism that has become commonplace since the nineteenth century, particularly through the works of Rammohun Roy, Bankimcandra, Swami Vivekananda, and other reformers: God is One, though He is known by many names, dwelling in the heart of every being;[33] and this universal, pure faith in the One True God has nothing to do with the gross superstition and *guru*-worship of the ignorant masses, who so easily fall for trickery and chicanery—above all, for the occult deceptions of the *tāntriks*.

In sum, like *Gehrayee*, *Jaadugar* narrates the ultimate defeat of the sinister *tāntrik*. But in this case, the victory is accomplished not by a "good" or "real" *yogī* but rather by a kind of "authentic fake," a stage magician who uses his trickery to

unmask the pretender. Yet the end result is ultimately very much the same: "true" religion and a "real" understanding of God triumphs over the deceptive, exploitative, and indeed "satanic" imitation of religion concocted by the false *guru*. The former is a kind of neo-Hindu universalist faith in the Supreme Lord who is found in all religious traditions, while the latter is the blind faith and fraud of the sinister *tāntrik*.

The Silence and the Struggle: Blending Hollywood and Bollywood Horror in *Sangarsh*

Like most Bollywood films, many in the sinister *tāntrik* genre make oblique references to American Hollywood productions. *Gehrayee*, as some viewers have noted, does bear a hint of the American horror classic, *The Exorcist* (1973, dir. William Friedkin), in its possession/exorcism narrative; and many of the low-budget productions such as *Shaitan Tantrik* (1999) contain clear imitations of Hollywood classics, with murderous bald *tāntriks* who bear a remarkable resemblance to the bald priest of Kālī in Stephen Spielberg's classic work of Orientalist excess, *Indiana Jones and the Temple of Doom* (1984).

However, the 1999 film *Sangarsh* is a more interesting blend of American and Indian themes, with both clear references to and complex reworkings of Jonathan Demme's 1991 film, *The Silence of the Lambs*.[34] The film begins with a series of child abduction and murder cases that have remained unsolved by the police and so are turned over to a CBI trainee named Reet Oberoi. Reet's investigations lead her to suspect Lajja Shankar Pandey, yet another embodiment of the sinister *tāntrik* figure, who also brings in an added dimension of psychological and sexual perversion. Like myriad *tāntrik* characters before him in both Indian and Western narratives,[35] Lajja Shankar is hoping to achieve immortality through the rite of human sacrifice, using the blood of children to engender his own eternal life.

Meanwhile, detective Reet suffers psychological traumas of her own, having witnessed the death of her brother—a Sikh separatist—at the hands of the police when she was a child. Tortured by her childhood memories and by this complex criminal case, she seeks advice from Professor Aman Varma, a brilliant man who has been unjustly imprisoned. The professor is initially rude and unresponsive but eventually agrees to help her, guiding her through her childhood traumas and ultimately tracking down the villain. Reet discovers that the killer has been offering to buy street-beggar children for his rituals and so lays a trap for him with the help of a beggar's child, using his son as bait. The fiendish Lajja Shankar

does indeed arrive to buy the boy, but he is wearing the disguise of a woman with a *sari* and makeup—thus adding a new, gender-bending twist to the sinister *tāntrik* motif. When Reet and her team confront Lajja Shankar, he displays superhuman strength, throwing them around, and surviving a seemingly fatal gunshot before escaping.

Back in his forest home, Lajja Shankar exhibits psychotic and/or fanatical symptoms, beating his own head with a rock and engaging in a conversation with the goddess Kālī like a child speaking to his mother (Mā). The goddess instructs him to slay the father who had lured him into the trap, which he does; and as he is strangling the man, he reveals that he has been offering blood sacrifices to the goddess since he was eleven years old—"satisfying the Mother's hunger"—in order to attempt to cheat death and achieve immortality: "I went to a shed and butchered eleven buffaloes. The god of death has been afraid of me since then. I'll keep fighting death until I defeat it!"[36] Meanwhile, Reet finds an old video tape of Lajja Shankar when he had been held in a mental institution, in which he claimed to have been speaking to his Mother Kālī since he was a tiny child: "She orders me, and I obey all her orders," he says, chanting mantras and going into a trance, "Look into these eyes. These are the eyes of a messenger of God . . . Small kids can peep into them and find heaven."[37]

Lajja Shankar's next child victim is none other than the son of the Minister himself, whom he plans to offer as his ultimate gift to the Mother—a child sacrifice on the last day of a solar eclipse—which will at last bring him immortality. The sacrifice is to take place in a secret underground cave-temple, which very much recalls the cave temple in Spielberg's *Indiana Jones and the Temple of Doom* (as does Lajja Shankar himself, who has now shaved his head and resembles the bald priest of Kālī in Spielberg's film). "I am going to be freed of this cycle of life and death today!" he declares, asserting his superhuman status as the all-powerful *tāntrik* who has now mastered death itself: "This child is my last gift to goddess Kālī . . . I am not a human being. Life and death are part of the lives of ordinary beings like you."[38] Fortunately, Reet and the professor (now escaped from prison) have tracked him down in time to prevent the heinous act. Just as Lajja Shankar is about to deliver the fatal blow to the child, the professor leaps across the temple and engages in a bloody fight, during which Lajja Shankar repeatedly bites him, leaving his mouth dripping blood (recalling images of Kālī, Tārā and other *tāntrik* goddesses). While the professor beats down the *tāntrik*, Reet finally overcomes her childhood traumas and rescues the child.

Most readers have no doubt by now recognized the similarities between the basic plot and characters of *Sangarsh* and those of Demme's *Silence of the Lambs*.

Both films center on a female investigator who is pursuing a cross-dressing serial killer with some form of mental illness, and in both, the key to solving the case comes from an imprisoned genius, who reluctantly agrees to offer his insight (the special, maximum security prison cell in which the professor is placed in *Sangarsh* is even visually very similar to Hannibal's cage in *Silence of the Lambs*). In both films, the investigator has suffered some childhood trauma that has permanently shaped her character—witnessing the death of her brother, in Reet's case, and witnessing the screaming lambs, in Starling's. And in both cases, the villain is seeking some kind of personal transformation through bloodshed—the quest for immortality in Lajja Shankar's case, and the quest for a woman's body in Buffalo Bill's.

Sangarsh, however, translates these themes through the uniquely South Asian idioms of the sinister *tāntrik*. Here the villain is not a man tormented by his gender identity crisis and failed sex-change, but rather one driven by the more classically South Asian spiritual goal of freedom (*mokṣa*) from death and rebirth. And he pursues this goal through the means not of mere slaughter and skinning his victims but human sacrifice, a practice that has a long and intensely controversial reputation—both real and imaginary—in *tāntrik* traditions for over a millennium. Human sacrifice and its tremendous material rewards are described in a number of Śākta and Tāntrik texts, such as the *Kālīkā Purāṇa*, *Muṇḍamāla Tantra*, and others;[39] the eighteenth century *Yoginī Tantra* even explicitly calls for the offering of a male child (*narasya kumāra*).[40] Yet the specter of mixed horror and power embodied in human sacrifice was clearly amplified and exaggerated wildly through British and American novels and films from the nineteenth century to the present, culminating in the bloody offerings to Kālī that we see in the *Gunga Din* (1939, dir. George Stevens), the Beatles' film *Help!* (1965, dir. Richard Lester) and, most famously, *Indiana Jones and the Temple of Doom* (1984).[41] *Sangarsh* has clearly been informed by all of these various historical influences, weaving them together with the narrative structure and psychological dynamics of modern American films.

The Great Goddess and the *Tāntrik* Demon in *Ammoru*

The figure of the sinister *tāntrik* is not, of course, limited to Hindi films or to Bollywood; indeed, he is in some ways an even more colorful and vibrant character in many other South Asian language films such Telugu, Malayalam, Bangla, and Assamese, among many others. In some cases, he even becomes a kind of unexpected anti-hero, as in the case of the kick-boxing martial artist

tāntrik aghorī in *Naan Kadavul*. And in others, he is a terrifically evil figure of pure sorcery and malice who can only be defeated by the great goddess (*devī*) herself, as in the 1995 Telugu film *Ammoru*.[42]

Directed by Kodi Ramakrishna, *Ammoru* centers on the character Bhavani, a beautiful young lower caste orphan and devotee of the goddess Ammoru. A local form of the great goddess (*devī*), Ammoru is worshipped in her temple in the form of a pillar with three eyes and lolling tongue that looks much like the famous Kālī image at Kālīghāṭ in Kolkata. The villain in the film, meanwhile, is a criminal black magician named Gorakh, who in many ways embodies the ultimate stereotype of the sinister *tāntrik*—at once tremendously powerful and yet filled with malice and hatred, using his occult knowledge only for vengeance and material gain. Bhavani is responsible for Gorakh being imprisoned, and so he vows to take terrible revenge upon her, upon her husband and upon their infant child. Gorakh's mother, Leelamma, first tries to kill Bhavani, but the goddess Ammoru protects her by assuming the form of a young maidservant. Upon his release from jail, Gorakh uses his dark *tāntrik* magical arts to invoke an evil spirit called Chenda and so finally kills the child and tortures the husband.

In the climactic final scene, Bhavani takes her wounded husband into the temple of Ammoru and locks the gate. Gorakh then deploys his full powers as a sinister *tāntrik*, creating a *yantra* diagram, uttering *mantras*, and invoking a terrifying, hideous spirit in order to create a kind of voodoo doll. Sticking pins into the doll, he tortures the helpless husband while Bhavani screams in terror. As Gorakh finally bursts through the temple gate, Bhavani places her hand on the spikes of the trident that stands in front of Ammoru's image. Invoking a classic scene from the Mahābhārata (the disrobing of Draupadī by Duḥśāsana), Gorakh grabs Bhavani's *sari* and tries to disrobe her; however, the act rips her hand across the points of the trident and sprays her blood across the temple, splashing it on the face of Ammoru. The blood is enough to awaken the goddess, who rises in a spectacular display of CGI effects, morphing through all the various forms of the goddess (Durgā, Lakṣmī, Sarasvatī, Parvatī, etc.) before finally assuming a terrible Kālī-like manifestation. Grabbing the trident and performing a ferocious dance, she impales the evil Gorakh, beheads him, and finally annihilates him completely. The impalement and beheading, we should note, are clearly reminiscent of the classic myth of the great goddess (Durgā or Caṇḍī) slaying the buffalo demon (Mahiṣa) as narrated in the *Devī Mahātmyā* and countless other Sanskrit and vernacular texts. In the end, the goddess returns to her childlike, maidservant form and restores Bhavani's lost baby to life, as the whole village cheers and rejoices.

Once again, *Ammoru* narrates the ultimate defeat of the sinister *tāntrik*. In this case, however, the *tāntrik* is conquered not by another *yogī* or by a magician, but directly by the awesome power of the goddess herself. As such, the film is not only invoking classic Hindu myths such as the slaughter of the buffalo demon; it is also depicting the defeat of the evil black magic of the *tāntrik* by the good and true religion of the *devī*, the Hindu great goddess.

Conclusions: The Horrors of Power—Tantra and Abjection in Modern "Hinduism"

To conclude, I would like to make some broader comments on the place of the sinister *tāntrik* in the contemporary imagining of "Hinduism." In many ways, the *tāntrik* of Bollywood film appears to embody much of what Kristeva means by the "abject"—that is, the death, defilement, or impurity that violates the boundaries of individual identity and so generates the most intense feelings of dread, disgust, and horror:

> The corpse (or cadaver: *cadere*, to fall) ... is cesspool and death; it upsets even more violently the one who confronts it as fragile and fallacious chance ... [A]s in true theater, without makeup or masks, refuse and corpses *show me* what I permanently thrust aside in order to live.[43]

From his first description in Sanskrit literature, as we saw above, the *tāntrik* has been associated precisely with this kind of abjection in the form of corpses, skulls, severed heads, cremation grounds, impurity, and transgression. These themes of abjection are all clearly carried over into modern Indian horror. The Bollywood *tāntrik* is not simply a criminal con-man (as in *Jaadugar*), but also a power-hungry practitioner of secret rituals, offering a virgin before a *yoni* in the cemetery (as we see in the figure of Puttachari in *Gehrayee*); he is a cross-dressing, psychologically damaged pervert, seeking immortality through child sacrifice (as we see in *Sangarsh*); and he is a black magician, invoking hideous spirits in order to torture and kill his enemies (as we see in *Ammoru*). In each case, he is the very embodiment of abjection in Kristeva's sense—the death, blood, impurity, sickness, and perversion that gives horror its power and power its horror.

Yet the sinister *tāntrik*, I would argue, is "abject" not simply in relation to the individual body; it is also abject in relation to the larger social body and to the construction of modern "Hinduism" in the twentieth and twenty-first centuries.

As Douglas Brooks suggests, Tantra has consistently been seen as the "Other within" Hindu traditions, the uncomfortable presence of esoteric and transgressive traditions that do not fit tidily into the modern imagining of Hinduism as a world religion.[44] Like the terms "*tantra*" and "Tantrism," the term "Hinduism" is neither an indigenous nor a singular category but rather a modern construction used to label a vast and diverse array of texts, traditions, rituals, deities, and communities.[45] And since the nineteenth century, both Western Orientalist scholars and various Hindu reformers attempted to define the boundaries of this unruly body of traditions. In so doing, they have typically excluded those aspects of Indian tradition that seemed to violate the sensibilities of modern civilized society.[46] Perhaps above all, both Western scholars and Hindu reformers singled out the Tantric tradition as the worst, most debased and degenerate mixture of black magic and sexuality, and thus the first thing to be jettisoned in the re-imaging of Hinduism in the modern world.[47] As Swami Vivekananda warned his disciples, Tantra in its most perverse "left hand" (*vāmācāra*) form is corrupting modern India like a disease, and it must therefore be purged in order to restore the true teachings of the Vedas: "see how this Vamachara (immoral practice) of the Tantras has entered into your very marrow. Even modern Vaishnavism ... is saturated with Vamachara! We must stem the tide of Vamachara, which is contrary to the spirit of the Vedas."[48] In short, he tells them, "give up this terrible Vamachara which is ruining your country!"[49]

This attempt to purge the abjection of Tantra from the realm of legitimate Hinduism is replayed throughout modern Indian cinema. However, more than just the latest reiterations of an older trope, these films each rework this theme in different ways in a modern Indian context. Thus, in the case of *Sangarsh*, the film not only borrows heavily from American films, it also recasts the sinister *tāntrik* in terms of modern psychiatry and madness. *Jaadugar*, in turn, reflects on the modern ubiquity of fraudulent gurus (along with their gullible Western disciples). In the case of *Ammoru*, the film also grapples with the tensions and complexities of caste politics, which are central to much of Tamil and Telugu cinema. In short, the *tāntrik* is not simply a stock villain representing all that is "other" to the ideology of Hindu nationalism; rather, he is also a complex figure who is creatively recast in many different ways in relation to a wide array of contemporary social and religious concerns, conflicts, and anxieties.

Yet despite this diversity various castings and performances, the final scene for the sinister *tāntrik* in each of these films is fairly consistent. Time and again, the villainous *tāntrik* is conquered and destroyed—sometimes by a "good" *yogī*

who is devoted to a non-*tāntrik* deity such as Gaṇeśa (as in *Gehrayee*), and sometimes by the goddess herself, who slays him like Durgā slaying the power-hungry buffalo demon. In the end, the *tāntrik* is defeated, and the proper Hindu order is re-established. Yet the perpetual recurrence of the sinister *tāntrik* in Indian cinema suggests that he remains a haunting presence, a troubling form of abjection that can never fully be cast away.

5

Do You Want to Know the *Raaz*?
Sāvitri, Satyavān, and the Other Woman

Aditi Sen

Introduction

Vikram Bhatt's horror-drama *Raaz* (Secret 2002) was a major box office success in a year when most big budget films with successful stars had failed. In fact, its success was an anomaly. The film had everything stacked against it: it starred two relative newcomers, the horror film market had faded, and it was a low-budget B-film. The critics dismissed it instantly. The *Times of India* did not give it a rating because *Raaz* did not meet their basic rating requirements.[1] Yet *Raaz* was one of the most successful films of 2002, and it revived the horror genre that had ebbed since the mid 1990s. Not only is *Raaz* an important horror film that attempts to retell the myth of Sāvitri and Satyavān, it is also a horror film that opens up a space for discussion about the boundaries of *strīdharma*, religious sanctities of marriage, mainstream religion versus the folk realm, the limits of sexual morality, and madness.

The original Sāvitri myth appears in the *Āraṇyaka Parvan* of the *Mahābhārata*. Sāvitri, a princess falls in love with Satyavān who is fated to die soon from a snakebite. Sāvitri still marries him against her father's wishes. Satyavān is also a prince but his parents had lost their kingdom, were both blind and lived in abject poverty. Sāvitri had known when the snake would actually bite her husband and when it happens, the god of death Yama comes to take his soul to the other world. Sāvitri starts following Yama. He repeatedly requests her to leave, but she insists her place is only with her husband. Yama tries to negotiate with her and grants three boons to her, on the condition that she doesn't follow him or ask back for Satyavān's life. The first boon, she asks Yama to restore her in-law's eyesight. The second, she asks for the return of their lost wealth, honor, and kingdom. The third boon, she asks for a son. Without realizing the full

consequence Yama grants her all three wishes and is forced to return Satyavān back to life.[2]

What were the reasons behind the success of *Raaz*? Was it the marketing strategy and the catchy tagline that read, "Do you want to know the secret?" Or did the film just get lucky? In this chapter, I will first analyze the reasons for the unusual success of the film, then look at the ways in which *Raaz* complicates mainstream cinema's patriarchal narrative and renegotiates the role of horror and its position in Hindi cinema. The success of *Raaz* was concomitant with the revival of the horror genre and its current popularity.[3] It was a trendsetter; it rehashed established Bollywood horror tropes, added folklore and mythology, and introduced the audience to an amalgamation of familiar ambience with subversive content. *Raaz* uses every formula to first scare the audience, then twist the Sāvitri and Satyavān story and transform Satyavān into an adulterer. Finally, it appeases the audience by glorifying the sanctity of marriage and reestablishing the patriarchal order.

There are numerous methods that scholars employ in order to unpack the horror genre. The goal is often to understand its boundaries and origin, and to raise questions like why we enjoy being afraid. One may also inquire about the economic reasons behind the production of horror and the ways in which horror texts are marketed and distributed.[4] In focusing on larger thematic issues, studying the content of the film often takes a backseat.

The mid 1990s witnessed the rise of low budget horror films that were very likely targeted toward rural areas, small towns, and single-screen underbelly city theaters which specialized in screening sleazy films. This was the time when these filmmakers consciously transgressed the boundaries of conventional morality and created subversive content. The Indian Censor Board focused on editing glimpses of nipples or too much butt cleavage, and never thought about the actual content. It was their myopic outlook that allowed the creation of content that was shocking by global standards.[5]

For example, *Shaitaani Badla* (Demonic Revenge, 1993, dir. Harinam Singh) shows the male servant getting gang-raped by a group of women after they are drunk. The traditional gender roles are reversed completely, and after the servant threatens to complain to the police about the crime, he is killed, and his body is buried in the backyard. Mainstream cinema metes out this dehumanized treatment of rape victims only to women. Here, we are confronted with total reversal of conventional roles and Singh attempts to open a dialogue on female lust and repression.

Harinam Singh is not alone in this pursuit. Kanti Shah, Joginder Shelly, Teerath Singh, and B. Mittal have repeatedly created content that completely

challenges existing conventions. They have openly talked about discharge of bodily wastes as a situation of vulnerability when evil spirits can possess the body. They had the courage to talk about subjects that makes no appearance in mainstream cinema, and even if they do, they are used as crude comic sub-plots. Similarly, they negotiated transgendered identities and normalized them instead of resorting to stereotypes. Above all, they have managed to acknowledge female gaze and made discussion of consensual sexual pleasure relatively normalized.[6]

Bhatt is the bridge between the Gothic mainstream content of the earlier generation of horror directors and these subversive filmmakers. He is consciously using horror as a tool to start larger discussions on female lust, sexual perversions, and even necrophilia. His technique is subtle and he still keeps the conventional modes alive, yet *Raaz* is the first successful mainstream horror film that blatantly attacks the Sāvitri-Satyavān mythology. He has been able to destabilize the Ramsay code of good versus evil moral framework and has unleashed the uncanny in our living rooms. Regular Hindi cinema audiences generally avoid watching low budget horror films. Even with the recent interest in cult cinema, their popularity is limited to cinephiles and fans. Further, they are usually watched for their unintentionally funny content like terrible editing, hamming, bad make-up, and shoddy storylines. In the larger scheme of things, these films have had a minor impact on shaping the genre. Bhatt, however, has been a massive commercial success and his films have changed the horror scenario in Bollywood.

The content of a film may seem a simplistic subject for scholarly analysis. Why is it important to delve deep into a film that was so quickly dismissed by the critics? It is precisely for this reason that the film needs to be studied. The overwhelming dominance of elitist viewpoints in understanding Hindi cinema has deeply affected the ways in which the educated urban audience judges Hindi cinema. These days, we are repeatedly confronted with severely polarized opinions on social media that are seldom about the content of the film, instead, they are about its larger socio-political repercussions. There is absolutely nothing wrong in analyzing a cinema within larger cultural context, but it also completely misses out the significance of the story itself. My aim here is to show how by solely focusing on the narrative we can navigate the intersections of female lust, monogamy, and madness.

Raaz is a film that displays porosity between conventional Bollywood and the low-budget underbelly horror films. These B-grade films are structured very much like folktales; crude, unpolished, and yet they frequently subvert conformist canonical stories.[7] While these films allow marginalized groups a chance to

speak, Bhatt allows them to open a dialogue with patriarchy. One can only understand the layers of this process by unraveling different facets of the story. I use Bhatt's own views on the film, then, analyze all the tropes he employed, and finally, look at the conscious ways in which he convolutes the moral framework of Hindu marriage.

The Background

Raaz's director, Vikram Bhatt, is conscious of the Indian market and moulds his art to appeal to the masses. He uses conventional horror tropes from previously successful Hindi films to frame his narratives. In his words, "My main goal was to scare the audience. Even as a child, I enjoyed telling spooky stories to my cousins and scaring them. Honestly, it never bothered me when the *Times of India* refused to rate my film. I saw the audience screaming, laughing, clapping, I was satisfied. And look at the kind of success *Raaz* had."[8] To put the film in context it is important to briefly discuss the Hindi horror film scenario because *Raaz* is a product of that continuance. *Raaz* is heavily inspired by two films: *Mangalsutra* (1981, dir. Vijay B) and *What Lies Beneath* (2000, dir. Robert Zemeckis).

Mangalsutra is the story of a shunned lover who kills herself when the man she loves marries another woman.[9] She then possesses her lover and prevents him from consummating his marriage. His wife, with the aid of her *mangalsutra* (a sacred chain worn by married Hindu women), exorcizes the evil spirit and saves her husband. The Hollywood film, *What Lies Beneath*, on the other hand, is the tale of a philandering husband who murders his lover and hides her body. The spirit of the wronged woman communicates with the wife and the women unite to fight the evil husband.

There is clearly a thematic similarity between all three films, yet *Raaz* is different from the other two; it is a typical Bollywood *masala* film.[10] The film features good music, the right amount of action and sex; the idea is to make the audience feel that their money is not wasted. Besides that, it is also a horror film and thus ensuring that the ghost actually delivers is extremely important, and in order to do so, a filmmaker has to draw from popular horror films from the past. Scholars have grouped Bhatt's films with those of the Ramsay Brothers, whose name is synonymous with the horror genre in Bollywood.[11] For example, Sangita Gopal sums up Ramsay films as "structurally *masala*—they had song-and-dance sequences, action fights, comedy routines, family melodrama—while featuring

curses, monsters and gory slayings as major themes."[12] Retaining this mould is imperative. It allows the audience to explore a new story in an accustomed terrain, and it makes the entire experience more palatable.

It is important to briefly discuss Noël Carroll's idea of "horrific imagery" before discussing the depiction of evil in the film.[13] Carroll maintains that there are universal attributes that repulse and scare everyone. Some images and ideas are terrifying irrespective of their cultural context. I agree with him about the universality of horror. In this vein, Bhatt uses many popular universal horror tropes, such as possession, poltergeist activities, blood showers and loud screams, in *Raaz*, and, in particular, the jump-scares are very well executed in the film.[14]

However, the film also moves beyond universality, creating a complex story completely embedded in the Indian cultural matrix. *Raaz* is not a simplistic story of good versus evil. Hence, I consider *Raaz* to be a groundbreaking film that marks the transition of Bollywood horror from plain Gothic tales to stories about deeper fears that haunt our conscience and shake our moral universe while still maintaining all the popular storytelling devices.

Revealing the *Raaz*

The story begins with a prelude: a group of youngsters go into a forest, they play silly games around the campfire, two of them wander deeper into the woods, a scream is heard, and one of the young girls suddenly becomes possessed by a spirit. She then attacks her boyfriend and later dies in the hospital while screaming, "I have woken up. I shall have my revenge" (my translation). An expert named Professor Agni Swaroop (henceforth, "the Professor") is called to the hospital for consultation; he announces that this is just the beginning of more terrible things to come.

After the opening prelude, we are introduced to our protagonists, Sanjana and Aditya, whose marriage is on the rocks. Aditya is a wealthy businessman who has very little time for his wife, Sanjana. After a fight at a party, Sanjana is in a car accident but has a narrow escape. She then asks Aditya for a divorce because she is tired of their endless fights. Aditya promises to make it up to her and they go on a vacation to revive their marriage. Sanjana agrees to give their marriage another chance and says she wants to go to their secluded farmhouse in Ooty, the place where they first met. She wants to revive the mutual happy times she has of that place.

After their arrival in Ooty, Sanjana and Aditya's old friends help them rekindle their past love. Soon, they start making minor progress. Unfortunately, Sanjana is haunted by screams in the night. Aditya cannot hear them, but Sanjana hears them often and is deeply affected by them. Later, the strange occurrences increase: her gardening tools move on their own and blood begins to appear on them. Aditya dismisses all of Sanjana's fears and concerns, but Sanjana later discovers that their old servant, Robert, had also heard voices and had gone missing for a while. Eventually she finds out that Aditya was aware of Robert's disappearance, yet he had neglected to tell her about it. Sanjana's friend, Priya, believes her account and takes her to the Professor who is an expert on *Vastu* and the spirit world.[15]

The Professor agrees to come to their house to help them. He puts a lemon wrapped in a cloth in their attic and tells them that if it changes color within twenty-four hours, it would indicate the presence of an evil spirit; if not, the house is safe. Needless to say, the lemon turns red and Sanjana is visibly upset. In a rush of drama, Aditya loses his temper, beats up the Professor, and accuses him of fraud. The next day, because of a major business engagement, Aditya prepares to leave Ooty with Sanjana. Just as they are all set to go, the Professor tells Priya that the spirit would not allow Sanjana to leave the place because it wants to communicate with her. His prediction proves right; there is a landslide, and Aditya is forced to fly alone. While Aditya is away, Sanjana decides to communicate with the spirit. The Professor helps her and gives her a book that has incantations to call the spirit, and eventually it arrives.[16] The spirit behaves like a poltergeist; it showers blood on Sanjana, throws all of the furniture around, and finally shows her reflection on a mirror. Utterly terrified, Sanjana runs outside and screams, "This is my house! I will not let you take it away from me!"

When Aditya returns from Mumbai, he finds Sanjana to be behaving erratically. She recites erotic poetry and tries to seduce him, but Aditya knows that this is entirely uncharacteristic of her. Then he suddenly sees another woman's face in place of Sanjana's face and screams, "You! Why are you here? You are supposed to be dead!" As he screams, the spirit vanishes and Sanjana asks to whom he was referring.

Aditya's story unfolds in flashback. He confesses to having had a torrid affair with a woman named Malini, who had serious mental health issues and had run away from her home because she was about to be institutionalized. Aditya did not know anything about her condition (in fact, her mental illness was discovered later by Sanjana). She came to his house looking for shelter during a storm, and he later had an affair with her. Throughout the affair, Aditya completely neglected

Sanjana, but then he grew tired of the extramarital relationship, especially because of Malini's possessiveness and unpredictability. Malini became increasingly violent, demanding that Aditya leave Sanjana or she would kill herself. Aditya finally took a stand, telling Malini that not only would he never leave Sanjana, he would not see Malini again. Malini threatened to tell Sanjana about the affair; he dismissed her by saying that Sanjana would never believe her. In a fit of anger, Malini said Sanjana would believe her if she found her body there, and she shot herself with Aditya's gun. Aditya panicked and, instead of calling the police, asked his servant, Robert, to help him bury her body in the woods, in the exact spot where the girl in the prelude was possessed.

Aditya asks for forgiveness, but Sanjana refuses and decides to leave him. She tells the Professor about her discovery and decision. The Professor immediately informs her that leaving Aditya is precisely what the spirit desires and she has played into her hands. At this point, the Professor compares Sanjana to Sāvitri and says that even gods are afraid to take the life of a man whose wife is devoted to him. The only reason that Malini's evil spirit could not kill Aditya was that Sanjana's virtue—her *strīdharma*—protected him like a shield. He insists that, as a fellow human being, she must save his life from the evil spirit. Ignoring his advice, Sanjana leaves anyway.

With Sanjana gone, the spirit can now take Aditya's life. The Professor once again turns out to be correct and Aditya is found in a car accident and left hanging between life and death in a hospital. Sanjana decides to save him and the only way she can do it is by performing the last rites of the spirit and burning Malini's body—the body that Robert and Aditya had buried in the forest. Priya and the Professor agree to help Sanjana in her mission. The spirit does everything in its power to stop Sanjana, and the Professor is killed in the process. Finally, Sanjana emerges victorious and saves Aditya's life and their broken marriage.[17]

Formulas and Techniques

Colonialism

To understand the role of colonialism, we need to unpack the idea of Gothic first, especially, the ways in which it plays out in the context of Hindi cinema. The Gothic fixation with erecting sham medieval structures and indulging in moral decay had a massive appeal to Indian horror writers. Abandoned manors with dark history of cruel rulers became the Indian staple for horror tales. The Indian

visualization of the horror landscape is a reflection of British imagination. Even today, dilapidated castles that harbor dark secrets are box office successes.[18] The horror Indian audiences still consume was primarily created by the colonial presence and it influences the retelling of Indian folktale and mythology. No matter how Indian the story is, a Gothic setting is necessary for the right mood.

Simon Hay insists that populating native landscape with British ghosts is a method of colonization. European ghosts are used to either demonstrate "White" rationalism versus native irrationality, or to illustrate that rationalism is not applicable to the world outside Europe.[19] Further, a colonial framework, in many ways, legitimizes a ghost story. It works within established patterns of a horror tale and allows the audience to sit back and enjoy the story without feeling the stress of something actually horrifying. There are no White ghosts in *Raaz*, but the eternal debate between scientific rationalism and Hindu hocus pocus is a constant reminder of this legacy.

Raaz starts in a haunted forest. At the edge of the forest is a large mansion where the main action takes place. There are screeching owls, gigantic bats, and jarring, loud screams. In many ways, it is the perfect horror setup. It has everything an Indian audience expects in a horror film: the horror is confined to a space that effectively captures their imagination. The audience is allowed to indulge in imaginary fears without being challenged in any way.[20]

Colonialism plays a major role when it comes to visualizing the horror backdrop. Setting up the right ambience is critical to the success of a story. The British were always very interested in ghosts. They enjoyed a good spooky story and liked telling them too. India provided them with an excellent opportunity to expand their horizons. On one hand, several Victorian authors, such as Bram Stoker, Wilkie Collins, Arthur Conan Doyle, B.M. Crocker, and R.V. Smith, benefitted greatly from "exotic" Indian ghosts.[21] On the other hand, Indians used Victorian tropes to create a good, spine-chilling tale. To quote Ruskin Bond, "India is full of British ghosts—the ghosts of soldiers, adventurers, engineers, magistrates, memsahibs, their children, even their dogs."[22] For example, Warren Hastings allegedly still haunts his residence in Kolkata, and the ghost of Major Burton, a British officer killed during the 1857 mutiny, still haunts the Brij Raj Bhavan Palace Hotel in Kota, Rajasthan, while in Ekbalpur, a British ghost named Bihar regularly demands tea and cake.

The specters of the Raj still work; colonialism still evokes fear, and ghost stories with a Victorian setting always have an appeal. In fact, it would not be far-fetched to say that Wilkie Collins was instrumental in laying the foundation of Hindi horror cinema. His book, *The Woman in White* (1859), inspired Hindi

filmmakers to visualize ghosts. The book was even made into a blockbuster movie called *Woh Kaun Thi* (Who Was She, dir. Raj Khosla) in 1964. However, long before that, the Victorian staples of horror had already entered Indian pop culture. The horror-loving audience has always craved Gothic mansions, mysterious haunting music and ghostly wilderness.

Most successful Hindi horror films before *Raaz* had all of these features.[23] *Raaz* exploits the exact same tropes as these films. It is a continuation of a well-established horror legacy. Vikram Bhatt is a traditional storyteller and crafts almost all of his horror stories in the familiar Gothic mould.[24] Bhatt's other successful film series is *1920*, which is set exclusively in colonial India.[25] One of his most successful horror films, *Haunted* (2011), also has a Victorian backdrop in colonial India. To sum up the Indo-Victorian link in creating a horror story, I will use the lines of a hit song from the film, *Naya Daur* (New Age, 1957, dir. B.R. Chopra): "*English sur mein gaaoon main Hindustani gaana*" ("In English tune I sing my Hindustani song"). It is an Indian story, but the foundation is English.

Lustful Evil Spirit

A good setting is just the beginning. One of the main reasons behind the success of *Raaz* is the character of Malini. The measure of a good horror film depends on its depiction of evil. Horror stories permit evil spirits to tell their story, and *Raaz* does a phenomenal job of giving Malini a voice. Horror may be one of the few genres in which female subversion gets recognition.[26]

Female subversion as a horror trope is often neglected. Melissa Edmundson points out that Victorian women ghost-story writers, namely Bithia Mary Crocker and Alice Perrin, used "ghosts, native superstition, reincarnation and curses to illustrate the nebulous relationship and often fragile détente that existed between the colonized and the colonizer."[27] She further points out that the independence of *nautch* girls disturbed the British male gaze since they embodied many cultural contradictions, and their ghosts continued to terrify them.[28] *Nautch* girls were in every sense of the term "career women" and had economic independence. Therefore, men's relationship with women was ambivalent but they still felt the need to humiliate and destroy them. There is a need to demonize women who don't need men for social and economic security, but instead openly seek consensual sex from both married and unmarried men and remain unapologetic about their desire.

Malini is very clearly in the *nautch* girl realm. She is economically independent, doesn't care about Aditya's marital status or is ashamed of being the other

woman. Malini is hungry, driven by lust, and craves sex. She is also beautiful and alluring, which makes her all the more sinister because a married man cannot resist her. These are precisely the reasons why a *nautch* girl was feared. She is completely unapologetic about her sexual needs and does not care how they are satisfied. In patriarchy, male sexual appetite has a place but feminine lust is taboo and is something to fear. Patriarchy had failed to control Malini when she was alive; in death, Malini is a ravenous, evil spirit who now wants to consume the body of her lover. It is her insatiable lust that becomes the driving force behind her evildoings.

Women have been largely prevented from uninhibited, consensual sexual relations; a woman demonstrating her sexual needs is deemed evil.[29] In fact, female desire has always been deeply problematic, and horror is the only genre that has been able to accommodate and discuss it. Malini is attractive, does not associate morality with sex, and, therefore, has no qualms about loving a married man. We are also informed that she is insane. Yet in death she becomes a manipulative evil spirit who refuses to give up the man she desires. For a madwoman, she is a surprisingly sane and manipulative evil spirit. Malini is everything that the patriarchy fears. She is not afraid to violate boundaries and feels no guilt about transgressing these lines. To save the patriarchy, Malini has to be destroyed. This is not limited to cinema; in fact, there is a precedence in Indian folklore of women being repeatedly demonized for being lustful and demanding what society prevents them from consuming.

Historical Ghosts

Ghosts are never created in a vacuum. They are a culmination of numerous things: actual historical events, social oppressions, and injustice. They hold a mirror up to the things we do not want to see and force us to confront our deepest fears and insecurities. It is critical to look into Indian folklore because Bhatt's films are rich in folk symbolism.[30] Here, I will use popular Bengali ghosts to illustrate the folk symbology. Even though my examples are from Bengal, they raise pan-Indian issues.

Bengali folklore is rich in ghost stories, and the ghosts are layered and complex. Naturally, there is no shortage of female ghosts. Two of the most popular are *daini* (witch) and *petni*. Their haunting hours are at twilight; they usually haunt ponds, marshes, and bamboo groves, and sometimes they even live in *shayora* or sandpaper fig trees. A *petni* is the spirit of a dead, married woman who still craves fish.[31] Bengali ghosts often crave food, especially fish; there are

many stories of *petnis* stealing fish from people returning home with their groceries after work. Sometimes they even follow people home and demand cooked fish.

Why this love of fish? Bengali widows were forced to live on *Sattvik* food, and their diet was very restricted. Since fish plays a major role in the Bengali diet, the loss of fish created a major gap in their dietary pattern. Their diet was limited to grains and vegetables, and it severely lacked protein. Their main source of protein came from moong beans and the dairy they were allowed. Widows also had to reduce the amount of food they ate. The number of child widows in Bengal was very large. This was mainly because of the practice of Kulinism, which allowed Brahmin men to marry many women, often as many as ten to fifteen.[32] The death of one man, therefore, led to many widows, often child widows. These women, in their prime, were forced into widowhood and had to live on a restricted diet. *Sattvik* diet also meant very little or no spice. While the rest of the family ate wholesome meals that included fish and meat, they were deprived of all of it. It is only natural that the craving for fish would be a major trait of these restless spirits.

Since Bhatt draws so much of his inspiration from folklore it is worthwhile looking at some dominant themes in Indian folktales. In fact, there has been plenty of interest in rediscovering Indian folk ghosts and creating stories around them.[33] The character of Malini draws many features from female folk ghosts. At no point does anyone show any kind of compassion for her. Her father considers her sexuality deeply problematic and tries to seek medical treatment for her. She is repeatedly locked up in confined spaces for her defiance and no one is willing to listen to her. Like the *petni* craving fish after her death, Malini too craves sex and Aditya's body after her death.

Ghost stories as a genre "deny the irreducibility of those traumas."[34] One has to view ghosts as an integral part of historical memory—a memory that refuses to fade away—and they want their pain and suffering to be acknowledged. Ghosts are products of our failure to be humane, compassionate and kind.

The Right Techniques

Horror film is an exercise in establishing communication between our world and the spirit world. Therefore, techniques play a vital role. To spot Indian ghosts, one needs Indian techniques. For example, the Professor places a lemon in Sanjana's attic, telling her that if it turns red, there is a ghost in her house; if not, all is safe. The lemon turns bright red, confirming her fears. This is a very

common folk technique for detecting spirits and curses.[35] One could never prevent what was coming from the other side. Although the other side is unknown, it still reflects regional and religious cultural peculiarities. Therefore, Indian horror needs Indian methods and Indian experts.

The Professor is an upper-caste male named Agni Swaroop. The name is relevant: Agni is the god of fire, and fire dispels darkness, demons, and ghosts, and Agni is also invoked to cure someone of madness.[36] He has the knowledge of scriptures and knows how to identify evil spirits. The fact that the character is a professor is also important. The audience never questions his integrity; the only one who calls him an imposter is Aditya because he is the culprit. There is credibility in everything the Professor says. No one questions his techniques of spirit-detection, nor his methods of communicating with the spirit. He is not a typical exorcist whose words we doubt. We have a man educated in the western system, not someone steeped in religious "mumbo-jumbo." He is a man who has studied science, but he is also an expert on Indian methods. As well, he is uncannily correct about everything.

The Professor provides Sanjana with a portal to the spirit world. He is the link between the two worlds and his role is to keep the moral order of our world functioning. He tells Sanjana that, as a fellow human being, she should save Aditya's life because only she has the power to save him. The point about referring to her husband as a fellow human being is important. Aditya has abused the position of husband. While Sanjana may be Sāvitri, Aditya is no Satyavān. It is Sanjana who has the power and is left with the responsibility of restoring the patriarchal order that Malini desecrated through her affair with Aditya. Saving her husband and her marriage is not a personal choice, but an altruistic venture that Sanjana must undertake for the greater good. Her job is also to reiterate the position of the *mangalsutra* that Malini has undermined. Even though Malini destroys the Professor and possesses his body to stop Sanjana from burning her corpse, it is only because of him that Sanjana decides to fight the spirit. The Professor is the male voice of the established social moral order. When he sees it being so violently desecrated, he gets actively involved in the process of restoring it, even losing his life in the process.

The palpability of caste is almost always an underlying theme in Hindi horror films, as well as acknowledging religion and caste boundaries. Every recent successful Indian horror film (with the exception of *13B*), especially after the 1980s, has an "expert" who knows everything about the spirit world. The experts are often upper-caste professors[37] or learned Swamis. In fact, the presence of an expert is a critical storytelling technique. Since *Raaz* follows all the conventions

of horror, the expert is a major character in the film. The explanation of evil always comes from the expert; therefore, the only explanation we are offered is through the eyes of the upper-caste man.[38]

The Sex

Sex is the central theme of *Raaz*. Interestingly, it was never marketed as an adult film or a film that promised titillation.[39] Actually, *Raaz* was a family hit because it provided the entire family with a good scare and there were no graphic adult scenes; in fact, there are very few adult scenes in the film.[40] However, it would not be incorrect to say that the entire film is driven by the theme of lust. It is not male lust that we fear, even though it had fatal consequences for the woman; rather it is the lustful woman. It is losing control of our social conditioning that unnerves us and makes *Raaz* a horror film. The film opens a nuanced debate on sex, differentiating between extramarital and marital sex, and Aditya is the medium through whom the debate is presented.

Aditya is never a victim; he chooses to have an affair with Malini, and he chooses to cheat on his wife and lie to her. In fact, Malini even warns him before beginning the affair that she could destroy him, to which he responds, "I wish to be destroyed." After Sanjana discovers Aditya's affair, she accuses Aditya of enjoying the favors of a whore "in her bed, their marital bed." Why is Malini described as a whore? Clearly, any woman sleeping with a married man and not feeling guilty about it is a whore. Malini is branded as a mad whore who becomes a dangerous, cunning evil spirit only because she dared to love a married man and demand acknowledgement of that relationship. Also, it is she who actively seduced him and started the affair.

Malini must kill herself; she gets no compassion in the story, even though she is mentally ill and is seriously wronged by Aditya. Malini is the kind of woman whom the patriarchy has to annihilate because she challenges its very basis. Malini loved Aditya, even though Aditya used her for sex and backed out later; her love for him is central to the film's narrative. Her unrequited love for a married man is viewed as both dangerous and fatal, and it is Sanjana the devoted married woman who has the ability to save the situation. Aditya cannot hear Malini's screams nor witness any hauntings—only Sanjana can. He tries to negate his misdeeds by calling the Professor a liar. Considering that Aditya cheated on his wife and drove Malini to suicide, he gets off with almost no punishment whatsoever. Instead, his broken marriage is mended because the "evil" woman's

illegitimate love was successfully exorcized. Aditya is allowed to live because he is a man, and he is the board on whom sexual territories are etched. He is the medium, the instrument, so he has to be left unscathed.

Malini not only dared to seduce and love a married man, she even referred to Sanjana's *mangalsutra* as a dog's collar. She insists that Aditya "is only sticking to the bitch because she has a collar" and he could just tie the same collar on her it would solve things. Malini does not comprehend the sanctity of marriage. To her, symbols of marriage and marital fidelity mean nothing. She compared the marital symbols to signs of subservience and ownership. Her defiance of marriage and the marital space is significant; she stands as the antithesis to the existing social order. For Malini, sex is more important than symbols. It is consensual sex that determines the legitimacy of a relationship for her. Sanjana truly has no other option but to completely destroy Malini and what she represents. So, she has to save her philandering husband from a wronged spirit.

Even though Malini receives no empathy in the film from the other characters, the audience certainly feels some compassion for her. Despite the professor reiterating how evil she is, we cannot help but see her as a wronged victim whose only fault was to fall in love with a married man. We are aware that she is vengeful and vicious, but the film attempts to explain her story to us. It offers us her perspective as well; as a result, the boundaries between good and evil are challenged, and we are thrown into a moral conundrum that the film ultimately refuses to solve.

Sangita Gopal points out that we are now in a phase where, for the new romantic duo in Bollywood, conjugation is not the goal anymore; couples come "already conjugated."[41] In early cinema, the focus was on the romantic journey and the end result was sex. Gopal therefore believes that the concerns of the filmmaker have now shifted. In fact, she uses Bhatt's *1920* and *Raaz* to elaborate this idea. In both films, the couple is already married; as a result, their romantic journey is of no consequence to us. We have moved beyond the romance and are now looking at sexually experienced couples to complicate the narrative.

In principle, I agree with Gopal, especially her observations on *Raaz*. However, sex has always been complicated in horror films. Even the Ramsay films, which Gopal dismisses, have convoluted "conjugating" issues, namely sex with the *Shaitaan*,[42] premarital sex and extramarital relations. One of the main functions of horror films has always been to subvert sexual morality.[43] It is only natural that the process of "conjugation" would play out completely differently in horror films. Very often, the mechanism used for breaking norms is the phenomenon of possession. This allows horror films to cross limits that would otherwise be

impossible in mainstream cinema. Only in a horror film would Sāvitri want to divorce Satyavān, where Satyavān is the actual villain, the serpent is Malini, and the Professor is Yama who has to plead with Sāvitri to restore the order.

Rewriting the Myth

The protagonist of the film is Sanjana. She is a modern-day Sāvitri who rescues her dishonest, unfaithful Satyavān from an evil spirit. In the actual myth, Sāvitri knew her fate but still married Satyavān because she loved him. When Satyavān dies of a snakebite as fated, she chases Yama, the god of death, and tricks him into returning Satyavān's life. Sāvitri had gone against her father's will and had chosen to marry Satyavān for love. Sāvitri's love is extremely powerful, a love that can defeat death. Similarly, Sanjana turns out to be Aditya's amulet and shields him from Malini's powerful spirit. To make Aditya vulnerable, it becomes essential for Malini to ensure that the amulet is disarmed. The moment Sanjana makes the decision to leave him, Malini takes Sanjana's form and causes a car accident that nearly kills Aditya. He only lives because Sanjana decides to save him. Aditya is completely at the mercy of Sanjana. The question is why Sanjana chooses to save Aditya after she discovers his *Raaz,* or secret.

It is important to make a distinction between the different types of love explored in the film. Sanjana's love for Aditya has waned. In the beginning of the film, she wants a divorce. Aditya and Sanjana have stopped communicating, they have grown apart, and later we learn that Aditya has become a philandering spineless liar who does not care for his wife. Aditya's love for Sanjana is both selfish and abusive; he uses Malini to satisfy his lust and continues to mislead her until it is too late. Therefore, it is only Sanjana's love and virtue that matter here; her love is sanctioned through marriage and validated by symbols, particularly, the *mangalsutra*. Connected to both of the female characters is the idea of sexual purity. Even though they both have sex with the same man, Sanjana is sexually pure because it is a part of her *strīdharma*.[44] Sanjana has fulfilled her role as a wife; she has not slept with any other man and has not even entertained the thought of anyone other than her husband. Even though he ignores her and dismisses her concerns, she still remains loyal to him. She is the *pativrata stree* (the loyal wife) whose sexuality is operational only in the marital context.

Malini, on the other hand, violates the sacred marital space. She is driven by lust; she has sex to satisfy herself and does not care where she gets her satisfaction. She enters the forbidden territory, dares to love someone who is "unavailable,"

insults the institution of marriage, commits suicide with the intention of breaking Aditya's marriage, fights back as an evil spirit to win back her man, and is destroyed because she tries to defy the fundamentals of *strīdharma*. It is only because of *strīdharma* that Sanjana's broken love can fight Malini's obsessive, intense love. Here, love per se is not important but the source is what matters. The source is where the power of love lies; it is in the wife's love for her husband, a love that, as the Professor mentions, "even gods are afraid of." Aditya deserves to die because he was the one transgressing the boundaries, and death is often viewed as evil and not just as punishment for evil.[45] So, Aditya coming so close to death is also an acknowledgement that he did something evil.

Both female characters are extremely strong, and Aditya is moulded repeatedly to ultimately comment on women's position in the patriarchy. Even though I have noted that *Raaz* is about the restoration of the patriarchy, oddly enough Aditya has no agency in the film. Aditya simply allows the women to use their agency on him and to etch the borders of sexual morality and argue over the boundaries of *strīdharma*. Yet, we cannot deny the Western(ness) of *Raaz*; there are scenes that are copied directly from *What Lies Beneath*, but I will still maintain that *Raaz* is definitely an Indian story. I have already mentioned that the modern-day Sāvitri and Satyavān have changed drastically. Satyavān is an adulterer, liar, and coward. Sāvitri wants a divorce, she is tired of her endless fights with Satyavān and she refuses to forgive his infidelity until his life is in danger.

Concluding the *Raaz*

Sudhir Kakkar describes Hindi films "as a regressive haven for a vast number of people."[46] This view of the Indian viewer and Hindi cinema is not uncommon. As Ajay Gehlawat points out, the Indian viewer is like "a child to whom the national cinema panders."[47] Indian viewers are considered incapable of watching anything that is slightly different and beyond their realm of morality. Bollywood filmmakers also share this view and see the Bollywood audience as simple, naïve, unintelligent and incapable of understanding anything complicated.[48] This deeply problematic view badly affected the horror genre in the past. Infantilizing the audience influences the way critics review Hindi cinema. This attitude had also resulted in limited scholarship on Hindi horror films. The academic interest in horror cinema is recent and horror is finally becoming a popular mainstream genre in Bollywood.

Valentina Vitali argues that the 1980s often reflected mass stress and that found an outlet in horror films. Indira Gandhi created a political environment that nurtured the growth of horror films. From the emergency to her assassination leading to the Sikh genocide, these stressful times gave rise to horror.[49] Vitali further contends that horror films in India are a product of this political turmoil and that the Ramsay brothers' monster flicks were essential in those turbulent times because they represented the clash between modernity and religion. The 1980s saw Indira Gandhi's attacks on the Golden Temple followed by her assassination and the Sikh riots, as well as the rise of communal parties and Hindu extremism. Ramsay films were about the loss of this known world and the coming of a new era.

Vitali also adds that horror films ended in the 1990s because their whole purpose was to satisfy the subconscious conflict in the people's minds. India needed horror films to deal with the radical changes in the socio-political scenario.[50] In fact, scholars such as Brigid Cherry maintain that horror films are a way to express anxiety toward changing times, preserving horrifying memories, and Vitali seems to be on the same page as her.[51] While Vitali raises some excellent points, horror films did not end with the 1990s. True, the Ramsay brothers started failing in the early 1990s but the genre had taken on a very different form. The 1990s saw the peak of these low-budget flicks and the year 2000 saw horror films becoming mainstream again with the success of Vikram Bhatt's *Raaz* and Ram Gopal Verma's *Bhoot*.[52]

I want to reiterate that, while there is merit in looking at political backdrop while studying the horror genre, it is not adequate. Indian horror has to be unfolded through mythology and mythical figures, historical memories that are not recorded, evolution of various thought ferments, conscious processes of socio-economic marginalization, shifting notions of agency and anxieties of sexual transgressions. Discussion on horror requires an acknowledgement of all these facets and the ways in which they manifest in our psyche.

Bollywood horror is an extension of Indian history, religious beliefs, aesthetics, and social changes. While there is merit in analyzing the reasons behind the rise of horror, but it is equally important to study the content itself. *Raaz* effortlessly subverts a popular myth, convolutes existing moral codes and gives evil a nuanced voice. Bhatt successfully lures us with familiar Gothic settings to tell us a quintessential Indian tale of adultery and marital fidelity. He uses horror tale to provide us with a framework of ideological contradictions. Gone are the days of unidimensional monsters, instead, we meet a powerful woman who refuses to remain silent even after her death. Bhatt also makes sure that the audience feels

disdain for Aditya (Satyavān) and some resentment at patriarchy that chooses to keep him alive.

Hay maintains that ghosts are "historicized, and therefore politicized, reading of the genre of the ghost story, reading ghosts for the history and politics of which they are sedimented residue."[53] Bhatt wants to question the Hindu sanctity of marriage and monogamous relationships. He shows us that rules like fidelity are only applicable to women and transgression can have fatal consequences. He further shows us that the burden of preserving a marriage falls on the woman, even though she has not done anything to disturb it. She suffers the consequences of her husband's misdemeanors and is also made to stay in the marriage and make it work.

Bhatt wants the audience to think about the oppressiveness of Hindu marriages, and the pressure it puts on the woman. All Sanjana wanted in the beginning of the film was a divorce, instead, she has to go through depths of hell to rescue her philandering husband. Bhatt also makes it a point to mention that symbols like the *mangalsutra* are some of the methods that patriarchy employs to subjugate women. He wants us to question the symbolism behind these mundane objects.

We also witness a clash between monogamous marriage and extramarital sex. Bhatt is clearly trying to engage us in a dialogue between established ethical codes versus human instincts and passion. The film may have ended with the restoration of the old code, but we know that the code is shaken. The professor is sacrificed, Satyavān has lost all agency and is now fully dependent on Sāvitri, and Malini has punctured the sanctity of monogamous marriages.

Bhatt has always maintained that his films are educated. The critical dismissal of his films doesn't bother him as such, because he feels they pander too much to the existing elitist views on Hindi cinema. He also feels that the urban Indian audience is unaware of folklore and ghost stories. As he says, "I love history, I study a lot of folklore. No matter what critics say, my stories are Indian. Sure, I watch a lot of horror films in other languages and get inspired, but the soul of my films is purely Indian."[54]

Part Three

Cultural Horror

6

Cultural Horror in *Dev*: Man Is the Cruelest Animal

Ellen Goldberg

Sectarianism, bigotry, and its horrible descendant, fanaticism, have long possessed this beautiful earth. They have filled the earth with violence, drenched it often with human blood, destroyed civilizations and sent whole nations to despair. Had it not been for these horrible demons, human society would be far more advanced than it is now.

<div style="text-align: right">Swami Vivekananda</div>

We have exceeded the achievement of Nazi terror, Bosnian atrocities, and our own Partition violence—if not in numbers or scale then in the intensity of torture, the sheer opulence and exuberance in forms of cruelty. It is as if the most gruesome elements from all of the annals of mass destruction have pulled together to form a whole that is Gujarat today.

<div style="text-align: right">Tanika Sarkar</div>

Introduction: Background on the History of Communalism[1]

As we see in this collection of essays, horror can be construed in various ways, and while *Dev* (2004) is not strictly considered among the standardized Hindi formula horror genre films, it is director Govind Nihalani's extremely bold and graphic attempt to capture the "real-life" horror of recurring Hindu-Muslim communal violence. As *Dev* shows, a line has been crossed. The horror enacted during communal riots has reached a point of unspeakable brutality reminiscent of the most catastrophic atrocities committed in modern twentieth and twenty-first century history. Yet, the Hindu-Muslim communal expression of killing, rape, looting, arson, and barbarism bears witness to a particular history,

experience, and compulsion of its very own making. Thus, we must consider the specificity of the local Indian context, that is to say, the unresolved history of colonization, decolonization, modernity, and Partition in more detail.

We also need to find new words and ways, as Tanika Sarkar suggests, to describe the horrors perpetrated. Sarkar argues, regarding the events in Gujarat that inspired *Dev*:

> A serious inadequacy plagues our known vocabularies of horror. Words like communal violence or carnage or massacre have been over used to describe far too many situations whose horror is minimal, even relatively "innocent" compared to the last four months in Gujarat.[2]

The term "cultural horror" that I have chosen is perhaps also inadequate by Sarkar's standards, but through art (e.g., film, literature, theater, dance, music, and so on) it is sometimes possible to find cathartic ways to express trauma and mediate the unspeakable.

My goal in this chapter is to try to make sense of the horror depicted in *Dev*. I apply insights from Frantz Fanon on understanding colonialism, Hannah Arendt on the politics of evil, and Sigmund Freud on theories of repression. I also look at Indian film scholar Bhaskar Sarkar's work on trauma and cinematic mourning, and situate his scholarship on Partition films within the framework of what I call "cultural horror" to reiterate how the memories and ghosts of Partition continue to haunt the Indian nation. To begin, I provide some background on various positions *vis-à-vis* communalism that I hope will help explain the rise of Hindu nationalism and its role in contemporary communal riots such as those depicted in *Dev*.

Tanika Sarkar claims there is something "new" about the communal riots that took place in Gujarat, India in 2002. She claims that for the first time we hear explicit references to the Hindu Rashtra, or Hindu State—a concept conceived in 1923 by Vinayak Damodar Savarkar (1883–1966) in his work *Hindutva: Who is a Hindu?* Savarkar was a highly educated, nationalist freedom fighter who drafted an extreme racist and separatist ideology while in prison in Ratnagiri, claiming India is (and should be) the Hindu Homeland. He politicized religion and argued that any members of society who hold what is perceived to be foreign religious or cultural affiliations, such as Muslims, could not be considered Indian in his territorialized dream of India as the Hindu holy land or "*punyabhumi*."[3] For Savarkar, the designation "Hindu" refers to a common race. As such, "Hindutva" is an emphatically geographical, political, ethnic, and cultural designation defined much more broadly than simply religion—especially since

Hindu religion has no apparent "unity or uniformity," and no single, unanimously agreed on set of core beliefs, institutions, or scriptures analogous to Jewish, Christian, or Muslim monotheism.[4] As Savarkar puts it, Hinduism, solely as a religious designation, is "derivative" and comprises only a "fraction" of what is intended by the more inclusive term "Hindutva" (Hindu-ness).[5]

The rhetoric that Savarkar and other Hindutva leaders used to construct the origin myth of "common blood" that is shared by those belonging to a common Hindu race, culture, and nationality not only excludes Muslims (as well as Christians, secularists, Communists, and Westerners), it also privileges Hindus in India and normalizes Hindu-Muslim communalism based on relations of fear, suspicion, and hatred.[6] We see the effects of Savarkar's Hindutva ideology throughout *Dev*. For example, after Arman's death, Tej Khosla (Om Puri) embraces Hindutva rhetoric and portrays Muslims as a threat under the banner of the Hindu collective. Similarly, suspicion of Muslims has become routine, as we see when Dev Pratap Singh (Amitabh Bachchan) interrogates local Muslim leaders or when Farhaan Ali (Fardeen Khan) is searched on the train. Also, extreme retaliatory practices by Hindus are made to appear justified, such as when mob rioting occurs after the Hindu temple bomb blast. And, Chief Minister Bhandarker (Amrish Puri) insists that the right of citizenship belongs to Hindus only. In other words, Hindutva or Hindu-ness as a response and a weapon against perceived Hindu vulnerability is portrayed as normative in *Dev*.

But of course, the history of Hindu nationalism is even more complex. Broadly speaking, Indians essentially internalized contradictory European views of India. On the one hand, the British maintained that Indians were less than human. On the other hand, early Orientalists claimed India was the cradle of human civilization and a place of profound spiritual wisdom (i.e., the Vedas). These paradoxical views bequeathed India with an extraordinary spiritual identity while at the same time dehumanizing, shaming, and denying Indians status, agency, and personhood in their own country. The architects of Hindutva or Hindu nationalism aligned more closely with the Orientalist idea that India was once great and attributed India's cultural and social deterioration to foreign invasion. This sets the stage for Muslim "othering" as we will see.

It is also important to also bear in mind that the voice of right-wing politics in modern India is not a monolithic block. Nor is it correct to think of Hindu nationalism as a fringe or marginal movement. It has become mainstream (which in itself can be seen as an instance of cultural horror). Contributors to the rise of Hindu nationalism are diverse, starting with the nineteenth century Bengali author Bankimchandra Caṭṭopādhyāy (1838–94) who wrote a visionary

historical fiction about Hindu *saṃnyāsins* (Nāgas or ascetic warriors) mounting a rebellion against British rule.

In his 1882 novel *Anandamath* (Monastery of Bliss), Bankimchandra imagines Hindu nationalism at a time when such an idea seemed unimaginable.[7] What is of critical importance to our current discussion is how Bankimchandra envisions a pure, pre-Islamic, Hindu India, thereby offering an alternative non-secular vision of the nation. His militant and highly patriotic vision of India as "nation" and "mother" anticipated (and set the stage for) the Hindu, upper caste, male supremacist Hindutva agenda.[8] As Sarkar writes, Bankimchandra "was the first Hindu nationalist to create a powerful image of an apocalyptic war against Muslims and project it as a redemptive mission, an achievement intended to endow the Hindu with political energies that he had, all along, enviously associated with Islam."[9] These messages, and the anti-colonial male subject Bankimchandra imagined, are still invoked by Hindu revivalists, as his work went on to inspire political terrorist activity and the ideas of a Hindu national awakening, self-rule, and the fight for freedom from British colonial power. Echoes of this legacy are felt throughout *Dev* in the various voices of Hindutva portrayed on screen.

Other pioneers of Hindu nationalism include Madhav Sadashiv Golwalkar ("Guruji,"[10] 1906–75), a Marathi (Karhada) Brahmin who became the second leader (*sarsanghchalak*) of the RSS (Rashtriya Swayamsevak Sangh) shortly after the death of its founder Keshav Baliram Hedgewar's ("Doctorji," 1889–1940). Golwalkar expanded the RSS and built it into a popular pan-Indian organization to promote Hindutva. We see at least three strategies in Golwalkar's ethnic nationalism that are germane to the rise of communalism and evident in *Dev*.

One strategy is to create a selective history by "othering." Golwalkar posits a politics of religious opposition emphasizing the Hindu myth of tolerance, victimhood, and stigmatization, on the one hand, while creating a one-dimensional stereotype of Muslims as intolerant fanatics and terrorists, on the other hand.[11] As Romila Thapar maintains, this view resonates broadly with early Orientalist versions of Indian religious history where Muslims are depicted not only as foreigners but also as aggressive enemy invaders.[12] This binary approach, referred to by Sumit Sarkar as "the theme of medieval Muslim tyranny,"[13] was reified through Orientalist narratives and the novels of Bankimchandra and, furthermore, it acts to legitimate any and all violence that Hindus perpetrate against Muslims, including the more recent violence that was suffered during the Gujarat riots in 2002 and in *Dev's* finale.

Against this ideological backdrop, riots are not seen as pogroms (that is to say, conscious or planned attacks), but, rather, as legitimate and justifiable methods

for retaliation and retribution against long-term Muslim violence perpetrated against vulnerable Hindus. As Dibyesh Anand writes, "the state is absolved of all responsibility: after all, what can it do when the entire Hindu society lashes out in hurt caused by an arrogant expansionary minority?"[14] In *Dev*, we see this so clearly when Chief Minister Bhandarker justifies and supports Mangal Rao and the Hindu mob's impassioned need to retaliate after the bomb blast at the Hindu *mandir*.

Golwalkar also seems perfectly aware of the interplay between social formation (i.e., nation-building) and mythmaking.[15] Thus, another strategy in Golwalkar's tactics to fortify the RSS's Hindu nationalist agenda is the myth of Hindu unity (strength and belonging) based on race, not religion.[16] Golwalkar gained popular support for the RSS not only by promoting the idea of Hindu unity and indigeneity, but also by establishing a pervasive grassroots network of local cadres and Hindu-only social welfare strategies and philanthropic initiatives, including charities, hospitals, disaster relief funds, drinking water initiatives, education programs, and so on. For example, in 1947 the RSS set up exclusive Hindu-only hospitals and charities. Through these types of direct social work activities building on the myth of Hindu unity and belonging, the RSS gradually gained respect in local communities.

In *Dev*, Ali Khan (Pramod Moutho) recounts a story in flashbacks that reflects his deeply personal transformation based on the compassion he received from Hindus during a riot. We also see Dev's wife, Dr. Bharati Singh (herself a victim of terrorism and loss), nurturing and administering to the victims of communal violence on both sides of the Hindu-Muslim divide. These narrative portraits of secular and inclusive charity stand in stark contrast to the Hindu-only charities administered by the RSS under Golwalkar.

Golwalkar railed vehemently against the policies of secular politics, and the religious pluralism of M.K. Gandhi (1869–1948) and the Indian National Congress (INC), who openly opposed Hindu nationalism and embraced an Indian national identity that included all religious, ethnic, caste, and linguistic communities (symbolized in the film by the roles of Dev, Bharati, and Ali Khan). Rather, the RSS was established in direct opposition to the INC to promote India as an all-Hindu nation, with the myth of Hindu unity remaining an essential RSS identity marker especially when facing a perceived (real or imagined) Muslim threat. This is the ideal promoted by Tej, Bhandarker, and Mangal Rao throughout the film.

A third strategy used not only by Golwalkar but also by other RSS leaders, and which is especially relevant to the film, is the undermining and erosion of

the Indian Constitution. By law, India recognizes the human rights of all its citizens. Yet, under the RSS, and more recently the authoritarian government of the BJP (Bharatiya Janata Party or Hindu People's Party), attacks against secular-democracy and constitutional law in the name of a populist ethnic democracy or Hindu majority are eroding the freedoms and rights of minorities. Prior to the 1980s, Hindu nationalists (e.g., Hindu Mahasabha) had no seats in government, but under the RSS and BJP, Hindu nationalism has gained a much stronger political voice with broad mainstream appeal and growing access to the pan-Indian political apparatus. By 1989, the BJP had won eighty-five seats in Parliament. One reason credited for their rise is the anti-Sikh riots in 1984 under the rule of Indira Gandhi. Gandhi's "state of emergency" and the INC's rampant political corruption led to the eventual loss of Congress seats and opened the door to the rise of the BJP under the leadership of Atal Bihari Vajpayee (1924–2018). Under Rajiv Gandhi (1944–91), Congress and its hegemony collapsed. This ushered in a new type of government that was no longer based on the INC's Nehruvian secular-socialist ideals and system of patronage for votes, but, rather, one that is based on growing membership in Hindu national identity politics.[17]

During Vajpayee's third term in office from 1999 to 2004, two major political events set off campaigns of communal violence that threatened India's tradition of secularism based on the rule of law. On December 6, 1992, the Ram Janmabhoomi Mandir Movement led by Lal Krishna Advani (b. 1927) demolished the Babri Mosque built in 1528 in Ayodhya in an attempt to restore the glory of a Hindu temple considered by many nationalists to be the site of Lord Rāma's birthplace. A *rath yatra* (chariot procession) from Somnath to Ayodhya was organized with the explicit intention of storming the mosque and dismantling it stone by stone.

Two things are significant about this event that pertain to our analysis of *Dev*. First, latent hatred and anger was unleashed that resulted in killing an estimated 1,700 and injuring 5,500 (mainly Muslims) across India over the next four months. Second, the Babri mosque is an iconic symbol of Moghul rule and power under Babar. Razing the mosque was thus a political act (as opposed to a religious act) that announced the (symbolic) reversal of foreign power and tyranny in India, as well as the reversal of (the myth of) Hindu victimhood through centuries of invasion and conquest. As such, it stands as a sign of an "awakened Hindu nation" and the consolidation of nationalist and majoritarian movements across India.[18]

The second incident that bolstered the BJP's influence is the Godhra train riots in 2002 during Narendra Modi's tenure as Chief Minister of Gujarat. There

are various theories and discussions as to why this particular anti-Muslim riot happened, including lack of economic growth, retaliation against Congress's proposed affirmative action regulations, protest against preferential treatment for minorities and SEBC (Socially and Educationally Backward Castes), economic competition, inequality, insecurity, and revenge for the destruction of the Babri Mosque in Ayodhya.[19] But, what is perhaps more germane to our analysis of *Dev* is the fact that the Gurjarat riots were not random or spontaneous, they were organized. Hindu rioters had access to names and addresses of Muslims shops and homes and they came prepared to strike. As such, we can no longer refer to these incidents as "riots"—they are something much more sinister and horrendous, as Sarkar says.[20] Although the cultural horror portrayed in *Dev* is only a fictional rendering of contemporary communal violence, it nevertheless shows how communalism is manipulated and abetted by local politicians and police (e.g., Latif (Ehsan Khan), Tej, Mangal Rao (Milind Gunaji), and Chief Minister Bandarker), how it escalates, and how it is planned. Riots, as we see in *Dev*, are also perpetrated by conditions other than conflict between religious communities to such an extent that it is often difficult to claim the communal conflict narrative is in fact communalism. As David Ludden writes, "the history of communalism cannot be reduced to the activity or ideology of any one group or one set of social, cultural, or political forces."[21]

Dev shows us how India's commitment to secular democracy and the cultural practices of religious pluralism is eroding. Hindu nationalists and their often militant exclusionist politics regard secular-democracy as a foreign or alien system. Under the allure of Hindutva, or any militant right-wing Hindu rhetoric, for that matter, *sanatana dharma* is considered the only "true secularism."[22] Muslims are being excluded, or "crushed" to use Farhaan's reference, from the body politic under Hindutva rhetoric, and planned riots, such as we see in Gujarat and *Dev*, are sanctioned by government officials. Citizenship and full human rights are reserved for Hindus only, since majoritarian nationalism sees India as a Hindu-identified nation. As Chief Minister Bhandarker says, "if Hindus in *our own* country..." Thus, Hindu nationalism's task is no longer the protection of all India's citizens, but, rather, Hindu protectionism and the legitimation of explicit forms of revenge against minority Muslims for any and all historical wrongdoing, even to the point of organized murder, as we see in Gujarat and *Dev*. As Tej says, "we must root them [Muslims] out and kill them in the streets like dogs." Or, as Narendra Modi's election campaign slogan said, *"jo Hindu hit ki baat karega, wohi desh par raj karega"* (only one/he who promotes Hindu interests will rule the country).

Cultural Horror

In fact, I coined the term "art-horror" just to make sure that people didn't think I was talking about the Holocaust, or the horrors of the 20th [and 21st] century ...

Noël Carroll

It is important to explain the rationale for including *Dev* in a book titled *Bollywood Horrors*, especially since *Dev* is not considered a horror film in the strict sense of the term. In this section, I look to American philosopher Noël Carroll who, in attempting to understand and articulate the form and structure of the horror genre, distinguishes "art-horror" from what he calls "natural horror" (e.g., climate change, the Holocaust, terrorism, and so on). Essentially, he implies that although one might be horrified by murder, murder as a stand-alone act is not a criterion for art-horror. Examples of art-horror might be a film about a murder that takes place in a haunted house, or murderers who also happen to be creepy-crawling alien monsters made of green slime. So, then, what is *Dev*? How do we classify cinematic horror when the bloodthirsty monsters (or "horrible demons," as Vivekananda says) are ordinary human beings?

I propose a new category: cultural horror, which can be considered an extension of Carroll's natural horror, but differs somewhat as it depicts, translates, and represents acts of cultural violence through an artistic medium such as film (literature, art, music, theater, dance, etc.). Although cultural horror displays elements of Carroll's art-horror classification such as "departure from the normal," it omits other criterion such as "impure monsters."[23] The consideration for making these distinctions is based on a work of art's ability to intentionally provoke the negative affect (feeling, emotion) of horror (or disgust) and terror (also referred to in Indian aesthetic theory as *bībhatsa* and *bhayānaka rasa*).[24]

If one critical feature of the horror genre is the ability of a film or work of art to create the affect of horror, as Carroll claims, then by this definition *Dev* fits into or even extends the horror genre's semantic range. Many of the "positive human" characters portrayed in *Dev*, as we will see, trigger, mirror, reflect, and identify with emotions that fall well within the rubric of Carroll's definition.[25] The events portrayed in *Dev* cause the audience, as well as Dev, the film's main protagonist, to converge in a set of shared feelings. Like Dev, we "shudder" and feel "nausea," "disgust," and "loathing" when Mangal Rao and Tej retaliate against the Muslim community at the climax of the film. We "shrink" and "recoil" from watching this graphically disturbing scene because it "frightens," "shocks," and "revolts" us. Dev's emotional response, captured beautifully in a close-up shot of Amitabh Bachchan, instructs the audience how to react appropriately. Our

emotions mirror the affective contours of Dev's on-screen visceral reactions to the cinematic events of cultural horror portrayed on the big screen. As Carroll says, in horror the positive characters in the film show us "how to react."[26]

Not only do we confront these feelings, we also experience what Joseph Grixti refers to as "bone chilling" events on the big screen. We are aware something "ghoulish" is taking place.[27] By evoking such powerful affects in the audience and the protagonists in the film, *Dev* elicits emotions akin to Carroll's art-horror. The affective responses that the audience and the film's protagonists share are consistent with many of the essential affective markers outlined in Carroll's definition of the art-horror genre. Thus, as far as I can see, what distinguishes art horror from cultural (or natural) horror is not the depth or presence of the horror affect itself, but the degree of intentional realism portrayed.

For obvious reasons, *Dev* does not fit all of the presumed conventions and categories of the theoretically regimented art horror genre. Nor does *Dev* follow, in the strict sense, Carroll's extensive definition or blueprint even though similar features appear. That is to say, we do not encounter cliché monsters, demonic spirit possession, spooky ghosts, werewolves, curses, poltergeists, jump scares, or haunted houses, though we certainly experience a haunting quality in *Dev* that I will explain in more detail later in the chapter.

Carroll also concedes that horror is "not defined by the presence of monsters."[28] We see monsters in various genres including fairy tales and science fiction. What is considered one of the essential components or preconditions of the horror genre is the presence of the "abnormal" or, to put it another way, "a disturbance to the normal."[29] The events that unfold in *Dev* depict this clearly through the human capacity for evil, and it is precisely the film's portrayal of the "abnormal" that gives rise to the horror affect, as well as feelings of frustration, terror, and disgust that are central to Carroll's definition. He writes, "horror can be conceptualized as a symbolic defense of a culture's standards of normality: the genre employs the abnormal, only for showing it vanquished by the forces of the normal. The abnormal is allowed center stage solely as a foil to the cultural order, which will ultimately be vindicated by the end of the fiction."[30]

Instead, the critical issue we find with cultural horror, and also with more recent art horror, is that the so-called "abnormal" is not (always) vindicated at the end of the film.[31] What horrifies us in *Dev* is not only the symbolic abrogation of normality, but how the normality of daily life is bracketed or suspended to such an extent that planned acts of cultural horror are executed by local government officials including the police, as if these acts of violence were the law of the land. The film's antagonists, who violate what Carroll refers to as "standing cultural

categories," terrify us because their behavior signals a radical breakdown of morality and an existential threat to secularism.[32]

Dev's depiction of cultural horror, or the "abnormal" as Carroll calls it, is not a mere fiction—it is all too real. In the film, the protagonists' hoped for defeat against the "abnormal" takes the form of a constitutional appeal to the Supreme Court of India. The protagonists fight abnormal with normal, surreality with reality, and chaos with order. Sadly, as we know, progressive ideological and socio-political rhetoric in film does not guarantee real-life manifestations of social evil will be vanquished. But what we do know for certain is that Hindi films shift perceptions in the national imagination; in the case of *Dev*, for the purpose of illuminating the critical importance of ongoing commitment to secular democracy.

To conclude, I think it is important to once again identify that in art (e.g., film, literature, theater, dance, music, etc.) there are different types of horror. Introducing the designation "cultural horror" suggests a new category and a subtle distinction that I invite others to use and/or debate. In this case study, *Dev* presents a fictional account of reality that arouses violent, fearful, and profoundly disturbing emotions that are, without a doubt, horrifying. *Dev* exposes, in an undisguised cinematic account, a horror that haunts the Indian nation. As such, it offers a complex (albeit fictional) narrative that portrays horror perhaps at its most tacit level: reality. The audience feels and experiences the horror (affect) simultaneously along with the protagonists, and they know that the chilling events portrayed on (and off) screen could happen again at any time. The horror that director Nihalani and screenwriter Meenakshi Sharma[33] make abundantly clear in *Dev* is that the fragile normalcy of secular democracy and the constitutional promise of protection and individual human rights is eroding. In its place is a nauseatingly graphic and horrific depiction of the human capacity for evil.

Film Synopsis of *Dev*

Dev tells the story of Hindu-Muslim communal violence. The audience participates in the narrative through the eyes of Joint Commissioner of Police Dev Pratap Singh, who embodies the voice of rational-secular discourse and throughout the film defends the constitutional rights of religious pluralism. His character provides the emotional axis for the audience, and his heroic sense of duty (*dharma*) and his fight against the "politicization and communalization of the Indian police," to use Nihalani's own words, structures the film's overall plot.[34]

We meet Dev in the film's opening scene, through a series of black and white flashbacks, when he is called before a police tribunal to testify why he shot a Muslim student during a campus protest. When we meet Dev again several years later in the Technicolor present, he is standing in his well-appointed Mumbai apartment performing *pūjā* with his wife, Dr. Bharati Singh (Rati Agnihotri), to the elephant-headed god Gaṇeśa and a picture of Dev's young son Armaan who, we later learn through a flashback, was shot and killed by Muslim terrorists when he was eight years old. However, at no point in the film does Dev, as a survivor of trauma, allow his grief to obscure his reason or sense of duty (*dharma*). I use the term *dharma* in this synopsis because, as we will see, Dev conceptualizes his understanding of civic responsibility not only in terms of the Indian constitution, but also in terms of the philosophy of the *Bhagavad Gītā*

Dev is a character driven film. In the next scene, we are introduced to Ali Khan and his son Farhaan Ali in their Noor Manzil apartment complex where much of the film is shot. As the camera zooms in, Ali and Farhaan discuss (and also disagree on) the state of minority communities in India. Ali remains sympathetic to *his* country's need to monitor and curtail militancy in the name of national security, whereas, Farhaan, having witnessed Muslims in India being systematically disenfranchised and the tenets of non-violence (*ahiṃsa*) that once fortified the so-called fathers of modern India eroding, expresses disillusion with his father's generation and their outmoded rhetoric. On the train home from law school, Farhaan was searched by police simply because he was seen carrying a letter written in Urdu. Not only is his father's generation's philosophy meaningless, symbolized by photos hanging over Ali's desk of M.K. Gandhi (1869–1948), Jawaharlal Nehru (1889–1964), and Khan Abdul Ghaffar Khan (1890–1988), Farhaan argues that it has all but been replaced by Hindu national rhetoric. As he says, "Muslims are being crushed only to remind them who this country really belongs to." In this scene we are also introduced to Aaliya (Kareena Kapoor), a vibrant and modern young Muslim woman who we learn is in love with Farhaan.

In the next scene, we meet the film's antagonist Tejinder ("Tej") Khosla who, as Special Commissioner and Dev's boss, presents the perfect foil to Dev. Tej is Dev's best friend. He was also very close to Dev's son Armaan and was present the day he was killed. However, unlike Dev and Bharati, Tej has not been able to forgive Armaan's death at the hands of Muslim terrorists and has turned to Hindu nationalism to deal with his grief and need for revenge. In a pivotal moment in the film Tej openly declares that his religion or "*gītā*," as he calls it, is "Shakti"—defined by Tej as "the religion of power to annihilate enemies of the

nation." This is the first time in the film that the rhetoric of Hindutva (Hinduness) is made explicit.

What becomes abundantly clear at this point in the narrative is the extent to which *Dev's* plot is driven by ideologically fractured (male) relationships. As William Elison et al. show in their analysis of *Amar Akbar Anthony*, the "fracturing of the family and the trauma that ensues is a common theme in Indian film and literature."[35] The cinematic trope of fracture, as we will see, harkens back in part to the partitioning of India when millions of people were displaced and/or killed. As Elison says, "the brokenness of families [in Indian film] can indeed be read against Partition."[36] Thus, the breakdown of family relations and friendships also reflects complex and conflicting responses to personal and collective history.

Next day at the police station, Dev receives crucial information that suspected terrorist Karim Khan will be in Noor Manzil at midnight. The police prepare an ambush. However, while apprehending Khan, his wife and young son are accidentally shot and killed. The film's storyline is quite clear that police were apprehending a terrorist who resisted arrest, but news of Khan and his family's death is manipulated by a crafty local Muslim politician named Latif who escalates communal tension and turns the Khan family into martyrs.

At a meeting of the Noor Manzil residents, Latif delivers an impassioned speech punctuated with Hitler-like mannerisms that sends the already saddened Muslim community spiraling into rage. He twists the community's loss into an indictment of police brutality, claiming innocent (minority) Muslims are being slaughtered.[37] He also cleverly manipulates the situation for his own petty political ends or, as Dev identifies further on in the film, he treats his community "merely as a pawn in vote bank haggling." In the name of the martyrs, Latif goads the local Muslim community into staging a demonstration. Ali accepts the role of leader on the condition that the rally follow Gandhian principles of nonviolent protest (*ahiṃsa*). However, Latif's gang intentionally incite the police, and Ali is accidentally shot and killed by one of Dev's policemen. Ali's death signals the end of an era.

Farhaan is grief stricken over his father's death. Seeking revenge, he turns to Latiff who sends him to a terrorist training camp. Latiff tests Farhaan's loyalty, first, by sending him on a failed mission to assassinate Dev, and then later asks him to deliver a package to the Gaṇeśa Mandir. Unbeknownst to Farhaan, his motorcycle has been rigged with explosives. As crowds of Hindus enter the *mandir* to celebrate a religious festival, the bomb explodes. One hundred and five people lie wounded or dead on the temple's steps. When Dev arrives on the scene

to assess the aftermath, he sees Farhaan holding a dying young Hindu girl in his arms.

This scene presents an ironic turning point in the narrative for two reasons. First, the carnage at the temple offers a dramatic backdrop that ultimately brings two very different people and their alien experiences together. Farhaan and Dev begin to forge a deep bond based on shared loss. Secondly, from this point on in the narrative Nihalani shows how communal violence escalates. Ali's earlier comment becomes salient, that "the real battle is not between Hindus and Muslims, or between the Muslim community and the Law—the real battle is against political greed and escalating corruption."

Local politician Mangal Rao organizes a mob of enraged Hindu men who pile into open trucks on route to the Muslim neighborhood ready to retaliate. In a clever split screen shot, we also see Dev, Tej, and Chief Minister Bhandarker meeting to discuss the need to maintain civil peace. However, Bhandarker tells Tej privately that the blast at the *mandir* has ignited Hindu passions. He says, "this rage cannot and should not be suppressed. If in *our own country* such attacks occur at our places of worship, it is natural for emotions to be inflamed. These feelings should be respected. They must be allowed an expression" (emphasis mine). He instructs Tej to ensure Dev "stands down" at the riot.

During the riot, Farhaan's girlfriend Aaliya and her best friend Shabnam witness police culpability first-hand. Police ask their names and when they learn they are Muslims they deliberately send the girls into harm's way. In a chilling scene, male Hindu rioters chase the girls through the streets to Shabnam's apartment where she is gang raped, and her mother, pregnant aunt, and younger brother are slaughtered.[38] When Farhaan arrives on the scene, he finds Aaliya— the sole survivor—in a state of shock with a dazed dissociative look in her eyes, holding a knife in her hand that like the goddess Kālī's is dripping with human blood. Outside, police arrive on the scene ready to stop the massacre. Tej orders Dev to "stand down" and let the riot proceed. Dev refuses.

Next day, Dev is summoned to Bhandarker's office to explain why he disobeyed the order. His explanation rests with the law. He says, "Using the powers given to me, I did what I thought was right. Breaking people into factions is beyond my duty." The law, as he understands it, is blind to caste, community, gender, and religious differences: all are equal before the law. Thus, he takes his orders not from Tej or Bhandarker, but, rather, from the very institution he took an oath to uphold and defend—the Indian Constitution.

As we reach the film's climax, Mangal Rao leads one final premeditated act of savagery. An armed horde of enraged Hindu rioters light pre-made wooden

torches with kerosene and chant their *mantra*-like battle cry "*Har Har Mahadev*" as they lock the residents of Noor Manzil inside their apartments and torch the wooden building to the ground, knowing full-well no one can escape. Dev arrives, but Tej, at the behest of the government, ensures the cold-blooded massacre is not interrupted and Dev is ordered to "stand down." Once again he refuses, shouting "To hell with your orders!" He commands his police officers to open the apartments as hundreds of burning men, women, and children jump to their inevitable deaths. The graphic realism of the scene is horrific. Upon returning home from the premeditated massacre, with a look of sheer horror on his face, Dev says directly into the camera: "The stench. People burning alive. God, that smell of bodies consumed in flames [*agni*]. Flesh, bones, eyes, faces. And, the screams. Soul-rending screams. Burning women, burning children, small innocent children... and that smell. Before my very eyes."

The very next day, Dev prepares a detailed legal brief with Farhaan's help that chronicles the local government's full complicity in the massacre. As Dev arrives to testify before the Supreme Court, Tej has him assassinated on the courthouse steps. In the film's final scene, as his body is being cremated, Dev delivers a voice-over soliloquy to his family (and the audience), including Farhaan who has officially taken the role as his surrogate son signified by his lighting the funeral pyre. He says:

> A man really dies the day he sees injustice and stays silent. The question is not whether I may win or lose—or even whether I live or get killed—the question is whether as a police officer am I doing my duty [*dharma*] or not? As a human being, am I fighting for truth or justice or not? Life is a battlefield. Facing victory or defeat a soldier's duty is to fight. The meaning of life is to struggle continuously for truth and justice. That is all.

This extremely important soliloquy echoes the teachings of the *Bhagavad Gītā*. Set on Dharmakṣetra or the field of law, at the climactic moment just before the Mahābhārata war, Kṛṣṇa likewise tells Arjuna, "Look to your law and do not waver."[39] Kṛṣṇa's instructions to Arjuna resonate when Dev says to his family, and the audience, "stand up" and "fight." However, throughout the entire film we hear the opposite each time Tej and Bhandarker command Dev to "stand down." In other words, *Dev's* closing thoughts direct the audience and the film's central characters to the *Gītā*'s moral universe, rather than the inverted (and, at times, perverted) new-*dharma* of Hindutva politics and governance. Director Nihalani uses Hindu religion and Indian nationalism, as well as the affective *rasas* of horror and terror, to challenge Hindu nationalism and show that Hindutva is an

abnormality—a breakdown of earlier Hindu tradition rather than its fulfillment. As viewers, we too are called upon to contemplate the message of the *Gītā*, the meaning of our actions, and the problem of communal and ideologically driven violence. By illuminating these horrific, grotesque acts the film becomes a powerful social commentary on Indian secularism and the fight for "truth and justice," which are gradually slipping away.

Theorizing Cultural Horror in *Dev*: Fanon, Arendt, and Freud

Violence is not a simple act of will, but needs for its realization certain very concrete preliminary conditions.

Frantz Fanon

A political community that constitutes itself on the basis of a prior, shared, and stable identity threatens to close the spaces of politics, to homogenize or repress the plurality and multiplicity that political action postulates.

Hannah Arendt

In spite of his present happiness, he cannot banish the memories associated with the mysterious and terrifying death of his beloved father.

Sigmund Freud

Sadly, the narrative portrayed in *Dev* echoes the all too real-life cultural horror Indians face as a consequence of religious, social, and ideological confrontation stemming, in part, from Indian colonialism, Independence, Partition, and the rise of Hindu nationalism. The failure of nationalism and the myth of national unity that we discussed earlier perpetrates epistemic violence in many colonized nations. Frantz Fanon (1925–61) claims that the deficiencies of the middle class, who essentially took over the role of rulers at the end of the colonial period, are responsible for the unrelenting carnage and mass slaughter we see.[40] In India, national leaders (e.g., Nehru and Jinnah) hurried the process of self-rule and separatism in order to gain access to power, and in their haste (or perhaps self-interest?) made strategic errors that ultimately resulted in Partition—a fatal event that some argue could have been averted.

Fanon helps us understand that violence, or "blood and anger," is inherent not only in colonization and decolonization, but also in the newly invented post-colonial, independent, nation-state or "imagined community."[41] Although decolonization clearly set out to change the world order, it turns out to be a "program of complete disorder."[42] As Fanon puts it, the masses who were called

upon to "fight in the name of freedom and religion during this uprising," continue the "divisive fighting spirit" well after nationhood and independence is established.[43] We see this "divisive fighting spirit" depicted in the Hindutva rhetoric in *Dev*, and in a cluster of films that articulate the themes of Partition and communal violence, including *Garam Hawa* (Hot Winds, dir. Mysore Shrinivas Sathya, 1973), *Tamas* (Darkness, dir. Govind Nihalani, 1988), *Bombay* (dir. Mani Ratnam, 1995), *Train to Pakistan* (dir. Pamela Rooks, 1998), and *Black Friday* (dir. Anurag Kashyag, 2004), to name a few.

Fanon also explains that the mass violence that occurs as a result of severing from colonial rule is typically perceived in mythic terms as a "cleansing force."[44] In *Dev*, Tej, Mangal Rao, and Chief Minister Bhandarker unite in their (unlawful and illegitimate) use of violence or "cleansing force" at the film's climax. Every time Tej orders Dev to "stand down," or when police intentionally point young Muslim women toward a Hindu mob, the "cleansing force" is being invoked by Hindu nationalists. The "cleansing force" that Fanon identifies mutates from a myth into a type of aspirational project that enables Hindu nationalists to recover the Hindutva ideal of an undivided all-Hindu homeland. When Tej says "bring them [the Muslims] out into the streets and shoot them like dogs" we see how the "cleansing force" is imposed—not to uphold the law, but rather to subvert it.

The "cleansing force" springs from the desire for revenge or, to use Fanon's words, "my blood calls for the blood of the other."[45] We see this both literally and figuratively throughout the film. For example, Tej seeks revenge for Armaan's death at the hands of terrorists, so his interrogation of Farhaan is excessively violent. Revenge for Ali's death turns into a failed attempt on Dev's life, and a blood bath outside the Hindu *mandir*. Revenge for the bomb blast at the *mandir* results in a well-executed pogrom at the end of the film as innocent Muslim men, women, and children are burned alive.

And if this isn't gruesome enough, Fanon explains that the real horror lies not in the quest for revenge, but in the realization that generations of Hindus, whose families struggled to attain freedom and independence from colonial rule, have internalized the discourse of oppression—the very condition they fought so hard to overcome.[46] Fanon writes: "the native militant who confronted the colonialist war with his rudimentary resources realizes that while he is demolishing colonial oppression he is directly building another system of exploitation. Once it was all so simple, with the bad on one side and the good on the other," but now the truth surfaces—the Hindu who was once the exploited "other" or colonized subject, has now become "the exploiter."[47] One chant we

hear repeated by RSS boys conveys this idea clearly: "*ek ka badla sau milenge*" (we will revenge one death with a hundred).[48]

The colonial world, as Fanon puts it, is a world "divided into compartments."[49] The brush of communal color that Dev fights against throughout the entire film paints a racially divided 'us' versus 'them' world that is, as Fanon says, "cut in two."[50] The minority Muslim "other" is depicted in *Dev* by the voices of the majority Hindu right as "evil," "the enemy bastard," "a criminal," a "fanatic," a "betrayer," a "dog," and a "terrorist." In other words, Muslims are dehumanized and made to feel inferior. They become a repository, as Tej's character suggests, for all that is negated by the ruling Hindu majority.

In *Dev*, as in the real-life struggle against Hindutva politics, we also witness what Fanon refers to as "the gradual erosion" of the intellectual structures built by the "bourgeois colonialist environment."[51] I characterized this earlier as an example of the erosion of the Indian Constitution or the rule of law. As the film progresses, Dev and the audience become keenly aware how utterly powerless we are to change the deep social divisions that exist, or halt the mass murder of innocent men, women, and children at the climax of the film. All power lies with the totalitarian state, which negates not only the (Muslim) enemies of the nation, but also its founding institutions—secular democracy and religious pluralism. These are the very institutions Dev defends with his life.

Dev's murder at the end of the film, as well as Ali Khan's at the beginning of the film, are an extremely important comment on the current state of the Indian secular nation. When Dev is assassinated, the legal brief he prepared falls to Farhaan as his surrogate son and the voice of morality and secular democracy. Yet, there is no closure at the end of the film. It raises the question: Is secular democracy still possible for India, or are Dev and Ali's deaths a sign of the collapse of tradition and the rise of a new totalitarian era of increasing hate and terror? Fanon's approach to culture allows us to examine these questions under the lens of racism, as an evil that is ubiquitous in almost every society. If we look through this lens, we begin to wonder how ideological violence could ever be avoided.

Next, political theorist Hannah Arendt's (1906–75) prescient work on totalitarianism and the politics of evil helps to explain the cultural horror depicted in *Dev*. Given that the Holocaust is often referred to as the primary trauma of the modern era, Arendt's considerations are very useful. Her thesis on the "banality of evil," now widely applied yet also acrimoniously and hotly debated, seems fitting to our analysis of the narrative of Indian communalism presented in *Dev* for many reasons including the (misplaced) admiration and reverence Hindutva pioneers had for Hitler and Nazi Germany's Final Solution.[52]

After considerable deliberation, Arendt concludes in her still deeply controversial book *Eichmann In Jerusalem: A Report on the Banality of Evil* that Nazi Germany's Adolf Eichmann, who was responsible for engineering the mass deportation of Jews to extermination camps during the Second World War, was "not a monster."[53] Arendt characterizes Eichmann as "diligent," lacking in imagination," a "clown," and "terribly and terrifyingly normal."[54] Arendt is (perhaps) correct in identifying that Eichmann was not a "sadist or killer by nature," but like the many Nazis who "became murderers" he did his duty according to the "law of the land."[55] Thus, what is controversial and profoundly disturbing about Arendt's argument is that she portrays Eichmann as a "law abiding citizen."[56]

In *Dev*, ostensibly law-abiding citizens and recognized government officials (e.g., Tej, Bhandarker, Rao, the police, etc.) perform and sanction horrific crimes against humanity in the name of Hindutva. Chief Minister Bhandarker's ultimate refusal to uphold the law empowers ordinary citizens to act as sadists, criminals, rapists, and murderers. That is, Bhandarker authorizes murder, rape, and looting when he suspends Muslims' constitutional rights and allows inflamed Hindu passions "an expression."

Dev's refusal to obey orders to "stand down" at two critical junctures in the film challenges the mandate of the local government (while also reinforcing Arendt's central argument that communal mobs are acting as law abiding citizens). However, unlike the case of Nazi Germany, the scenes depicted in *Dev* are an aberration, and though certainly not unprecedented they are ultimately criminal in nature because they do not accord with Indian constitutional law. There is criminal intent in the government's execution of the massacre though, as evidenced by Dev's police investigation and Aaliya's attempt to identify the culprits, no charges are ever made because the crimes took place, as Arendt submits, under a "legal order."[57]

The "legal order" in *Dev* and during the actual Gujarat riots issues from Hindutva ideology, strengthening Arendt's argument that politics in the modern world is built on deception and lies, with the most brazen lie of all being the totalitarian state rewriting history. The rewriting of history, as Arendt says, "not only denies the history of the past but also moves forward as the creation of an entirely fictitious world."[58] In other words, lies that once served a political agenda "replace history altogether" and begin to appear as "true history." In *Dev*, the lies and agendas endorsed by local politicians do not serve the local communities they represent, but rather their own petty political self-interest.[59] Through organized propaganda and mythic social histories, the architects of Hindutva create layers of cultural horror *vis-a-vis* minorities when they refashion, manipulate, and execute their narrowing version of reality.

Dev, however, unlike Eichmann, refuses to be lulled into blind or unquestioning obedience.[60] As the film's voice of reason, he defends the institutions of modernity (democracy, pluralism, secularism) when he dares to "stand up" and fight for his *gītā*. It is this very challenge to authority that eventually costs him his life on the courthouse steps. Nevertheless, he clings to the Constitution. What is implied at the end of the film, even though Nihalani leaves it open to audience interpretation, is that monsters and horrible demons who trespass against secularism and democracy will be brought to trial. The prescripts of Dev's religion or *gītā* and the manifestly unlawful orders that he encounters demand, as Arendt proclaims, a deliberate refusal "to collude in the abnegation of moral and legal authority."[61] We referred to this earlier in our discussion of Carroll's markers of the horror genre.

Cultural horror lies in the very fact that Eichmann *per se* was not a monster, but rather the "banality of evil" that Arendt sees in him was "human, all too human," as Nietzsche has it. The demonization of Muslims in *Dev* is also "all too human" and, as Sarkar would probably agree, "terribly and terrifyingly normal."[62] In *Dev*, Bhandarker too easily appropriates the police and turns them into an ethnic-identified force of "muscular Hinduism" that advances the populist ideology of Hindutva. Over decades of Hindutva racist rhetoric seeping into public discourse, it seems the perpetrators of riots and pogroms have become anaesthetized against "one's elementary sensitivity to the others' suffering," just as Arendt shows in the case of Eichmann.[63] In Nazi Germany, "the law of Hitler's land demanded that the voice of conscience tell everybody: "'Thou shalt kill!'"[64] Such terrifying moments when muscular groups rise up in honor of extreme national ideologies mark (almost) every kind of history and mythology we know. What does this say about human nature?

While the events portrayed in *Dev* are emphatically not those of Nazi Germany, during the Gujarat riots they come close, if not in scale, then in cruelty. By his own admission, Tej's ideology is informed by Nazi literature, as is Savarkar's, Golwalkar's, and other Hindu nationalists. Tej sees the state as a natural way to carry out genocide. Wearing a police uniform shrouds and legitimates the governments ethnic cleansing agenda. It also protects one's actions from being perceived as criminal. According to Sarkar, "Gujarat became a testing ground to see how much tolerance there is for genocidal behavior."[65] In retrospect, it appears there is a great deal of tolerance considering that Narendra Modi, Chief Minister during the actual Gujarat riots, later became Prime Minister (in 2014 and 2019) with an elected and reelected majority government.

Another relevant point Arendt makes is that once such cultural horrors happen, it is likely that they can and will happen again. In *Dev*, we see precisely

what Arendt is saying—there is "no deterrence to prevent them [e.g., communal riots, pogroms, genocide, ethnic cleansing, etc.] if the law is behind them."[66] The totalitarian agenda to eradicate or exterminate whole groups of people, particularly in Nazi Germany, became normalized. So, even though Sarkar argues earlier in the chapter that something "new" is happening when the Hindu Rashtra is mentioned in conjunction with the Gujarat riots, a level of brutality was unleashed that, I would sadly argue, is not altogether new. Nazis engaged in propagandist and violent partisan rhetoric in order to mobilize Germans based on the myth of "common blood." We see this myth, as I have shown, being used by the architects and advocates of Hindutva. The Nazi fight against inferior races is the same stance taken in the film by the characters who espouse the voice of Hindutva. For them, it is a moral fight against threatening foreigners and outsiders (*mlecchas*, in Golwalkar's words) who humiliated Hindus through invasion, colonization, partition, terrorism, and so on. *Dev's* story is set against the real life rise of anti-Muslim practices that have not only increased but, as Sarkar says, have become even more horrific. Thus, Arendt's theory of social evil foreshadows this new world stage of authoritarianism when she claims there is an increase in brutality with each incident of terror.[67] Although Arendt does not use the term "cultural horror" explicitly, she does explain it in the broader context of human nature, which is disquieting in its visceral resonance.

My third and final point derives from Sigmund Freud's (1856–1939) theory of the "uncanny" and also Bhaskar Sarkar's study of trauma and cinematic mourning.[68] Sarkar writes that the Partition of India in August 1947 was "a bloody and protracted affair that tainted the euphoria of freedom [from colonial rule] with a profound sense of loss."[69] The violence and trauma that lie at the root of colonial occupation and decolonization are absorbed and rerouted into murderous communal riots during and after the Partition of India. According to varying estimates, somewhere between 200,000 to one million people were savagely murdered in riots that broke out all over north India following Partition. Between seven and twelve million refugees fled their homeland in search of safety and refuge, either in India or Pakistan. Yet, as Sarkar explains, under Prime Minister Jawaharlal Nehru's newly formed government the "exigencies of nation building required a collective disavowal of this loss leading to an inability to mourn."[70] Thus, the overwhelming social trauma of Partition remains a painful wound that continues to fester until today in the consciousness of the Indian nation as "the uncanny."

Sarkar explains that the extreme brutality perpetrated during Partition is generally viewed by Indians as "an aberration within an otherwise harmonious tradition."[71] That is, as something "abnormal," a trait identified earlier in the

chapter as one of Carroll's key markers of the horror genre. But, as we also have shown, the violence that we see at the end of colonialism is all too familiar in nations that were cut into compartments by British divide and rule administrative practices. The human atrocities perpetrated during the bifurcation of India into India and Pakistan are not an aberration as such, but rather a horror that returns (again and again) to haunt the Indian nation in the form of communal riots. *Dev* is one of a cluster of cinematic portrayals that triggers the horror affect as the audience and on-screen protagonists witness a fictional reenactment of the so-called "original event." The looting of shops, raping of women, mutilation of bodies, arson, moral collapse, and the grotesque forms of murder that we see on screen trace back to something familiar that has been repressed, as Freud explains in his famous 1919 essay on the "uncanny" (or *unheimlich*).

Citizens of the newly formed Indian nation-state cannot simply "banish the memories" associated with the cultural horror of Partition—especially since under Nehru's newly formed government their latent memories have not been properly mourned or addressed. As Freud knows, unresolved feelings have an uncanny effect that arouses "the compulsion to repeat." He writes, "the compulsion to repeat is powerful enough to overrule the pleasure principle, lending to certain aspects of the mind their daemonic character."[72] The "compulsion to repeat" and the "daemonic character" that these memories elicit overpowered the celebratory era of Independence that was ushered in, and also fostered a receptivity toward Hindu nationalism and ethnic democracy that has resulted in the human enactment of communal violence. Freud questions whether these memory-driven behaviors are a type of "possession" or even a sort of "fate" that is outside of one's control. Thus, we also must ask to what extent the "uncanny" in India is a recurring national and/or collective uncanny.[73]

From a Freudian perspective, the "social foreclosure of grief," as Sarkar calls it, under Nehru's newly formed government after Independence thus surfaces as the "uncanny." Hindu rage is expressed against Muslims "as the group responsible for the lost object."[74] That is to say, Hindu rage is tied to the belief that Muslims are responsible for ravaging the land, the catastrophic loss of human life, and the Partition of the Motherland (Bharat-ma).

Uncontrollable repressed rage also explains why the cruelty enacted on the bodies of women during communal rioting is particularly horrific. Hate and ethnic rancor is inscribed in a perversely sexualized way—as female victims of communal violence are frequently (gang) raped, mutilated, and dishonored.[75] Women's violated bodies become the living indexes of communalism. Though Aaliya plays a secondary role in *Dev*, her character bears witness to the suffering of the victims of

violence during communalism. Not only is she a symbol of the many thousands of women whose bodies have been violated, mutilated, and tortured during communal violence, she is also the "voice" that cries out from the wound, as trauma expert Cathy Caruth explains.[76] Yet, in a pivotal scene when Aaliya courageously comes forward to tell her story as an eye-witness, she is silenced.

Freud's theory of the uncanny provides a critical theoretical backdrop for our discussion of cultural horror in *Dev* because it explains how we are haunted by what we have repressed, or in the case of modern India after Partition by what we have not had a chance to mourn. Unassimilated and unresolved traumatic memories recur as ghosts, or in modern India as the ghosts of Partition. Freud writes, "this uncanny is in reality nothing new or alien, but something which is familiar and old—established in the mind and became alienated from it only through the process of repression. This reference to the factor of repression enables us, furthermore, to understand the uncanny as something which ought to have remained hidden but has come to light."[77] Thus, we can understand people's reluctance to remember the horrors they live with.[78]

As Freud relays Jacques Offenbach's story of "The Sand-Man" who tears out the eyes of children as an example of the uncanny, similar feelings of the uncanny are aroused in *Dev* as the "dread of him [i.e., the "Other"] became fixed in his heart."[79] Freud does not differentiate between the uncanny in art or in life, what Carroll refers to as art horror and natural horror. Whether it is a fictional example drawn from Offenbach's *The Tales of Hoffman,* Nihalani's portrait of communal violence in *Dev,* or the real-life communal riots in Gujarat, Freud's *unheimlich* "belongs to all that arouses dread."[80] This includes the various elements Carroll employs to frame his philosophy of horror (e.g., graveyards, ghosts, haunted space, monsters, etc.), as well as individual and collective repressed memories produced from unconscious moments of cultural horror (real or imagined). In art as in life, the sense of dread that arises from phantom horrors is thus projected onto the "other." By using Freud's psychoanalytic understanding of the uncanny to observe *Dev*, we realize that the mirroring and melding of cinematic horror and real-life violence is not new, but a tactic in aesthetic movements throughout much of history to highlight how disquieting and surreal our instincts as humans can be.

Summary and Conclusion

I argued in this chapter that contemporary communal violence against Muslim minorities in India, and in *Dev,* is a case of recurring cultural horror enacted in

part because, as Bhaskar Sarkar claims, post-Partition Indians were not allowed to grieve. As Freud and Sarkar suggest, the repressed memories of Partition haunt the Indian nation. *Dev* and other films about Partition and communal violence unveil the persistence of the uncanny in art and also offer extensive and meaningful reflection on this provocative subject. The visceral feelings of the uncanny that we experience in *Dev*, that is to say, the horror that comes with the collective unleashing of repression, the "uncanny," or the "affect of horror" is aroused by our identification with the positive human protagonists Dev and Farhaan (as well as Aaliya, Ali Khan, and Dr. Bhrarati Singh). This calls us to create a new category of cultural horror in film mediation that is not ambiguous or dislocated from the context it loosely portrays.

Also, the "haunting" that Fanon gestures to in his discussion of colonization and decolonization is reiterated by Jacques Derrida in *Specters of Marx* when he writes, "haunting belongs to the structures of every hegemony."[81] What Fanon claims, and what Derrida makes explicit, is that "hegemonic power—the dominance of one group over another—is structured around ghosts."[82] So the question that Derrida asks is how do we "learn to live with ghosts?"[83] In *Dev*, communal riots are triggered not only by the ghosts of Partition, but also by Muslim othering, by Hindutva's crushing hegemonic binary rhetoric, by the petty greed of local politicians, by vote bank haggling, by terrorism, and by the myth that India somehow belongs more to Hindus than to Muslims. Although ghosts are usually immaterial and visually non-existent, they nonetheless structure the lives of the nation (e.g., in terms of trauma, social memory, patterns of history, myths, stereotypes, socio-economic inequality, communal riots, etc.). Thus, as I have argued, an explicit relationship between nationalism (past and present) and the uncanny (or "hauntedness") appears in *Dev* as cultural horror.

In *Violence and Personhood in Ancient Israel and Contemplative Contexts*, T.M. Lemos claims the process of dehumanization and the erasure of subjectivity that is required to perform horrific acts of violence is not unique to any one context or peoples. Obliterating the lines of personhood it seems is a necessary and universal strategy before engaging in egregious acts of violence. Elaine Scarry writes, the way is not "through war," but rather through "the suspension of civilization."[84] As we have shown in this chapter, this is precisely what happens in *Dev* when Chief Minister Bhandarker withholds police protection so that enraged Hindus can have their revenge. When Tej tells Dev to "stand down," he is in effect sanctioning the withdrawal of Muslims' constitutional rights on behalf of the local government and permitting a level of planned violence to occur without punishment or retribution to (Hindu) rioters. As we have shown, the erasure of

Muslim personhood and subjectivity is linked directly to the unlawful attempt by the government to attribute superior status to Hindus written into the Hindutva worldview. Hindu privilege and rights are tied to their perceived social dominance and the erasure of Muslim subjectivity (e.g., Tej likening Muslims to "dogs").

We have also shown that what horrifies us in *Dev* is the (mis)treatment of Muslims during the suspension of law and order by Bhandarker's government. The abnegation of normalcy is not only sanctioned, it is legitimated, rationalized, and enforced over and above the constitutional rights of minority citizenship. Thus, the "abnormal," symbolized in *Dev* by the erosion of constitutional law, is allowed center stage, as Carroll states in his discussion of the horror genre, solely as a foil to the cultural order, or in *Dev* until secular democracy is defended and restored. Yet, we also see in *Dev* that communal violence is not always communal in nature, but, rather, is often opportunistic exploitation by petty local politicians who take advantage of the existing communal/caste issues on both sides of the Hindu-Muslim divide.

As an expression of the uncanny, *Dev* plunges us into a gruesome narrative that arouses feelings of cultural horror and dread through scenes containing graphic realism and extremely frightening images of communal violence that include terrorized bodies, innocent victims including children being burned alive, and the gang rape of women. The question as to why India must write itself as haunted relates to its social and political history of colonization, decolonization, and partition. As we have shown, the portrait of Muslims as the threatening "foreign other" allows powerful Hindus nationalists like Tej, Rao, and Bhandarker to demonize, dehumanize, and find ways to erase them from Indian history. Yet, the cultural horror that is aroused because of underlying repression, which Bhaskar Sarkar identifies as the "social foreclosure on grief" after Partition, returns again and again.

Here we showed that the uncanny traces back to something familiar that has been repressed, or what Freud refers to as "the return of the dead." We are doomed to repeat what we have repressed unless the frightening elements are reconciled and addressed. Sarkar's thesis that Bollywood films can be a "cinematic mediation to aid in collective mourning" is an important rationale for including *Dev* in our study of Bollywood horror. Collective memorialization and acknowledgement did not happen in India. We see few if any national memorials or monuments to the victims of Indian Partition.[85] Thus, *Dev* belongs in an archive of truth and reconciliation to show how communalism is linked to the transmission of Indian memory, and why the politics of contemporary communalism are deplorable. The rhetoric of racial inferiority that is behind the growing solidarity of Hindu

nationalism, portrayed by Tej and Bhandarkar's on screen characterizations, is a myth operating as a social message to destroy minorities through a world of fear and hatred. But this worldview is nothing like the message *Dev* leaves us with at the end of the film that tasks each and every person with the responsibility to stand up and fight for truth and justice. If violence, racism, and terror are not only social norms but also elements of human nature, then we must not give up, but, rather, work even harder. We must see cultural horror and violence in art not as a symbol of doom, but as a wake-up call—a megaphone, a ground zero, a prodigal moment. Peace, if not natural, must then be our new social construction.

7

Bandit Queen, Rape Revenge, and Cultural Horror

Morgan Oddie

Introduction

The film *Bandit Queen* (1994, dir. Shekhar Kapur) is not an obvious inclusion for an anthology on Indian horror films. It was controversial in India at the time of release, largely for the graphic depictions of rape and violence. The cinematic portrayal of the horrors is based on the real-life story of Phoolan Devi. The filmmakers' emphasis on truth in the portrayal was accompanied by an assertion of their right to revise the story as needed, regardless of Phoolan's protestations. As a subaltern subject, Phoolan experiences the double-bind of the production and representation of her story. Her existence is needed to authenticate the story as truthful and worthy of audience consumption. At the same time, she is silenced in favor of the storyteller's agenda. Her truth becomes less relevant when it contradicts the constructed story, yet this story is sold on the basis of truth. In attempting to draw attention to caste and gender-based oppression, certain conflict threads were emphasized in the film at the expense of more complicated events. The numerous rapes of Phoolan in the film contribute to a specific version of her as an avenging woman. Her transformation into a figure for retributive justice is thereby circumscribed in a rape revenge narrative, limiting the subversive potential of her story, and undermining her agency as a successful dacoit. This is how I read *Bandit Queen* as horror in multifaceted ways. Firstly, rape revenge as a narrative structure merits *Bandit Queen*'s consideration as a horror film because of the bodily violations it is premised on. Women's subjective experience of violence qualifies in and of itself as horror, and the representation of that in film expands what we might superficially think of the horror genre. Secondly, the caste and gender-based oppression experienced by subaltern subjects is also horror. Birth and subsequent socialization into caste and gender

are marked by an inescapability of corresponding cultural horrors, a trope employed in many generic horror films, but read specifically within both the Indian context and the international reception of this representation. Lastly, and most alarmingly, the real-life violation of Phoolan Devi's consent in the cinematic portrayal of the film adds an additional element of horror to this film. These elements combine to make an analysis of *Bandit Queen* a relevant inclusion in this collection.

This chapter will first explore what rape revenge is as a narrative structure and how it functions as horror on the basis of women's bodily violations. I will then examine competing claims of 'truth' in *Bandit Queen*, emphasizing how it was expressed by filmmakers and Phoolan Devi's own accounts and objections to the film. The over-simplification of caste conflict and oppression in the film, among other cinematic strategies, has been criticized as pandering to international tastes. While the film experienced a successful run in international film festival circuits, it was also domestically popular. The international and domestic success means that the film experienced a wide range of audiences, and a number of different interpretations. In this chapter, I have attempted to take the varying audiences and filmic readings into account in my analysis of *Bandit Queen*. I situate rape revenge films and their international appeal by exploring Indian films, as well as early films from the West that helped define the narrative structure and generic features of rape revenge in the 1970s and 1980s.[1] In doing so, I highlight that the cultural horror depicted in this film is multifaceted in both its location in the filmic genre, as well as the implications for the production of a biopic of a living and marginalized subject.[2] That is, while a defining feature of horror may be its capacity for social critique, *Bandit Queen* has a unique positioning of being a supposed biopic of a living subject who experienced real-life horrors, that in turn were compounded by filmic and non-consensual representation that drew on rape revenge tropes for audience appeal.

Film Synopsis

Bandit Queen begins with eleven-year-old Phoolan Devi as she is married against her will to much older widower, Putti Lal. As a member of the low Mallah (boatmen) caste and one of six children, Phoolan's impoverished family was eager to be rid of their defiant daughter. Taken as a child to her new husband's village, Phoolan is mistreated by her mother-in-law, raped by her husband, and experiences caste-based discrimination by others in the village. Phoolan

(portrayed by Seema Biswas as a teenager and adult) runs away and returns to her natal home with a disgraced reputation only to experience more violence at the hands of higher caste Thakurs in her village in Uttar Pradesh. She is framed for a crime, raped by policemen, and then bailed out by Thakurs who expect explicit sexual favors in return. First banished to live with her cousin Kailash, she returns home after a dispute with his wife. Her refusal and general disruption of the social caste-based order of village life leads to Thakurs orchestrating her kidnap by a gang of dacoit bandits. There, she befriends Vikram Mallah (portrayed by Nirmal Pandey), the only man who treats her with any respect. After Phoolan is raped by the current gang leader, Babu Gujjar, Vikram kills him and seizes interim control of the gang. Under Vikram and Phoolan's leadership, the gang targets their banditry at redistributing wealth from higher to lower caste people. Vikram is then murdered in betrayal by the recently released Lala Ram and Sri Ram brother gang leaders. They take Phoolan hostage to be gang raped and beaten. After her escape, she forms her own gang to take revenge on the brothers and is the primary agitator in the Behmai massacre of twenty-two Thakurs. After eluding police capture for a while, the film concludes with her surrendering to the police and being taken to prison for her crimes.

Rape Revenge as Horror

One of the primary criticisms levelled at the film was by feminist critic Madhu Kishwar, who argued that director Shekhar Kapur went so far in distorting Phoolan's story so as to fit it into a formulaic rape revenge narrative.[3] There is some disagreement as to what this formula is, but this critique largely invokes the singularity of narrative structure where someone is raped, and that action becomes the motivating—and not incidental—source of their revenge, either by the victim of the assault or someone else on their behalf. In these films, rape is not just a plot device; it is central to the transformation of the characters.[4] My comparison between *Bandit Queen* and other rape revenge films is not to contend with Hollywood hegemony especially since the Western rape revenge films I discuss are primarily B-horror films outside of the mainstream Hollywood structure.[5] I also do not want to gloss over the complexities involved in a cross-cultural analysis of the depiction of sexual assault.[6] Instead, this discussion of rape revenge is predicated on the language of Indian critics of the film. Additionally, *Bandit Queen* is also consumed internationally as an Indian example of rape revenge.[7] As scholars like Jyotika Virdi and Lalitha Gopalan point out,

there is an Indian cinematic history of avenging women (see, for example, Chapter 5 in this book). Virdi asserts that avenging women narratives are most prevalent in the "woman's film genre" that are characterized by female protagonists.[8] Gopalan similarly groups these films as the "avenging women genre," paralleling B-list Western rape revenge films and noting how important genre is for standardized narratives and audience expectations.[9] Because multiple narrative threads and genre features are common in mainstream Bollywood films, Uma Maheswari Bhrugubanda and other scholars of Indian cinema argue that the logic of Western genre distinctions does not apply to Indian cinema.[10] Even if this is true, given the international circuits of production, which will be discussed in more detail later in this chapter, a discussion of genre in terms of cinematic consumption is pertinent to this analysis.

There is considerable disagreement on the genre placement of rape revenge. Without falling into the long history of genre and sub-genre defining in horror film studies, I will briefly contextualize the major perspectives on rape revenge. Carol Clover and Barbara Creed position rape revenge as a horror sub-genre,[11] while Jacinda Read and Alexandra Heller-Nicholas argue that it is not a genre at all, but rather a narrative structure found in a wide range of genres.[12] Though she disagrees with Clover and Creed's reading, Heller-Nicholas states it is easy to understand why themes of rape and their accompanying graphic and violent depictions are automatically relegated to horror, precisely because rape is horrifying. Conversely, Claire Henry proposes that rape revenge is a genre itself and argues that this is an important distinction because it makes it worthier of attention and analysis.[13] Henry's argument seems to succumb to parochial opinions about the limitations of horror, but because horror as a genre itself is both worthy of study and centrally motivated by social critique, these types of distinctions seem unnecessary for analytic purposes. I think that Linda Williams is helpful here, as she describes horror as the affective sensory and emotional experience and response of the audience as much as it is about the crisis of filmic bodies.[14] Although Williams extends this argument to other "body genres" to include drama and pornography, it is the fear jerking response of horror that this analysis of *Bandit Queen* is most concerned with. So, if visceral spectator response is a marker of defining horror, and rape and its depiction is horrifying, then at risk of oversimplification, rape revenge ought to be read as horror on this basis. Defining horror, Robin Wood argues that one of the core characteristics is that "normality is threatened by the Monster."[15] Further to this, Read argues that because rapists are frequently normalized in rape revenge,[16] there is often no identifiable monster, making it seemingly more difficult to define many rape

revenge films as horror from a cursory glance. I think that this unnecessarily limits the possibilities for monstrosity in film. In *Bandit Queen*, the context that produces Phoolan Devi's oppression is simultaneously normal and monstrous. The monstrosity is in the normalization. The raped female body is not an aberration of normalcy but occurs under monstrous conditions. While it could be argued that *Bandit Queen* is generically hybrid, much in the same way that many Bollywood films are, I see this film as part of Indian horror film canon, guided by a rape revenge narrative structure as a partial but not sufficient condition for its inclusion.

Though revenge can be undertaken by a loved one, it is typically more satisfying for the viewer when the avenger is the woman—and it is almost always a woman—who experienced the rape.[17] Clover argues that this is because of the spectator's empathetic position with the rape survivor.[18] Writing about *I Spit on Your Grave* (1978, dir. Meir Zarchi), Clover says, "all viewers, male and female alike, will take Jennifer's [the rape survivor's] part, and via whatever set of psychosexual translations, 'feel' her violation."[19] This identification is thus necessary for the spectator to empathize with the revenge, which is typically at least as graphic as the depiction of the rape. For example, *Zakmi Aurat* (Wounded Woman, 1988, dir. Avatar Bhogal), thought to be inspired by *I Spit*, visually locates the castrated male body analogously to the raped female body to escalate this horrific empathetic cross-gender identification.[20] Feeling and empathizing with the raped avenger elicits the embodied visceral reaction that Williams refers to. In this way, rape revenge enacts a type of body horror. Ronald Allen Lopez Cruz argues that body horror is a type of "biological horror" by manipulating normal bodily states and playing on the fear of the body and its potential destruction.[21] Although Cruz focuses on monstrous bodily hybridities and metamorphoses, I argue that the characterization of body horror aptly describes the depictions of rape in *Bandit Queen*, and many other rape revenge horror films because of the potential threat of destruction of women's bodies. So, rather than body horror in the way it's conceived of in threatening a universal body, this is a particularly gendered conception of destructive threat and body horror.

The Last House on the Left (1972, dir. Wes Craven) is largely credited with popularizing rape revenge,[22] and displaces the onus of revenge onto loved ones. When their teenaged daughter is raped and murdered by a brutal gang, her parents become the avengers against her assailants.[23] Tellingly, film critic Roger Ebert awarded *Last House* three and a half stars out of four and called it a "powerful narrative."[24] Ebert likened it to a more compelling, but similar philosophical engagement as *Straw Dogs* (1971, dir. Sam Peckinpah), a film where a beta-male

academic avenges the rape of his wife and siege of his property. Though Ebert does not make the connection, in both *Last House* and *Straw Dogs*, the avengers sublimate the rape of their loved ones as a violation of themselves. That is, the parents—and particularly the patriarch—in *Last House* are responsible for protecting their daughter's bodily integrity and virginal purity. In *Straw Dogs*, his wife's rape is seen in conjunction with the physical siege of *his* property. Neither are avenging directly on behalf of the victim but are instead obtaining retributive justice for the transgressions against themselves.[25] Sarah Projansky argues that this changes the crucial ideological meaning making in the films, so that rape and murder "justify a particularly violent version of masculinity, relegating women to minor 'props' in the narrative,"[26] whereas women taking revenge into their own hands after facing rape and recognizing the inefficacy of traditional law are feminist narratives.[27]

In comparison to *Last House*, Ebert reviewed *I Spit* with zero stars, referring to it as "sick, reprehensible and contemptible."[28] He questioned the audience's over-identification and vocal endorsement of the violence but treated the rape and retributive acts as equally horrific grounds, going so far as to question a female audience member's cheering for the protagonist by likening her murders of the perpetrators to the violence of her own rape. This confuses the violent refusal of victimhood by women avengers. It is not the revenge that is necessarily empowering, but the enactment of violence and the identification of the viewer with the avenging heroine.[29] The final scene in *I Spit* is Jennifer's last revenge killing precisely because the retributive justice is final. After pretending to show him mercy, she uses a boat motor to tear apart her last attacker's body. Here, Jennifer re-appropriates an object of terror; the motorboat that was used in her initial capture becomes a weapon to destroy the male body of her attacker. This problematically lends to a narrative that rape can in fact be undone by the deaths of the perpetrators, but as Clover points out, that is the appeal of the film. The straightforwardness is unrealistic but immensely enjoyable.[30]

Indian Rape Revenge

Despite Kishwar's criticism, *Bandit Queen* isn't exactly formulaic. Jenny Lapekas describes rape revenge films as having three stages.[31] First, the leading actress is raped by one or more men. Second, she or another character carries out revenge on her behalf. Lastly, justice arrives in an unconventional way, leading the viewer to question the cost of the revenge. Similarly, in Hindi cinema, Gopalan refers to

rape revenge as the avenging women genre, which has an identifiable narrative structure.[32] It opens with family settings of normalcy and Hindi happiness conventions without dominant paternal figures, and the female protagonist is depicted as a modern and working woman. Then, she is raped, and the initial conditions are upset. Charges are filed against the perpetrator, but the law is highlighted to show little potential for state ability to punish rapists. Finally, there is a "miscarriage of justice" that allows the protagonist to transform into avenger.[33] In this way, vigilante justice is forced because the traditional justice system fails sexual assault survivors.

Insaaf Ka Taraazu (Scales of Justice, 1980, dir. B.R. Chopra), inspired by the American film *Lipstick* (1976, dir. Lamont Johnson), highlights the inefficacy of the courts. After Bharti charges her rapist with sexual assault, he is found not guilty because of the apparently blurred lines between consent and non-consent. Like *Lipstick*, *Insaaf Ka Taraazu*'s female protagonist, a fashion model—portrayed by real life model and beauty queen, Zeenat Aman—is raped by an acquaintance and industry professional, and loses her job and boyfriend during the trial. Bharti's lawyer says, "for the woman, a rape trial is no less a rape." Although the perpetrator admits to his lawyer that he was guilty of rape, the trial proceeds to attack Bharti's character. Although this is common rhetoric in diminishing the validity of testimony against rape, Gopalan points out that in the film, there is a particular confusion of voyeuristic masochism in the eroticization of violence.[34] As such, revenge is only unambiguously allowed after Bharti's virginal younger sister is raped. Similarly, *Zakmi Aurat* has the female protagonist Kiran join a group of other rape survivors who plan to snare and castrate rapists after none received justice in court. This is more complicated by the fact that Kiran was a police officer prior to her gang rape. In both films, obvious miscarriages of justice lead to the transformation of women avengers.[35]

As Gopalan's analysis indicates, it is the idea of modern women who are raped that causes the distortion of normalcy (e.g., Kiran as a police officer; Bhakti as a fashion model).[36] But, Phoolan Devi is not a modern woman, so her rape was not considered an aberrant violation of her body in a way that disrupted the social order. Although the viewer identifies the body horror of rape, it is actually the "perverse social relations [that] breed monstrosity"[37] that form the basis of the cultural horror central to the film. Despite *Bandit Queen*'s self-declared aims to highlight the horrors of gender-based violence, it deals with imagined meanings of rape in a manner in line with problematic mainstream discourse, or as Karen Gabriel states, "conjugal rape, caste-based rape, vengeful rape, and yet more rape."[38] Phoolan had no access to the state justice system to even have the

possibility of justice being miscarried. In the film, Phoolan's return to her village from her cousin's is met with interrogation by law enforcement after her false arrest for the burglary of the head Thakur's house. Phoolan is already implicated in her association with the bandits and questioned about her sexual history and promiscuity, rumors spawned from leaving her husband. She is then raped by the policemen, in a scene implied to the viewer (rather than direct visual depiction of the rape, which is liberally employed later in the film). While the rape by the police officers could symbolize the miscarried justice experienced by others, ultimately Phoolan did not have access to the law in a way uncircumscribed by her caste and gender. She is metaphorically raped by the law. So, this formula of vigilantism that usually comes as a necessity after a failure of the justice system does not work for the already oversignified Phoolan. The viewer is thus drawn to masochistically empathize with the plight of her station, but not with her as a real subject. This is also true of audiences in the West who may not understand this caste-based entitlement to rape or abuse her body (an idea explored later in this chapter with a discussion of orientalist assumptions and inscriptions).

After her kidnapping, gang leader Babu Gujjar is shown as cruel and abusive towards Phoolan. Despite Vikram's protestations, Babu Gujjar beats her with the butt of his gun and rapes her as the gang sits in silence, with Phoolan's screams audible in the background. Even the physical abuse oversignifies Phoolan's gendered sexuality, as the attacks are focused on her pelvis and lower abdomen. Later in a botched dacoity, two gang members are killed. While raping Phoolan in the ravines, Vikram kills Babu Gujjar. The low caste gang members immediately see the ramifications and declare Vikram the gang leader after a fight ensues between different castes within the gang. Vikram declares, "Victory to the goddess! She has taken Babu Gujjar." This development frames the action in terms larger than revenge directly for Phoolan's rape, which would not typically justify murder in the social structure of the dacoits. It is by no accident that this is the first rape that is visually depicted in the film because the revenge is immediate. That is, Babu Gujjar is killed mid-rape so that Phoolan must struggle to free herself from underneath his naked dead body. This is the scene in the film that could be most easily read as straight-forward rape revenge, following the cinematic history of men avenging the rape of a loved one who is dead, incapacitated, or otherwise unable to obtain revenge herself. However, this is not usually considered part of the rape revenge in analysis of this film, as Vikram's actions are framed in larger terms that the individual bodily violation of Phoolan.

Rape, Revenge, and Banditry

Kapur says that there is "less than five minutes of footage of actual rape in a two-hour film, yet some people will have you believe that rape is all that my film is about."[39] Regardless of how many minutes of rape are depicted in the film, it is the driving plot device. As Heller-Nichols argues, rape does not need to be shown for the intensity of sexual violence in a film.[40] For example, *Zakmi Aurat* portrays the gang rape of Kiran without visually depicting the action of rape. It instead cuts from the characters immediately prior to the rape and cinematically focuses on the fetishization of banal room objects. It is disingenuous to assert that rape must be visually depicted in order for it be considered included in a film. As such, Kapur's inclusion of graphic rape scenes for any amount of time is an intentional cinematic choice and a marked deviation from other Indian films. The narrative structure is intentionally employed so that, in Kapur's words, "Long after the film is over, never again will [the viewer] be able to look at an item about a woman raped in the morning paper and then go back calmly to a cup of tea."[41] Kapur seems to think that this visceral spectator response is predicated on the visual depiction of rape, or why else would it have been included? What I am interested in is what this does to the "true" depiction of the story of a real person. Although Phoolan's rape was experienced as private trauma, it was made public through cinematic depiction. Phoolan comments, "In the film I'm portrayed as a sniveling woman, always in tears who never took a conscious decision in her life. I'm simply shown as being raped, over and over again."[42] Roy's indictment of the film is just that:

> According to Shekhar Kapur's film, every landmark—every decision, every turning-point in Phoolan Devi's life, starting with how she became a dacoit in the first place, has to do with having been raped, or avenging rape. He has just blundered through her life like a Rape-diviner. You cannot but sense his horrified fascination at the havoc that a wee willie can wreak. It's a sort of reversed male self absorption. Rape is the main dish. Caste is the sauce that it swims in.[43]

She further suggests, "how about changing the title of the film to: Phoolan Devi's Rape and Abject Humiliation: The True Half-Truth?"[44]

The emphasis on Phoolan's rape marked her transformation from sexual victim to avenging bandit as it focused more heavily on her victimization, rather than her own empowerment. This is not to argue that other types of oppression can be delinked from sexuality. But by defining her role as an avenger primarily in terms of her sexuality, the film downplays the intersections of oppression, as

well as the historical context of dacoits and banditry. As Eric Hobsbawm argues, "the point about social bandits is that they are peasant outlaws whom the lord and the state regard as criminals, but who remain within the peasant society, and are considered by their people as heroes, champions, avengers, fighters for justice, perhaps even leaders of liberation, and in any case as men [sic] to be admired, helped and supported."[45] The real Phoolan connects her role as a dacoit to gender-based violence, but not as a direct result of her own rapes: "If all these gang leaders, who happen to be men, would fight against these atrocities, then they would end. It's not to earn money that a woman becomes a dacoit; it's for retribution and revenge."[46] But Phoolan's popularity as a bandit is largely downplayed in the film. William Pinch, historian of South Asia, notes that the film would have been more successful with the added complexity of real life, rather than one-dimensional characters, including Phoolan as a protagonist who is "a sexually wronged woman hell-bent on revenge—a kind of rampaging Kali cleverly styled to suit both Western and Indian action-drama appetites."[47]

Under Vikram's leadership in *Bandit Queen*, the gang is seen at a village shrine, praying to Śiva and Bhavānī, as they cultivate relationships with low caste village members. Vikram declares Phoolan to be a reincarnation of the Goddess Durgā for village protection and dons her with the red bed bandana so iconic to Phoolan's image. Sarah Caldwell argues that the mythological paradigm of redemptive violence of Durgā is exactly what made Phoolan's story resonate with public imagination in India (see also Chapter 3 in this book).[48] While this is probably an oversimplification, it does contribute to the rationale for the comprehensibility of female violence as compared to the self-evidence of male violence. Phoolan and Vikram play up the association with righteous goddess avengers, but as Indian feminist scholar Rajeswari Sunder Rajan points out, there is no reason to suspect that this association was insincere in real life.[49] Even though this was not her intention, under the idiom of the goddess myth, Phoolan was restored as a figure for Indian feminism as a model of female heroism. However, many Indian feminists were less interested in her as a living "feminist figure or a figure for feminism" because of their reluctance to embrace militant feminist models, and the agency that has been attributed to militancy— particularly Hindutva woman leaders—or the exceptionality of a single figure.[50] Gabriel complicates this location of Phoolan as a vengeful goddess, precisely because it is by rape that she is engendered as a woman.[51] Though the divine association complicates the revenge narrative, mostly the gang's actions are framed as a caste rebellion. As a gendered subject who is supposedly emblematic of cultural horror in Kapur's construction, Phoolan's cinematic revenge is

somehow mostly related to her rapes. Her vigilantism is determined by her sexuality. Phoolan's real life attempts to rebel against caste receive little attention in the film, which ignores her biographical accounts of anger, and sidelines any reformist agenda.[52]

Perhaps because Babu Gujjar is not the most brutal rapist nor is Vikram's revenge the most extreme in *Bandit Queen,* it is not typically interpreted as part of the film's rape revenge narrative. The first instance of Phoolan's transformation into an avenging woman is when she and Vikram find Putti Lal to take revenge. Vikram tells her that she has avenged her honor like "a real bandit." Although women bandits were rare, Hobsbawm notes that "the most usual role of women in banditry is as lovers," and the bandit "turns to outlaw in general and revenge on men in particular, because she has been 'dishonoured,' i.e., deflowered."[53] The real-life Phoolan notes the power and authority of being a dacoit that allowed her agency for revenge. She says, "once I became a dacoit and started making lists of all the people who had tortured me, who had abused me, and I was able to pay them back in kind, that pleased me tremendously."[54] But the film does not mark her complete transformation into avenging bandit until Lala Ram and Sri Ram murder Vikram in front of Phoolan.

The film shows a hysterical Phoolan being carried away from Vikram's body and taken to Behmai to be gang raped by a series of Thakurs, led by the brothers. This scene is the source of much of the controversy surrounding the film. In Mala Sen's biography, Phoolan says "*un logo ne mujhse bahut mazak ki*" (those people really fooled with me) but she was reluctant to speak of any details of "her *bezathi*" (dishonor).[55] In her refusal to speak of the rape, Sen (among others) interpreted Phoolan's position within the larger framework of rape shame.[56] Anuradha Ramanujan complicates this reading in arguing that this is actually a refutation of the patriarchal notion that female sexual existence and selfhood are tantamount to each other.[57] By delinking these two, damage to the former does not obliterate the latter, and the meaning of rape as subject is thereby destabilized.

The account of rapes in the film instead comes from American journalist Jon Bradshaw's *Esquire* article that detailed the attack. Kapur is emphatic that "the point is that the effective portrayal of a rape scene churns viewers."[58] He's not necessarily wrong here. When rape is covertly addressed but overly inscribed as common plot features, much of Hindi cinema has failed to address sexual violence in a substantial way. Most commonly, rape is used as a framing device, but does not contribute to commentary on gender based sexual violence. In this way, the depiction of the actual rape of Phoolan could be considered positive as a marked departure from the general Hindi cinematic unwillingness to show the

brutality of rape. However, it is debatable as to whether the rape needed to be shown to communicate to the audience that rape is horrific and abhorrent. The word "rape" evokes association with a physically violent act and the moral and emotional responses to it. Clover says that depicting rape always risks sadistic participation by the viewer, but there are cinematic and narrative devices that encourage that participation or foreclose on it.[59] In *Bandit Queen*, the camera lingers to the point of disgust and indicts the voyeuristic and objectifying gaze of the spectator to emphasize the empathetic translation of the rape survivor. As Heller-Nicholas writes, this cinematic strategy forces the spectator to bear the onus of attempting "to comprehend the brutal incomprehensibility of rape."[60] Although this was a criticism of *Bandit Queen*, these shots are not titillating, nor do they lack consensual ambiguity. This has also been a common criticism of other films that depict rape, which is problematically read as potentially consensual sex.[61] Many of these films, *Bandit Queen* included, could be criticized for encouraging voyeuristic fetishism of violence against women, but reading rape as ambiguously consensual or anything less than cultural horror in scenes like this one is a mistake.[62]

The rape scene implicates the viewer as a voyeur, as the camera views the scene as an onlooker with a slightly obstructed view of the rapes from different objects in the barn. The banality of the obfuscated view—as opposed to the fetishistic motivation of objects in the shot of *Zakmi Aurat* that implies the gang rape—makes these angles more unsettling. As Gopalan states, there is reliance on "masochistic identification in the rape scene to fully play out its horrifying potential, the sadistic dimensions... [to] propel the revenge plot and remind us retroactively that the ensemble of elements in the rape scene is always a volatile marriage between sex *and* violence."[63] As a strategy, lingering to the point of disgust relies on the subject position of the spectator finding the act disgusting. I question if the excess is enough to elicit this on its own and what excess means in terms of the depiction of rape. Problematically, how do we even define "excess" in this regard? The twenty-minute rape scene in *I Spit* was considered the height of excess at its release,[64] whereas the nine-minute rape scene in *Irréversible* (2002, dir. Gaspar Noé) is considerably more unsettling given its steady and unwavering single frame shot. Roy asks:

> How does one grade film-rapes on a scale from Exploitative to Non-exploitative? Does it depend on how much skin we see? Or is it a more complex formula that juggles exposed skin, genitalia, and bare breasts? Exploitative I'd say, is when the whole point of the exercise is to stand on high moral ground, and inform us (as if we didn't know), that rape is about abject humiliation.[65]

Roy highlights the contradictions inherent in the necessity of a brutalized female body in order to facilitate the transformation to avenger. Similarly, film studies scholar Gohar Siddiqui notes how the brutal depictions of sexual violence bring films close to exploitative, but simultaneously represent the realities of abuse and the necessary motivation for protagonist empowerment.[66] The critique is that women's agency becomes contingent on the gratuitous depiction of a rape scene, which may simultaneously be eroticized, thereby limiting the subversive potential of these narratives.

After three days of rape and physical assault, Phoolan is released from the barn only to be stripped naked and told to draw water from the village well with a brass pot.[67] Lala Ram announces to the village, "this thing called me a motherfucker... this is what we do to low caste goddesses." Unclear to the viewer whether she escaped or was released, Phoolan's cousin finds her on the street. Gabriel reads this scene as Phoolan misrecognizing her cousin Kailash as a potential rapist;[68] a scene that thrusts the viewer out of voyeuristic anonymity because their gaze approaches with her. I didn't read this as a fundamental misrecognition. Instead, it is an indictment of all men as potential rapists, as Phoolan states she does not "trust any man." The cultural horror faced by the protagonist did not end with the cessation of the body horror of rape because her escape/release maintained her caste and gender-based inscription. Phoolan asks bandit leader Baba Mushtaquim for her own gang to exact her revenge on Sri Ram, Lala Ram, and their supporters. Appealing to the Muslim leader, she says that caste divisions will be the downfall of the bandit kingdom. He grants her supplies and men out of "loyalty to Vikram" and with the support of Man Singh as co-leader of her gang. By many accounts, the real-life Man Singh was likely Phoolan's lover. However, this was omitted from the film, further contributing to Kapur's narrativization of preferable victimhood. Baba Mushtaquim tips off Phoolan about Sri Ram and Lala Ram's presence in Behmai but warns her against rashness. Although the two are not there, all the men in the village are implicated by their lack of intervention in the brutal assaults and rapes Phoolan in Behmai. The screen flares and images move to slow motion as twenty-two Thakurs are lined up and killed by the gang.

Shanthie Mariet D'Souza and Bibhu Prasad Routray argue that an avenger is someone who feels wronged and does not calibrate their use of proportionate violence.[69] I'm unwilling to assert whether the Behmai massacre was disproportionate or not. What is important for this analysis is how it was depicted in the film. The real-life Phoolan claims that she was not present when the massacre took place, and she was wanted by the authorities in the state over the

murders when the film was released. It is important to note that Sen's depiction of the event in the biography does not refute Phoolan's assertion in the same way that the cinematic gaze does.[70] Regardless, this massacre is the culmination of revenge. As Mridula Nath Chakraborty argues:

> Phoolan Devi's case is precisely that the widespread approbation she received at the hands of mainstream *and* feminist readings is *not* because she enacted revenge upon the husband and the same-caste men who abused her physically and sexually, for her particular version of pushed-to-the-limit domestic violence might have merited an entry in some forgotten column hidden in the depths of a newspaper.[71]

Instead, the murders of upper caste men on such a large scale by a low caste woman makes it all the more shocking in the national imagination. The avenging woman in cinema intervenes in the stable binary of masculine violence and feminized victimhood that typically characterizes the gendered politics of spectatorship.[72] Read argues that this is often accompanied by the hyper-sexualization of the female vigilante, but in the case of *Bandit Queen*, Phoolan is masculinized in her revenge. Caldwell remarks that Phoolan actually chooses to become a man by denying her social gender when fixating on revenge.[73] This seems to be an over-simplification, but the denial of her social gender as disavowal of her rapes as a gendered inscription of a feminine body reinscribes her resistance within a heteropatriarchal script.

With her long period in the ravines avoiding capture, real-life Phoolan had created sophisticated networks with police and government officials and her arrest was actually a disruption of these networks.[74] In the film, she is seen as being forced to surrender after the murders of almost all of the members of her gang and with no access to supplies. While subversive potential can be limited through the inscription of the raped body, Gopalan expands this critique of the subversive potential due to the role of the state and the concluding restoration of the social imaginary.[75] The narrative of the avenging woman is initially transgressive, in that her vigilantism addresses the void of state sponsored order. However, this power is inevitably undercut by the resolution of state authority. Phoolan is shown in the film as laying her weapons down in a ceremonious or even ritualized manner under photos of Mahatma Gandhi and Durgā, at the feet of the Chief Minister. This is relatively accurate in terms of its portrayal of her real-life surrender, but her negotiations were not successful in securing demands for her family's and her own protection. Instead, the film encourages the audience to pity her, ensuring that the balance of power remains unthreatened.

Truth and Testimony

Bandit Queen begins with three declarations which are important for the film's framing. First, "This is a true story." Secondly, "'Animals, drums, illiterates, low castes and women are worthy of being beaten.' Quote from the 'Manu Smriti' a book of Hindu religious scriptures."[76] Lastly, "The events in this film are based on the dictated prison diaries of Phoolan Devi—*Goddess of Flowers—The Bandit Queen*." Seema Biswas appears on screen as an adult Phoolan and defiantly yells into the camera: "I am Phoolan Devi, you sisterfuckers." Kapur emphasized the truth in his conception of Phoolan's story and has her declare her identity and story for the viewer. Biswas becomes the authorial figure. She *is* Phoolan Devi and it is *her* story, and she is directly inviting the viewer to consume it. In the spectator's anonymity, their gaze becomes interchangeable with that of the omnipresent camera, privy to the most intimate details of Phoolan's life.[77] As Trinh T. Minh-ha states, "Factual authenticity relies heavily on the Other's words and testimony. To authenticate a work, it becomes therefore most important to prove or make evident how this Other has participated in the making of his/her own image."[78] This is not the same as facilitating subaltern agency or using power to subvert dominant storytelling narratives.[79] Rather, it is a method that exacerbates the dispossession of already marginalized people by co-opting them into a constructed image, and this contributes to a static conception of the subaltern subject. Instead, as Ramanujan suggests, the "conception of subalternity as relational and fluid rather than as an absolute category" negates the necessity of an authentic "real" story.[80]

Kapur claims a higher truth in his ability to portray Phoolan's story on film. Even if he didn't have all of the facts right or try to portray a version consistent with Phoolan's account of the events, he is able to retell her life as a *better* representation of gender and caste oppression.[81] In the film, after returning to her family in shame of her marital discord, the now adolescent Phoolan is shown as an object of desire and disdain for higher caste men in her village. She rejects the sexual advances of the head Thakur's son in a physical struggle that lacks consensual ambiguity. This is important because Phoolan's promiscuity would diminish the audience's capacity for empathy for her. She is banished from her village because the Thakurs believe "this girl's bad for our boys." From Kapur's position, an audience is unable to comprehend a nuanced depiction of a subject's actions. Kapur says, "I left out many other things that could have gone against her. I wanted to create empathy for her."[82] Kapur decided that on her own Phoolan wasn't a sympathetic character or

entirely appropriate for her relevance to caste and gender-based oppression.[83] Phoolan Devi becomes *his* subject. Kapur is then able to expose "everyday acts of violence that sustain gender and caste relations in much of north Indian society"[84] by erasing individual agency and subjectivity and translating it to his creation and vision.

In this case, Kapur's emphasis on authentic truth received criticism. Arundhati Roy was a vocal critic of *Bandit Queen* and argues that the strategy of truth is a tactic to insulate the film from criticism "against accusations of incompetence, exaggeration, and even ignorance."[85] If the filmmakers had made a fictional film, the discussion of its reception and controversy would be different. The more common criticism was the assessment of the perceived truth of the biopic. Pinch, for example, critiques the film on the basis that it is not "wholly true" despite its claims, and the overemphasis on rapes were a directorial invention.[86] Phoolan Devi requested that the film not be shown at the Toronto International Film Festival (TIFF) and asserted that the public didn't have the right to consume her story and participate in her humiliation. She stated, "I would not go and watch you being raped, if I knew you didn't want me to."[87] The director of TIFF screened the film despite the controversy because he was "satisfied that the movie is based on Devi's own testimony, that she freely sold the rights of her story to Channel Four (the film's co-producer) and that *The Bandit Queen* does not condone the denigration of women."[88] It mattered little that the subject of the biopic disputed these claims, because the director of TIFF—much like Kapur as the film's director—felt entitled to make a judgment and decision about the film that excluded the real-life Phoolan as a subject with the agency to dictate her own story. It is notable that with the exception of screenwriter Mala Sen's brief encounter with Phoolan for her biography, nobody involved with the film actually met Phoolan Devi. There was also an ongoing refusal to screen the film for her, so many of her objections came from what she learned about the film second-hand from other viewers.[89] Roy pejoratively commented, "It didn't matter to Shekhar Kapur who Phoolan Devi really was. What kind of a person she was. She was a woman, wasn't she? She was raped, wasn't she? So what did that make her? A Raped Woman! You've seen one, you've seen 'em all. He was in business. What the hell would he need to *meet* her for?"[90] This is the additional layer of cultural horror and the replication of social relations that lead to that horror in the blatant disregard for the subjectivity of a real-life referent. Phoolan was bolstered to represent horrors to domestic and international audiences, while she was silenced and violated.

Circuits of Power, Representation, and Production

If the film is approached solely from the inquiry of whether this is a "true story" or not, those in judgment are able to use their power to make assessments of truth claims. Critics who disbelieved this assertion asked why Kapur would not have made the film more accurate or abandon the format of a biopic, while others saw authenticity in the film for what they believed merited accolades for truth. However, as Leela Fernandes states, "binary oppositions between reality and fiction or truth and partiality, choosing one pole of the dichotomy will not in itself circumvent the problem of power and representation."[91] The circuits of representation are even more complicated by the international production of this film and its intentions for Western and international film festival consumption. Mala Sen's biography, *India's Bandit Queen: The True Story of Phoolan Devi*, does a better job of exposing these circuits. I am not asserting that the biography is more effective because it is more "true," but by detailing the methodological complications of creating a linear biography of a living subject, Sen acknowledges the imperfect nature of the biography. The biography presents contradicting accounts of the same events using reconstructions from journalism, meetings with Phoolan Devi, conversations with her family, and written accounts from her prison diaries that were smuggled out of the institution while she was incarcerated. All of this lends to a more complicated and nuanced depiction. Interestingly, Brenda Longfellow actually criticizes this literary form because the real subject and authorial voice in the biography is Sen, and Phoolan Devi's voice is only one "faint discursive thread," which implicates the power relations of Sen as a "post-colonial intellectual" over Phoolan as a "subaltern subject."[92] This, too, is an oversimplification of the circuits of power that went into the cultural production of Phoolan's biography and inscribes subalternity in a relatively fixed way. However, it does highlight another thread of cultural horror, where it is reasonable that because of Phoolan's caste status, her biography could be produced without her input. Regardless, this nuancing is lost in the film, made even more complicated by the fact that Sen was an original screenwriter of *Bandit Queen*.

The opening of the film includes a passage from *Manu Smṛti* that seems to justify the abhorrent treatment of low caste women. That is to say, the viewer gets the "true story" of Phoolan Devi, as framed in the "truth" of caste conflict. Western film critic Stanley Kauffman summarizes the beginning of the film:

The child of low-caste impoverished parents in central India, she was sold in marriage at the age of 11 for a bicycle and a cow. This was 1970, not 1470. Her husband, in his 20s, wanted her immediately for labor because his mother was too old for work, but sexually he couldn't wait for her to ripen. Soon after their marriage, despite her screams, he raped her.[93]

Kauffman is able to read gender-based violence as a particular problem of the Other. That is, because rural India is temporally backwards, there is a lack of civilized social relations. Religious justification of caste oppression is apparently contrary to the secular modernity of the West. In Kauffman's opinion, the horrors in *Bandit Queen* are a misplacement of antiquated social relations. This is of course a fallacy with orientalist roots that diminish the gender and class-based violence that occurs in the West. As Fernandes points out, the representation of rape in *Bandit Queen* resulted in the re-invocation of orientalist narratives.[94] That is, when barbarism is located with the Other, the West is not implicated in violence against and hyper-sexualization of women.

Kapur claimed he had feminist intentions with the film, explaining his motivations for the viewer to be particularly horrified by the film's events and thus able to connect this empathetic reaction to ongoing caste oppression and gender-based violence. However, the circuits of representation and production complicate readings of the film. Kauffman's interpretation is not entirely wrong. The narrative begins in Phoolan's childhood village in the summer of 1968. Her mother pleads with Phoolan's father Devideen that at eleven years old, Phoolan is too young to leave and live with the much older Putti Lal as her new husband. Devideen is portrayed as uncaring as he states that all daughters are burdens. The first instance of physical violence against Phoolan is early in the film. When fetching water for Putti Lal, she is harassed by young boys in the village who break her clay water pot. She quarrels with her mother-in-law, highlighting the material differences between castes for the viewer.[95] Putti Lal then beats her for disrespect and, immediately after, rapes her for the first time. There is an intimate connection between sex and violence that threads throughout the film that is poignantly highlighted when read on the body of the prepubescent Phoolan. As the young girl screams, the camera cuts to her mother-in-law, reinforcing the acceptability of martial rape. In physical pain from the rape, Phoolan is told to continue to work anyway under threat of further physical violence. She leaves the village to complete chores, and after looking over the expanse of the surrounding hills, she takes off running. These events prelude the opening film credits—a thematic undercurrent is set for the rest of the film—predicated on the cultural horror of caste and gender discrimination marked by sexual violence and rape.

Kishwar criticized many of Kapur's choices as pandering to Western audiences, who needed a more simplified version of caste-based warfare.[96] This narrative did not function well with the inclusion of the real-life land disputes with Phoolan's same-caste, but literate and wealthier, cousin and uncle.[97] Readings are complicated because the film was intended for both domestic and international audiences. Fernandes refers to these as "discrepant audiences."[98] There was a significant controversy over state certification of the film in India, leading it to be screened internationally prior to entering domestic theaters. Kishwar claimed the filmmakers framed this as politically motivated high caste censorship of the film.[99] The producer stated that the Censor Board requested the elimination of profanity, large portions of the rape sequences, and "all references to the Thakurs" in deference to the lobbying against the film's portrayal of caste injustice.[100] Kapur also claimed that the film was censored because of the politics of a film risking box office success that didn't follow a Bollywood filmmaking formula.[101] Kauffman's reading of the controversy was that India was proud of the candor of exposing internal conditions abroad, but it was considered to be "too risky at home."[102] These responses reinforce the notion that caste-based oppression is still salient and in need of the critique provided by the film.

Absent in responses to Indian censorship is the fact that Phoolan herself was a vocal advocate against the film. Her voice was silenced in public discourse in the same way it was in translating her narrative to film. The only response to Phoolan's objections was Kapur's emphasis on her request for more money and that her marriage to an upper caste man indicated her desire for bourgeois respectability, which motivated the censorship of more unsavory aspects of her history.[103] This is contradictory, as Kapur claimed to have taken license with the portrayal of Phoolan to make her more sympathetic. Kapur disregarded Phoolan's direct response, "What I object to is that when I can't even talk to another woman about *balaatkar* [rape], how does Shekhar Kapur have the right to show me being raped?"[104] Even critics of the nudity and graphic sexual violence in the film drew less on Phoolan's objections and instead focused on larger social and moral implications of film representation of rape and nakedness. Although rape is a popular as a plot device in Hindi cinema,[105] it is rarely actually depicted—it is instead implied—and full-frontal nudity is relatively unheard of in popular *masala* cinema. This led some to conclude that sex was crucial in developing wider viewer interest given that Bandit Queen was not cast with well-known actors or followed the Bollywood formula.[106] Kapur said this criticism, especially as it was directed at the humility of women viewing the film in public, was baseless and supported by the popularity of the women-only shows that

were organized in deference to the critics who claimed that the nudity was driving the film's popularity.[107] Interestingly, a double was used for the scene where Phoolan is completely naked. Actress Seema Biswas says, "that height of humiliation was beyond my boundary. As an actress, not a part of my execution."[108] While assertions of right to privacy by Phoolan were met with either derision or completely ignored, conversely, the actress who portrayed her had the agency and was given the respect to decide whether she wanted to be naked on camera.

Conclusion

In this analysis, I am not attempting to appropriate Phoolan Devi's real-life experiences into a script of feminist resistance and patriarchal subversion. Instead, this chapter has shown that there were a set of contradictory effects of *Bandit Queen*. The graphic of depiction of rape and caste-based oppression disrupted certain patriarchal perceptions, but simultaneously reproduced problematic relationships of power that contextualize the correspondence of real-life cultural horror. Rape revenge films are not automatically implicated in the reification of feminine victimization through the representation of rape. The history of avenging women in Hindi cinema is firmly established, and Indian rape revenge films are not mere replications of their Western counterparts, though there are analytical overlaps that allowed me to draw comparisons in this chapter. Additionally, I have not argued that the representation of rape to an international audience need automatically resinscribe orientalist tropes. Take for instance, the recent film *Marlina Si Pembunuh Dalam Empat Babak* (Marlina the Murderer in Four Acts, 2017, dir. Mouly Surya). *Marlina* has seen similar international circuits of production experienced by *Bandit Queen*, however, the Indonesian film has found widespread critical acclaim for its feminist vision of justice, vengeance, and a unique take on rape revenge.[109] Unlike *Bandit Queen*, *Marlina* focuses on a fictional character, her journey as an avenger, and the relationships with other women in the film who contribute to a collectivist revenge.[110] Adversely, the inscribed rapes onto Phoolan's filmic body have considerable ramifications when the referent is a real-life and fluidly subaltern woman who voiced criticism of the depictions. The cultural horrors Kapur attempted to critique through *Bandit Queen* are instead reproduced and re-enacted in various ways.

Whether Phoolan was a dacoit fighting for revolutionary social justice or a thwarted woman with single minded revenge did not matter to the filmmakers.

As Roy concludes, "using the identity of a living woman, re-creating her degradation and humiliation for public consumption, was totally unacceptable to me. Doing it without her consent, without her *specific, written repeated, wholehearted, unambiguous* consent is monstrous."[111] When depiction of personal horrors without consent dehumanizes the real-life person that the truth is based on, the subject is oversignified to the point abjection. This is an additional layer to the horror of *Bandit Queen*. As a rape revenge, it elicits the visceral spectator response of filmic horror. Focused on caste and gender-based violence, it represents the cultural horror that led to the context and circumstances of a/the Bandit Queen. But most troublingly, the violation of Phoolan's consent in the film's creation made it an object of horror that subverted any feminist motivations of the filmmakers.

8

Mardaani: The Secular Horror of Child Trafficking and the Modern Masculine Woman

Beth Watkins

Introduction

In *Mardaani* (2014, dir. Pradeep Sarkar), Inspector Shivani Roy, a detective in the Mumbai police, tracks the leader of a child trafficking ring. Because the inspector is a woman, both the hero and the villain represent societal evils. The villain abducts children and sells them into sex slavery; the hero subverts expectations of women to thrive in the domain of the home and to serve family and/or god. *Mardaani* moves the avenging figure away from the spiritual and familial and into a professional, anonymous, public-serving world that derives its power from human-made law. In its mundane world, individuals remain largely unconnected to one another, and innocent children are not protected by the community or the supernatural. Shivani restores a fraction of the moral order, but she ignores most societal conventions to do so. Her violence is not on behalf of god or family but for public good, and she transfers physical power to victims for their personal catharsis.

As a film, many would label an investigative thriller, *Mardaani* may be an unusual subject for a study of Hindi horror cinema: it was not marketed as such, nor does it contain traditional genre elements like supernatural forces, mythology, spectral surveillance, or unnervingly empty spaces. Through interviews with Hindi horror film viewers in India and the UK, Shakuntala Banaji found that "In Bollywood, horror is professional women who undermine men, families who abandon their elderly, those who disrespect the gods; but it is also the rape and murder of vulnerable persons;... the bloodthirsty rage of the unavenged; the inexplicable 'other' who refuses to die, to change, or to submit."[1] *Mardaani* imagines a world in which Hindi cinema's usual narratives about traditional social systems of safety (religion, the family and home, state authority figures)

are ineffective or absent, not to eventually reinstate their powers but to show their failures. Instead of triumphing in the efficacy and righteousness of the police or other figures of moral order, it reveals them to have a reach too limited to defeat the complex, global threat of human trafficking. It establishes as ordinary the unsettling ideas of anonymous monstrous forces and their uncountable victims (all real people in the world of the film). Its bleak ending reveals an ambivalence about the efficacy of contemporary society and state, and an inevitable worsening of conditions. Modern society is too distracted to notice the evils in its midst.

By considering elements of this film as part of the horror genre and discussing the horror of the film's subject areas we find a truly horrific picture of modern urban India. *Mardaani* reveals a cultural horror of the failure by all traditional sources of reassurance to protect vulnerable members of society. Furthermore, its female hero calls upon those very members to break out of traditional gender- and age-based roles to enter the public sphere and protect themselves, rejecting the need for a proscribed domestic life prescribed by a patriarchal figure. At the same time, the film portrays as normal, even necessary, features that traditionally-minded audiences may find upsetting. The lead of the film is a woman who is also the hero, decidedly not a heroine. She is fully autonomous and she drives what little resolution the film offers. She "transgresses" into typically masculine tasks, and her claim to and use of power are not subjugated. Nuclear families, religious figures, and effective parents are all absent, replaced in the arc of the plot by a secular, professional, childless woman.

The release of *Mardaani* by probably the most mainstream production house in Bollywood, Yash Raj Films, suggests that creators are willing to gamble occasionally on their audiences being able to handle a less optimistic view of contemporary society. This was not always so in Hindi horror. As Meheli Sen notes, during the rise of Ramsay brothers films in the 1970s and 1980s, "the divorce between horror and a certain idea of 'respectability' thus comes to be firmly entrenched."[2] *Mardaani* and some other films of the 2010s such as *Stree* (The Woman, 2018, dir. Amar Kaushik) or the largely unnoticed *Gang of Ghosts* (a 2014 Hindi remake by Satish Kaushik of the more popular 2012 Bengali horror-comedy film *Bhooter Bhabishyat*, dir. Anik Dutta) have begun reuniting respectability and elements of horror. The film itself (particularly its production house) and the lead character are respectable. Sen's observation that "recent horror cinema… is very much about the bourgeoisie as well as made for metropolitan, bourgeois spectators" rings true for *Mardaani*.[3]

Plot Summary

Mardaani focuses all but its first twenty minutes on Shivani Shivaji Roy (Rani Mukerji), a Senior Inspector in the Crime Branch of the Mumbai Police, chasing a group of criminals who traffic children. The group has several arms, but most of her significant interactions are with an ambitious younger man who calls himself Walt after the lead character in the American TV show *Breaking Bad* (Tahir Raj Bhasin). Shivani lives with her husband Bikram (Jisshu Sengupta), a doctor, and orphaned niece Meera (Avneet Kaur). The initial section of the film establishes Shivani as no-nonsense, procedure-oriented, and unafraid of physical confrontation.

When Meera is unable to find her friend Pyaari (Priyanka Sharma) for a scheduled get-together, she worries to Shivani that Pyaari has been kidnapped (Shivani had previously saved Pyaari from trafficking by her own uncle). Pyaari lives in a shelter run by an NGO and also works as a flower-seller on the street. Shivani asks at Pyaari's school, where classmates and staff also haven't seen her. A brief scene of Rajasthan license plates on vehicles in the desert and Pyaari and a few other girls huddled in the back of a truck confirms everyone's fears that she has been abducted. Shivani and her colleagues begin investigating Pyaari's disappearance. By tracking clues on a witness's phone, they learn about an organizer named Vakil (Anil George). Vakil and his associate (Walt, who is not yet named) discover the police are surveilling them, and Walt volunteers to deal with Shivani.

This begins the first of several cycles of phone conversations between Walt and Shivani, alternating with Shivani's investigative work and Pyaari's life with the traffickers. In their first conversation, Shivani tells Walt she wants her (figurative) daughter back, and he is surprised to hear of her connection to one of the girls. We next see Pyaari and other girls being auctioned to older men, and one of the customers rapes Pyaari.

After Shivani disrupts more of Walt's plans in Mumbai, he sends her a package with Pyaari's severed finger inside. Shivani follows him to Delhi, where she meets with Delhi police about the case and is given authority to work with a local officer and pursue Vakil's criminal ring. They manage to close in on Vakil, who shoots himself rather than face questioning. Shivani tracks down another of Vakil's known associates, Minu (Mona Ambegaonkar). Minu admits to Shivani that she is Walt's mother and then sedates her.

The action then moves to another auction party at a hotel, where Minu prepares the girls in revealing clothing and heavy makeup. Walt leaves Shivani tied up on a bed in a hotel room, and one of his important clients, a political

minister, tries to rape her. Fighting off the politician, she drags him back to the party and uses threats against him to bargain with Walt to free the girls. In a final confrontation, Shivani isolates Walt from the rest of the criminals and customers and, while waiting for the Delhi police to arrive, physically beats him and invites the girls to do the same. The film ends with the police apprehending the people at the auction, and in the final scene Shivani narrates that Walt dies from his injuries and his surviving associate becomes a witness for the prosecution. The girls are free, but their fates are unknown.

The hero of *Mardaani* proved popular enough with audiences that a sequel film was released in December 2019 by the same production company (*Mardaani 2*, dir. Gopi Puthran), and at the time of writing it has earned almost double its budget.[4] As in the first film, Shivani effectively pursues a criminal whose focus is sexual violence against women.

Horror Tropes and Appetites

Shivani, Pyaari, and Walt live in a very different world to that which we may picture when we think of a Hindi horror film. There are no mysterious figures in white, mad scientists, or fanged monsters. Horror has expanded to include new evils: the façade of the vanilla-looking villain, the anonymity of the mundane urban setting, and the complexities of international systems of exploitation. If a horror film is, as Mithuraaj Dhusiya describes, one of those "that make it their primary business to generate horripilation in their audiences,"[5] then *Mardaani* is a horror film. It wants viewers to be startled and repulsed, before becoming engaged in a real-life issue or emboldened to fight back for ourselves and for others. Its most significant goose-bump moment may be the finale, which refuses to tie up the story or the underlying issue happily. Instead of resolving, *Mardaani* fractures, sending Shivani and the victims to unknown next stages of their lives, the issue of child trafficking looming somehow larger than it was before Shivani identified and apprehended this handful of perpetrators.

Modernizing and urbanizing definitions of some genre traits reveals some other standard horror tropes in the film. Minu, the mother with twisted affection for her own horrible offspring, can be read as an old hag who corrupts and scars children. Airless, windowless spaces in which the girls are held serve as secret dungeons. Vakil and his helpers coalesce into a sort of mad scientist who sexualizes young girls, an inverted Dr. Frankenstein who transforms independent people into objects.

Mardaani does not need many other genre elements. In the modern, urban, global world, international networks and spectral anonymity take the places of curses and the supernatural. It also avoids the macabre: Vakil's death is not a focus of glee or triumph for Shivani but instead simply a method he chooses to enable his criminal business to survive. Real people and real issues are frightening enough. If Hindi cinema like *Stree* (2018) and *Tumbbad* ([the name of a village in Maharashtra], 2018, dir. Rahi Anil Barve) is creating new territory for horror by using Indian literature and folktales in new ways,[6] *Mardaani* turns to the news and UN statistics for a source of the terrifying. Child trafficking is not uniquely Indian; as the film mentions in passing, it connects India to other parts of the world. The captions in the finale with statistics about the issue in India remind viewers that this is not a fantastical subject and that these villains are only nominally make-believe.

While greed and lust loom in the background of the story as the obvious root causes of sex trafficking, they are mostly unadorned and unexamined. The criminals may be warped in how they choose to feed their avarice, but they act as rationally within their professional system as the police do in theirs. Shivani's wrath, which is hers alone until she transfers it to the victims at the end, is the driving appetite. Beyond the children, no one is fully good, including us as viewers, who are implied to be turning a blind eye to this particular evil like all the passers-by on the city streets. We global citizens should all be able to agree that this treatment of children is unacceptable, yet we accept it. It is nothing otherworldly—just our worst nightmare.

Unlike the plots of most Ramsay brothers' films, *Mardaani* coheres quickly and focuses tightly. It is not *masala*: no romance, no comedy, no song sequences. Its only significant social gatherings, music, or even embellished clothing occur in scenes of child trafficking. A modern urban India that pays attention to despicable actions is drained of most joy and color. As Nair writes, "Bollywood horror today arguably surfaces anxieties buried in the delirium of consumerism, globalization, and the new media sensorium."[7] This is exactly where *Mardaani* lands: our fears that among all the demands and diversions of contemporary life in the city, we cannot (or do not) take care of our children. We do not love them (Pyaari's mistreatment by her uncle), and sometimes we do not even see them (Pyaari's begging to cars on the street is met by closed by windows; the film does not mention any of the other children's families reporting them missing). The figures who challenge Western cultural influences—a conservative mob angered over public celebrations of Valentine's Day—are dismissed easily once, but they return to menace much closer to home by attacking Bikram and his clinic.

The human body is very much the subject and the object of *Mardaani*'s lessons and actions. Walt, Vakil, Minu, Shivani, and her colleagues all detain, transform, or attack bodies. The only adult in the film who does not is Bikram, and he is the subject of physical humiliation by the mob. The theft of the girls' agency over their own bodies also suggests an anxiety about loss of autonomy (or, less progressively, a loss of control by those who more "rightfully" have it over girls, such as their parents or teachers). Like many movie monsters, the children are transmuted—from innocents into unwilling sexual partners. The criminals transgress both nature and culture. And like mad scientists, the criminals "undermine the long-held sacrosanct traditional concept of the integrity of the human body,"[8] at least ideologically if not literally.

If recent Hindi horror can be characterized by "fears and anxieties that involve the impact of globalization on the family—women entering the workplace, increased abortion rates, premarital sex, male unemployment, divorce, adultery, and the disintegration of the extended family,"[9] as Sen claims, then *Mardaani* is squarely a horror film. Significant story and action elements are driven by an independent woman using her professional expertise. All the named adult women work, and even Pyaari sells flowers on the road when she's not in school.

Extended families are absent, and nuclear family units are ad hoc and complicated (e.g., the passing reference by Shivani's male colleague to his child who spends too much time on the internet and too little doing homework, or the team's discussion of their boss's marital spats). Villains like Walt and Vakil earn money entirely illegally (so, not quite unemployed but certainly not traditional workers). Non-consensual premarital sex is rape, not romance.

A Woman Hero

In its title, *Mardaani*—the feminine form of the Hindi adjective for courageous, manly, macho—specifies that a woman can be a hero and that its hero is a woman. The female lead here is not a heroine in the usual sense of being a love interest or emotional support of a male character who drives most of the action. She determines goals, logistics, procedures, wrongdoers, and punishments. She exerts herself physically, attacking, capturing, and restraining men. And she is not the only *mardaani* in the film. Minu uses physical threats against Shivani, and the girls use their own strength to attack Walt as soon as Shivani creates the opportunity for them to do so. They even use symbols of their oppression: the high-heeled shoes the traffickers make them wear.

Mardaani's lead female exists fully formed before the film begins. Is this a fear to be discussed in the twenty-first century: women who decide for themselves what missions to pursue, confident in their skills and the appropriateness of their decisions and involvement? Shivani is complicated as a marker of social values, because she actively steps away from many of the values usually assigned to women—caretaking in the home, involvement in extended family life—but does embody many of the values usually assigned to men—physical protective action, involvement in and humaneness for the public sphere, self-determined pursuits thinly disguised under the umbrella of "duty." *Mardaani*'s hero also does not fit the "recognition of women as despised markers of both social values and of the 'specious good.'"[10] Rani Mukerji also played this sort of topsy-turvy woman-as-hero in the comic romance *Aiyyaa* (Oh My! 2012, dir. Sachin Kundalkar), where she chooses and pursues a romantic interest with a zeal and disregard for social consequences never seen in a Hindi film heroine. In *Aiyyaa*, these actions read as absurd and desperate simply by being assigned to a conventionally attractive woman.[11] In *Mardaani*, Shivani's story is surprising for similar reasons: a woman taking officially-permitted action on behalf of someone else, with an eye towards the public, rather than the good of a specific family or love interest.

Shivani also operates beyond religious and personal spheres. The authority with which she investigates and apprehends villains is formally established and legally recognized, not temporarily granted by divine power in a private moment of prayer or worship. Elsewhere in this volume, Kathleen M. Erndl discusses the avenging goddess figure in Bollywood. She writes:

> A woman can also manifest the fierce aspects of the Goddess when pushed to the limit and redressing injustice. A woman, subject to violent oppression, transforms into a horrific Durgā or Kālī-like goddess to exact revenge upon the demonic forces and re-establish justice. This she does with bloodshot eyes and wild hair, wielding a sword, axe, or sickle, or even tearing at the flesh of the miscreant with her teeth. Severed heads are often involved.[12]

Shivani does not manage to re-establish justice on a grand scale, as the final narration of the film makes clear. The justice she gets is limited: the criminals in this particular story are part of a larger, global web, and the victims have the rest of their lives ahead of them, with no indication by the film of how they will cope with what they experienced, how their families and society will treat them, etc. Erndl suggests that *Mardaani* may verge on transforming Shivani into an avenging goddess. In the last confrontation with Walt, "a non-diegetic voice in

the background chants: *ya devi sarvabhiuesu sakti rupena samsthita* (Devī, you live as power in every being in the form of *śakti* [feminine energy]). The film ironically is called *Mardaani* (manliness), while the *dhvani* clearly establishes the female power."[13] This moment seems to be more a cue for the viewer, connecting a specific moment to other Hindi film tropes, rather than a conscious thought by Shivani. There is no evidence that she is a religious person.

Mardaani's lead presumably functions within the hierarchical structure of the police, but she seldom discusses her work with a superior officer. Her work is centered on the public good; even though the investigation at the center of the film is initiated through Shivani's family-like relationship with Pyaari, the film actually opens with her team successfully working a case to which she has no personal connection. Shivani's world has expanded beyond the home: while love of family was the impetus for Shivani's quest, her professional duties are the wider context and establish as reasonable the skills she must use to complete it. Shivani is not a lioness protecting her cubs. She is a professional protecting her society. The film's writers (Gopi Puthran and Vibha Singh) also avoid assigning her most of the traits and tasks that female leads are usually given: she focuses her energies entirely outside of the domestic sphere, unfettered by the social expectations that tend to accompany married women in films. The fact that she and Bikram both work outside the home and do not have a biological child is presented as neither shortcoming nor tragedy.[14]

Shivani disciplines herself. She carries and uses weapons; she jokingly but with truth compares herself to one of the most famous male police officers in recent Hindi films (Chulbul Pandey, played by Salman Khan in *Dabangg* in 2010); and she works within the limits of the patriarchal and traditional police system. Following procedure is little discussed, so we can assume that characters do not give much weight to it and that we viewers shouldn't either, since Shivani's mission is more meaningful than following proper channels. She isn't going rogue, exactly—for example, she checks in with a senior officer in Delhi to whom she has a personal connection—but rules are not discussed. The world of the police in Hindi cinema is not particularly restrained, and we routinely see officers like Chulbul Pandey breaking the laws of physics in fight sequences, as well as taking illegal vigilante-type action to solve crimes to which they have an individual personal attachment. Compared to her professional peers in recent Hindi films like the *Singham* series, the *Dabangg* series, or even the *Dhoom* series, Shivani seems like a throwback to officers of the 1970s who are depicted as physically strong and morally uncompromising but who work at a human scale. Her final confrontation with Walt is hand-to-hand and utterly alone. Like

many cops of many eras of films, she blends professional and personal duties and codes of conduct—and is mostly left unsupervised with the freedom to do so.

Just as it makes its hero a woman, Mardaani assigns the traits it considers monstrous to men. Wanton male desire is primarily the root of the fear in *Mardaani*, and a woman in a very non-traditional role for her gender dispels it and presumably puts victims back on their rightful path home. Their safe return from trafficking does not necessarily return them to "normative femininity."[15] Depending on what their families and social circles learn of their ordeal, they may be outcast from consideration for traditional marriage and motherhood: like Sītā, their sexual status may be assumed to be compromised, regardless of their utter innocence of how the status was lost. Their fate is unknown, and in the case of Pyaari, there is no guarantee she won't be abducted again, especially with the shadow of already having been rescued by Shivani once before the film begins.

If in many Hindi horror films "exorcism becomes the means not only of expelling the interstitial phantasmal being but also of punishing and disciplining the female body for unrestrained desire and look,"[16] then *Mardaani* also updates this idea: it is men who exert power from dark corners in the name of fulfilling other men's lusts. Female desire is not an issue or method in the film. Male scopophilic gaze is at play and presented as wrong, notably at the parties where the traffickers' clients can shop for girls they want to rape.

Mardaani does not explicitly put forward a "patriarchal fear of the all-powerful feminine," as Mubarki puts it, but it certainly does exist "within the larger framework of cultural misogyny."[17] It tries to pull the viewer in a little bit to this particular type of crime and wants us to look at the people who engage in it and sanction it. There is an extremely cathartic moment in which multiple victims punish their perpetrator, and what makes this scene work so well is that the punishers are so unlikely to get such an opportunity, even in cinema: they are female, they are young, and some of them come from very underprivileged backgrounds. They are, by most definitions, nobody, but the film lets their presence be felt strongly.

Pushing Definitions of Acceptable Womanhood in Pradeep Sarkar's *Laaga Chunari Mein Daag*

Mardaani shares some similarities with director Pradeep Sarkar's second feature film, *Laaga Chunari Mein Daag* (My Veil Is Stained, 2007), also starring Rani

Mukerji. This too is a story about the dangers of the big city for young women, but it more directly discusses women taking on typically masculine duties like bread-winning and protection. Mukerji plays Vibha Sahay, the older sister in a financially struggling nuclear family threatened with homelessness by inheritance claims on their house. Vibha moves from Varanasi to Mumbai to earn for her family; upon arriving in Mumbai, she discovers that office jobs are not open to her because of her lack of education, so she becomes a sex worker catering to elites. Vibha's father (Anupam Kher) belittles her decision to move to Mumbai, saying she's just pretending to be a son and will accomplish nothing. Once she starts sending large amounts of money home that enable the Sahays to repair and protect their house, he describes her success in similarly gendered tones (unaware of how she earns): "She's our son now," he proclaims to his wife Savitri (Jaya Bachchan) (who until this time has been the family's primary earner through her sewing). At the conclusion of the film, when he admits to the family his own shortcomings as a proactive patriarch, he tells Savitri that he knows his failures required her to be both mother and father to their daughters.

Mardaani omits the gendered assessments that *Laaga Chunari Mein Daag* voices through Vibha's buffoon-ish, failed father. Shivani's suitability for the police force is assumed, and the film spends no energy showing how she earned her place there. Her professionalism and competence are as matter-of-fact as any Bollywood hero's strength or wealth. Shivani's world is established with confidence, and no details need to be justified in order for the stories to work. *Mardaani* also sheds the religious rectitude implicit in *Laaga Chunari Mein Daag*'s setting in the Hindu holy city of Varanasi and Vibha's visits to a Mumbai temple.

In both films, Sarkar disrupts the traditional norm of honor (*izzat*) so commonly assigned to women by men in Hindi cinema. He implies that women can continue their lives after unconventional experiences that change their sexual status—and that there are far worse fates than existing outside sexual "purity," whether by desperate semi-choice (Vibha) or by other people's crimes (Pyaari and implied others). The films reject any questioning of Vibha's or Pyaari's worth. *Laaga Chunari Mein Daag* depicts this social acceptance concretely by employing traditional markers: Vibha marries a love interest who knows about her past, and they celebrate within the embrace of her family and home community. The fact that *Laaga Chunari Mein Daag* was a box-office flop[18] may suggest audiences at the time were uninterested in soapy sacrifice and reward on the big screen. The fate of the girls Shivani rescues is unknown, but their agency and freedom are not ruled out, now that they have demonstrated emotional and physical bravery. A few decades ago, films regularly depicted

villains abducting, raping, and/or pimping out daughters or sisters of the central family in a narrative, with victims then committing suicide rather than transfer the "dishonor" of their victimhood to their family. But *izzat* is yet another traditional power and social dynamic that *Mardaani* refuses to engage with. The film will not judge or write off victims of sex crimes. Interestingly, this bleaker, less conventional film was much more financially successful, earning well over double its budget at the box office and supporting a sequel on similar themes in 2019.[19]

Beyond Avenging Women

In "Avenging Women in Indian Cinema," Lalitha Gopalan lays out a standard narrative for a specific type of film, from which *Mardaani* diverges in several ways. In Gopalan's typology, a happy family exists without a dominant father figure, and their stable existence is upset when the female lead is raped. The court system fails the protagonist, at which point she transitions in status from victim and sexual subject to avenger.[20] At the end, "the avenging woman's unhindered access to power is always limited by the arrival of the police."[21] The 1980 film, *Insaf Ka Tarazu* (The Scales of Justice, 1980, dir. B.R. Chopra), in which fashion model Bharti (Zeenat Aman) is raped and then kills her attacker after he also rapes her younger sister Neeta (Padmini Kolhapure), is a key example of this type.[22]

Mardaani is not constrained by the older standard formula. A happy family exists, but it is non-traditional, with the married heterosexual couple not having biological children of their own and instead reaching out to other children. Shivani herself may be read as the paternal figure, given the non-hyper-masculine nature of her husband. *Mardaani* limits rape as the traditional fuse to action for both male and female protagonists and replaces it with threats to Shivani's and the girls' self-determination and personal agency. And because of Shivani's profession, there is no point of transition from victim to avenger or from vigilantism to formality. She is already a representative of the state with legitimate powers and responsibilities to apprehend criminals.

Underscored by the rapist's use of locked rooms and bondage, *Insaf Ka Tarazu* limits the autonomy of both its lead women characters, including vengeance on their own behalf. The film only lets Bharti kill the rapist after he tortures and attacks her sister, and because he dies by someone else's hand, Neeta is denied victory over him as a plaintiff in court or as a vigilante. *Insaf Ka Tarazu* also insists that society has a right to and authority over women's bodies. Bharti's job

as a model means she is treated as a commodity that men command, and her fiancé insists that she will stop modeling as soon as they marry so that she can bear and raise children. Bharti herself and at least two other characters state that the rape damages her worth as a person, but in the end the film restores her not just to her pre-victimhood place as a single working woman but even "elevates" her to the imminent status of wife, daughter-in-law, and mother. On one hand, the film rewards Bharti with legal freedom for her vigilante killing; on the other, it implies her utmost reward is returning to the embrace of a (to-be) husband and traditional motherhood contained in the domestic sphere. To a traditionally-minded audience, Bharti's suitability for marriage and motherhood may have been the most terrifying aspect of the film, more than the two brutal rapes and public character assassinations of innocent victims. Even viewers watching the film almost forty years after its release must ask themselves: are we happy that Bharti becomes an unlikely crusader, ridding the world of a violent criminal and upending the legal system with her arguments, or are we happy that she gets what women in mainstream cinema of the time were supposed to want?

Conversely, Shivani enjoys unquestioned status and autonomy. Shivani's place in the police force is never discussed: no one wonders how she obtained the rank she has or even comments on why she became a cop in the first place. *Mardaani* rejoices in this confidence. It does not interrogate the girls' behavior to see if they may have done something to suggest they deserve or wanted to be trafficked. Women and girls deserve autonomy.

Mardaani also diverges from films like *Damini* (Lightning, 1993, dir. Rajkumar Santoshi), in which a rape of another character becomes the catalyst for the female lead risking her own safety by testifying against her husband's brother in court. In *Damini*, heroic action is spread across at least three characters: the titular Damini (Meenakshi Sheshadri), who witnessed the rape and bravely goes against her in-laws' wishes to cover it up to protect their reputation; her husband (Rishi Kapoor), who also witnessed the rape and is eventually inspired by her integrity to corroborate her testimony; and her lawyer (Sunny Deol), who verbally hammers the defense attorney's arguments in intense courtroom dialogues. Damini as a female lead shares Shivani's moral correctness but flinches when her husband is cross-examined in his initial statements that deny the crime. Her physical strength is also not called upon. When attacked by the opposing attorney's goons on the way to the courtroom, she picks up a weapon and challenges them, but it is a huge crowd of onlookers who actually fell her attackers, pelting them with bricks from a construction site. *Mardaani* rolls the ethical guardian, the orator, and the attacker into Shivani's character and has no need for

male saviors. Damini is named for lightning, a natural phenomenon as visually striking as it is dangerous; Shivani's middle name is Shivaji, the seventeenth-century Maratha warrior king. *Mardaani* also dismisses *Damini*'s idealized courtroom outcome as useless fantasy, deciding that potential formal justice isn't worth an uncertain slog through the corruption, misogyny, and backlogs of the courts.

What sets *Mardaani* apart most significantly from the standard rape-revenge formula, including films in which a female police officer is raped and formulates a violent revenge plan (such as *Zakhmi Aurat* (Wounded Woman, 1988, dir. Avtar Bhogal)), is that the lead female character is not raped. The crimes are perpetrated against someone the lead cares for, the same structure often followed by male hero-centered films. The threat of rape lurks constantly, not just because Shivani routinely visits dangerous locations full of criminal men through the responsibilities of her profession, but also because of the trafficking of the young girls, in whose lives we know rape will occur imminently and repeatedly.

In reference to *Insaf Ka Tarazu*, which Gopalan describes as "the inaugural moment in the avenging woman genre," the author discusses "our inability as spectators to tell the cinematic difference between a scene of sexual consent and rape."[23] *Mardaani* avoids any confusion by making all of the sexual objects children, whose inability and unsuitability to give informed consent to sexual activity are never questioned. There is no leeway for interpreting their actions as consensual or even desirous, as the rapist's lawyer does in *Insaf Ka Tarazu*. The film states clearly that the criminal gang's activities are reprehensible.

Mardaani refuses to show female bodies in pleasure, denying the audience titillation through the criminals' lens and thus emphasizing their wrongness. The only "body genre" it focuses on is horror, depicting female bodies in emotional extremes of terror and violence.[24] It more often shows the former but, quite significantly at the film's end, the latter as well, where one specific woman is subjected to violence as part of her job and other women, at her behest, commit violence against their perpetrator once he has been subjugated enough to no longer be threatening. Their violence is for revenge rather than containment.

As Gopalan points out, "revenge allows female stars to dominate the screen, but the [avenging woman] genre demands that a violent assertion of masculine power in the form of rape is the price to exact for such power."[25] Shivani does not have to pay this price. The ability, right, and necessity to assert physical power were hers all along. The significant transition of power in the denouement is from the police to the victims and on behalf of the public, instead of from the victims to the police, as in the described formula. Shivani's physical fight against

Walt to subdue him ends with her handing him over to the now-liberated girls, who beat him further in revenge—or at least catharsis of fear and anger.

Unlike the avenging woman archetype, Shivani's pursuit of Walt is not solely motivated by her own survival of violence. While she is motivated to protect Pyaari, she also wants to make sure other victims can survive. The war in this film isn't as personal as the film's tagline suggests. Contrast this with *Kahaani* (Story, 2012, dir. Sujoy Ghosh), which also features an independent woman out in the public world demanding answers and finding perpetrators to specifically personal crimes. *Kahaani*'s female hero Vidya deliberately uses her pregnancy, a uniquely female state, to lower people's expectations of her skills, to distract them from her true goals, and to create sympathetic responses that benefit her. Visibly very pregnant, she comes to Calcutta from Mumbai to investigate the disappearance of her husband two years earlier. Vidya quickly ingratiates herself into a city police station, thanks in part to her technical skills as a computer scientist but mostly due to the emotional response to her plight by a particular officer, who becomes her sidekick and whose presence provides access to resources and formal authority to her personal quest. In the film's final sequence, acting on her own, Vidya kills one of the villains and disappears into a crowd of women celebrating Durgā Pūjā, all dressed in similar red and white saris while worshipping the goddess. We learn that Vidya's pregnancy was just a disguise and that she had miscarried a pregnancy upon learning of her husband's death two years ago. Vidya's actual status as a childless widow is not nearly as sympathetic as the role she has cleverly created and convincingly played, a possibly single mother who physically carries a more traditionally respected bond to her husband. Shivani's sexual and parental statuses do not enter into anyone's assessment of her. She claims as much agency as *Kahaani*'s lead but does so with more of her own authority and less duplicitousness.

The finale of *Mardaani* holds only a partial "conventional rearrangement of law and order."[26] The criminals who survive are arrested, and the most important antagonist dies. But beyond the immediate freeing of the victims, most threads are left loose. We don't see Shivani returning to Mumbai or reuniting with her husband, and she doesn't need to be reintegrated into society because she was already on its fringes. We don't see the girls reintegrating into whatever society they left. The film's point is that this cultural horror is not over, and it refuses to let these particular characters stand in for a society in which the global problem of child trafficking is resolved. The narrow specificity of its conclusion is unsettling.

Notably, Shivani does not represent formal justice, as the film ends before we can see any legal action taken. Explicitly naming the inability of society's systems to

prevent crime and to protect women and girls, Shivani calls on all of them to become their own *mardaani* as the war on exploitation continues. The film recognizes the limitations of the state in prosecuting such crimes. She wants to stop Walt from committing these crimes again, whether or not the public will ever know if this goal is met. Shivani and then the girls annihilating an adult man is just one of the horrors in the finale: justice is determined by the victims themselves, not by any civil authority, and in scale far greater than is necessary to subdue the evil-doer.

In these final scenes, Walt too points out the justice system's failings in punishing criminals like himself. He taunts Shivani with the inefficacy of the system, asking what tools are in her repertoire other than the physical violence she's inflicting. She turns the argument against him, implying that society overlooking corruption and unauthorized action benefits her cause as well.

> **Shivani** "You're right. This is India. This is what goes on here," twisting his neck. "Those people sitting outside will bury your crime? They can do it only if you reach the police station. But you won't reach the police station because this is India. If you don't want to bother the court too much, issues can be settled this way. Some people call it an encounter.[27] Some people call it teaching a lesson… Some also call it the Lokpal Bill."[28]
>
> **Walt** "What's your plan? An encounter in front of everyone?"
>
> **Shivani** "This is India. If 50 people take the law in their hands and kill someone, then it's not called an encounter. It's called 'public outrage.'"

At this point in the action, the devotional chant Erndl noted and the sound of a conch appear. Shivani looks directly at the girls before leaving the room, and Pyaari leads their attack on Walt. Divine and popular power are invoked as Shivnai wordlessly gives the girls permission to take their revenge. *Mardaani* extends the concept of righteous, invigorating revenge to a group unlikely to have agency and whose voices are usually ignored or silenced: females who are young, poor, and even orphaned. Shivani does not wait for any other official to appear and instead immediately encourages the victims to physically unleash their anger and fear. The girls represent India, backed by the ideological power of a hypothetically enraged populace and a direct, uncontrolled democracy.

An Ordinary Monster

One of *Mardaani*'s most frightening choices is to make the villain Walt into an average-seeming thirty-something man. Film critic Anuj Kumar of *The Hindu*

says, "Sarkar doesn't portray the villain as the odd one out with a hideous laughter and obvious choices. In fact, he is the most ordinary character in the film... It is this familiarity with the villain that sucks you in and keeps you anxious about his next move."[29] Walt is absolutely terrifying, both at the personal level through his unremarkable everydayness and at the societal level in the lack of consequences for his cruelty to children.

His surface appearances as a film character suggest Walt could be the friend of any standard urban Bollywood hero. But the film uses this blandness to conceal destructive actions and monstrous traits. From behind his invisibility, he provokes anxieties and fears. He actively threatens traditional domesticity by removing girls from their homes and enabling his clients' philandering. His personal entrepreneurial success comes at a very high cost to other people. He's close enough to his mother to work with her, though the story never explores whether their bond is based on affection or fear. Walt's room looks like that of many urban heroes and their friends in Bollywood films of the 2010s. In fact, Walt's apartment is the closest *Mardaani* gets to what Meheli Sen labels new horror's obsession with carefully-accessorized urban apartments.[30] He has an expensive computer, a bookshelf, and images of Western pop icons (John Lennon on the pillow and a framed poster of his namesake Walter White from *Breaking Bad* just above it). Walt's heroes are foreign, perhaps a symbol of the economic and cultural globalization of which the trafficking network is also a part? This vaguely aspirational but predictable setting would render Walt forgettable if it weren't for his horrifying actions.

The actor (Tahir Raj Bhasin) plays his interactions with Shivani as almost deadpan, as though Walt doesn't really find her threatening and is only bothering to taunt her because he knows she will react, despite her efforts to sound blasé. Bhasin's casting is significant: a relatively unknown face in his second feature film, this actor is a blank slate. He elicits no major preconceptions in the audience of villainy or heroism. This actor can almost slip past audiences the way Walt slips past the Mumbaikar bystanders to his crimes.

Through interviews with horror film audience members, Shakuntala Banaji found that "For Hindi horror audiences, it appears to be a combination of banality and otherness that characterizes the monstrous."[31] Walt looks and sounds banal, but his actions reveal his monstrousness, and *Mardaani* chooses to focus on what the villain does and how that impacts society rather than on who he is and his identity's significance to his actions. Walt as an individual adds nothing special to the crimes he commits, his facelessness an insidious part of

the arms of trafficking rings. His averageness may be key in sealing his fate as well: specifically because he appears to be an average person who could easily disappear back into the crowds and continue his crimes, Shivani must eliminate him as soon as she has the chance. *Mardaani* mutates this exceptionally unexceptional young man: if he seems so normal, why is he so pointlessly evil, and how can he become so disposable? The film does not give him the respect of an explanation. In the end, his punishment—becoming a corpse who never even gets a TV news camera shined on him in an arrest or courtroom—mirrors the facelessness of the girls he stole.

Walt's involvement in the child trafficking ring is evil for the sake of profit. There is no specific or emotional motivation in his choice of how to earn money. He apparently has no connection whatsoever to his victims: unlike villains in Hindi films of other eras, he does not target the relatives of his (or his family's) enemies or try to expunge from society people he feels are transgressors or inferiors. His targets are not predetermined or predictable. He seems deeply detached, and that's part of what makes him scary. His businesslike demeanor, talking with Vakil about the girls like widgets on an assembly line, is a weapon against Shivani, who tries her best to put on a cool façade but whom we know to be deeply upset. Towards the end of the film, we learn about Walt's family tie to Minu, as well as his very emotional connection to Vakil, who stands as a father figure to him just as Shivani acts as a mother figure to Meera and Pyaari. It is only after these affiliations are revealed that Shivani gets close enough to defeat him, as though his bits of humanity form a useful crack in his shadowy persona.

By some definitions, Shivani too may be a type of villain in her choices that oppose Hindi cinema's traditionally preferred roles for heroes and heroines. As described, she resolutely does not fit the categories mainstream Hindi films like to assign to women in their thirties. She is a married, healthy woman without a biological child, a figure whom Hindi cinema typically pities at best. She displays great physical strength and exerts herself in areas other than dance, the medium through which women performers are expected to show aptitude. Her husband's profession is much less macho than her own. They are both caretakers, but her work is completely outside the home, public-facing, and more system-focused, while his is done in privacy, one patient at a time. We never meet the Roys' neighbors, but if we did, they would probably gossip about the unusual couple. Neither Shivani nor Pyaari have parents, yet these motherless females are in a better moral position than the villain who works in tandem with his.

Children and Vulnerability

Film scholar Meheli Sen points out that Bollywood has largely ignored the physical and mental plights of India's children (e.g., participation in the labor force, extreme stress in competitive school exams). She writes, "melodrama's favorite stomping ground—the family—becomes, almost exclusively, the site for the eruption and elaboration of the horrific."[32] *Mardaani* extends the fear by removing children from their families (both biological and functional, in the case of Pyaari). If the modern nuclear family is a marker of economic and social progress, *Mardaani* upends these concepts by explicitly refusing to show any such families and implicitly indicating that they cannot protect their most vulnerable members.

Mardaani centers the plights of children in one specific way, depicting an extreme version of what children, specifically prepubescent girls, could suffer. *Mardaani* uses children as signifiers of hope and resistance: most of the girls resist succumbing to the criminals' way of life, unlike Alka (Sharika Raina), a young woman who was once one of them and now helps groom them. Still, ultimately the children read as a question mark. At the end of the film, we do not know whether they will reunite with their families, succeed in school, or be restored to perfect health. Their future is unsecured. Even Shivani's narrative contains no finality; she talks about restoring a smile to Pyaari's face rather than establishing a new life for her with financial and bodily security.

Children slide more easily between worlds: they are small, they are ubiquitous (maybe especially in urban India), and they are curious, often wanting to explore unknown spaces. As Pyaari is broken off from the system that tries to look after her (school, Shivani), she slips into the world we try not to see. Once kidnapped, she and the other girls must exist in between identities, mourning the one taken from them and resisting the one forced onto them. Sexualized children fall outside standard social taxonomies. This is the abject—defined by Meraj Ahmed Mubarki as "that which threatens to break down the distinction between the subject and the object or between the self and others"[33]—that *Mardaani* illustrates. Stealing children, hiding them, and relocating them for money is the method of abjection, and we even see the hero slide into the world where this crime happens, starting with the impetus of Pyaari.

The film expands the concept of vulnerability beyond the victimized children. Most of the characters are shown in a weak or exposed state at least once. Vakil is frightened by Shivani's close pursuit into killing himself rather than giving up information that would endanger the rest of the gang, and Walt is left shaken by his death.[34] The gang kills off some of its own members to stop them from

informing, and powerful clients are eventually apprehended. Even Shivani is physically distressed when Walt sends her Pyaari's severed finger. Friends, families, and professional networks are uncertain in modern urban India. The international criminal web of which Walt, Vakil, and Minu are a part threatens the innocent (children) and destabilizes the middle-class comfort (Shivani and Bikram). As Sen suggests, "recent Bollywood horror films function as excellent barometers for India's post-economic liberalization anxieties... [T]he genre articulates the under-tow of the large transformative processes brought about by globalization via the depiction of fear, resentment, vulnerability, and disempowerment."[35]

Although *Mardaani* does not really have a subplot, certainly not one unrelated to the main story, there is an important small episode about Shivani's husband Bikram, whose demographic category of professional-class male suggests he is the most secure character in the film. But Bikram too is shown as vulnerable. A right-wing mob Shivani disrupted and publicly scolded earlier in the film attacks him at his workplace, humiliating him. Later, he is as horrified by Pyaari's dismembered finger as Shivani is—Walt's monstrosity has now infiltrated Shivani's most intimate space. Referring to the culprits, he tells Shivani "Hunt this guy down, no matter what." The film cuts to Shivani in Delhi, talking on her cell phone. His voice on the other end says "Be calm. You are the most dangerous when you are calm."

In these two tiny moments, Bikram becomes an almost fatherly figure before departing from the film: he offers comfort, voices a moral imperative, and gives advice. The film is not interested in the question of whether Shivani's departure to Delhi leaves Bikram more vulnerable. A further attack on her partner is less important to Shivani than the safety of the children. To Shivani, the good of the collective outweighs that of the individual, even though that choice requires much greater physical risk. Bikram's interactions with Shivani are a reminder that she is not a completely solitary figure and that other people would notice if she were to vanish from the fabric of society. This woman's life is significant, and she extends that significance to the girls who are victimized by Walt.

However, Bikram is essentially inconsequential to the film's central story. He does not appear in the second part of the film at all. This absence mirrors the structure of many Hindi films in which female characters (mostly mothers and love interests of heroes) vanish from stories while physical action sequences dominate towards the climax, only to reappear or step in from the sidelines in the very final scene in which a family unit is reunited. For some viewers, the emasculation and irrelevance of this Hindu patriarch may be the film's biggest horror element.

Maximum City Horror

The urban settings of *Mardaani* are crucial. The crevices and hiding spots of the modern Indian city permeate the film; even the scenes shot in daylight have a layer of dread, especially once Pyaari goes missing. There is darkness, startlingness, mystery, and fear.[36] The film makes clear that the horrors of sex trafficking and child rape that seem ancient, or at least as though they should be relegated to history, exist just as much in the here and now. As Sen explains,

> The supernatural's retreat from the rural haveli to the urban high-rise has not necessarily signaled a disabling of feudalism in this larger sense... If the narrative of South Asian modernity remains constitutively unsettled, forces of globalization have further complicated the scenario... Put differently, the genres of the supernatural—perhaps more efficaciously than many others—demonstrate that the feudal/modern, past/present, myth/history binaries that remain so beloved to Hindi cinema, in fact, crystallize as mutually haunted categories.[37]

The film quietly suggests that growth of cities and the technologies and infrastructures that enable them are part of the systems of child trafficking. Crowds unknowingly obscure girls going missing. Highways connect Mumbai to Rajasthan to Delhi. Mobile phones capture images of victims and obscure perpetrators' locations. While *Mardaani* does not discuss the history of child trafficking, it implies that the current era is no more enlightened than what preceded it. Perhaps this crime may be read as a Gothic haunting of the present-day dense urban landscape by colonial histories of violent displacement of populations.[38]

By initiating the story of the kidnapping in Mumbai, India's financial capital, the film suggests a nightmarish extension of capitalism. The city stands for the triumph of money over values, with both the risks and freedoms that entails. Wealth and efficiency have created a monstrous machine that turns human children into sexualized automatons and financial profit. When people like Walt, Minu, and Vakil are given freedom to choose how they live their lives, this is the path they take. *Mardaani* juxtaposes the rich and poor in a predatory relationship, mediated by what appears to be middle-class criminals and interrupted by middle-class police. This is where some of the film's fears lie. The vast middle classes—most of us—have a role in furthering these unethical, exploitative transactions, and we also have a role in stopping them. The victims and perpetrators of child trafficking exist in a hidden city that remains out of view mostly because the rest of us don't know or bother to look for it. Current horror

films, as Sen argues, "reflexively render late capitalism as a fissured, contradictory, and contested terrain in spaces like South Asia."[39] The monster in *Mardaani* is specifically urban: an uncontainable global trafficking network, motivated by greed and feeding off of the most vulnerable and overlooked in a society that ironically has sufficient resources to protect them.

Mumbai is also the entertainment capital of India, but that's not the version of the city that *Mardaani* inhabits. Stylistically, *Mardaani* is remarkably unadorned, devoid of Hindi cinema's famous imaginative exuberance. Instead of using music to let viewers escape the increasing fear of the story through the magic of song-sequence teleportation, comic relief, or elements devoted to glamor, this particular piece of Mumbai-created cinema drags us into a disorienting secret holding cell, where childhood, safety, and identity are interrupted. There are no weddings or fantasy sequences, no undercover missions that require Shivani to dress in expensive clothes or blend in at a five-star hotel. The two scenes with colorful costumes and attention to physical appearance are focused on the trafficked girls being dressed and made up against their will in order to make clients "see their lovers, not their daughters," as Minu says as she grooms them. Even with the aspirational, glamorous Yash Raj Films as its production house, *Mardaani* depicts an unhappy modern city: "Even as horror becomes more technologically competent—referencing a shinier, more global India—it continues to interrogate this gloss through narrative and content."[40]

In addition to ignoring urban pleasures and conveniences, *Mardaani* creates a city that is unsafe and unstable. It is the terrain of the disruption of moral order as well as of the rational thinking used to apprehend those who disrupt. When the film follows Shivani to the criminals' hub in Delhi, the urban landscape expands to include the capital and, by extension, the nation. It enables these monsters who seem like ordinary people, living in ordinary places. The hero is as isolated in the metropolis as her counterparts in horror films set in villages or rural mansions. The film isn't interested in showing the city fighting alongside her. One poster for the film shows only Shivani in plain clothes and Vakil's body, with no other officers or even symbols of her official authority.

"Every war is personal," the tagline says, and the end of the film shows us that "personal" also carries the sense of "individual" or "self-determined," as Shivani works almost alone in apprehending Walt and his crew and as the girls recognize their own physical strength and anger. By showing them as unhelpful in protecting Pyaari, *Mardaani* rejects the assumed good of automatic and inherited social groupings such as the neighborhood, the school, or the biological family. Instead, the story is based on connections forged person to person—antagonist,

friend, mentor, colleague, protector. The social freedoms experienced in the city require a self-determination that is in direct opposition to extended family systems and traditionally assumed roles.

Nor can victims or their protectors rely on the divine. Justice comes through hard work and logic by humans. *Mardaani* seldom refers to the divine and only once in the final sequence, when Shivani states that a divinity meted out Minu's punishment: a person so invested in control and machinations was stricken with paralysis. All principal actors in this world are human and all the systems and resources are secular. By its omission from the film, religion is portrayed as irrelevant. In her final voiceover, Shivani says she and her colleagues could save Pyaari, but there are many others who need to be rescued. These particular criminals were brought to justice, but many others remain. Each woman will have to discover her inner *mardaani* (translated as fighter) to win the war. The closing scene offers no guarantee of a sunny future or of omnipotent protectors, and the statistics on child trafficking (i.e., 1.2 million children trafficked worldwide for sexual exploitation), it quotes from the UN support this outlook.

Values of light and dark are combined to uneasy effect in *Mardaani*. During a scene of Pyaari being eyed by a politician at a party, Walt's voice (speaking to Shivani in another room) narrates that girls are abducted in broad daylight—public and highly visible areas are a locus for evil. The eventual rescue is at night, and we never see the sunrise of the next day. The optimism of the lyrics in the closing song, in which the girls stride forward confidently and independently, is countered by the dark street on to which all characters exit. Rule of (informal) justice prevails this time, but it must struggle, case by case.

Unlike the heroes of India's first post-Independence horror film who traveled from the rural and irrational to the urban and Nehruvian rational over the course of their stories—the ghost in *Mahal* (1949) turns out to be an ordinary girl who fell in love with an old painting[41]—Shivani cannot emerge into the light at the end of the story. The underworld in *Mardaani* is dark and overlooked like a decrepit *haveli*, but it is physically closer to the everyday world. As the child victims demonstrate, it is distressingly easy to slip between the two. A woman is the "urban-rationalist hero" here, and she uses reasoned thinking and physical strength to restore people from victimhood to their rightful place, at least for the time being.

In the Indian context, *Mardaani* may be Nehruvian in its secularism, but there is only limited confidence that individuals will make better choices. If, as Nair says, Ramsay Brothers films "could be said to dramatize this unraveling of state authority and secular consensus that had underpinned the Nehru years,"[42] then

Mardaani goes a step beyond unraveling to irrelevance. The depiction of state authority is shared between police and a politician, one good, one bad, canceling each other out. Somewhat like a *noir* hero, Shivani has little hope in the future. She looks ahead with a sort of weary resolve: there's a lot of "if" implied in her final narration. The film's alarming outcome is not fully certain of social progress and the prevalence of rationalism, but neither does it surrender to the inevitability of chaos and suffering. The public can defeat evil but only if we try, even those of us most likely to be its targets. The real horror in this world—our contemporary urban world—is that there is no divine power to save us, and we can't automatically rely on people in positions of power. We have to save ourselves.

Conclusion: Order Restored?

Mardaani constructs its action on a firm foundation of women's agency. It is female in the subject who carries out the actions associated with the hero of an investigative thriller, as well as in the objects and motivations of her actions. Even in its final voiceover, the film argues the importance of women and girls looking within themselves to find the strength to take further action. Unlike *Damini*, in which a woman's witness testimony is not enough to convict wealthy young men of rape but the addition of her husband's testimony spurs the court's conviction, *Mardaani* says a male savior is absent, unlikely and, most notably, unnecessary. "The massive ideological apparatus that typically underpins commercial Hindi cinema"[43] has largely been absent from the film and remains irrelevant and ignored in its final points.

Says Sen, "the horror genre continues the Gothic tradition of staging a confrontation with the feudal: these films enact a reckoning of sorts with what has come before and will not be easily left behind or rest easily in the dungeons and grottoes of the feudal haveli."[44] While *Mardaani* does not comment on the historical roots of child trafficking, as I mentioned earlier, or the lack of control over appetites and bodies more generally, Shivani confidently and violently confronts the patriarchal monstrosity of the crime and, more significantly, the lack of formal justice for its victims. The film leaves us without the kind of firm answers that we tend to hope for, including any solution to the "real-life" horror of child trafficking.

How could such a solution actually be created? The film provides no suggestions. Technology cannot help much, because these crimes are largely unplugged except for mobile phones, and even those are locked away at the

auctions. Politicians are the criminals' clients. Bystanders lack the moral courage to pay attention and intervene. No civic rituals can be performed by police or the justice system to bring Walt to justice.

In "Bollywood Horror as an Uncanny Public Sphere," Shakuntala Banaji uses the wonderful term "wallow" to describe how Bollywood horror elaborates the issues it depicts. These include places that are too quiet, figures who ignore traditional sources of power like men and the divine, victims who seek revenge, and nonconformists who refuse to submit. She writes, "Unlike their romantic counterparts, Hindi horror films do not excise any of these issues: they wallow in them. They probe the effects both of apparently indigenous traditions and of unevenly experienced modernity."[45]

Mardaani wallows unapologetically. For a mainstream production, it shows remarkable refusal to conclude tidily or harmoniously. It will not let viewers leave the film feeling content. It unsettles through its use of superficially everyday people who are revealed to be heroic and monstrous, all contained in metropolises whose promise of modernity does not extend to everyone. In the bleak world of *Mardaani*, women and children must fight for themselves and for other people, talented men must be monitored, and networks continue to spread their dangerous tentacles across the globe.

Notes

Introduction

1. There were also some films that deviated from the Ramsay formula. *Gehrayee* (Depth, 1980, dirs. Aruna Raje and Vikas Desai) was one of the earliest films to eschew the "good versus evil" structure, but it was not considered mainstream cinema since it never got a proper theatrical release and was instead made for television.
2. For an account of the practice in Bangladesh, see Lotte Hoek, "Cut-Pieces as Stag Film: Bangladeshi Pornography in Action Cinema," *Third Text* 24, no. 1 (2010): 135–48.
3. For an example of how horror can be connected to political crisis see Valentina Vitali, "The Evil I: Realism and Scopophilia in the Horror Films of Ramsay Brothers" in *Beyond the Boundaries of Bollywood*, edited by R. Dwyer and J. Pinto (New Delhi: Oxford University Press, 2011), 77–101.
4. Aditi Sen, "Tumbbad," *Open Magazine*, May 17, 2019.
5. See Tim Paxton, *The Cinematic Art of Fantastic India. Volume 1: The VCDs* (WK Books, 2018); Vibhushan Subba, "The Bad-Shahs of Small Budget: The Small-budget Hindi Film of the B Circuit," *BioScope: South Asian Screen Studies* 7, no. 2 (2016), 215–233 and "The Returned: The Rise of B-movie Cinephelia," Sarai.net, April 13, 2016, http://sarai.net/the-returned-the-rise-of-b-movie-cinephilia/, accessed January 20, 2020; Pete Tombs, *Mondo Macabro: Weird and Wonderful Cinema from Around the World* (New York: St. Martin's Griffin, 1998) and "The Beast from Bollywood: A History of the Indian Horror Film" in *Fear Without Frontiers: Horror Cinema from Across the Globe*, edited by Stephen Jay Schneider (Goldaming, UK: FAB Press, 2003), 243–53.
6. Noël Carroll, "The Nature of Horror," *The Journal of Aesthetics and Art Criticism*, 46, no. 1 (Autumn 1987): 53.
7. Carroll, "The Nature of Horror," 53.
8. That is to say, *ṭhags* or thugs.
9. It is possible that this disclaimer is a gimmick to scare viewers in an ironic way like the tagline of *The Last House on the Left* (1972, dir. Wes Craven): "To avoid fainting, keep repeating: 'It's only a movie, only a movie, only a movie . . .'" But this kind of advertising is only necessary before people have actually purchased their ticket, so it makes no sense to put it in where people will only see it after they are already in their seats.

10 One could of course make the same kind of argument about an American film in which a crucifix wards off a vampire. Are Christian audiences compelled to place the power of the crucifix in the same category of make-believe as the vampire it repels? This important question only demonstrates that the study of horror through a religious studies lens is useful outside of India as well. See Douglas E. Cowan, *America's Dark Theologian: The Religious Imagination of Stephen King* (New York: New York University Press, 2018) and *Sacred Terror: Religion and Horror on the Silver Screen* (Waco, TX: Baylor University Press, 2008).

11 Ronald Hutton, *The Witch: A History of Fear from Ancient Times to the Present* (New Haven: Yale University Press, 2017), 34.

12 Sowmya Aji, "Cabinet Clears Anti-superstition Bill with Dilutions," *The Economic Times*, September 28, 2017, https://economictimes.indiatimes.com/news/politics-and-nation/cabinet-clears-anti-superstition-bill-with-dilutions/articleshow/60866028.cms?from=mdr, accessed January 20, 2020.

13 David Gordon White, "*Netra Tantra* at the Crossroads of the Demonological Cosmopolis," *Journal of Hindu Studies* 5, no. 2 (2012): 145–71. They may even have spread as far west as the Mediterranean, where the Ancient Greek *strix* ("screecher") became the Latin *strīga* and the Italian *strega*, both of which refer to (often blood-sucking) witches.

14 See Erik W. Davis, *Deathpower: Buddhism's Ritual Imagination in Cambodia* (New York: Columbia University Press, 2016) and Benedict Anderson, *The Fate of Rural Hell: Asceticism and Desire in Buddhist Thailand* (London: Seagull Books, 2012).

15 Natasha Mikles and Joseph P. Laycock, "Tracking the *Tulpa*: Exploring the 'Tibetan' Origins of a Contemporary Paranormal Idea," *Nova Religio: The Journal of Alternative and Emergent Religions* 19, no. 1 (2015): 87–97.

16 Carroll, "The Nature of Horror," 53–4.

17 Quoted in Sheldon Pollock, *A Rasa Reader: Classical Indian Aesthetics* (New York: Columbia University Press, 2016), 50–2.

18 Pollock, *A Rasa Reader*, 53.

19 Charles Darwin, *The Expression of the Emotions in Men and Animals* (New York: D. Appleton & Company, 1872), 278–308. On Darwin and disgust in the context of Hinduism, see also Herman Tull, "Kālī's Tongue: Shame, Disgust, and the Rejection of Blood and Violence in Vedic and Hindu Thought," *International Journal of Hindu Studies* 19, no. 3 (2015): 301–32 and Thomas B. Ellis, "Disgusting Bodies, Disgusting Religion: The Biology of Tantra," *Journal of the American Academy of Religion* 79, no. 4 (2011): 879–927.

20 Robert Bloch, "Dr. Psycho and Mr. Stein," *Rogue* (January 1962).

21 Devendra P. Varma, *The Gothic Flame: Being a History of the Gothic Novel in England: Its Origins, Efflorescence, Disintegration, and Residuary Influences* (New York: Russell & Russell, 1966), 130.

22 Stephen King, *Danse Macabre* (New York: Berkeley Books, 1982), 25.
23 William Paul, *Laughing Screaming: Modern Hollywood Horror and Comedy* (New York: Columbia University Press, 1994), 48.
24 David L. Gitomer, "Such as a Face Without a Nose: The Comic Body in Sanskrit Literature," *Journal of South Asian Literature* 26, no. 1/2 (1991): 86.
25 Quoted in Edward C. Dimock, "A Theology of the Repulsive: The Myth of the Goddess Śitalā" in *The Sound of Silent Guns and Other Essays* (Delhi: Oxford University Press, 1989), 140
26 Pollock, *A Rasa Reader,* 163.
27 Dimock, "A Theology of the Repulsive," 141-2.
28 See http://indianhorrortales.blogspot.com/ accessed July 12, 2020.
29 Chicago Film Critics Association, "Top 100 Scariest Movies." Filmspotting, October 2006. https://web.archive.org/web/20080117102530/http://www.filmspotting.net/top100.htm accessed July 12, 2020.
30 Arindam Chakrabarti, "Refining the Repulsive: Toward an Indian Aesthetics of the Ugly and the Disgusting," in *The Bloomsbury Research Handbook of Indian Aesthetics and the Philosophy of Art*, edited by Arindam Chakrabarti (London: Bloomsbury, 2016), 152.
31 Shakuntala Banaji, "Bollywood Horror as an Uncanny Public Sphere: Genre Theories, Postcolonial Concepts, and the Insightful Audience," *Communication, Culture and Critique* 7, no. 4 (2014), 468.

1 Monsters, *Masala*, and Materiality: Close Encounters with Hindi Horror Movie Ephemera

1 Stephen Haggard, "Mass Media and the Visual Arts in Twentieth-Century South Asia: Indian Film Posters 1947–Present," *South Asia Research* 8, no. 2 (1988): 73; Rachel Dwyer and Diva Patel, *Cinema India: The Visual Culture of Hindi Film* (New Brunswick: Rutgers University Press, 2002), 110; Ranjani Mazumdar, "The Bombay Film Poster: A Short Biography," in *India's Popular Culture: Iconic Spaces and Fluid Images*, ed. Jyotindra Jain (Mira Bhayandar, India: Marg Publications, 2007), 92.
2 Dwyer and Patel, *Cinema India*, 110.
3 Haggard, "Mass Media," 72.
4 Rajesh Devraj and Edo Bouman, *The Art of Bollywood* (Köln: Taschen GmbH, 2010), 161.
5 Devraj and Bouman, *The Art of Bollywood*, 161.
6 Haggard, "Mass Media," 75.
7 Haggard, "Mass Media," 75.

8 Bhrigupati Singh, "*Aadamkhor Haseena* (The Man-Eating Beauty) and the Anthropology of a Moment," *Contributions to Indian Sociology* 42, no. 2 (2008): 256–7.
9 Dwyer and Patel, *Cinema India*, 102.
10 And so do Indian political poster designs. For a brilliant send-up of these posters from a Chennai-based blogger, see Krish Ashok, "Guide to Designing Indian Political Posters." *Doing Jalsa and Showing Jilpa*, December 10, 2017, https://krishashok.me/2007/12/10/guide-to-designing-indian-political-posters/ accessed July 12, 2020.
11 Catherine Geel and Catherine Lévy, *100% India* (Paris: Éditions du Seuil, 2005), 16.
12 Arjun Appadurai, "Introduction: Commodities and the Politics of Value," in *The Social Life of Things: Commodities in Cultural Perspective*, edited by Arjun Appadurai (Cambridge: Cambridge University Press, 2017), 5.
13 The reality of their precarious existence was brought home to me when a poster was rolled out for my inspection and immediately ripped in half right down the middle (after which it was subsequently marked down in price).
14 Geel and Lévy, *100% India*, 15.
15 Appadurai, "Introduction," 5.
16 See Brian Collins, *The Other Rāma: Matricide and Genocide in the Mythology of Paraśurāma* (Albany: SUNY Press, 2020).
17 Richard Kearney, "Diacritical Hermeneutics" in *Hermeneutic Rationality*, edited by Maria Luísa Portocarrero, Luis António Umbelino, and Andrzej Wiercinski (Münster: LIT Verlag, 2012), 195.
18 Ruth S. Freed and Stanley A. Freed, *Ghosts: Life and Death in North India* (Seattle: University of Washington Press, 1994), 80–1.
19 Pete Tombs, *Mondo Macabro: Weird and Wonderful Cinema from Around the World* (New York: St. Martin's Griffin, 1998), 85.
20 See William Crooke, "Demons and Spirits (Indian)," in *Encyclopaedia of Religion and Ethics, Vol IV, Confirmation-Drama*, ed. James Hastings (New York: Charles Scribner's Sons, 1908), 601–7. I should note that there are some exceptions, like the 2013 film *Ek Thi Daayan* (dir. Kannan Iyer) and a single scene in the Ramsay brothers' *Veerana* (Desolate, 1988) in which a man picks up a possessed woman hitchhiking and is then horrified to watch her right foot turn around backwards as she sits next to him in the car.
21 Pete Tombs, "The Beast from Bollywood: A History of the Indian Horror Film," in *Fear Without Frontiers: Horror Cinema from Across the Globe*, ed. Stephen Jay Schneider (Godalming, UK: FAB Press, 2003), 246.
22 Personal conversation, July 18, 2016. A real-life *lomaharṣaṇa-katha* ("hair-raising tale"): At one point, Aseem's grandmother threw all his posters away.

23 Vidya Dehejia, "On Modes of Visual Narration in Early Buddhist Art," *The Art Bulletin* 72, no. 3 (1990): 382.
24 Devraj and Bouman, *The Art of Bollywood*, 161.
25 Mohammad Shahid, Prasad Bokil, and Darmalingam Udaya Kumar, "Title Design in Bollywood Film Posters: A Semiotic Analysis," in *ICoRD '15: Research into Design Across Boundaries Volume 1*, ed. Amaresh Chakrabarti (New Delhi: Springer India, 2015): 296–7.
26 Meheli Sen, *Haunting Bollywood: Gender, Genre, and the Supernatural in Hindi Commercial Cinema* (Austin: University of Texas Press, 2017), 62.
27 Mark Jancovich, Antonio Lázaro Reboli, Julian Stringer, Andrew Willis, "Introduction" in *Defining Cult Movies: The Cultural Politics of Oppositional Tastes*, ed. by Mark Jancovich, Antonio Lázaro Reboli, Julian Stringer, Andrew Willis (Manchester: Manchester University Press, 2003), 4.
28 Rachana Dubeyl, "The Original Poster Boys of Bollywood," *The Times of India*, 23 April 2017.
29 There is some irony in the fact that most of my analysis of the poster comes through my engagement with its two-dimensional avatar, a high-resolution digital photograph, taken with a fixed camera mounted above the poster, then digitally corrected to take out the distortion created by the fisheye lens that made the picture-taking possible.
30 Library of Congress, "The Deterioration and Preservation of Paper: Some Essential Facts," https://www.loc.gov/preservation/care/deterioratebrochure.html accessed July 12, 2020.
31 Dubeyl, "The Original Poster Boys of Bollywood."
32 *Caveat emptor.*
33 The trope of a demonic or haunted tree has deep roots in India, especially in Tamil country. See George L. Hart, *The Poems of Ancient Tamil: Their Milieu and Their Sanskrit Counterparts* (Berkeley: University of California Press, 1975), 25 *et passim*.
34 The Hindi paranormal romance *Daayan*, which began airing on the &TV network in 2018, features a male and a female *daayan*.
35 Rachel Dwyer, "The Erotics of the Wet Sari in Hindi Films," *South Asia* 23, no. 1 (2000): 148.
36 The title on the card reads *Chained Girls* (the title of a black-and-white 1965 pseudo-documentary about the "lesbian underworld") but the images and stars are from *Chained Heat II*.
37 Grady Hendrix notes that the cover for the hardcover version of the Peter Benchley novel showed a stylized, blunt-nosed, all-white shark with no visible teeth coming up towards a similarly featureless and white swimming woman. Bantam's art director Len Leone then hired Kastell to make the new, lurid, and photo-realistic cover in order to maximize its impact for the mere six weeks that paperbacks were given on

the shelf before being sent back to the publisher for pulping. See Grady Hendrix, *Paperbacks from Hell: The Twisted History of '70s and '80s Horror Fiction* (Philadelphia: Quick Books, 2017),156.
38 J.A.B. Van Buitenen, trans, *The Bhagavadgītā in the Mahābhārata: A Bilingual Edition* (Chicago: University of Chicago Press, 1981), 115.
39 Hugh Urban, "Secret Bodies: Re-imagining the Body in the Vaiṣṇava-Sahajiyā Tradition of Bengal," *Journal of South Asian Literature* 28, no. 1/2 (1993): 45.
40 As one early nineteenth century historian has it: "It is well known that the Brahmins have in all ages had their human victims, and that even in our days thousands have voluntarily perished under the wheels of their god Jaghernaut." See Joseph Townsend, *The Character of Moses: Established for Veracity as an Historian, Recording Events from the Creation to the Deluge* (Bath and London: M. Gye, et al.,1816), 84.
41 Asko Parpola, *The Roots of Hinduism: The Early Aryans and the Indus Civilization* (Oxford: Oxford University Press, 2015), 252–3.
42 Stanley M. Kurtz, *All the Mothers Are One: Hindu India and the Cultural Reshaping of Psychoanalysis* (New York: Columbia University Press, 1992), 135.
43 Alf Hiltebeitel, *The Cult of Draupadī 1: Mythologies, from Gingee to Kurukṣetra* (Chicago: University of Chicago Press, 1988), 77.
44 See Brian Collins, *The Head Beneath the Altar: Hindu Mythology and the Critique of Sacrifice* (East Lansing: Michigan State University Press, 2014), 282 n. 97.
45 Usha Menon and Richard A. Shweder, "Dominating Kālī: Hindu Family Values and Tantric Power," in *Encountering Kālī: In the Margins, at the Center, in the West*, eds. Jeffrey J. Kripal and Rachel Fell McDermott (Berkeley and Los Angeles: University of California Press, 2003), 82.
46 Stephanie Jamison and Joel P. Brereton, trans, *The Rigveda: The Earliest Religious Poetry of India* (Oxford: Oxford University Press, 2014), 1524.
47 Carol Clover, "Her Body, Himself: Gender in the Slasher Film," *Representations* 20 (1987): 191.
48 Clover, "Her Body, Himself," 204.
49 Geel and Lévy, *100% India*, 15.

2 Vampire Man Varma: The Untold Story of the "Hindu Mystic" Who Decolonized Dracula

1 This was the second edition of the book.
2 See "2 Canadians survive night at Dracula's Castle," *Toledo Blade*, November 1, 2016, https://www.toledoblade.com/news/World/2016/11/01/Romania-2-Canadians-survive-a-night-at-Dracula-s-Castle-Brother-sister-were-first-people-in-70-years-to-stay-there/stories/20161101200 accessed July 12, 2020.

3 Valentina Vitali, "The Hindi Horror Film: Notes on the Realism of a Marginal Genre," in *Genre in Asian Film and Television: New Approaches*, ed. Felicia Chan, Angelina Karpovich, and Xin Zhang (New York: Palgrave Macmillan, 2011), 130.
4 Wendy Doniger, *The Woman Who Pretended to Be Who She Was: Myths of Self-Imitation* (New York: Oxford University Press, 2005), 135.
5 *Horror of Dracula* director Terrence Fisher would go on make the 1959 Thugee-themed colonialist exploitation movie *The Stranglers of Bombay* on the very same sets.
6 Devendra P. Varma, "The Vampire in Legend, Lore, and Literature," in *The Vampire in Literature: A Critical Bibliography*, ed. by Margaret L. Carter (Ann Arbor and London: UMI Research Press, 1989), 14.
7 Brian Collins and Kristen Tobey, "From *Middlemarch* to *The Da Vinci Code*: Portrayals of Religious Studies in Popular Culture," *Religious Studies Review* 44, no. 2 (2018): 173–82.
8 Devendra Varma, "Meeting with Mahatma," *Folio Quarterly Magazine*, unpublished manuscript version, 1984, 3.
9 Varma, "Meeting with Mahatma," 4.
10 Charles S. Blackton, "The Colombo Plan," *Far Eastern Survey* 20, no. 3, (1951): 29.
11 Daniel Oakman, *Facing Asia: A History of the Colombo Plan* (Canberra: ANU Press, 2010), 75.
12 He also put on a production of *Julius Caesar* (which may not have been quite as big a hit if it had been staged after the King's dissolution of Parliament and assumption of emergency powers in 1960).
13 The reviewer must be referring to some promotional materials that came with the review copies of the book, since nowhere does this line appear in the first edition.
14 A publisher's note on the first edition of *The Gothic Flame* reads, "Due to unrest in the Middle East and the closure of the Suez Canal, we regret that Dr. Varma's list of acknowledgments has not been received at the time of going to press."
15 Hikmat Hashim, untitled letter. October 21, 1961.
16 Varma also put on plays by Kālidāsa and Tagore, but I am unable to determine where.
17 That same year, partially in honor of Nehru's visit to Palmyra, the government of the UAR published a collection of essays based on Varma's researches in Syria, titled *Palmyra: The Caravan City of Queen Zenobia*.
18 G.H. Jansen, "Indian Professor Expelled: Indication of Syria's Nervousness," *The Statesman* CXXVI, no. 29296, November 17, 1961.
19 Michael Bevers, "An Interview with Visiting Professor Dr. Samar Attar," *NELCommuniqué* 3 (2012): 3.
20 At this point, I must engage in some speculation. The timeline of Varma's adventures in Syria and Egypt make it appear likely he was doing more than performing Shakespeare and teaching English literature. A lot of elements in this story suggest that Varma may also have been using his popularity and widely advertised

connection to Nehru to gather intelligence on the UAR. How else can we understand his relationship to spymaster al-Sarraj? Why was Varma "writing [al-Sarraj's] biography," inquiring about his escape after the coup, then going to Egypt for a semester upon learning that he was there? Why would an English professor be summarily expelled after the coup if there were no suspicion that he was anything more? There is no direct evidence, but given these details and the Colombo Plan's dual purpose of serving the west's interests while spreading culture, I suspect that Varma was involved in some clandestine activities.

21 Jane Austen, *Northanger Abbey, and Persuasion* (London: Simms and McIntyre, 1853), 20.

22 He also attempted to replicate the success of the seven horrid novels by seeking out the seven novels attributed to "Lydia Languish" in Richard Brinsley Sheridan's 1775 comedic play *The Rivals*. These have not been found.

23 Lee is perhaps best known, apart from his role as Dracula in the Hammer films series, for portraying the evil wizard Saruman in Peter Jackson's *The Lord of the Rings* and *The Hobbit* trilogies as well as Muhammad Ali Jinnah in a 1988 biopic.

24 He also received, over the years, the Count Dracula Society's Horace Walpole Award and Montague Summers Award.

25 A.E. van Vogt to Devendra Varma, August 13, 1968.

26 Beth Neily, "Varma Digs Vampires," n.d.

27 Chris Wood, "Close-Up: Devendra Varma: A Connoisseur of Horror," 1986, 10.

28 The publisher had read his profile in *Maclean's* and approached him about the project.

29 Devendra P. Varma, "Gothic Romances and Horror Movies," unpublished manuscript, 9.

30 Strangely, though, later in the essay he leaves out India when he lists the names of countries to which the popularity of the horror movie has spread (though he includes the Philippines and Mexico), suggesting he may have been unaware of developments in Indian horror, unlikely as that sounds.

31 Varma seems to have been quite a serious actor who was a Fellow of the Royal Shakespeare Company and once trained with Sir Laurence Olivier.

32 D. Varma to D. Reed. March 3, 1968.

33 Hyam Maccoby traces the legend of the Wandering Jew to the story of the Roman guard Cartaphilus, who hits Jesus on his way to the cross and tells him to hurry. Jesus then tells him, "I go, and you will wait for me until I return," meaning "until the Second Coming." See "The Wandering Jew as Sacred Executioner." In *The Wandering Jew: Essays in the Interpretation of a Christian Legend*, ed. by Galit Hasan-Rokem and Alan Dundes (Bloomington: Indiana University Press), 237.

34 Vijay Mishra, *Bollywood Cinema: Temples of Desire* (New York and London: Routledge, 2002), 51.

35 Meheli Sen, *Haunting Bollywood: Gender, Genre, and the Supernatural in Hindi Commercial Cinema* (Austin, TX: University of Texas Press, 2017), 59.

36 Andrew Smith and William Hughes, "Introduction: The Enlightenment Gothic and Postcolonialism," in *Empire and the Gothic*, edited by Andrew Smith and William Hughes (London: Palgrave Macmillan, 2003), 3.

37 Philip Holden, "The 'Postcolonial Gothic': Absent Histories, Present Contexts," *Textual Practice* 23 (2009): 353.

38 Rachel Dwyer, "Bombay Gothic: On the 60th Anniversary of Kamal Amrohi's *Mahal*," in *Beyond the Boundaries of Bollywood: The Many Forms of Hindi Cinema*, ed. by Rachel Dwyer and Jerry Pinto (Delhi: Oxford University Press, 2011), 136.

39 Sen, *Haunting Bollywood*, 24.

40 Smith and Hughes, "Introduction: The Enlightenment Gothic and Postcolonialism," 1.

41 Sen, *Haunting Bollywood*, 11, 28,

42 Mishra, *Bollywood Cinema*, 51.

43 Benjamin F. Fisher, "Poe's 'Metzengerstein': Not a Hoax," *American Literature* 42, no. 4 (1971): 487.

44 Chris Baldick and Robert Mighall, "Gothic Criticism," in *A New Companion to the Gothic*, edited by David Punter (West Sussex: Blackwell, 2012), 267–8.

45 Devendra P. Varma, "Curriculum Vitae," (1991), 1.

46 Baldick and Mighall, "Gothic Criticism," 271.

47 Baldick and Mighall, "Gothic Criticism," 278.

48 Varma, "Meeting with Mahatma," 2.

49 Varma, "Meeting with Mahatma," 4.

50 J.M.S. Thompkins, "Introduction," in *The Gothic Flame: Being a History of the Gothic Novel in England: Its Origins, Efflorescence, Disintegration, and Residuary Influences* by Devendra P. Varma (New York: Russell & Russell, 1966), xv.

51 David Richter, "*Art of Darkness: A Poetics of Gothic* by Anne Williams," *The Modern Language Review* 93, no. 1 (1998): 191. Richter then notes that Varma "proceeded to make genuine contributions to the field," an acknowledgment that most of Varma's career was spent finding and publishing scholarly editions of lost Gothic texts, not writing monographs. Indeed, *The Gothic Flame* stands alone in his *oeuvre* as the only true work of Gothic criticism; the planned sequel, *The Gothic Galaxy*, was never completed. The only other work of book-length scholarship he produced was *The Evergreen Tree of Diabolical Knowledge*, a study of the growth of lending libraries in England. He also granted his imprimatur as a faculty advisor to scholars representing a variety of perspectives on the Gothic that differed from what he expresses in *The Gothic Flame*, including the Lacanian queer theorist Eve Kosofsky Sedgwick, whose dissertation he supervised, and the atheism proponent and renowned Lovecraft scholar S.T. Joshi, for whose seminal *The Weird Tale* he served as a reader.

52 Malcolm Dunlop, "Demonologist Lecturing at Dal," *The Chronicle-Herald*, March 18, 1986: 3.

53 Seán Manchester, *The Highgate Vampire* (London: Gothic Press, 1991), 84–7. In the typed draft of his foreword to a 1991 revision of Manchester's book, *The Highgate*

Vampire, Varma is circumspect as to the reality of the events described therein, writing "It will enthrall the curious, keep rapt the petrified readers and even amuse the disbelievers, specially [*sic.*] at the time of a new Gothic Revival." For more on the Highgate Vampire, see Bill Ellis, "The Highgate Cemetery Vampire Hunt: The Anglo-American Connection in Satanic Cult Lore," *Folklore* 104, no. 1/2: 13–39.

54 Quoted in "Devendra P. Varma," *Friends of Bishop Seán Manchester,* October 31, 2010, http://friendsofbishopseanmanchester.blogspot.com/2010/10/devendra-p-varma.html. Accessed August 1, 2017.

55 Devendra P. Varma, "The Genesis of Dracula: A Re-Visit by Dr. Sir Devendra P. Varma," in *The Vampire's Bedside Companion: The Amazing World of Vampires in Fact and Fiction,* edited by Peter Underwood (London: Leslie Frewin, 1975), 61.

56 Varma, "The Genesis of Dracula," 61.

57 Marcus Youssef, "Vampires, Apparitions, Bleeding Nuns: A View into Varma's Supernatural World," *The Queen's Journal,* October 31, 1986.

58 Devendra P. Varma, *The Gothic Flame: Being a History of the Gothic Novel in England: Its Origins, Efflorescence, Disintegration, and Residuary Influences* (New York: Russell & Russell, 1966), 131.

59 Varma, "The Vampire in Legend, Lore, and Literature," 14. He could as well have deployed the Latin verse by Martin Luther that Poe uses as the epigraph for "Metzengerstein:" *Pestis eram vivus—moriens tua mors ero* ("Living I have been your plague, dying I shall be your death").

60 Varma, "The Vampire in Legend, Lore, and Literature," 15.

61 Varma, "The Vampire in Legend, Lore, and Literature," 29.

62 See Natasha Mikles and Joseph P. Laycock, "Tracking the *Tulpa*: Exploring the 'Tibetan' Origins of a Contemporary Paranormal Idea," *Nova Religio: The Journal of Alternative and Emergent Religions* 19, no. 1 (2015): 87–97. It is also worth noting that David Gordon White has made a convincing argument that during the period from the fourth century BCE to the seventh century CE, the West Asian "cultural zone" comprising Kashmir, Gandhara, and Bactria, bordering Greek, Indian, Iranian, and Chinese cultures, was a "clearing house" for demonological traditions that may have spread all the way into the Mediterranean. See "*Netra Tantra* at the Crossroads of the Demonological Cosmopolis," *The Journal of Hindu Studies* 5 (2012): 145–71.

63 Varma, "The Vampire in Legend, Lore, and Literature," 17.

64 See Hugh Urban, *Tantra: Sex, Secrecy, Politics, and Power in the Study of Religion.* Berkeley: University of California Press, 2003), 62 *et passim.*

65 *The Evening News,* September 9, 1955.

66 "Robert Innes-Smith on Books," *The Tatler and Bystander,* May 1968.

67 Devendra P. Varma, "Introduction," in *The Necromancer* by Ludwig Flammenberg (London: The Folio Press, 1968), ix.

68 See Robert Cowan, *The Indo-German Identification: Reconciling South Asian Origins and European Destinies, 1765–1885* (Rochester, NY: Camden House, 2010).

69 Barbara Hinds, "Professor Seeks Source of Vampire Legends," *The Mail-Star*. September 17, 1969.
70 Youssef, "Vampires, Apparitions, Bleeding Nuns. A View into Varma's Supernatural World," *The Queen's Journal*, October 31, 1986.
71 Wood, "Close-Up: Devendra Varma: A Connoisseur of Horror."
72 Giorgio Agamben, *State of Exception* (Chicago: The University of Chicago Press, 2005), 64.
73 See Jan Harold Brunvand, *The Vanishing Hitchhiker: American Urban Legends & Their Meanings* (New York: W.W. Norton, 1981).
74 See Carol Clover, "Her Body, Himself: Gender in the Slasher Film," *Representations* 20 (1987): 187–228 and *Men, Women, and Chainsaws: Gender in the Modern Horror Film*. (Princeton: Princeton University Press, 1992).
75 Varma, "Gothic Romances and Horror Movies."
76 The background score, meanwhile, is lifted from Harry Manfredini's iconic soundtrack for *Friday the 13th* (1980, dir. Sean S. Cunnigham) and the equally recognizable "Tubular Bells" from *The Exorcist* (1973, dir. William Friedkin).
77 Usha Iyer, "Nevla as Dracula: Figurations of the Tantric as Monster in the Hindi Horror Film," in *Figurations in Indian Cinema*, edited by Meheli Sen and Anustup Basu (Basingstoke: Palgrave Macmillan, 2013), 106.
78 David Gordon White, *Kiss of the Yoginī: "Tantric Sex" in its South Asian Contexts* (Chicago: The University of Chicago Press, 2003), 50.
79 Iyer, "Nevla as Dracula," 103.
80 See Brian Collins, *The Head Beneath the Altar: Hindu Mythology and the Critique of Sacrifice* (East Lansing, MI: Michigan State University Press, 2014), 127–32.
81 *India Today Online*, "Ramsay Brothers' Sex Horror Flick: Are Your Neighbours Vampires?" March 11, 2014. Accessed May 25, 2018.
82 The Sanskrit, which he also includes (in Roman script), is

> *Vedā vibhinnāḥ smṛtayo vibhinnā,*
> *Nāsau munir yasya mataṃ na bhinnam,*
> *Dharmasya tattvaṃ nihitaṃ guhāyāṃ,*
> *Mahājano yena gataḥ sa panthāḥ*

It seems to be a paraphrase of a line that occurs in slightly different forms in the Bombay and Calcutta editions of the *Mahābhārata*, as well as a palm-leaf manuscript of the epic in Devanāgari script from Madras and a Grantha one from Tanjore. It is inserted in the Critical Edition between 3.297.61 and 62:

> *tarko 'pratiṣṭhaḥ śrutayo vibhinnā*
> *naiko ṛṣir yasya mataṃ pramāṇam*
> *dharmasya tattvaṃ nihitaṃ guhāyāṃ*
> *mahājano yena gataḥ sa panthāḥ.*

It also appears in the collection of verses called the *Mahāsubhāṣitasaṃgraha*. The specific version quoted by Varma is attributed to Paṇḍit Rāmanārāyaṇa Vidyāratna. The most likely way that Varma found the quotation was as a *subhāṣita*, Sanskrit proverbs that circulate widely in India.

83 Devendra P. Varma, "True Identity of Arminius Vambery: The Disguised Dervish, Hungarian Professor, and Stoker's Source of Dracula," Paper presented at Twelfth International Conference on the Fantastic in Arts, Fort Lauderdale, Florida, March 23, 1991, 2.

3 Divine Horror and the Avenging Goddess in Bollywood

1 Philip Lutgendorf, "Cinema." In *Studying Hinduism: Key Concepts and Methods*, edited by Sushil Mittal and Gene Thursby (New York: Routledge, 2008), 50.
2 The most accessible English translation of the Sanskrit text is Thomas B. Coburn, *Encountering the Goddess: A Translation of the Devī-Māhātmya and a Study of Its Interpretation* (New York: SUNY Press, 1991). The *Devī-Māhātmya*, dated fifth century CE, is part of a much larger work, the *Mārkaṇḍeya Pūraṇa*, though it is typically published as a self-contained book in inexpensive bazaar editions, with auxiliary hymns and translation, commentary and ritual instructions, in one of the vernacular languages such as Hindi or Bengali. The stories of the *Devī-Māhātmya*, with many regional variants, are found in other Sanskrit texts, vernacular texts, and oral traditions all over India.
3 Ashish Rajadhyaksha and Paul Willemen, *Encyclopedia of India Cinema*, New Revised Edition (New Delhi: Oxford University Press, 1999), 446.
4 The *jagrata* is a ritual performance for the Goddess popular in the northern state of Panjab and among Panjabi speaking people elsewhere in India. Shivani's surname, Chopra, indicates that she and her husband are Panjabi. For more on the *jagrata*, see Kathleen M. Erndl, *Victory to the Mother: The Hindu Goddess of Northwest India in Myth, Ritual, and Symbol* (New York: Oxford University Press, 1993), 84–104.
5 The name Chaṇḍī in the previous scene is also mistranslated in the DVD English subtitles as "demon." Furthermore, the refrain of the song "When a Woman Becomes Chaṇḍīkā," is missing from the subtitles. The inconsistent quality of subtitles in Indian films is an obstacle to their appreciation by non-Indian audiences, particularly when it comes to cultural and religious references.
6 According to Hindu custom, adults are cremated, but children below a certain age are often buried.

4 Horrifying and Sinister *Tāntriks*

1. *Jaadugar*, dir. Prakash Mehra (Mumbai: Eros Entertainment, 1989).
2. See Hugh B. Urban, "The Extreme Orient: The Construction of 'Tantrism' as a Category in the Orientalist Imagination," *Religion* 29 (1999): 123–46; Hugh B. Urban, *Tantra: Sex, Secrecy, Politics and Power in the Study of Religion* (Berkeley: University of California Press, 2003).
3. See Urban, *Tantra*; Douglas Renfrew Brooks, "Encountering the Hindu 'Other': Tantrism and the Brahmans of South India," *Journal of the American Academy of Religion* 60, no. 3 (1992): 405–36; David Gordon White, ed., *Tantra: In Practice* (Princeton: Princeton University Press, 2000); Istvan Keul, ed., *Transmission and Transformation of Tantra in Asia and Beyond* (Berlin: De Gruyter, 2012); André Padoux, *The Hindu Tantric World: An Overview* (Chicago: University of Chicago Press, 2017).
4. Urban, *Tantra*, 29–39, 106–33.
5. White, *Sinister Yogis* (Chicago: University of Chicago Press, 2006).
6. See Urban, "The Extreme Orient."
7. See Urban, *Tantra*, and Urban, *The Power of Tantra: Religion, Sexuality, and the Politics of South Asian Studies* (New York: Palgrave Macmillan, 2010).
8. *Shaitan Tantrik*, dir. Wajid Sheikh (Gold Mines, 1999); *Khooni Tantrik*, dir. Teerat Singh (Shafugta Arts Productions, 2001); *Naan Kadavul*, dir. Bala (Chennai: Pyramid Saimira Group, 2009).
9. *Jaadugar*; *Gehrayee*, dir. Aruna Desai and Vijay Tendulkar (Bombay, 1980); *Sangarsh*, dir. Tanuja Chandra (Mumbai: Vishesh Films, 1999); *Ammoru*, dir. Kodi Ramakrishna (M.S. Arts, 1995).
10. Julia Kristeva, *The Powers of Horror: An Essay in Abjection* (New York: Columbia University Press, 1982); Judith Butler, *Bodies that Matter: On the Discursive Limits of Sex* (New York: Routledge, 2011).
11. Mishra, *Bollywood Cinema: Temples of Desire* (New York: Routledge, 2002).
12. See Douglas Renfrew Brooks, "Encountering the Hindu "Other:" Tantrism and the Brahmans of South India," *Journal of the American Academy of Religion* 60, no. 3 (1992): 405–36; Urban, *Tantra*.
13. See Padoux, *Hindu Tantric World*; White, *Tantra in Practice*; Urban, *Tantra*.
14. See Urban, *Power of Tantra*; White, *Kiss of the Yoginī: "Tantric Sex" in its South Asian Contexts* (Chicago: University of Chicago Press, 2002); Geoffrey Samuel, *The Origins of Yoga and Tantra: Indic Religions to the Thirteenth Century* (Cambridge: Cambridge University Press, 2008).
15. White, *Tantra in Practice*, 9; see Padoux, *Hindu Tantric World*; Urban, *Power of Tantra*.
16. *Tāntrik* texts often distinguish between "left-hand" (*vāmācāra*) traditions, which engage in explicitly transgressive practices such as consumption of meat, wine, and

sexual fluids, and "right-hand" (*dakṣiṇācāra*) traditions, which engage in non-transgressive rites and internalized forms of meditation. See Douglas Renfrew Brooks, *The Secret of the Three Cities: An Introduction to Hindu Śākta Tanta* (Chicago: University of Chicago Press, 1998), 28; Urban, *Power of Tantra*.

17 See Urban, *Power of Tantra*; White, *Kiss*.

18 Alexis Sanderson, "Purity and Power among the Brahmins of Kashmir," in *The Category of the Person: Anthropology, Philosophy, History*, ed. Michael Carrithers, Steven Collins, and Steven Lukes (Cambridge: Cambridge University Press, 1985), 199.

19 Gwendolyn Lane, trans., *Kādambarī: A Tale of Magical Transformation* (New York: Garland Publishing, 1991), 226.

20 Sita Krishna Nambiar, trans., *Prabodhacandrodaya of Kṛṣṇa Miśra* (Delhi: Motilal Banarsidass, 1971), 3.12–13.

21 Wilhem Halbfass, *India and Europe: An Essay in Understanding* (Albany: SUNY Press, 1988), 339.

22 Bankimcandra Caṭṭopādhyāy, *Kapālakuṇḍalā* (Calcutta: Tipti Publishing, 1966), 87–8.

23 Penny, *The Swami's Curse* (London: Heinemann, 1929), 48.

24 See Urban, *Tantra*, chapters 2–4.

25 Frederick K. Smith, *The Self Possessed: Deity and Spirit Possession in South Asian Literature* (New York: Columbia University Press, 2006), 363–90.

26 *Gehrayee*.

27 *Gehrayee*.

28 *Jaadugar*.

29 See Tulasi Srinivas, *Winged Faith: Rethinking Globalization and Religious Pluralism through the Sathya Sai Movement* (New York: Columbia University Press, 2010); Hugh B. Urban, *Zorba the Buddha: Sex, Spirituality and Capitalism in the Global Osho Movement* (Berkeley: University of California Press, 2016).

30 *Jaadugar*.

31 *Jaadugar*.

32 William E. Elison, Christian Lee Novetzke, and Andy Rotman, *Amar Akbar Anthony: Bollywood, Brotherhood and the Nation* (Boston: Harvard University Press, 2016), 3; see also *Amar Akbar Anthony*, dir. Manmohan Desai (Bombay: Manmohan Films, 1977); Vijay Mishra, *Bollywood Cinema: Temples of Desire* (New York: Routledge, 2001). As Mishra notes, *Amar Akbar Anthony* portrays three brothers "who grow up in different religions but can come together as one in a secular India," while still not challenging the dominance of the Hindu majority: "The secular can be celebrated provided that (Hindu) dharma remains intact" (176–7). See also Mihir Bose, *Bollywood: A History* (London: Tempus Publishing Limited, 2006), 279.

33 See Richard King, *Orientalism and Religion: Post-colonial Theory, India, and the "Mystic East"* (New York: Routledge, 1999), 118–42; Urban, *Tantra*, 159–64; Halbfass,

India and Europe. As Halbfass summarizes this theme in Vivekananda's version of Neo-Hinduism or Neo-Vedānta: "the idea and practice of toleration and brotherhood is India's gift to the world . . ." As Vivekananda sees it, "the world is waiting for this grand idea of universal toleration" and spirituality to be passed on by India" (231).

34 *The Silence of the Lambs*, dir. Jonathan Demme (Los Angeles: Orion Pictures, 1991).
35 See Urban, "Extreme Orient" and Urban, *Tantra*.
36 *Sangarsh*.
37 *Sangarsh*.
38 *Sangarsh*.
39 Urban, *Power of Tantra*, 94–7.
40 Biswanarayan Shastri, ed., *The Yoginī Tantra* (Delhi: Bhāratīya Vidyā Prakāśana, 1982), 2.7.163–6. See also Urban, *Power of Tantra*, 215.
41 *Gunga Din*, dir. George Stevens (Hollywood: RKO Radio Pictures, 1939); *Help!*, dir. Richard Lester (Beverly Hills: United Artists, 1965); *Indiana Jones and the Temple of Doom*, dir. Stephen Spielberg (Hollywood: Paramount Pictures, 1984).
42 *Ammoru*.
43 Kristeva, *Powers of Horror*, 3; see Butler, *Bodies that Matter*.
44 Brooks, "Encountering the Hindu 'Other.'"
45 See Urban, *Tantra*; King, *Orientalism and Religion*.
46 See Halbfass, *India and Europe*; King, *Orientalism and Religion*.
47 See Urban, "Extreme Orient" and Urban, *Tantra*, chapters 1–3.
48 Vivekananda, *The Complete Works of Swami Vivekananda*, volume 7 (Calcutta: Advaita Ashram, 1984), 174.
49 Vivekananda, *The Complete Works of Swami Vivekananda*, volume 3 (Calcutta: Advaita Ashram, 1984), 340. It is worth noting that Vivekananda also identifies Tantra as a non-Indian, non-Aryan tradition that first infected Buddhism and then later Hinduism: "From central Asia the cruel barbarians came, having established their terrible practices in their own land; in order to attract the ignorant barbarians the true path took on the form of the Tantras and Mantras; and that is why when then became misunderstood, weakened and corrupt . . . they resulted in the terrible abominations of Vamacara" (*The Complete Works of Swami Vivekananda*, volume 6 [Calcutta: Advaita Ashram, 1984], 226).

5 Do You Want to Know the *Raaz*? Sāvitri, Satyavān, and the Other Woman

1 Ratings are completely arbitrary and dependent on the critic. There are no set codes. In most cases, critics give one star to bad films, so giving no rating is a special scenario. *The Times* critic was Khaled Mohammad who is also a filmmaker.

2. For further details see Bharadvaja Sarma's *Vyasa's Mahabharatam* (Kolkata: Academic Press, 2008), 329–65.
3. *Raaz* is now a famous horror franchise. The success of *Raaz* was followed by *Raaz 2* and *3*. The latest one is *Raaz Reboot*, released in 2016. They are all horror films, but the stories are independent of each other.
4. Noël Carroll, *The Philosophy of Horror: Or, Paradoxes of the Heart* (New York: Routledge, 1990).
5. In 2012, I interviewed Amrit Pal, who had acted in many low budget horror films and had produced a low budget horror film called *Woh Kaun Thi* in 1996. He gave me details on how the Censor Board worked. I also interviewed screenplay writer Kiran Kotrial in the same year, he had spent many years working with producers of horror films and their unique ways of hoodwinking the Censor Board.
6. Aditi Sen, "I Wasn't Born with Enough Middle Fingers: How Low-budget Horror Films Defy Sexual Morality and Heteronormativity in Bollywood." In *Acta Orientalia Vilnesia* 12, no. 2 (2011): 75–89.
7. Gloria Goodwin Raheja and Ann Grodzins Gold, *Listen to the Heron's Words: Reimagining Kinship and Gender in North India*, (Berkeley, Los Angeles: University of California Press, 1994).
8. In 2012, I interviewed Vikram Bhatt. This is an excerpt from the interview.
9. A *mangalsutra* is a chain worn around the neck by Hindu married women. Since it is a sign of marriage, it is considered extremely powerful. Its approximate western equivalent is the wedding band. *Mangalsutra* was a box office failure, not a mainstream release. In fact, it was pitched as a parallel cinema.
10. The idea of *masala rasa* has already been explored in chapter 1 of this volume.
11. The films of the Ramsay brothers have been discussed by Brian Collins, and as well, there is a good amount of other scholarship available on them, the most important being Shamya Dasgupta's *Don't Disturb the Dead: History of the Ramsay Brothers* (Delhi: Harper Collins, 2017).
12. Sangita Gopal, *Conjugation: Marriage and Form in New Bollywood Cinema* (Chicago: University of Chicago Press, 2012), 95.
13. Noël Carroll, *The Philosophy of Horror: Or, Paradoxes of the Heart* (New York: Routledge, 1990).
14. Like the Ramsay brothers' films, *Raaz* too has a cult following outside India. Even though they are famous as campy, horror B-films, their universal appeal because of clichéd horror tropes is undeniable.
15. *Vāstu Śāstra* is a traditional Hindu system of architecture.
16. The book is in Brahmi. It shows pictures of Ashokan edicts. In fact, I had mentioned it to Vikram Bhatt and he said, "You are a discerning audience. I like that. Most of my audience just sees an old book."

17 Vikram Bhatt told me that, in the first draft of the story, he wanted to end the film in divorce. However, he later realized that it would never work with the audience and changed the ending.
18 This is the basic premise of the successful Bollywood horror film *Tumbbad* (2019).
19 Simon J. Hay, *The History of the Modern British Ghost Story* (London: Palgrave Macmillan, 2011), 126.
20 David Stevens, *The Gothic Tradition* (Cambridge: Cambridge University Press, 2000), 10.
21 *Dracula* (1897) clearly borrowed from the Indian vampire, Vetala. Stoker's family had served in India and he became fascinated with Indian occult; he was a product of his time—India to him was the exotic land of sinister magic. He knew Sir Richard Burton, the renowned Indologist who translated the Sanskrit collection of stories, *Baital Pachisi*, that featured Vetala the vampire. Burton often spoke of how he had discussed Hindu myths with Stoker, and Stoker studied *Baital Pachisi* thoroughly before writing *Dracula*. See Jill Galvan, "Occult Networks and the Legacy of Indian Rebellion in Bram Stoker's *Dracula*," *History of Religions* 54, no. 4 (2015): 434–58.
22 Bond Ruskin, "Season of Ghosts" *Blackwood Magazine* 320, no. 1929 (July-December 1976): 456.
23 Other important successful Hindi films with Victorian backdrops include *Mahal* (Mansion, 1949), *Bees Saal Baad* (Twenty Years Later, 1964), *Bhoot Bungla* (Haunted House, 1965), and *Purana Mandir* (Old Temple, 1984). In fact, almost all horror films have used a Victorian setting.
24 Growing up, most of the ghost stories Bhatt read and watched had a Gothic backdrop. He feels most comfortable telling his story in that set-up (personal communication 2012).
25 The *1920* series includes *1920*, *1920 Evil Returns*, *1920 London*, and *1921*. All take place in that year and are set in Victorian mansions. Many of these films did well at the box office.
26 For female gaze and male bodies, see Aditi Sen, "I Wasn't Born with Enough Middle Fingers: How Low-budget Horror Films Defy Sexual Morality and Heteronormativity in Bollywood," *Acta Orientalia Vilnesia* 12, no. 2 (2011): 75–89).
27 Melissa Edmundson, "Supernatural Empire: The Anglo Indian Ghost Stories of Bithia Mary Croker and Alice Perrin," in *The Male Empire Under the Female Gaze: The British Raj and the Memsahib*, eds. S. Roye and R. Mittapalli (Amherst: Cambria Press, 2013), 130.
28 Palaces and manor houses being haunted by the ghosts of nautch girls is a popular horror trope. Films like *Bhool Bhuliya* (2007), *Poonam ki Raat* (Full Moon Night, 1965), *Parde Ke Peeche* (Behind the Curtain, 1971) have all used this.
29 Lusty female ghosts appear in the Ramsay Brothers' *Veerana* (Wilderness, 1988) and Bhatt's *Raaz 3* (2012).

30 Bhatt has read a lot of folktales, and ghost stories are his favorite (personal communication 2012).
31 Lal Behari Dey, *Folk-Tales of Bengal* (London: Macmillan, 1883).
32 Raj S. Gandhi, "Sati as Altruistic Suicide Beyond Durkheim's Interpretation," in *Contribution to Asian Studies*, Vol 10 (Leiden: Brill, 1977): 148.
33 A TV show called *Anjaan: Rural Myths* (2019) focuses solely on folk ghosts from all over India. They also have an episode on *petni* where she is linked with consumption of fish and lust for men.
34 Hay, *History of Modern British Ghost Story*, 2.
35 Archana Mishra, *Casting the Evil Eye: Witch Trials in India* (New Delhi: Lotus Roli, 2003).
36 Moriz Winternitz, "Ancient Indian Witchcraft" in *Indian Antiquary* 38 (Bombay, 1899): 71–83.
37 In Bhatt's film *Shaapith* (The Cursed, 2013) there is a similar upper caste expert, named Professor Pashupati.
38 Bhatt is the only Indian filmmaker who also made films with Brahmin ghosts. Iyer in *Haunted* (2011) is a Brahmin ghost and he is easily the most powerful evil spirit in Bhatt's universe. While Bhatt brings the idea Brahma Rakshasha alive in *Creature* (2014), it is a very flat depiction. However, Iyer is a truly complicated ghost. He is sophisticated, educated, and a teacher. His downfall is his lust for his young pupil whom he tries to rape; he then gets killed accidentally. Iyer becomes a very powerful evil spirit. He kills his pupil's caretakers and his spirit keeps raping her. In order to escape the torture, she kills herself. However, he manages to trap her spirit and keeps raping her every night for more than eighty years. To save her, the hero has to travel back in time and alter events just so he can somewhat reduce the power of Iyer. It is a complicated story and plenty of things happen, but we are never told why Iyer is such a powerful spirit. One can only assume that being a Brahmin makes him so powerful. Also, the only thing that can control him is a talisman from a Fakir, so there is no solution from Hinduism. You have to seek help from Islam in order to weaken the ghost. Only in 2018, films like *Tumbbad* and *Stree* raised the question of caste.
39 Many horror films are marketed as "adult" with "bold sexy scenes." This is a common technique for attracting the young male population, the perceived target audience for horror films.
40 The film had a PG certificate. I have seen it five times in theatres in Mumbai. Every single screening was full of families who clapped and screamed throughout the film.
41 See Gopal, *Conjugations*.
42 *Darwaza* (Door, 1979), *Purana Mandir* (Old Temple, 1988), *Mahakaal* (1990).
43 Brigid Cherry, *Horror* (Routledge Film Guidebooks. Abingdon, UK: Taylor & Francis, 2009), 8–19.

44 Julia Leslie, *Roles and Rituals for Hindu Women* (Delhi: Motilal Banarsidass, 1992).
45 Wendy Doniger, *The Origins of Evil in Hindu Mythology* (Berkeley: University of California Press, 1980).
46 Ajay Gehlawat, *Reframing Bollywood* (Delhi: Sage Publications, 2010), 28–9.
47 Gehlawat, *Reframing Bollywood*, 3.
48 Kiran Kotrial, personal communication, August 17, 2012.
49 Valentina Vitali, "The Evil I: Realism and Scopophilia in the Horror Films of Ramsay Brothers," in *Beyond the Boundaries of Bollywood*, eds. R. Dwyer and J. Pinto (New Delhi: Oxford University Press, 2011), 77–101.
50 Vitali, "The Evil I."
51 Cherry, *Horror*, 8–19.
52 Ram Gopal Verma had earlier directed a critically acclaimed horror film called *Raat* in 1992 but *Bhoot* opened up a new style in horror films. It brought the Asian style of horror filmmaking to Bollywood.
53 Hay, *History of Modern British Ghost Story*, 23.
54 Bhatt, V. Interview, August 14, 2012.

6 Cultural Horror in *Dev*: Man Is the Cruelest Animal

1 I would like to express my gratitude to Veronika Shulman who made very helpful comments and suggestions on an earlier draft of this chapter. I would also like to thank Shelley Cohl without whom this book would not have come to fruition.
2 Tanika Sarkar, "Semiotics of Terror: Muslim Children and Women in the Hindu Rashra," *Economic and Political Weekly* 37, no. 28 (July 13–19, 2002): 2872.
3 V.D. Savarkar, *Hindutva: Who Is A Hindu?* (https://archive.org/stream/hindutva-vinayak-damodar-savarkar-pdf/hindutva-vd-savarkar_djvu.txt, 1923), 11, 95. See also Jyotirmaya Sharma, *Hindutva: Exploring the Idea of Hindu Nationalism* (New Delhi: Viking, 2003), 24.
4 Savarkar, *Hindutva: Who Is A Hindu?* ii.
5 Savarkar *Hindutva: Who Is A Hindu?* 3–5.
6 The myth of common blood, shared by a common race, plays a sizeable role in Savarkar's ethnic nationalism and those who follow in his footsteps. However, what is particularly critical here is that the self-referencing notion of "blood" excludes Muslims and Christians (as foreigners). In *Dev*, Chief Minister Bhandarker reiterates Savarkar's and Golwalkar's insistence that citizenship belongs only to Hindus. See V.D. Savarkar, *Hindutva: Who Is A Hindu?* 23, 33, 39, 74, 84–90, and 100; Christophe Jaffrelot "Towards a Hindu State," *Journal of Democracy* 28 (2017): 28; Christophe Jaffrelot, *The Hindu Nationalist Movement in India* (New York: Columbia University

Press, 1996); and, Gyanendra Pandey, *Hindus and Others: The Question of Identity in India Today* (New Delhi: Viking, 1993).

7 See J.J. Lipner, *Anandamath, or The Sacred Brotherhood* (New York: Oxford University Press, 2005); Tanika Sarkar, "Birth of a Goddess: 'Vande Mantaram,' Anandamath, and Hindu Nationhood," *Economic and Political Weekly* 41, no. 37 (September 16–22, 2006): 3959–69; http://www.jstor.org.proxy.queensu.ca/stable/pdf/4418703.pdf; and, Tanika Sarkar, "Imagining Hindurashtra: The Hindu and the Muslim in Bankim Chandra's Writings," in *Contesting the Nation: Religion, Community, and the Politics of Democracy in India*, ed. by David Ludden (Philadelphia: University of Pennsylvania Press, 1996), 162–85.

8 Caṭṭopādhyāy also wrote the lyrics to *Bande Mataram* ("Hail to the Motherland"), India's national anthem. In the anthem, he imagines India as a mother goddess who, like Durgā, fights the enemies of the nation on behalf of her children (see Chapter 3 in this volume). This has become the "rallying-cry" for Sangh Parivar. See Sarkar, "Birth of a Goddess," 162.

9 See Sarkar, "Birth of a Goddess," 141.

10 Ramachandra Guha refers to Golwalkar as the "guru of hate." See "The Guru of Hate," in *The Hindu. Sunday Magazine,* 2006, https://www.thehindu.com/todays-paper/tp-features/tp-sundaymagazine/the-guru-of-hate/article3232784.ece, n.p.

11 See Jaffrelot, *The Hindu Nationalist Movement in India*, 51; Barbara, Metcalf, "Too Little and Too Much: Reflections on Muslims in the History of India," *Journal of Asian Studies* 54 (1995): 95–96; and Arvind Sharma, "On Hindu, Hindustān and Hindutva," *Numen* 49 (2002): 23.

12 So, too, K.V. Paliwal writes, "the history of Christianity and Islam is full of bloodshed, barbarism, massacre and genocide of innocent people of other faiths... mainly due to the concept of prophetism, revelational methodology, and prophecies," see K.V. Paliwal, *Challenges Before the Hindus: From Islam, Christianity and Pseudo-Secularism* (Delhi: Hindu Writers Forum, 2003), 15. History, when viewed from this perspective, is reduced to a clash of distinct and antagonistic cultures. But, in fact, Hindu nationalist history is ahistorical. As Dibyesh Anand argues, contexts are unimportant in the larger perpetual war of religions. See Dibyesh Anand, *Hindu Nationalism in India and the Politics of Fear* (New York: Palgrave Macmillan, 2011), 31; and Romila Thapar, "Politics and the Rewriting of History in India," *Critical Quarterly.* 47 (2005): 195–203.

13 See Sumit Sarkar, "Indian Nationalism and the Politics of Hindutva," in *Contesting the Nation: Religion, Community, and the Politics of Democracy in India*, edited by David Ludden (Philadelphia: University of Pennsylvania Press 1996), 229.

14 See Anand, *Hindu Nationalism in India and the Politics of Fear*, 16.

15 For more on the relationship between myth, myth-making, and social formation, see Burton Mack, "Social Formation," in *The Guide to the Study of*

Religion, edited by Willi Braun and Russell McCutcheon (New York: Continuum, 1999), 283–96.

16 See, M.S. Golwalkar, *We, or Our Nationhood Defined* (India: Bharat Publications, 1939), http://www.culturism.us/booksummaries/We%20or%20our%20Nationhood%20Defined%20Newer%20PDF.pdf.

17 See David Ludden, "Introduction: Ayodya: A Window on the World," in *Contesting the Nation: Religion, Community, and the Politics of Democracy in India*," edited by David Ludden (Philadelphia: University of Pennsylvania, 1996), 1–27.

18 Ludden sees Ayodhya as a lens for looking at other global nationalist movements including the "ethnic cleansing" in Serbia, the "moral majority" in the United States, as well as other majoritarian movements in Sri Lanka, Rwanda, Iran and so on. See Ludden, "Introduction," 7.

19 See Ornit Shani, "The Rise of Hindu Nationalism in India: The Case Study of Ahmedabad in the 1980s" in *Modern Asian Studies* 39 (2005): 861–96.

20 Tanika Sarkar writes that chemicals were used to burn the bodies so that no evidence remains. Thus, Muslims just vanish. This, she says, denies "the body a burial, forcing Hindu cremation—post-mortem conversion." See Sarkar, "Semiotics of Terror: Muslim Children and Women in the Hindu Rashra," 2876.

21 Ludden, "Introduction: Ayodya: A Window on the World," 16.

22 Anand, *Hindu Nationalism in India and the Politics of Fear*, 16.

23 See Noël Carroll, *The Philosophy of Horror: Or Paradoxes of the Heart* (New York: Routledge, 1990), 28.

24 It is not the goal of this chapter to become embroiled in a discussion of Indian aesthetic theory *vis-à-vis* Indian cinema. However, it is still significant since *rasa* has been foundational to India's performative traditions, for example, dance and theater, since c. 300 CE. For more information on *rasa*, see, Sheldon Pollock's *A Rasa Reader: Classical Indian Aesthetics* (New York: Columbia University Press, 2016). Also, for a more in-depth explanation of "affect" see Sigmund Freud, "The Uncanny," in *The Standard Edition of the Complete Psychological Works of Sigmund Freud. Volume XVII (1917–1919): An Infantile Neurosis and Other Works*, edited by James Strachey (London: Hogarth Press and the Institute of Psycho-Analysis, 1955 [1919]) 217–56; Mark Solms and Edward Nersessian, "Freud's Theory of Affect: Question for Neuroscience," *Neuropsychoanalysis*, 1, no. 1 (1999): 5–14; and Gregory J. Seigworth and Melissa Gregg, *The Affect Theory Reader* (Durham, NC: Duke University Press, 2010).

25 See Noël Carroll and Caetlin Benson-Allott, "Paradoxes of the Heart: The *Philosophy of Horror* Twenty-five Years Later: An Interview with Caetlin Benson-Allott," *Journal of Visual Culture* 14 (2015): 336–43.

26 Carroll, *Philosophy of Horror*, 22–4. In this section, Carroll delineates various affects associated with the art horror genre.

27 Carroll, *Philosophy of Horror*, 16–18; see also Joseph Grixti, *Terrors of Uncertainty* (New York: Routledge, 1989), x; and S.S. Prawer, *Caligari's Children* (New York: Oxford University Press, 1980), 108.
28 See Carroll, *Philosophy of Horror*, 15.
29 See Carroll, *Philosophy of Horror*, 16.
30 See Carroll, *Philosophy of Horror*, 199.
31 In an interview with Caetlin Benson-Allott twenty-five years after the publication of *Philosophy of Horror*, Carroll says that typically there is closure in most American horror films. But, Japanese horror and more recent American horror films such as *The Blair Witch Project* (1999) or *It Follows* (2014) do not give closure. This is something new. The "evil can't be explained and maybe can't be extricated." This is closer to the kind of horror we see in films depicting cultural horror. See Carroll and Benson-Allot, "Paradoxes of the Heart," 336–43.
32 See Carroll, *Philosophy of Horror*, 200.
33 *Dev's* screenwriter Meenakshi Sharma's father was a police officer. She witnessed the politicization and communalization of the Indian police's brutality first-hand, and writes about it candidly in *Dev*.
34 See Saibal Chatterjee, "It's a cop's life," in *The Tribune India*. Sunday, June 13, 2004. https://www.tribuneindia.com/2004/20040613/spectrum/main6.htm. Accessed November 5, 2018. N.P.
35 See William E. Elison, Christian Lee Novetzke, and Andy Rotman, *Amar Akbar Anthony: Bollywood Brotherhood and the Nation* (Boston: Harvard University Press, 2016), 41.
36 See Elison, Novetzke, and Rotman, *Amar Akbar Anthony*, 41.
37 In Latif's emotionally charged speech he declares, "Today is a day of grief. The calamity that befell Noor Manzil at the hands of the brutal cops of this government is just another face of a system that has been seen in different guises over the years all over the country. Sometimes it is a face of terror for us ... elsewhere it is destroying our sacred places ... at other times it runs rivers of blood. The system has nothing but hatred for us. This system allows the slaughter of people like animals. To this day! There is no limit to intolerance. If we stay silent they will be emboldened and we will continue to be slain like this" (*Dev*).
38 See Paolo Bacchetta, "Hindu Nationalist Women as Ideologues: The 'Sangh', the 'Samiti' and Their Differential Concepts of the Hindu Nation," in *The Sangh Parivar: A Reader*, edited by Christophe Jaffrelot (New Delhi: Oxford University Press, 2004), 108–47. Bacchetta argues that Hindus project sexuality onto its 'Others.' Ironically, it is a Hindu man who rapes Shabnam in *Dev*. Bacchetta explains that to be masculine is to perform heterosexual sex; yet, ideal Hindu masculinity, which in many ways rests on notions of renunciation, denigrates sexuality and sexual acts as demeaning, distracting, and weakening. Real men, says Bacchetta, are those who control and/or

transcend these bodily weaknesses. The prototypical activist in the RSS, for example, is "enjoined to be a *brahmachari*, that is to say, a self-less, celibate disciple whose devotion to the common good is in direct proportion of his self-control" (108). Thus, the ideal of Hindu nationalist masculinity does not lend itself to an easy analysis in terms of virile heterosexuality, since the ideal of masculinity is world-renouncer and virile asexuality for activists and controlled sexuality for the general population. Sex is not meant for pleasure, but, rather, as a means of producing Hindu children to proliferate the Hindu population. This explains why many senior leaders in the Hindu nationalist movement remain unmarried and celibate in the name of total devotion to the Motherland. Like religious ascetics, they see marriage as a distraction from the higher goals of life; but unlike ascetics, the Hindu nationalists' goal is nationalist salvation (108). This adds to Tanika Sarkar's argument that Hindu males fear the virility of the male Muslim body and take it out on Muslim women. Sarkar writes, "Hindu male sex organs function as instruments of torture." See Sarkar, "Semiotics of Terror: Muslim Children and Women in the Hindu Rashra," 2872–6.

39 See, J.A.B. van Buitenen, *The Bhagavadgītā in the Mahābhārata: A Bilingual Edition* (Chicago: University of Chicago Press, 1981), 24 [2] 30.
40 See Frantz Fanon, *Wretched of the Earth* (New York: Grove Press., 1963), 93.
41 Fanon, *Wretched of the Earth*, 93. See also Benedict Anderson, *Imagined Communities: Reflections on the Origin and Spread of Nationalism* (London: Verso, 1983).
42 Fanon, *Wretched of the Earth*, 93.
43 Fanon, *Wretched of the Earth*, 93.
44 Fanon, *Wretched of the Earth*, 93–5.
45 Fanon, *Wretched of the Earth*, 94.
46 Fanon, *Wretched of the Earth*, 94.
47 Fanon, *Wretched of the Earth*, 94.
48 Sarkar, "Semiotics of Terror: Muslim Children and Women in the Hindu Rashra," 2875.
49 Fanon, *Wretched of the Earth*, 38, 50.
50 Fanon, *Wretched of the Earth*, 38.
51 Fanon, *Wretched of the Earth*, 45.
52 For example, one source of Golwalkar's inspiration lay in the ethnocentric fascist ideology circulating in Germany under Adolf Hitler. The antecedents of his adulation derive primarily from the Nazi party's genocidal mandate, as well as German Romanticism's reverence for India. Like Hitler and Savarkar, Golwalkar portrayed India as a hereditary Aryan society, with a common or shared history. And like Jews in Germany, Muslims in India are portrayed as outsiders (*mlecchas*). In fact, Golwalkar even suggests the Nazi campaign of extermination "is a good lesson for us in Hindusthan to learn and profit by." See Golwalkar, *We, or Our Nation Defined*, 35.

53 Hannah Arendt, *Eichmann in Jerusalem* (New York: Viking Press, 1963), 30.
54 Arendt, *Eichmann in Jerusalem*, 135, 30, 130.
55 Arendt, *Eichmann in Jerusalem*, 52, 61.
56 Arendt, *Eichmann in Jerusalem*, 61.
57 Arendt, *Eichmann in Jerusalem*, 136.
58 Hannah Arendt cited in C. Caruth, *Literature in the Ashes of History* (Baltimore: John Hopkins Press, 2013), 43. See also Thapar, "Politics and the Rewriting of History in India," and Martha Nussbaum, *The Clash Within: Democracy, Religious Violence and India's Future* (Cambridge, MA: Harvard University Press, 2007).
59 Slavoj Žižek, "Notes on a Poetic Military Complex," *Third Text* 23 (2009): 503–9. Žižek puts it this way: "the superego's suspension of moral prohibitions is the crucial feature of today's post-modern nationalism." He continues: "Passionate ethnic identity, far from further restraining us, rather functions as a liberating call 'You may!'—you may violate... the stiff regulation of peaceful coexistence in a liberal tolerant society, engage in patriarchal mores prohibited by liberal political corrections, even hate, fight, kill and rape... You may—turns into the prescriptive 'You must!'"
60 Arendt, *Eichmann in Jerusalem*, 31, 60, 66, 67.
61 Hannah Arendt, *The Origins of Totalitarianism* (New York: Harcourt Brace, 1976), 70.
62 Arendt, *Eichmann in Jerusalem*, 130.
63 Arendt, *Eichmann in Jerusalem*, 505.
64 Arendt, *Eichmann in Jerusalem*, 137.
65 Sarkar, "Semiotics of Terror: Muslim Children and Women in the Hindu Rashra," 2872.
66 Arendt, *The Origins of Totalitarianism*, 127.
67 Arendt, *The Origins of Totalitarianism*, 127.
68 Here I use Cathy Caruth's definition of trauma. She writes, "in its general definition, trauma is described as the response to an unexpected or overwhelming violent event or events that are not fully grasped as they occur, but return later in repeated flashbacks, nightmares, and other repetitive phenomena. Traumatic experience, beyond the psychological dimension of suffering it involves, suggests a certain paradox: that the most direct seeing of a violent event may occur as an absolute inability to know it; that immediacy, paradoxically, may take the form of belatedness. The repetitions of the traumatic event—which remain unavailable to consciousness but intrude repeatedly on sight—thus suggest a larger relation to the event that extends beyond what can simply be seen or what can be known, and is inextricably tied up with the belatedness and incomprehensibility that remain at the heart of this repetitive seeing." Cathy Caruth, *Unclaimed Experience: Trauma, Narrative, and History* (Baltimore: John Hopkins University Press, 1996), 92–3. See also Stef Craps,

"Wor(l)ds of Grief: Traumatic Memory and Literary Witnessing in Cross-cultural Perspective," in *Textual Practice* 24, no. 1 (2010): 55, who writes: "exposure to acts or threats of physical or psychological violence is a constant reality – the rule rather than the exception—for members of oppressed groups, who do not lead safe, sheltered, and protected lives."

69 Bhaskar Sarkar, *Mourning the Nation* (Durham, NC: Duke University), 18–19.
70 Sarkar, *Mourning the Nation*, 34.
71 Sarkar, *Mourning the Nation*, 1–2.
72 Freud, "The Uncanny," 226.
73 See Bill Brown, "Reification, Reanimation, and the American Uncanny," in *Critical Inquiry* 2 (2006): 175–207. Also, Urvashi Butalia recounts that after Indira Gandhi's assassination when the Sikh riots of 1984 broke out, older people in Delhi kept saying: "We didn't think it could happen to us in our own country ... This is like Partition again." See Urvashi Butalia, *The Other Side of Silence: Voices from the Partition of India* (Durham: Duke University Press, 2000), 4.
74 Freud, "The Uncanny," 242.
75 Although not occurring during a specific riot, on January 12, 2018 an eight-year-old Muslim child named Asifa Bano was found after she was strangled and stoned to death. She had been the victim of multiple gang rapes inside a Hindu Temple over the course of four days. Among the alleged rapists were two BJP ministers from the local Jammu and Kashmir government. Rallies were organized by the BJP in defense of the accused. See https://www.aljazeera.com/news/2018/04/india-nationwide-protests-demand-justice-rape-victims-180415142954535.html. Accessed September 21, 2019.
76 Caruth, *Literature in the Ashes of History*, 4.
77 Freud, "The Uncanny," 240.
78 See James E. Young, *Writing and Rewriting the Holocaust: Narrative and the Consequences of Interpretation* (Bloomington: Indiana University Press, 1988); and, Butalia, *The Other Side of Silence*, 10.
79 Freud, "The Uncanny," 240.
80 Freud, "The Uncanny," 242.
81 Jacques Derrida, "*Specters of Marx: The State of the Debt, the Work of Mourning, and the New International*, translated by Peggy Kamuf (New York: Routledge, 1999), 46.
82 Derrida, "*Specters of Marx*, 46.
83 Derrida, *Specters of Marx*, 46.
84 Elaine Scarry, *The Body in Pain. The Making and Unmaking of the World* (Oxford: Oxford University Press, 1985), 18. See also T.M. Lemos, *Violence and Personhood in Ancient Israel and Contemplative Contexts* (Oxford: Oxford University Press, 2017).

85 At the EASAS conference I attended in Paris 2018, a group of panelists gathered to discuss the first Partition museum to open in India in 2017. The Panel was called "The Ethics and Practice of Remembering in India," organized by S. Kapila and G. Ganapathy-Doré.

7 *Bandit Queen*, Rape Revenge, and Cultural Horror

1 The "West" is not used in an uncritical manner, recognizing the constructed nature and semiotics of power that contribute to this type of naming. Instead, I use it to refer to films and filmic conventions rooted in North American production and film reception.
2 Phoolan Devi was murdered in 2001, in a crime linked to the Behmai massacre, discussed later in the chapter. Upper caste man, Sher Singh Rana, was fined and sentenced to life imprisonment for the crime. Ten others were charged, but acquitted. See Patrick Reevell, "Killer of India's 'Bandit Queen' Gets Life Sentence," *The Globe and Mail*, August 14, 2014, https://www.theglobeandmail.com/news/world/killer-of-indias-bandit-queen-gets-life-sentence/article20057370/.
3 Madhu Kishwar, "Film Review: *The Bandit Queen*," *Manushi* 84 (1994): 34–7. Madhu Kishwar is an Indian academic, writer, and founder of feminist publication *Manushi*. However, recently she has received attention for her problematic Tweets about the Kathua case. Asifa, an eight-year-old Muslim nomad was brutally raped and murdered, and Kishwar wrote about the scapegoating of Hindu nationalists who have been accused of the crime. This has contributed to social strife and led to a lawsuit filed against her. See National Herald, "Kathua: Prashant Bhushan Files Complaint Against Madhu Kishwar," *National Herald*, April 16, 2018, https://www.nationalheraldindia.com/india/senior-lawyer-prashant-bhushan-filed-criminal-complaint-against-madhu-kishwar-tweets-kathua-rape-case-tweet.
4 This leads me to exclude films like the blaxploitation hit, *Foxy Brown* (1974, dir. Jack Hill). This film does have a revenge narrative, as the title character is motivated by her boyfriend's murder. However, her rape in the film is incidental to the plot. The castration of a male character who is not her rapist is not in revenge for the rape but to avenge her boyfriend's murder.
5 Lalitha Gopalan comments that the location of rape revenge in low-budget Western horror and exploitation films raises questions about taste and distribution networks of B-films in the Third World. See, Lalitha Gopalan "Avenging Women in Indian Cinema," *Screen* 38, no. 1 (1997): 42–59.
6 See, E. Ann Kaplan, "Problematizing Cross-Cultural Analysis: The Case of Women in the Recent Chinese Cinema," in *Asian Cinemas: A Reader and Guide*, ed. Dimitris Eleftheriotis and Gary Needham (Honolulu: Hawai'i University Press, 2006): 156–67.

Notes to Pages 142–144

7 For example, Alexandra Heller-Nicholas' chapter on international rape revenge films includes a brief analysis of *Bandit Queen* as "the most immediately recognizable intersection of rape and revenge in Indian cinema" outside of India. See Alexandra Heller-Nicholas, *Rape-Revenge Films: A Critical Study* (Jefferson, NC: McFarland & Company, 2011), 135.
8 Jyotika Virdi, "Reverence, Rape—And Then Revenge: Popular Hindi Cinema's 'Women's Films,'" *Screen* 40 (1999): 17.
9 Gopalan, "Avenging Women," 44.
10 Uma Maneswari Bhrugubanda, "Devotion and Horror in a Women's Genre: Exploring Subalternity in Cinema," *Critical Quarterly* 56, no. 3 (2014): 21–33.
11 Carol Clover, *Men, Women, and Chain Saws: Gender in the Modern Horror Film* (Princeton, NJ: Princeton University Press, 1992); Barbara Creed, *The Monstrous-Feminine: Film, Feminism, Psychoanalysis* (London: Routledge, 1993).
12 Jacinda Read, *The New Avengers: Feminism, Femininity and the Rape-Revenge Cycle* (Manchester: Manchester University Press, 2000); Heller-Nicholas, *Rape-Revenge*.
13 Claire Henry, *Revisionist Rape-Revenge: Redefining a Film Genre* (New York: Palgrave Macmillan, 2014).
14 Linda Williams, "Filmic Bodies: Gender, Genre, and Excess," *Film Quarterly* 44, no. 4 (1991): 2–13.
15 Robin Wood, "An Introduction to the American Horror Film," in *Movies and Methods, Volume II: An Anthology*, ed. Bill Nichols (Berkeley: University of California Press, 1985): 203.
16 Read gives the example of Clover's analysis of the perpetrators in *I Spit on Your Grave* (1978, dir. Meir Zarchi). Though Clover argues that the urban-rural divide is an important defining feature of horror and is embodied by the main character as an urban writer and her rural attackers, ultimately the male perpetrators in *I Spit* are not abnormal. Read sees this as a misstep by Clover because it suggests that the transformation of victim to avenger is the monstrosity and attack on normalcy.
17 Clover argues that many revenge-horror films owe a debt to *Deliverance* (1972, dir. John Boorman), an all-male rape revenge narrative. However, rape revenge films are largely based on female rape, and as Gopalan argues, rape acts as "a violent litmus test of identity" (1997, 51) in many of these films.
18 Clover uses the term "victim", while I use the language of "survivor/ship" to describe experiences of sexual assault. This is not to flatten the experiences or depictions of rape or to impose prescribed language on a complicated topic, but to acknowledge the mobility and agency of those who experience sexual assault. See Liz Kelly, *Surviving Sexual Assault* (Cambridge: Polity Press, 1988). When writing about characters who were killed in assault, I tend to revert to the language of victim for accuracy, as they literally did not survive the assault.
19 Clover, *Chain Saws,* 159.

20 Gopalan, "Avenging Women."
21 Ronald Allen Lopez Cruz, "Mutations and Metamorphoses: Body Horror is Biological Horror," *Journal of Popular Film & Television* 40, no. 4 (2012): 161.
22 This is at least true in the West, as *Last House* was the first in a series of rape revenge films throughout the 1970s and 1980s. There are earlier examples of rape revenge that are often cited, starting with the racist film *The Birth of a Nation* (1915, dir. D.W. Griffith) where Ku Klux Klansmen avenge the attempted rape of a white woman by Black attackers. However, *Last House* marked the beginning of popularizing rape revenge as a narrative in B-list exploitation/horror genre films and spawned a number of international remakes. It is thought to be inspired by the Italian film *The Virgin Spring* (1960, dir. Ingmar Bergman).
23 In the remake of *The Last House on the Left* (2009, dir. Dennis Iliadis), the daughter is not killed in the attack and instead makes a remarkable escape from her rapists. However, her incapacitation still leads to her parents being responsible for the revenge on the perpetrators.
24 Roger Ebert, "*Last House on the Left* Review (1972)," January 1, 1972, https://www.rogerebert.com/reviews/last-house-on-the-left-1972.
25 For example, *The Crow* (1994, dir. Alex Proyas) centres on the transformation of the lead character into a supernatural figure to seek revenge for the rape and murder of his fiancée. Because the film begins after the crime occurred, the audience only knows her character through the memories of the masculine avenger. The other films in the series also indicate that the powers of revenge are bestowed for the murder of a loved one (as rape is only in the plot of the first film and is incidental to her murder).
26 Sarah Projansky, *Watching Rape: Film and Television in Postfeminist Culture* (New York: New York University Press, 2001): 60.
27 This has been complicated by recent films where mothers take revenge on behalf of their children. For example, *Mom* (2017, dir. Ravi Udyawar) has a mother, played by Sridevi, taking vigilante justice against her step-daughter's attackers after a failure of the traditional justice system.
28 Roger Ebert, "*I Spit on Your Grave* Review (1980)," July 16, 1980, https://www.rogerebert.com/reviews/i-spit-on-your-grave-1980.
29 Casey Ryan Kelly, "Camp Horror and the Gendered Politics of Screen Violence: Subverting the Monstrous-Feminine in *Teeth (2007)*," *Women's Studies in Communication* 39, no. 1 (2016): 86–106.
30 Films like *Descent* (2007, dir. Talia Lugacy) problematize this notion. After the avenger succeeds in literal retributive revenge, where she rapes her rapist, the film concludes with her lack of resolution from the act. Her rape was not undone by the rape of her rapist. Similarly, the avengers in the New French Extremity film *Irréversible* (2002, dir. Gaspar Noé) unknowingly kill the wrong assailant, making the graphic violence of the murder even more questionable for the viewer.

31 Jenny Lapekas, "*Descent*—'everything's okay now': Race, Vengeance, and Watching the Modern Rape-Revenge Narrative," *Jump Cut: A Review of Contemporary Media* 55 (2013).
32 Gopalan, "Avenging Women."
33 Gopalan, "Avenging Women," 44.
34 This is also highlighted by the defence's manipulation of Bharti's younger sister to testify against her, because she was a brief witness to the sexual assault.
35 *The Accused* (1988, dir. Jonathan Kaplan) and *Extremities* (1986, dir. Robert M. Young) are sometimes cited as films that show how the legal system can be leveraged by survivors in avenging their assault. However, it's important to note that these were both relatively mainstream Drama films with well-known actresses, perhaps limiting their subversive potential in state critique.
36 Gopalan, "Avenging Women."
37 Shelley Stamp Lindsey, "Horror, Femininity, and Carrie's Monstrous Puberty," in *The Dread of Difference: Gender and the Horror Film*, ed. Barry Keith Grant (Austin, TX: University of Texas Press, 1996): 280.
38 Karen Gabriel, "Reading Rape: Sexual Difference, Representational Excess and Narrative Containment," in *Narratives of Indian Cinema*, ed. Manju Jain (Delhi: Primus Books, 2009), 154.
39 Quoted in Madhu Jain, "The Truth on Trial," *India Today*, October 15, 1994, http://indiatoday.intoday.in/story/shekhar-kapur-bandit-queen-raises-moral-questions-on-individual-right-toprivacy/1/294276.html.
40 Heller-Nicolas, *Rape-Revenge*.
41 Quoted in Jain, "Truth on Trial."
42 Quoted in Mary Anne Weaver, "India's Bandit Queen," *The Atlantic*, November 1, 1996, https://www.theatlantic.com/magazine/archive/1996/11/indias-bandit-queen/304890/?single_%20page1%E2%81%844true.
43 Arundhati Roy, "The Great Indian Rape-Trick I," October 11, 2004, http://arundhatiroy.blogspot.ca/2004/11/great-indian-rape-trick-i.html.
44 Roy, "The Great Indian Rape-Trick I."
45 Eric Hobsbawm, *Bandits* (New York: Delacorte Press, 1969), 13.
46 Quoted in Weaver, "Bandit Queen."
47 William R. Pinch, "Film Review: The Bandit Queen," *The American Historical Review* 101 (1996): 1149.
48 Sarah Caldwell, "Subverting the Fierce Goddess: Phoolan Devi and the Politics of Vengeance," in *Playing for Real: Hindu Role Models, Religion and Gender*, ed. Jacqueline Suthren Hirst and Lynn Thomas (New Delhi: Oxford University Press, 2004): 161–78.
49 Rajeswari Sunder Rajan, *The Scandal of the State: Women, Law, and Citizenship* (Durham, NC: Duke University Press, 2003).

50 Rajan, *The Scandal of the State*, 217.
51 Gabriel, "Reading Rape," 160.
52 A few moments in the film notwithstanding, including her interaction with low caste village girl during a raid where she gives her looted jewelry.
53 Quoted in Rajan, *Scandal*, 225.
54 Quoted in Weaver, "Bandit Queen."
55 Mala Sen, *India's Bandit Queen: The True Story of Phoolan Devi* (London: Pandora, 1991), 25.
56 Rajan, *The Scandal of the State*, 25.
57 Anuradha Ramanujan, "The Subaltern, the Text and the Critic: Reading Phoolan Devi," *Postcolonial Writing* 44 (2008): 367–78.
58 Quoted in Jain, "Truth on Trial."
59 Clover, *Chain Saws*.
60 Heller-Nicolas, *Rape-Revenge*, 37.
61 Urvashi Butalia, "Women in Indian Cinema," *Feminist Review* 317 (1984): 108–10.
62 For example, the major source of feminist criticism against *Straw Dogs* was the exploitative depiction of rape as something that may be enjoyed by the victim. A newer rape revenge narrative that explores this ambiguity with more nuance is *Elle* (2016, dir. Paul Verhoeven), where the relationship between the rapist and the lead character is complicated and challenges the notion of a "perfect" rape survivor who acts in ways intelligible to the spectator. However, these themes are larger than this chapter can explore.
63 Gopalan, "Avenging Women," 49.
64 Among the changes made in the remake, *I Spit on Your Grave* (2010, dir. Steven R. Monroe) has a considerably shorter rape scene than the original, though to a lesser extent, it does similarly employ the deception that Jennifer may get away from her attackers. Conversely, the revenge portion is considerably more graphically violent and more inspired by slasher and torture porn horror genres.
65 Roy, "Rape-Trick I."
66 Gohar Siddiqui, "Behind her laughter . . . is fear!' Domestic Abuse and Transnational Feminism in Bollywood Remakes," *Jump Cut: A Review of Contemporary Media* 55 (2013).
67 This is an interesting contrast to the initial scene of water drawing when Phoolan was a child.
68 Gabriel, "Reading Rape."
69 Shanthie Mariet D'Souza and Bibhu Prasad Routray, "*Bandit Queen*: Cinematic Representation of Social Banditry in India," *Small Wars & Insurgencies* 26, no. 4 (2015): 688–701.
70 Sen, *Bandit Queen*.

Notes to Pages 153–157

71 Mridula Nath Chakraborty, "'*Ye haath mujhe de dey, Thakur!*': The Dacoit, the Insurgent and the Long Arm of the Law," *South Asia: Journal of South Asian Studies* 38, no. 1 (2015): 95. Italics original.
72 Kelly, "Camp Horror."
73 Caldwell, "Subverting."
74 D'Souza and Routray, "*Bandit Queen*."
75 Gopalan, "Avenging Woman."
76 The *Manu Smṛti* (The Laws of Manu) are the most authoritative books of the *Dharmaśāstra* (Hindu Code), which dictate the caste-based duties and obligations for Hindus. It had a profound impact on caste divisions but was also appropriated in various ways under British rule to misinterpret Indian barbarism and justify colonial order.
77 Gabriel, "Reading Rape."
78 Quoted in Leela Fernandes, "Reading 'India's Bandit Queen:' A Trans/Nationalist Perspective on the Discrepancies of Representation," *Signs* 25 (1999): 132.
79 See Gayatri Chakravorty Spivak, "Can the Subaltern Speak?" in *Marxism and the Interpretation of Culture,* ed. Cary Nelson and Lawrence Grossberg (Chicago: University of Illinois Press, 1988), 271–316.
80 Ramanujan, "The Subaltern," 368.
81 Mina Kumar, "Beyond Mere Factual Truth: The Filmi Bandit Queen," *India Currents Magazine* 9 (1995): 28–9.
82 Quoted in Jain, "Truth on Trial."
83 Meera Kosambi, "Bandit Queen Through Indian Eyes: The Reconstructions and Reincarnations of Phoolan Devi," *Hecate* 24, no. 2 (1998).
84 Pinch, "Film Review," 1149.
85 Arundhati Roy, "The Great Indian Rape-Trick II," July 8, 2012, http://baajve.blogspot.ca/2012/07/arundhati-roy-on-shekhar-kapurs-bandit_08.html.
86 Pinch, "Film Review," 1149–50.
87 Quoted in John-Thor Dahlburg, "'The Bandit Queen' Still an Outcast in India," *LA Times,* October 20, 1994, http://articles.latimes.com/1994-10-20/entertainment/ca-52584_1_bandit-queen.
88 Brenda Longfellow, "The Bandit Queen," *Cineaction* 36 (1995): 10.
89 Kishwar, "Film Review."
90 Roy, "Rape-Trick I."
91 Fernandes, "Reading," 149.
92 Longfellow, "Bandit Queen," 12.
93 Stanley Kauffman, "On Films: Sexual Violations," *The New Republic,* July 10, 1995: 24.
94 Fernandes, "Reading."

95 Phoolan notes that the higher caste women have metal pots for water and blames the destruction of the clay pot on the family's low caste material status. Earlier in the scene, it also shows that higher castes have an easier time fetching water with the use of a pulley. It doesn't explicitly say in the film what caste Putti Lal is, but it is reasonable to expect that he was also low caste but was in a better financial situation that Phoolan's family.

96 Kumar additionally cites the lack of music or dance that is characteristic of Bollywood cinema. Kapur's first films, *Masoom* (1983) and *Mr. India* (1987) were filmed in a more quintessentially Bollywood style. The departure in *Bandit Queen* was explained as an attempt to launch an international career, which ended up being largely successful with his later direction of *Elizabeth* (1998) and *Elizabeth: The Golden Age* (2007), among other films for predominantly Western audiences.

97 Kishwar, "Film Review."

98 Fernandes, "Reading," 126.

99 Kishwar, "Film Review."

100 Dahlburg, "Outcast in India."

101 Shekhar Kapur, "Is Bandit Queen My Best Movie?" *Shekhar Kapur Blog*, June 1, 2008, http://shekharkapur.com/blog/2008/06/is-bandit-queen-my-best-film/2008

102 Kauffman, "On Films," 24.

103 Kumar, "Beyond."

104 Quoted in Jain, "Truth on Trial."

105 Virdi, "Reverence."

106 D'Souza and Routray, "*Bandit Queen*."

107 Kapur, "Best Movie."

108 Quoted in Archana Masih, "An Actress Remembers," *Rediff*, April 4, 1997, http://www.rediff.com/movies/apr/04sema.htm.

109 Maggie Lee, "Film Review: 'Marlina the Murderer in Four Acts'," May 26, 2017, https://variety.com/2017/film/reviews/marlina-the-murder-in-four-acts-review-1202446324/

110 Perhaps to Roger Ebert's possible dismay, the screening of this film that I attended included spectator identification with the heroine in terms of audible and visceral responses to her revenge.

111 Roy, "Rape-Trick II." Italics in original.

8 *Mardaani*: The Secular Horror of the Child Trafficking and the Modern Masculine Woman

1 Shakuntala Banaji, "Bollywood Horror as an Uncanny Public Sphere: Genre Theories, Postcolonial Concepts, and the Insightful Audience," *Communication, Culture & Critique* 7 (2014): 468.

2 Meheli Sen, "Terrifying Tots and Hapless Homes: Undoing Modernity in Recent Bollywood Cinema." *Literature Interpretation Theory* 22 (2011): 198.
3 Sen, "Terrifying Tots and Hapless Homes," 198.
4 Box Office India, "*Mardaani 2*," www.boxofficeindia.com/movie.php?movieid=5741, accessed February 7, 2020.
5 Mithuraaj Dhusiya, *Indian Horror Cinema: (En)Gendering the Monstrous* (London: Routledge, 2018), 19–20.
6 Aditi Sen, "Hindi Horror Films: Beyond the Gothic," *Open Magazine* (May 17, 2019), www.openthemagazine.com/article/cinema/hindi-horror-films-beyond-the-gothic
7 Kartik Nair, "Book Reviews," *BioScope* 8, no. 2 (2017): 283.
8 Meraj Ahmed Mubarki, "Monstrosities of Science: Exploring Monster Narratives in Hindi Horror Cinema," *Visual Anthropology* 28 (2015): 257.
9 Meheli Sen, *Haunting Bollywood: Gender, Genre, and the Supernatural in Hindi Commercial Cinema* (Austin: University of Texas Press, 2017), 19–20.
10 Banaji, "Bollywood Horror as an Uncanny Public Sphere," 461.
11 Audiences were much more accepting of Mukerji as an investigation-oriented female hero in *Mardaani* than they were of her as a parodic romantic female hero; Aiyyaa was financially very unsuccessful. Box Office India, "*Aiyyaa*," www.boxofficeindia.com/movie.php?movieid=1149, accessed August 5, 2019.
12 Kathleen M. Erndl, "Divine Horror and the Avenging Goddess in Bollywood," Chapter 3 in this volume.
13 Erndl, "Divine Horror."
14 As an adult woman who works outside the home, Shivani is in a distinct minority: only 28 per cent of Indian women of working age were in the labor force in 2018. Smriti Sharma, "The Conspicuous Absence of Women in India's Labor Force," *The Conversation*, May 15, 2019, http://theconversation.com/the-conspicuous-absence-of-women-in-indias-labour-force-109744, accessed August 15, 2019.
15 Meraj Ahmed Mubarki, "The Monstrous 'Other' Feminine: Gender, Desire, and the 'Look' in the Hindi Horror Genre," *Indian Journal of Gender Studies* 21, no. 3 (2014), 379.
16 Mubarki, "The Monstrous 'Other' Feminine," 379.
17 Mubarki, "The Monstrous 'Other' Feminine," 397.
18 Box Office India, "Laaga Chunari Mein Daag," www.boxofficeindia.com/movie.php?movieid=344, accessed August 5, 2019.
19 Box Office India, "Mardaani," www.boxofficeindia.com/movie.php?movieid=2296, accessed August 5, 2019.
20 Lalitha Gopalan, "Avenging Women in Indian Cinema," *Screen* 38:1 (Spring 1997), 44.
21 Gopalan, "Avenging Women in Indian Cinema," 52.
22 In the film, successful model Bharti lives with her teenage sister Neeta in an apartment in Mumbai. At a beauty contest, millionaire Ramesh (Raj Babbar)

becomes obsessed with Bharti. He visits her apartment and violently attacks her when she is distracted from their conversation by a phone call from her fiancé Ashok. Neeta returns home unexpectedly and witnesses the crime but quickly flees, upset by what she sees. Bharti reports the crime to the police immediately and presses charges. Opposing counsel torments both Bharti and Neeta on the witness stand, and the court finds Ramesh not guilty. Bharti and Neeta leave Mumbai, but in a twist of fate years later Neeta ends up at a job interview with Ramesh, who taunts and rapes her. Bharti immediately tracks Ramesh down and, without any disguise or pretext, shoots him point blank. In her trial, she makes an impassioned speech about the effect of having been denied justice originally and the role of the law in protecting criminals. The judge frees her and declares himself so ashamed of his previous ruling that he quits the bench. Bharti is reunited with Ashok and his parents.

23 Gopalan, "Avenging Women in Indian Cinema," 47.
24 Sen, *Haunting Bollywood*, 6.
25 Gopalan, "Avenging Women in Indian Cinema," 51.
26 Gopalan, "Avenging Women in Indian Cinema," 57.
27 A term for violent, often extrajudicial police attacks on criminals.
28 Draft legislation to create an independent body investigating corruption charges and protecting whistleblowers.
29 Anuj Kumar, "Mardaani: Packs a Punch," *The Hindu*, August 22, 2014.
30 Sen, *Haunting Bollywood*, 117.
31 Banaji, "Bollywood Horror as an Uncanny Public Sphere," 460.
32 Sen, "Terrifying Tots and Hapless Homes," 201.
33 Mubarki, "The Monstrous 'Other' Feminine," 381.
34 Vakil's sacrifice is, interestingly, the closest the film comes to the traditional cinematic mother figure who gives up her life for her children. By reassigning this action to a villain, the filmmakers create space for Shivani to value her own life as much as other people's.
35 Sen, "Terrifying Tots and Hapless Homes," 198–9.
36 Patrick Kennedy, "Definition of Gothic Literature," Thought Co., www.thoughtco.com/gothic-literature-2207825Thought Co, accessed July 9, 2019.
37 Sen, *Haunting Bollywood*, 15.
38 In *Haunting Bollywood*, Meheli Sen discusses the fit of Gothic elements into postcolonial settings and refers to the idea from David Punter and Glennis Byron (*The Gothic*, 2004) that "the transplantation of peoples" that runs throughout "half-buried" colonial histories colors cinematic attempts to portray modern nations. *Haunting Bollywood*, 22–3.
39 Sen, *Haunting Bollywood*, 119.
40 Sen, *Haunting Bollywood*, 118.

41 Nair, "Book Reviews," 280.
42 Nair, "Book Reviews," 281.
43 Sen, *Haunting Bollywood*, 43.
44 Sen, *Haunting Bollywood*, 18.
45 Banaji, "Bollywood Horror as an Uncanny Public Sphere," 468.

Bibliography

The Accused. Film. Dir. Jonathon Kaplan. Hollywood: Paramount Pictures, 1988.
Agamben, Giorgio. *State of Exception*. Trans. by Kevin Attell. Chicago: University of Chicago Press, 2005.
Aiyyaa. Film. Dir. Sachin Kundalkar. India: Ranjit Gugle, Anurag Kashyap, Vikram Malhotra, and Guneet Monga, 2012.
"*Aiyyaa*." Box Office India. www.boxofficeindia.com/movie.php?movieid=1149 (accessed August 5, 2019).
Altman, Michael. *Heathen, Hindoo, Hindu: American Representations of India, 1721–1893*. New York: Oxford University Press, 2017.
Amar Akbar Anthony. Film. Dir. Manmohan Desai. Bombay: Manmohan Films, 1977.
Amavasai Iravil. Film. Dir. P. Chandrakumar. India: Shree Janani Enterprises, 1989.
Ammoru. Film. Dir. Kodi Ramakrishna. India: M.S. Arts, 1995.
Anand, Dibyesh. *Hindu Nationalism in India and the Politics of Fear*. New York: Palgrave Macmillan, 2011.
Anderson, Benedict. *Imagined Communities: Reflections on the Origin and Spread of Nationalism*. London: Verso, 1983.
Anderson, Benedict. *The Fate of Rural Hell: Asceticism and Desire in Buddhist Thailand*. London: Seagull Books, 2012.
Andheri Raat. Film. Dir. V. Prabhakar. India: Sree Padmavathi Devi Productions, 1995.
Anjaam. Film. Dir. Rahul Rawail. India: Shiv-Bharat Films, 1994.
Appadurai, Arjun. "Introduction: Commodities and the Politics of Value." In *The Social Life of Things: Commodities in Cultural Perspective*. Edited by Arjun Appadurai, 3–63. Cambridge: Cambridge University Press, 2017.
Arendt, Hannah. *Eichmann in Jerusalem: A Report on the Banality of Evil*. New York: Viking Press, 1963.
Arendt, Hannah. *The Origins of Totalitarianism*. New York: Harcourt Brace, 1976.
Ashok, Krish. "Guide to Designing Indian Political Posters." *Doing Jalsa and Showing Jilpa*, December 10, 2017. Available online: https://krishashok.me/2007/12/10/guide-to-designing-indian-political-posters/ (accessed August 27, 2019).
Austen, Jane. *Northanger Abbey, and Persuasion*. London: Simms and McIntyre, 1853.
Baazigar. Film. Dir. Abbas-Mustan, 1993. Mumbai: Eros, 2003.
Bacchetta, Paolo. "Hindu Nationalist Women as Ideologues: The 'Sangh', the 'Samiti' and Their Differential Concepts of the Hindu Nation." In *The Sangh Parivar: A Reader*. Edited by Christophe Jaffrelot, 108–47. New Delhi: Oxford University Press, 2004.

Bacchetta, Paolo. *Gender in the Hindu Nation: RSS Women as Ideologues*. New Delhi: Women Unlimited, 2005.
Baldick, Chris and Robert Mighall. "Gothic Criticism." In *A New Companion to the Gothic*. Edited by David Punter, 267–87. Chichester: Blackwell, 2012.
Banaji, Shakuntala. "Bollywood Horror as an Uncanny Public Sphere: Genre Theories, Postcolonial Concepts, and the Insightful Audience." *Communication, Culture & Critique* 7, no. 4 (2014): 453–71.
Bandh Darwaza. Film. Dir. Shyam Ramsay and Tulsi Ramsay. India: Ramsay Productions, 1990.
Bandit Queen. Film. Dir. Shekhar Kapur. Port Washington, NY: Koch Vision, 1994.
Bees Saal Baad. Film. Dir. Biren Nag. India: Geetanjali Pictures, 1962.
Bevers, Michael. "An Interview with Visiting Professor Dr. Samar Attar." *NELCommuniqué* 3 (2012): 3, 7.
Bharati, Agehananda. "The Hindu Renaissance and Its Apologetic Patterns." *The Journal of Asian Studies* 29, no. 2 (1970): 267–87.
Bhattacharyya, Narendra Nath. *Indian Demonology: The Inverted Pantheon*. New Delhi: Manohar, 2000.
Bhavabhūti. *The Mālatīmādhava of Bhavabhūti, with the Commentaries of Tripurāri and Jagaddhara*. Bombay: T. Jāvajī, 1900.
Bhayaanak. Film. Dir. S.U. Syed. India: AVM Arts International, 1979.
Bhrugubanda, Uma Maneswari. "Devotion and Horror in a Women's Genre: Exploring Subalternity in Cinema." *Critical Quarterly* 56, no. 3 (2014): 21–33.
The Birth of a Nation. Film. Dir. D.W. Griffith. Chatsworth, CA: Image Entertainment, 1915.
Black Friday. Film. Dir. Anurag Khashyap. India: Adlabs, 1998.
Black Sunday (*La maschera del demonio*). Film. Dir. Mario Bava. Italy: Galatea Film, 1960.
Blackton, Charles S. "The Colombo Plan." *Far Eastern Survey* 20, no. 3 (1951): 27–31.
Bloch, Robert. "Dr. Psycho and Mr. Stein." *Rogue*, January 1962.
Bombay. Film. Dir. Mani Ratnam. India: Mani Ratnam Films, 1995.
Bond, Ruskin. "A Season of Ghosts." *Blackwood Magazine* 320, no. 1929 (July–December 1976): 456.
Bose, Mihir. *Bollywood: A History*. London: Tempus Publishing Limited, 2006.
Brooks, Douglas Renfrew. "Encountering the Hindu 'Other': Tantrism and the Brahmans of South India." *Journal of the American Academy of Religion* 60, no.3 (1992): 405–36.
Brooks, Douglas Renfrew. *The Secret of the Three Cities: An Introduction to Hindu Śākta Tanta*. Chicago: University of Chicago Press, 1998.
Brown, Bill. "Reification, Reanimation, and the American Uncanny." *Critical Inquiry* 32 (2006): 175–207.
Brunvand, Jan Harold. *The Vanishing Hitchhiker: American Urban Legends & Their Meanings*. New York: W.W. Norton, 1981.

van Buitenen, Johannes Adrianus Bernardus, trans. *The Bhagavadgītā in the Mahābhārata: A Bilingual Edition*. Chicago: University of Chicago Press, 1981.

Butalia, Urvashi. "Women in Indian Cinema." *Feminist Review* 317 (1984): 108–10.

Butalia, Urvashi. *The Other Side of Silence: Voices from the Partition of India*. Durham: Duke University Press, 2000.

Butler, Judith. *Bodies that Matter: On the Discursive Limits of Sex*. New York: Routledge, 2011.

Caldwell, Sarah. "Subverting the Fierce Goddess: Phoolan Devi and the Politics of Vengeance." In *Playing for Real: Hindu Role Models, Religion and Gender*. Edited by Jacqueline Suthren Hirst and Lynn Thomas, 161–78. New Delhi: Oxford University Press, 2004.

Candyman. Film. Dir. Bernard Rose. USA: Candyman Films, 1992.

Candyman: Farewell to the Flesh. Film. Dir. Bill Condon. USA: PolyGram Filmed Entertainment, 1995.

Candyman: Day of the Dead. Film. Dir. Turi Meyer. USA: Artisan Entertainment, 1999.

Carroll, Noël. "The Nature of Horror." *The Journal of Aesthetics and Art Criticism* 46, no. 1 (Autumn, 1987); 51–9.

Carroll, Noël. *The Philosophy of Horror: Or, Paradoxes of the Heart*. New York: Routledge, 1990.

Carroll, Noël and Caetlin Benson-Allott. "Paradoxes of the Heart: *The Philosophy of Horror* Twenty-five Years Later: An Interview with Caetlin Benson-Allott." *Journal of Visual Culture* 14 (2015): 336–43.

Caruth, C. *Unclaimed Experience: Trauma, Narrative, and History*. Baltimore: John Hopkins University Press, 1996.

Caruth, C. *Literature in the Ashes of History*. Baltimore: John Hopkins University Press, 2013.

Caṭṭopādhyāy, Bankimcandra. *Kapālakuṇḍalā*. Calcutta: Tipti Publishing, 1966.

Chakrabarti, Arindam. "Refining the Repulsive: Toward an Indian Aesthetics of the Ugly and the Disgusting." In *The Bloomsbury Research Handbook of Indian Aesthetics and the Philosophy of Art*. Edited by Arindam Chakrabarti, 149–65. London: Bloomsbury, 2016.

Chakraborty, Mridula Nath. "'*Ye haath mujhe de dey, Thakur!*': The Dacoit, the Insurgent and the Long Arm of the Law." *South Asia: Journal of South Asian Studies* 38, no. 1 (2015): 84–99.

Chandralekha. Film. Dir. Subramaniam Srinivasan Vasan. India: Gemini Pictures, 1948.

Chatterjee, Saibal. "It's a cop's life." In *The Tribune India*. Sunday, June 13, 2004. https://www.tribuneindia.com/2004/20040613/spectrum/main6.htm (accessed November 5, 2018).

Cheekh. Film. Dir. Mohan Bhakri. India: MKB Films Combines, 1985.

Cherry, B. *Horror*. Routledge Film Guidebooks. Abingdon, UK: Taylor & Francis, 2009.

Chicago Film Critics Association, "Top 100 Scariest Movies." Filmspotting, October 2006. https://web.archive.org/web/20080117102530/http://www.filmspotting.net/top100.htm (accessed February 4, 2020).

Chingaari. Film. Dir. Kalpana Lajmi. India: Kalpana Lajmi and Vikas Sahni, 2006.

Clover, Carol. "Her Body, Himself: Gender in the Slasher Film." *Representations* 20 (1987): 187–228.

Clover, Carol. *Men, Women, and Chainsaws: Gender in the Modern Horror Film*. Princeton: Princeton University Press, 1992.

Coburn, Thomas B. *Encountering the Goddess: A Translation of the Devī-Māhātmya and a Study of Its Interpretation*. New York: SUNY Press, 1991.

Collins, Brian. *The Head Beneath the Altar: Hindu Mythology and the Critique of Sacrifice*. East Lansing: Michigan State University Press, 2014.

Collins, Brian and Kristen Tobey. "From *Middlemarch* to *The Da Vinci Code*: Portrayals of Religious Studies in Popular Culture." *Religious Studies Review* 44, no. 2 (2018), 173–82.

Cowan, Douglas E. *America's Dark Theologian: The Religious Imagination of Stephen King*. New York: New York University Press, 2018.

Cowan, Douglas E. *Sacred Terror: Religion and Horror on the Silver Screen*. Waco, TX: Baylor University Press, 2008.

Cowan, Robert. *The Indo-German Identification: Reconciling South Asian Origins and European Destinies, 1765–1885*. Rochester, NY: Camden House, 2010.

Craps, Stef. "Wor(l)ds of Grief: Traumatic Memory and Literary Witnessing in Cross-cultural Perspective." *Textual Practice* 24 (2010): 51–68.

Creed, Barbara. *The Monstrous-Feminine: Film, Feminism, Psychoanalysis*. London: Routledge, 1993.

Crooke, William. "Demons and Spirits (Indian)." In *Encyclopaedia of Religion and Ethics*. Vol. IV, Confirmation-Drama. Edited by James Hastings, 601–7. New York: Charles Scribner's Sons, 1908.

The Crow. Film. Dir. Alex Proyas. Los Angeles: Miramax Lionsgate, 1994.

Cruz, Ronald Allen Lopez. "Mutations and Metamorphoses: Body Horror is Biological Horror." *Journal of Popular Film & Television* 40, no. 4 (2012): 160–8.

The Curse of Frankenstein. Film. Dir. Terence Fisher. UK: Hammer Films, 1957.

Dahlburg, John-Thor. "'The Bandit Queen' Still an Outcast in India." *LA Times*, October 20, 1994. http://articles.latimes.com/1994-10-20/entertainment/ca-52584_1_bandit-queen. (accessed July 12, 2020).

Daman: A Victim of Marital Violence. Film. Dir. Kalpana Lajmi. India: Hrishikesh Mukherjee and N.C. Sippy, 2001.

Damini. Film. Dir. Rajkumar Santoshi. India: Aly Morani, Karim Morani, and Bunty Soorma, 1993.

Darawani Haveli. Film. Dir. Rakesh Sinha. India: Jai Shiva International, 1997.

Darwin, Charles. *The Expression of the Emotions in Men and Animals*. New York: D. Appleton & Company, 1872.

Dasgupta, Shamya. *Don't Disturb the Dead: History of the Ramsay Brothers*. Delhi: Harper Collins, 2017.

David-Néel, Alexandra. *Magic and Mystery in Tibet*. New York: Claude Kendall, 1932.

Davis, Erik W. *Deathpower: Buddhism's Ritual Imagination in Cambodia*. New York: Columbia University Press, 2016.

Dehejia, Vidya. "On Modes of Visual Narration in Early Buddhist Art." *The Art Bulletin* 72, no. 3 (1990): 374–92.

Deliverance. Film. Dir. John Boorman. Burbank, CA: Warner Brothers, 1972.

Derrida, Jacques. *Specters of Marx: The State of the Debt, the Work of Mourning, and the New International*. Translated by Peggy Kamuf. New York: Routledge, 1999.

Descent. Film. Dir. Talia Lugacy. Sepulveda: City Lights Pictures, 2007.

"The Deterioration and Preservation of Paper: Some Essential Facts." Available online: https://www.loc.gov/preservation/care/deterioratebrochure.html (accessed August 27, 2019).

Dev. Film. Dir. Govind Nihalani. India: Udbhav Productions, 2004.

"Devendra P. Varma." *Friends of Bishop Seán Manchester*. October 31, 2010. http://friendsofbishopseanmanchester.blogspot.com/2010/10/devendra-p-varma.html (accessed August 1, 2017).

Devraj, Rajesh and Edo Bouman. *The Art of Bollywood*. Köln: Taschen GmbH, 2010.

Dey, L.B. *Folk-Tales of Bengal*. London: Macmillan, 1883.

Dhusiya, Mithuraaj. *Indian Horror Cinema: (En)Gendering the Monstrous*. London: Routledge, 2018.

Dimock, Edward C. "A Theology of the Repulsive: The Myth of the Goddess Śitalā." In *The Sound of Silent Guns and Other Essays*, 130–49. Delhi: Oxford University Press, 1989.

Doniger, Wendy. *The Origins of Evil in Hindu Mythology*. Berkeley: University of California Press, 1980.

Doniger, Wendy. *The Woman Who Pretended to Be Who She Was: Myths of Self-Imitation*. New York: Oxford University Press, 2005.

D'Souza, Shanthie Mariet and Bibhu Prasad Routray. "*Bandit Queen*: Cinematic Representation of Social Banditry in India." *Small Wars & Insurgencies* 26, no. 4: 688–701.

Dubeyl, Rachana. "The Original Poster Boys of Bollywood." *The Times of India*, April 23, 2017. Available online: http://timesofindia.indiatimes.com/entertainment/hindi/bollywood/news/the-original-poster-boys-of-bollywood/articleshow/58303021.cms (accessed August 27, 2019).

Dunlop, Malcolm. "Demonologist Lecturing at Dal." *The Chronicle-Herald*. March 18, 1986.

Dwyer, Rachel. "The Erotics of the Wet Sari in Hindi Films." *South Asia* 23, no. 1 (2000): 143–59.

Dwyer, Rachel. "Bombay Gothic: On the 60th Anniversary of Kamal Amrohi's *Mahal*." In *Beyond the Boundaries of Bollywood: The Many Forms of Hindi Cinema*. Edited by Rachel Dwyer and Jerry Pinto, 130–55. Delhi: Oxford University Press, 2011.

Dwyer, Rachel and Diva Patel. *Cinema India: The Visual Culture of Hindi Film*. New Brunswick: Rutgers University Press, 2002.

Ebert, Roger. "*Last House on the Left* review (1972)." January 1, 1972. https://www.rogerebert.com/reviews/last-house-on-the-left-1972 (accessed July 12, 2020).

Ebert, Roger. "*I Spit on Your Grave* Review (1980)." July 16, 1980. https://www.rogerebert.com/reviews/i-spit-on-your-grave-1980 (accessed July 12, 2020).

Edmundson, M. "Supernatural Empire: The Anglo-Indian Ghost Stories of Bithia Mary Croker and Alice Perrin." In *The Male Empire Under the Female Gaze: The British Raj and the Memsahib*. Edited by S. Roye and R. Mittapalli, 129–64. Amherst: Cambria Press, 2013.

Ek Aur Khoon. Film. Dir. Ramesh Bedi. India: Vision International Productions, 1985.

Elle. Film. Dir. Paul Verhoeven. Paris: SBS Production, 2016.

Ellis, Bill. "The Highgate Cemetery Vampire Hunt: The Anglo-American Connection in Satanic Cult Lore." *Folklore* 104, no. 1/2 (1993): 13–39.

Ellis, Thomas B. "Disgusting Bodies, Disgusting Religion: The Biology of Tantra." *Journal of the American Academy of Religion* 79, no. 4 (2011): 879–927.

Elison, William E., Christian Lee Novetzke, and Andy Rotman. *Amar Akbar Anthony: Bollywood, Brotherhood and the Nation*. Boston: Harvard University Press, 2016.

Erndl, Kathleen M. *Victory to the Mother: The Hindu Goddess of Northwest India in Myth, Ritual, and Symbol*. New York: Oxford University Press, 1993.

Evening News. "Indian Found Secret Britons Had Missed." December 9, 1955.

The Exorcist. Film. Dir. William Friedkin. USA: Warner Brothers, 1973.

Extremities. Film. Dir. Robert M. Young: Los Angeles: MGM Studios, 1986.

The Fall of the House of Usher. Film. Dir. Roger Corman. USA: MGM, 1960.

Fanon, Frantz. *Wretched of the Earth*. New York: Grove Press, 1963.

Fernandes, Leela. "Reading 'India's Bandit Queen:' A Trans/Nationalist Perspective on the Discrepancies of Representation." *Signs* 25 (1999): 123–52.

Final Girl. Film. Dir. Tyler Shields. USA: NGN Productions, 2015.

Fisher, Benjamin F. "Poe's 'Metzengerstein': Not a Hoax." *American Literature* 42, no. 4 (1971): 487–94.

Freed, Ruth S. and Stanley A. Freed. *Ghosts: Life and Death in North India*. Seattle: University of Washington Press, 1994.

Freud, Sigmund. "The Uncanny." In *The Standard Edition of the Complete Psychological Works of Sigmund Freud. Volume XVII (1917–1919): An Infantile Neurosis and Other Works*. Edited and translated by James Strachey, 217–56. London: Hogarth Press and the Institute of Psycho-Analysis, (1955 [1919]).

Friday the 13th. Film. Dir. Sean S. Cunningham. USA: Paramount Pictures, 1980.

Fright Night. Film. Directed by Tom Holland. USA: Vistar Films, 1985.

Gabriel, Karen. "Reading Rape: Sexual Difference, Representational Excess and Narrative Containment." In *Narratives of Indian Cinema*. Edited by Manju Jain, 145–66. Delhi: Primus Books, 2009.

Galvan, J. "Occult Networks and Legacy of Indian Rebellion in Bram Stoker's *Dracula*." In *History of Religions* 54, no. 4 (2015): 434–58.

Gandhi, R.S. "Sati as Altruistic Suicide Beyond Durkheim's Interpretation." In *Contribution to Asian Studies*, Vol 10, 142–61. Leiden: Brill, 1977.

Garam Hawa. Film. Dir. M.S. Sathye. India: Sathyu and Ishan Arya, 1973.

Geel, Catherine and Catherine Lévy. *100% India*. Paris: Éditions du Seuil, 2005.

Gehlawat, A. *Reframing Bollywood*. Delhi: Sage Publications, 2010.

Gehrayee. Film. Dir. Aruna Desai and Vijay Tendulkar. Bombay: N.B. Kamat, 1980.

Gitomer, David L. "Such as a Face Without a Nose: The Comic Body in Sanskrit Literature." *Journal of South Asian Literature* 26, no. 1/2 (1991): 77–110.

Golwalkar, M.S. *We, or Our Nationhood Defined*. India: Bharat Publications, 1939. http://www.culturism.us/booksummaries/We%20or%20our%20Nationhood%20Defined%20Newer%20PDF.pdf (accessed November 25, 2018).

Gopal, S. *Conjugation: Marriage and Form in New Bollywood Cinema*. Chicago: University of Chicago Press, 2012.

Gopalan, Lalitha. "Avenging Women in Indian Cinema." *Screen* 38, no. 1 (Spring 1997): 42–59.

Grixti, Joseph. *Terrors of Uncertainty: The Cultural Contexts of Horror Fiction*: New York: Routledge, 1989.

Guha, Ramachandra. "The Guru of Hate." *The Hindu. Sunday Magazine*. https://www.thehindu.com/todays-paper/tp-features/tp-sundaymagazine/the-guru-of-hate/article3232784.ece, 2006 (accessed July 12, 2020).

Gunga Din. Film. Dir. George Stevens. Hollywood: RKO Radio Pictures, 1939.

Haggard, Stephen. "Mass Media and the Visual Arts in Twentieth-Century South Asia: Indian Film Posters 1947–Present." *South Asia Research* 8, no. 2 (1988): 71–88.

Haiwaan. Film. Dir. Ram and Rono Mukherjee. India: Filmalaya Private Limited, 1977.

Halbfass, Wilhelm. *India and Europe: An Essay in Understanding*. Albany: SUNY Press, 1988.

Hart, George L. *The Poems of Ancient Tamil: Their Milieu and Their Sanskrit Counterparts*. Berkeley: University of California Press, 1975.

Hay, S. *The History of the Modern British Ghost Story*. London: Palgrave Macmillan, 2011.

Heller-Nicholas, Alexandra. *Rape-Revenge films: A Critical Study*. Jefferson, NC: McFarland & Company, 2011.

Help! Film. Dir. Richard Lester. Beverly Hills: United Artists, 1965.

Hendrix, Grady. *Paperbacks from Hell: The Twisted History of '70s and '80s Horror Fiction*. Philadelphia: Quick Books, 2017.

Henry, Claire. *Revisionist Rape-Revenge: Redefining a Film Genre*. New York: Palgrave Macmillan, 2014.

Hilarious House of Frightenstein. TV show. Created by Ted Barris and Ross Perigoe. Canada: CBS Television Distribution, 1971–2.

Hiltebeitel, Alf. *The Cult of Draupadī 1: Mythologies, from Gingee to Kurukṣetra*. Chicago: University of Chicago Press, 1988.

Hilton, James. *Lost Horizon*. London: Macmillan Publishers, 1933.

Hinds, Barbara. "Professor Seeks Source of Vampire Legends." *The Mail-Star*. September 17, 1969.

Hobsbawm, Eric. *Bandits*. New York: Delacorte Press, 1969.

Hoek, Lotte. "Cut-Pieces as Stag Film: Bangladeshi Pornography in Action Cinema." *Third Text* 24, no. 1 (2010): 135–48. doi:10.1080/09528820903489008 (accessed June 10, 2017).

Holden, Philip. "The 'Postcolonial Gothic': Absent Histories, Present Contexts." *Textual Practice* 23 (2009): 353–72.

Holy Bible, King James Version. New York: American Bible Society, 1999.

Horror of Dracula. Film. Dir. Terence Fisher. UK: Hammer Films, 1958.

The House That Dripped Blood. Film. Dir. Peter Duffell. UK: Amicus Films, 1971.

Hutton, Ronald. *The Witch: A History of Fear from Ancient Times to the Present*. New Haven: Yale University Press, 2017.

I Love Trashy Hindi Movies. Available online: https://ilthm.wordpress.com/ (accessed August 27, 2019).

I Spit on Your Grave. Film. Dir. Meir Zarchi. Beverly Hills: Anchor Bay Entertainment, 1978.

I Spit on Your Grave. Film. Dir. Steven R. Monroe. West Hollywood: CineTel, 2010.

Illustrated Weekly of India. "Gothic Novel." July 14, 1957.

India Today Online. "Ramsay Brothers' Sex Horror Flick: Are Your Neighbours Vampires?" March 11, 2014 (Accessed May 25, 2018).

Indian Horror Tales. Blog. http://indianhorrortales.blogspot.com/ (accessed July 12, 2020).

Indiana Jones and the Temple of Doom. Film. Dir. Stephen Spielberg. Hollywood: Paramount Pictures, 1984.

Innes-Smith, Robert. "Robert Innes-Smith on Books." *The Tattler and Bystander*. May 1968.

Insaaf Ka Tarazu. Film. Dir. B.R. Chopra. India: Venus Movies, 1980.

Iyer, Usha. "Nevla as Dracula: Figurations of the Tantric as Monster in the Hindi Horror Film." In *Figurations in Indian Cinema*. Edited by Meheli Sen and Anustup Basu, 101–15. Basingstoke: Palgrave Macmillan, 2013.

Jaadugar. Film. Dir. Prakash Mehra. Mumbai: Eros Entertainment, 1989.

Jaani Dushman. Film. Dir Rajkumar Kohli. India: Shankar Films, 1979.

Jaffrelot, Christofe. *The Hindu Nationalist Movement in India*. New York: Columbia University Press, 1996.

Jaffrelot, Christofe. "Towards a Hindu State?" *Journal of Democracy* 28 (2017): 52–63.

Jain, Madhu. "The Truth on Trial." *India Today*, October 15, 1994. http://indiatoday.intoday.in/story/shekhar-kapur-bandit-queen-raises-moral-questions-on-individual-right-toprivacy/1/294276.html (accessed July 12, 2020).

Jamison, Stephanie and Joel P. Brereton, trans. *The Rigveda: The Earliest Religious Poetry of India*. Oxford: Oxford University Press, 2014.

Jancovich, Mark, Antonio Lázaro Reboli, Julian Stringer, and Andrew Willis, eds. *Defining Cult Movies: The Cultural Politics of Oppositional Tastes*. Manchester: Manchester University Press, 2003.

Jansen, G.H. "Indian Professor Expelled: Indication of Syria's Nervousness." *The Statesman* CXXVI, no. 29296. November 17, 1961.

Joshi, S.T. *The Weird Tale*. Austin: University of Texas Press, 1990.

Kahaani. Film. Dir. Sujoy Ghosh. India: Boundscript Motion Pictures, 2012.

Kalyan Khajina. Film. Dir. Baburao Painter. India: Maharashtra Film, 1924.

Kaplan, E. Ann. "Problematizing Cross-Cultural Analysis: The Case of Women in the Recent Chinese Cinema." In *Asian Cinemas: A Reader and Guide*. Edited by Dimitris Eleftheriotis and Gary Needham, 156–67. Honolulu: Hawai'i University Press, 2006.

Kapur, Shekhar. "Is Bandit Queen My Best Movie?" June 1, 2008. http://shekharkapur.com/blog/2008/06/is-bandit-queen-my-best-film/2008 (accessed July 12, 2020).

Kauffman, Stanley. "On Films: Sexual Violations." *The New Republic*, July 10, 1995: 24–5.

Kearney, Richard. "Diacritical Hermeneutics." In *Hermeneutic Rationality*. Edited by Maria Luísa Portocarrero, Luis António Umbelino, and Andrzej Wiercinski, 177–96. Münster: LIT Verlag, 2012.

Kelly, Casey Ryan. "Camp Horror and the Gendered Politics of Screen Violence: Subverting the Monstrous-feminine in *Teeth* (2007)." *Women's Studies in Communication* 39, no. 1 (2016): 86–106.

Kelly, Liz. *Surviving Sexual Assault*. Cambridge, UK: Polity Press, 1988.

Kennedy, Patrick. "Definition of Gothic Literature." Thought Co. https://www.thoughtco.com/gothic-literature-2207825 (accessed July 9, 2019).

Keul, Istvan. *Transmission and Transformation of Tantra in Asia and Beyond*. Berlin: De Gruyter, 2012.

Khatarnak Raat. Film. Dir. Muneer Khan. India: S.P. Films Creations, 2003.

Khooni Murdaa. Film. Dir. Mohan Bhakri. India: MKB Films Combines, 1989.

Khooni Panja. Film. Dir. Vinod Talwar. India: N.H. Studioz, 1991.

Khooni Tantrik. Film. Dir. Teerat Singh. India: Shafugta Arts Productions, 2001.

King, Richard. *Orientalism and Religion: Post-colonial Theory, India, and the "Mystic East."* New York: Routledge, 1999.

King, Stephen. *Danse Macabre*. New York: Berkeley Books, 1982.

Kipling, Rudyard. *The Phantom Rickshaw and Other Eerie Tales*. London: Sampson Low, Marston, Searle, & Rivington, 1888.

Kishwar, Madhu. "Film review: *The Bandit Queen*." *Manushi* 84 (1994): 34–7.

Kosambi, Meera. "Bandit Queen Through Indian Eyes: The Reconstructions and Reincarnations of Phoolan Devi." *Hecate* 24, no. 2 (1998): n.p.

Kotrial, K. Personal communication. August 17, 2012.

Kristeva, Julia. *The Powers of Horror: An Essay in Abjection*. New York: Columbia University Press, 1982.

Kudrat. Film. Dir. Chetan Anand. India: Trishakti Productions, 1981.

Kumar, Anuj. "*Mardaani*: Packs a Punch." *The Hindu*. August 22, 2014. www.thehindu.com/features/cinema/cinema-reviews/mardaani-film-review/article6341938.ece (accessed July 12, 2020).

Kumar, Mina. "Beyond Mere Factual Truth: The Filmi Bandit Queen." *India Currents Magazine* 9 (1995): 28–9.

Kurtz, Stanley M. *All the Mothers Are One: Hindu India and the Cultural Reshaping of Psychoanalysis*. New York: Columbia University Press, 1992.

Laaga Chunari Mein Daag. Film. Dir. Pradeep Sarkar. India: Yash Raj Films, 2007.

"*Laaga Chunari Mein Daag*." Box Office India. www.boxofficeindia.com/movie.php?movieid=344 (accessed August 5, 2019).

Lady Killer. Film. Dir. S.A. Chandramohan. India: Abhilasha Productions, 1995.

Lane, Gwendolyn, trans. *Kādambarī: A Tale of Magical Transformation*. New York: Garland Publishing, 1991.

Lapekas, Jenny. "*Descent*—'everything's okay now:' Race, Vengeance, and Watching the Modern Rape-Revenge Narrative." *Jump Cut: A Review of Contemporary Media* 55 (2013): n.p.

Last House on the Left. Film. Dir. Wes Craven, Los Angeles: MGM Studios, 1973.

Last House on the Left. Film. Dir. Dennis Iliadas. Universal City: Universal Pictures, 2009.

Lee, Maggie. "Film review: *Marlina the Murderer in Four Acts*." May 26, 2017. https://variety.com/2017/film/reviews/marlina-the-murder-in-four-acts-review-1202446324/ (accessed July 12, 2020).

Lemos, T.M. *Violence and Personhood in Ancient Israel and Contemplative Contexts*. Oxford: Oxford University Press, 2017.

Leslie, J. *Roles and Rituals for Hindu Women*. Delhi: Motilal Banarsidass, 1992.

Lindsey, Shelley Stamp. "Horror, Femininity, and Carrie's Monstrous Puberty." In *The Dread of Difference: Gender and the Horror Film*. Edited by Barry Keith Grant, 279–95. Austin, TX: University of Texas Press, 1996.

Lipner, J.J. *Anandamath, or The Sacred Brotherhood*. New York: Oxford University Press, 2005.

Longfellow, Brenda. "The Bandit Queen." *Cineaction* 36 (1995): 10–6.

Lorenzen, David N. *The Kāpālikas and Kālāmukhas: Two Lost Śaivite Sects*. Berkeley: University of California Press, 1972.

Ludden, David E. "Introduction: Ayodya: A Window on the World." In *Contesting the Nation: Religion, Community, and the Politics of Democracy in India*. Edited by David Ludden, 1–27. Philadelphia: University of Pennsylvania, 1996.

Lutgendorf, Philip. "Cinema." In *Studying Hinduism: Key Concepts and Methods*, edited by Sushil Mittal and Gene Thursby, 41–58. London and New York: Routledge, 2008.

Maccoby, Hyam. "The Wandering Jew as Sacred Executioner." In *The Wandering Jew: Essays in the Interpretation of a Christian Legend*. Edited by Galit Hasan-Rokem and Alan Dundes, 236–60. Bloomington: Indiana University Press, 1986.

Mack, Burton. "Social Formation." In *Guide to the Study of Religion*. Edited by Willi Braun and Russell T. McCutcheon, 283–97. New York: Continuum, 1999.

Manchester, Seán. *The Highgate Vampire*. Revised Edition. London: Gothic Press, 1991.

Mangalsutra. Film. Dir. Vijay B, India: Gaurav Films International, 1981

Mardaani. Film. Dir. Pradeep Sarkar. India: Yash Raj Films, 2014.

"*Mardaani*." Box Office India. www.boxofficeindia.com/movie.php?movieid=2296 (accessed August 5, 2019).

"*Mardaani 2*." Box Office India. https://boxofficeindia.com/movie.php?movieid=5741 (accessed February 7, 2020).

Masih, Archana. "An Actress Remembers." *Rediff*. April 4, 1997. http://www.rediff.com/movies/apr/04sema.htm (accessed July 12, 2020).

Maturin, Charles. *Melmoth the Wanderer*. Edinburgh: Archibald Constable and Company, 1820.

Mazumdar, Ranjani. "The Bombay Film Poster: A Short Biography." In *India's Popular Culture: Iconic Spaces and Fluid Images*. Edited by Jyotindra Jain, 90–103. Mira Bhayandar, India: Marg Publications, 2007.

Mehbooba. Film. Dir. Shakti Samanta. India: M.R. Productions. 1976.

Menon, Usha and Richard A. Shweder. "Dominating Kālī: Hindu Family Values and Tantric Power." In *Encountering Kālī: In the Margins, at the Center, in the West*. Edited by Jeffrey J. Kripal and Rachel Fell McDermott, 80–99. Berkeley and Los Angeles: University of California Press, 2003.

Metcalf, Barbara. "Too Little and Too Much: Reflections on Muslims in the History of India." *Journal of Asian Studies* 54 (1995): 951–67.

Metcalfe, Robin. "Dr. Varma and Mr. Hyde." *Books in Canada*, 1986, 4–5.

Mikles, Natasha and Joseph P. Laycock. "Tracking the *Tulpa*: Exploring the 'Tibetan' Origins of a Contemporary Paranormal Idea." *Nova Religio: The Journal of Alternative and Emergent Religions* 19, no. 1 (2015): 87–97.

Mishra, A. *Casting the Evil Eye: Witch Trials in India*. New Delhi: Lotus Roli, 2003.

Mishra, Vijay. *Bollywood Cinema: Temples of Desire*. New York and London: Routledge, 2002.

Mishra, Vijay. "Towards a Theoretical Critique of Bombay Cinema." In *The Bollywood Reader*. Edited by Rajinder Dudrah and Jigna Desai, 32–44. New York: Open University Press, 2008.

Mother India. Film. Dir. Mehboob Khan. India: Mehboob Productions, 1957.

Mrityudand. Film. Dir. Prakash Jha. India: Prakash Jah, 1997.

Mubarki, Meraj Ahmed. "The Monstrous 'Other' Feminine: Gender, Desire, and the 'Look' in the Hindi Horror Genre." *Indian Journal of Gender Studies* 21, no. 3 (2014): 379–99.

Mubarki, Meraj Ahmed. "Monstrosities of Science: Exploring Monster Narratives in Hindi Horror Cinema." *Visual Anthropology* 28 (2015): 248–61.

Mubarki Meraj Ahmed. *Hindi Cinema, Ghosts and Ideologies*. New Delhi, Sage Publishing. 2016.

Naan Kadavul. Film. Dir. Bala. Chennai: Pyramid Saimira Group, 2009.

Nair, Kartik. "Taste, Taboo, Trash: The Story of the Ramsay Brothers." *BioScope: South Asian Screen Studies* 3, no. 2 (2012): 123–45.

Nair, Kartik. "Book Reviews." *BioScope* 8, 2 (2017): 280–92.

Nambiar, Sita Krishna, trans. *Prabodhacandrodaya of Kṛṣṇa Miśra*. Delhi: Motilal Banarsidass, 1971.

National Herald. "Kathua: Prashant Bhushan Files Complaint Against Madhu Kishwar." *National Herald India*, April 16, 2018. https://www.nationalheraldindia.com/india/senior-lawyer-prashant-bhushan-filed-criminal-complaint-against-madhu-kishwar-tweets-kathua-rape-case-tweet (accessed July 12, 2020).

Neel Kamal. Film. Dir. Ram Maheshwari. India: Kalpanalok, 1968.

Neily, Beth. "Varma Digs Vampires." N.D.

Nietzsche, Friedrich. *Human, All Too Human: A Book for Free Spirits*. Translated by R.J. Hollingdale. Cambridge: Cambridge University Press, 1996.

Nussbaum, Martha. *The Clash Within: Democracy, Religious Violence and India's Future*. Cambridge, MA: Harvard University Press, 2007.

Otto, Rudolf. *The Idea of the Holy: An Inquiry into the Non-Rational Factor in the Idea of the Divine and Its Relation to the Rational*. London: Oxford University Press, 1923.

Oakman, Daniel. *Facing Asia: A History of the Colombo Plan*. Canberra: Australian National University Press, 2010.

Padoux, André. *The Hindu Tantric World: An Overview*. Chicago: University of Chicago Press, 2017.

Paliwal, K.V. *Challenges Before the Hindus (From Islam, Christianity and Pseudo-Secularism)*. Delhi: Hindu Writers Forum, 2003.

Pandey, Gyanendra. *Hindus and Others: The Question of Identity in India Today*. New Delhi: Viking, 1993.

Parpola, Asko. *The Roots of Hinduism: The Early Aryans and the Indus Civilization*. Oxford: Oxford University Press, 2015.

Parosi. Film. Dir. Shyam Ramsay. India: Ramsay Entertainment, 2014.

Paul, William. *Laughing Screaming: Modern Hollywood Horror and Comedy*. New York: Columbia University Press, 1994.

Paxton, Tim. *The Cinematic Art of Fantastic India. Volume 1: The VCDs*. WK Books, 2018.

Penny, F.E.F. *The Swami's Curse*. London: Heinemann, 1929.

Pinch, William R. "Film review: The Bandit Queen." *The American Historical Review* 101 (1996): 1149–50.

Pinto, Jerry and Sheena Shippy. *Bollywood Posters*. New York: Thames & Hudson, 2008.

Poe, Edgar Allan. "Metzengerstein." In *Tales and Sketches*, Vol. 1, 1831–42. Edited by Thomas Ollive Mabbott, Eleanor D. Kewer, and Maureen Cobb, 15–29. Champaign, IL: University of Illinois Press, 2000.

Pollock, Sheldon. *A Rasa Reader: Classical Indian Aesthetics*. New York: Columbia University Press, 2016.

Pratighaat. Film. Dir. N. Chan. India: Ushakiran Movies, 1987.

Prawer. S.S. *Caligari's Children: The Film as Tale of Terror*, New York: Oxford University Press, 1980.

Projansky, Sarah. *Watching Rape: Film and Television in Postfeminist Culture*. New York: New York University Press, 2001.

Psycho. Film. Dir. Alfred Hitchcock. USA: Paramount Pictures, 1960.

Purana Mandir. Film. Dir. Shyam Ramsay and Tulsi Ramsay. India: Ramsay Productions, 1984.

Pyaasa. Film. Dir. Guru Dutt. India: Guru Dutt Films Pvt. Ltd, 1957.

Raaz. Film. Dir. Vikram Bhatt. India: Vishesh Films, 2002.

Radhakrishnan, Sarvepalli. *Bhagavadgītā*. London: George Allen & Unwin, Ltd, 1948.

Raheja, Gloria Goodwin and Ann Grodzins Gold, *Listen to the Heron's Words: Reimagining Kinship and Gender in North India*, Berkeley, Los Angeles: University of California Press. 1994.

Raja Harishchandra. Film. Dir. Dadasaheb Phalke. India: Phalke Films Company, 1913.

Rajadhyaksha, Ashish and Paul Willemen. *Encyclopedia of India Cinema, New Revised Edition*. New Delhi: Oxford University Press, 1999.

Rajan, Rajeswari Sunder. *The Scandal of the State: Women, Law, and Citizenship*. Durham, NC: Duke University Press, 2003.

Ramanujan, Anuradha. "The Subaltern, the Text and the Critic: Reading Phoolan Devi." *Postcolonial Writing* 44 (2008): 367–78.

Read, Jacinda. *The New Avengers: Feminism, Femininity and the Rape-Revenge Cycle*. Manchester, UK: Manchester University Press, 2000.

Reevell, Patrick. "Killer of India's 'Bandit Queen' Gets Life Sentence." *The Globe and Mail*, August 14, 2014. https://www.theglobeandmail.com/news/world/killer-of-indias-bandit-queen-gets-life-sentence/article20057370/ (accessed July 12, 2020).

Richter, David. "*Art of Darkness: A Poetics of Gothic* by Anne Williams." *The Modern Language Review* 93, no. 1 (1998): 191–2.

Roy, Arundhati. "The Great Indian Rape-Trick I." October 11, 2004. http://arundhatiroy.blogspot.ca/2004/11/great-indian-rape-trick-i.html (accessed July 12, 2020).

Roy, Arundhati. "The Great Indian Rape-Trick II." July 8, 2012. http://baajve.blogspot.ca/2012/07/arundhati-roy-on-shekhar-kapurs-bandit_08.html (accessed July 12, 2020).

Samuel, Geoffrey. *The Origins of Yoga and Tantra: Indic Religions to the Thirteenth Century*. Cambridge: Cambridge University Press, 2008.

Sanderson, Alexis. "Purity and Power among the Brahmins of Kashmir." In *The Category of the Person: Anthropology, Philosophy, History*. Edited by Michael Carrithers, Steven Collins, and Steven Lukes, 190–216. Cambridge: Cambridge University Press, 1985.

Sangarsh. Film. Dir. Tanuja Chandra. India: Vishesh Films, 1999.

Sarkar, Baskar. *Mourning the Nation: Indian Cinema in the Wake of Partition*. Durham, NC: Duke University, 2009.

Sarkar, Sumit. "Indian Nationalism and the Politics of Hindutva." In *Contesting the Nation: Religion, Community, and the Politics of Democracy in India*. Edited by David Ludden, 270–95. Philadelphia: University of Pennsylvania Press, 1996.

Sarkar, Tanika. "Birth of a Goddess: 'Vande Mantaram,' Anandamath, and Hindu Nationhood." In *Economic and Political Weekly* 41, no. 37 (September 16–22, 2006): 3959–3969. http://www.jstor.org.proxy.queensu.ca/stable/pdf/4418703.pdf (accessed July 12, 2018).

Sarkar, Tanika. "Semiotics of Terror: Muslim Children and Women in the Hindu Rashra." *Economic and Political Weekly* 37, no. 28 (July 13–19, 2002): 2872–2876.

Sarkar, Tanika. "Imagining Hindurashtra: The Hindu and the Muslim in Bankim Chandra's Writings." In *Contesting the Nation: Religion, Community, and the Politics of Democracy in India*. Edited by David Ludden, 162–85. Philadelphia: University of Pennsylvania Press, 1996.

Sarma, Bharadvaj. *Vyasa's Mahabharatam*. Kolkata: Academic Press, 2008.

Savarkar, V.D. *Hindutva: Who Is A Hindu?* 1923. https://archive.org/stream/hindutva-vinayak-damodar-savarkar-pdf/hindutva-vd-savarkar_djvu.txt (accessed July 1, 2018).

Scarry, Elaine. *The Body in Pain: The Making and Unmaking of the World*. Oxford: Oxford University Press, 1985.

Schopen, Gregory. "Archaeology and Protestant Presuppositions in the Study of Indian Buddhism." *History of Religions* 31, no. 1 (1991): 1–23.

Scream. Film. Dir. Wes Craven. USA: Woods Entertainment, 1996.

Scream 2. Film. Dir. Wes Craven. USA: Konrad Pictures, 1997.

Scream 3. Film. Dir. Wes Craven. USA: Konrad Pictures, 2000.

Scream 4. Film. Dir. Wes Craven. USA: Corvus Corax Productions, 2011.

Seigworth, Gregory J. and Melissa Gregg. *The Affect Theory Reader*. Durham, NC: Duke University Press, 2010.

Sen, Aditi. "I Wasn't Born with Enough Middle Fingers: How Low-budget Horror Films Defy Sexual Morality and Heteronormativity in Bollywood." *Acta Orientalia Vilnesia* 12, no. 2 (2011): 75–89.

Sen, Aditi. "Five Early Ramsay Thrillers." *The Hindu*, September 6, 2016.

Sen, Aditi. "Hindi Horror Films: Beyond the Gothic." *Open Magazine*, May 17, 2019. www.openthemagazine.com/article/cinema/hindi-horror-films-beyond-the-gothic (accessed July 12, 2020).

Sen, Mala. *India's Bandit Queen: The True Story of Phoolan Devi*. London: Pandora, 1991.

Sen, Meheli. "Terrifying Tots and Hapless Homes: Undoing Modernity in Recent Bollywood Cinema." *Literature Interpretation Theory* 22 (2011): 197–217.

Sen, Meheli. *Haunting Bollywood: Gender, Genre, and the Supernatural in Hindi Commercial Cinema*. Austin: University of Texas Press, 2017.

Shahid, Mohammad, Prasad Bokil, and Darmalingam Udaya Kumar. "Title Design in Bollywood Film Posters: A Semiotic Analysis." In *ICoRD '15: Research into Design Across Boundaries Volume 1*. Edited by Amaresh Chakrabarti, 291–301. New Delhi: Springer India, 2015.

Shaitan Tantrik. Film. Dir. Wajid Sheikh. India: Gold Mines, 1999.

Shani, Ornit. "The Rise of Hindu Nationalism in India: The Case Study of Ahmedabad in the 1980s." *Modern Asian Studies* 39 (2005): 861–96.

Sharma, Arvind. "On Hindu, Hindustān and Hindutva." *Numen* 49 (2002): 1–37.

Sharma, Jyotirmaya. *Hindutva: Exploring the Idea of Hindu Nationalism*. New Delhi: Viking, 2003.

Shastri, Biswanarayan. *The Yoginī Tantra*. Delhi: Bhāratīya Vidyā Prakāśana, 1982.

Siddiqui, Gohar. "'Behind her laughter . . . is fear!' Domestic Abuse and Transnational Feminism in Bollywood Remakes." *Jump Cut: A Review of Contemporary Media* 55 (2013): n.p.

The Silence of the Lambs. Film. Dir. Jonathan Demme. Los Angeles: Orion Pictures, 1991.

Singh, Bhrigupati. "*Aadamkhor Haseena* (The Man-Eating Beauty) and the Anthropology of a Moment." *Contributions to Indian Sociology* 42, no. 2 (2008): 249–79.

Sinha, R.K. "History of the Gothic Novel in England." *The Sunday Searchlight Magazine*. June 2, 1957.

Smith, Andrew and William Hughes. "Introduction: The Enlightenment Gothic and Postcolonialism." In *Empire and the Gothic*. Edited by Andrew Smith and William Hughes, 1–12. London: Palgrave Macmillan, 2003.

Smith, Frederick K. *The Self Possessed: Deity and Spirit Possession in South Asian Literature*. New York: Columbia University Press, 2006.

Solms, Mark and Edward Nersessian. "Freud's Theory of Affect: Questions for Neuroscience." *Neuropsychoanalysis* 1 (1999): 5–14.

Spivak, Gayatri Chakravorty. "Can the Subaltern Speak?" In *Marxism and the Interpretation of Culture*. Edited by Cary Nelson and Lawrence Grossberg, 271–316. Chicago, IL: University of Illinois Press, 1988.

Srinivas, Tulasi. *Winged Faith: Rethinking Globalization and Religious Pluralism through the Sathya Sai Movement*. New York: Columbia University Press, 2010.

Stevens, D. *The Gothic Tradition*. Cambridge: Cambridge University Press, 2000.

Stoker, Bram. *Dracula*. Westminster: Archibald Constable and Company, 1897.

Subba, Vibhushan. "The Bad-Shahs of Small Budget: The Small-budget Hindi Film of the B Circuit." *BioScope: South Asian Screen Studies* 7, no. 2 (2016), 215–33.

Subba, Vibhushan. "The Returned: The Rise of B-movie Cinephelia," Sarai.net. April 13, 2016. http://sarai.net/the-returned-the-rise-of-b-movie-cinephilia/ (accessed January 20, 2020).

Tamas. Television. Dir. Govind Nihalani. India: Govind Nihalani, 1988.

Thapar, Romila. "Politics and the rewriting of history in India." *Critical Quarterly* 47 (2005): 195–203.

Theater of Blood. Film. Dir. Douglas Hickox. UK: Harbour Productions, 1973.

Tombs, Pete. *Mondo Macabro: Weird and Wonderful Cinema from Around the World.* New York: St. Martin's Griffin, 1998.

Tombs, Pete. "The Beast from Bollywood: A History of the Indian Horror Film." In *Fear Without Frontiers: Horror Cinema from Across the Globe.* Edited by Stephen Jay Schneider, 243–53. Godalming, UK: FAB Press, 2003.

Townsend, Joseph. *The Character of Moses: Established for Veracity as an Historian, Recording Events from the Creation to the Deluge.* Bath and London: M. Gye, et al., 1816.

Train to Pakistan. Film. Dir. Pamela Brooks. India: Channel Four Films, National Film Development Corporation of India, and Kaleidoscope Productions, 1998.

Tull, Herman. "Kālī's Tongue: Shame, Disgust, and the Rejection of Blood and Violence in Vedic and Hindu Thought." *International Journal of Hindu Studies* 19, no. 3 (2015): 301–32.

Udan Khatola. Film. Dir. S.U. Sunny. India: Sunny Art Productions, 1955.

Urban, Hugh B. "Secret Bodies: Re-imagining the Body in the Vaiṣṇava-Sahajiyā Tradition of Bengal." *Journal of South Asian Literature* 28 no. 1/2 (1993): 45–62.

Urban, Hugh B. "The Extreme Orient: The Construction of 'Tantrism' as a Category in the Orientalist Imagination." *Religion* 29 (1999): 123–46.

Urban, Hugh B. *Tantra: Sex, Secrecy, Politics, and Power in the Study of Religion.* Berkeley: University of California Press, 2003.

Urban, Hugh B. *The Power of Tantra: Religion, Sexuality, and the Politics of South Asian Studies.* New York: Palgrave Macmillan, 2010.

Urban, Hugh B. *Zorba the Buddha: Sex, Spirituality and Capitalism in the Global Osho Movement.* Berkeley: University of California Press, 2016.

Urban Legend. Film. Dir. Jamie Blanks. USA: Original Film, 1998.

Urban Legends: Final Cut. Film. Dir. John Ottoman. USA: Original Film, 2000.

Urban Legends: Bloody Mary. Film. Dir. Mary Lambert. USA: NPP Productions, Inc., 2000.

Varma, Devendra P. *The Gothic Flame: Being a History of the Gothic Novel in England: Its Origins, Efflorescence, Disintegration, and Residuary Influences.* New York: Russell & Russell, 1966.

Varma, Devendra P. "Editor's Preface." In *Castle of Wolfenbach.* By Eliza Parsons, iix–xxiv. London: The Folio Press, 1967.

Varma, Devendra P. "Introduction." In *The Necromancer.* By Ludwig Flammenberg (Carl Friedrich Kahlert), i–xviii. London: The Folio Press, 1968.

Varma, Devendra P. "The Genesis of Dracula: A Re-Visit by Dr. Sir Devendra P. Varma." In *The Vampire's Bedside Companion: The Amazing World of Vampires in Fact and Fiction.* Edited by Peter Underwood, 53–68. London: Leslie Frewin, 1975.

Varma, Devendra P. "Meeting with Mahatma." *Folio Quarterly Magazine.* Unpublished manuscript version, 1984.

Varma, Devendra P. "The Vampire in Legend, Lore, and Literature." In *The Vampire in Literature: A Critical Bibliography.* Edited by Margaret L. Carter, 13–29. Ann Arbor and London: UMI Research Press, 1989.

Varma, Devendra P. "Curriculum Vitae." 1991.

Varma, Devendra P. "True Identity of Arminius Vambery: The Disguised Dervish, Hungarian Professor, and Stoker's Source of Dracula." Paper presented at Twelfth International Conference on the Fantastic in Arts. Fort Lauderdale, Florida. March 23, 1991.

Varma, Devendra P. "Gothic Romances and Horror Movies." Unpublished manuscript. N.D.

Varma, Eileen. *Basic Education in India: Its Origins and Development*. Patna and Hyderabad: Nagari Prakashan Private, Ltd, 1962.

Veerana. Film. Dir. Shyam Ramsay and Tulsi Ramsay. India: Ramsay Productions, 1988.

Virdi, Jyotika. "Reverence, Rape—and Then Revenge: Popular Hindi Cinema's 'Women's Films.'" *Screen* 40 (1999): 17–37.

The Virgin Spring. Film. Dir. Ingmar Bergman, New York, NY: Tartan, 1960.

Vitali, Valentina. "The Evil I: Realism and Scopophilia in the Horror Films of Ramsay Brothers." In *Beyond the Boundaries of Bollywood*. Edited by R. Dwyer and J. Pinto, 77–101. New Delhi: Oxford University Press, 2011.

Vitali, Valentina. "The Hindi Horror Film: Notes on the Realism of a Marginal Genre." In *Genre in Asian Film and Television: New Approaches*. Edited by Felicia Chan, Angelina Karpovich, and Xin Zhang, 130–48. New York: Palgrave Macmillan, 2011.

Vivekananda, Swami. *The Complete Works of Swami Vivekananda*. 8 volumes. Calcutta: Advaita Ashram, 1984.

van Vogt, A.E. A.E. van Vogt to Devendra Varma. August 13, 1968.

Weaver, Mary Anne. "India's bandit queen." *The Atlantic*. November 1, 1996. https://www.theatlantic.com/magazine/archive/1996/11/indias-bandit-queen/304890/?single_%20page1%E2%81%844true (accessed July 12, 2020).

What Lies Beneath. Film. Dir. Robert Zemeckis. USA: DreamWorks Pictures, 20th Century Fox, ImageMovers, 2000.

White, David Gordon, ed. *Tantra: in Practice*. Princeton: Princeton University Press, 2000.

White, David Gordon. *Kiss of the Yoginī: "Tantric Sex" in its South Asian Contexts*. Chicago: University of Chicago Press, 2003.

White, David Gordon. *Sinister Yogis*. Chicago: University of Chicago Press, 2006.

White, David Gordon. "*Netra Tantra* at the Crossroads of the Demonological Cosmopolis." *Journal of Hindu Studies* 5, no. 2 (2012): 145–71.

Williams, Linda. "Filmic Bodies: Gender, Genre, and Excess." *Film Quarterly* 44, no. 4 (1991): 2–13.

Winternitz, M. "Ancient Indian Witchcraft." *Indian Antiquary* 38 1899: 71–83.

Wohi Bhayakar Raat. Film. Dir. Vinod Talwar. India: Talwar Productions, 1989.

Wood, Chris. "Close-Up: Devendra Varma: A Connoisseur of Horror." 1986.

Wood, Robin. "An Introduction to the American Horror Film." In *Movies and Methods, Volume II: An Anthology*, edited by Bill Nichols, 195–220. Berkeley, CA: University of California Press, 1985.

Young, James E. *Writing and Rewriting the Holocaust: Narrative and the Consequences of Interpretation*. Bloomington: Indiana University Press, 1988.

Youssef, Marcus. "Vampires, Apparitions, Bleeding Nuns: A View into Varma's Supernatural World." *The Queen's Journal*. October 31, 1986.

Zakmi Aurat. Film. Dir. Avtar Bhogal, India: Manta Movies and Sheramoo, 1988.

Žižek, Slavoj. "Notes on a Poetic Military Complex." *Third Text* 23 (2009): 503–9.

Index

"A Theology of the Repulsive" (Dimock) 13
Aatma (film) 3
Abominable Dr. Phibes, The (US film) 36
Ackerman, Forrest J. 51
"Ackermansion" 51
adharma (unrighteousness) 16, 75
Advani, Lal Krishna 120
Agamben, Giorgio 62
Aghorīs 81
Ahmed, Meraj 4–5
Aitareya Brāhmaṇa 41
Aiyyaa (film) 167
Altman, Michael 57
Aman, Zeenat 146
Amavasai Iravil (film) 64
Ammoru (film) 79, 89–92
Amrohi, Kamal 1
Anand, Dibyesh 119
Anandamath (Caṭṭopādhyāy) 118
Anderson, Benedict 9
Andheri Raat Tu Mere Saath (film) 36–7
āndolan (oscillation) 13
Anger, Kenneth 32
Anhonee (TV show) 2
Anjaam (film) 71–2
"anti-Tantricism" 61–2
Appadurai, Arjun 24, 26, 42
Āraṇyaka Parvan 94
Arendt, Hannah 17, 116, 131–4
Arkoff, Samuel Z. 31
Arnold, Jack 36
Ārya Kṣemīśara 12
Assamese (film) 89
Association of Nepalis in America 61
asuras 16
Attar, Samar 49
Atwood, Margaret 55
Aur Kaun (film) 1
Austen, Jane 49, 62
"Avenging Women in Indian Cinema" (Gopalan) 171

Babri Mosque 120–1
Bacchan, Amitabh 53
Baker, Rick 29
balaatkar see rape
Baldick, Chris 56–8, 64
Bāṇabhaṭṭa 81
Banaji, Shakuntala 15, 161, 184
Bandh Darwaza (Ramsay) 2, 46, 62–4
Bandit Queen (film)
 circuits of power 155–9
 conclusion 159–60
 Indian rape revenge 145–7
 introduction 140–1, 210n.1
 rape, revenge, banditry 142–5, 148–53, 214n.52
 synopsis 141–2
 truth and testimony 154–5
Bangla (film) 89
Bartram, Laurie 26
Battleship Potemkin 32
Bava, Mario 63
Bees Saal Baad (film) 1, 56
Behmai massacre 152
Behroopiya (Hasan) 2
Bengali folklore 103–4
Bhagavadgītā 40, 60, 125, 128
Bhagavata Purāṇa 40
Bhakri, Mohan 2
Bhārati, Agehananda 45
Bhatt, Vikram 94, 96–8, 102–4, 110–11, 201nn.24, 25, 202nn.30, 38
Bhattacharyya, Narendra Nath 9
Bhāvabhūti 12
Bhayaanak (film) 46
bhayānaka rasa 11, 40, 71
Bhoot Bungla (film) 1
Bhoot (film) 110
Bhrugubanda, Uma Maheswari 143
bībhatsa 11, 71, 122
Biswas, Seema 154, 159
BJP (Bharatiya Janata Party) 120–1

Black Friday (film) 130
Black Sunday (film) 63
"Bleeding Nun" (drawing) 52
Bloch, Robert 11, 46, 51–2, 59
Bobby (film) 30
"Bollywood Bazaar" (stall) 32–3
"Bollywood Horror as an Uncanny Public Sphere" (Banaji) 184
Bombay (film) 130
Bond, Ruskin 101
Bouman, Edo 21–2
Bradbury, Ray 51
Bradbury, Sue 52
Bradshaw, Jon 150
Bran Castle 44
Breaking Bad (TV show) 163
British Occult Society 59
Brooks, Douglas 92
Brunvand, Jan Harold 62
Buddhism 57, 78, 80
"Buffalo King" 41
Buffy the Vampire Slayer (TV show) 5–6
Bungalow No. 666 (film) 38
Butler, Judith 79

Caldwell, Sarah 149
Candyman (US film) 62
Carmilla (Le Fanu) 50
Carroll, Noël 5–7, 10, 98, 122–4, 133, 136, 138, 206n.31
Caruth, Cathy 136
Castle Lauenstein, Thuringia 52
Caṭṭopādhyāy, Bankimcandra 81–2, 86, 117–18, 204n.8
Censor Board 158
Chained Heat II (US film) 39
Chakrabarti, Arindim 14–15
Chakraborty, Mridula Nath 153
Chandaver, Aseem 29, 188–9n.22
Chaṇḍīkā 74–7
Chandralekha (film) 21
Chaney, Lon Jr. 45
Channel Four 155
Cheekh (film) 40
Cherry, Brigid 110
Chicago Film Critics Association 14
child trafficking 165, 180, 183
chöd (Tibetan rite) 9
Christianity 82

curail 29, 39
Clover, Carol 42–3, 62, 143–4, 150, 211nn.17–18, 212–13n.30
Collins, Brian 15–16, 69
Collins, Wilkie 101
Colombo Plan 48, 62
colonialism 15, 17, 25, 54–5, 64, 100–2, 116, 135
communalism 115, 135–6
Conan Doyle, Arthur 101
Conway, Hugh 58
Corman, Roger 31, 50
Cosmopolitan (magazine) 35
Count Dracula Society, Los Angeles 46, 51
Creature from the Black Lagoon, The (US film) 31
Creed, Barbara 143
Crocker, Bithia Mary 101–2
Cruz, Ronald Allen Lopez 144
cultural horror 122–39, 205n.24
Curse of Frankenstein, The (UK film) 50
"cut-pieces" 2

Daayan (film) 27, 37–8, 41
Dabangg (film) 168
daini (witch) 103
ḍākinī 28
Dalhousie University, Halifax 49
Daman (film) 74
Damini (film) 172, 183
Darawani Haveli (film) 26–35, 188n.20, 189n.29
Darr Sabko Lagta Hai (TV show) xiii
Darwin, Charles 11
Dasgupta, Shamya 4
David-Néel, Alexandra 60–2
Davis, Erik 9
ḍāyan 28–30, 38–9
Dehejia, Vidya 29
Demme, Jonathan 87
Derrida, Jacques 137
Desai, Manmohan 21
Desai, Vikas 82
Dev (film) xiii, 17, 115–29, 130–9, 206–7nn.37–8, 208n.59
Devanāgarī script 27
devas 16
Devī (goddess) 41–3

Devi, Phoolan 18, 140-4, 146-58, 210n.2, 216n.95
Devī-Mahātmya 71-3, 76, 90
Devraj, Rajesh 21-2
dharma (righteousness) 16, 64, 75
Dharmakṣetra 128
Dhoom (film) 168
Dhusiya, Mithuraaj 164
dhvani (suggestion) 71
Dimitrova, Diana 69
Dimock, Edward 13
Dinkar, Ramdhari Singh 52-3
Do Gaz Zameen ke Neeche (film) 1
Do the Right Thing (US film) 32
Dobrée, Bonamy 48
Doniger, Wendy 45
Don't Disturb the Dead: The Story of the Ramsay brothers (Dasgupta) 5
Dracula (Stoker) 46
D'Souza, Shanthie Mariet 152
Durgā (goddess) 41, 72-5, 93, 149, 153
Dwyer, Rachel 38, 55

Ebert, Roger 244-5
Edmundson, Melissa 102
Egypt 48-9
Eichmann, Adolf 132-3
Eichmann In Jerusalem (Arendt) 132
Eisentein, Sergei 32
Ek Aur Khoon (film) 27, 36
Ek Thi Daayan (film) 3
Elfman, Richard 32
Elison, William 126
"Emergency Cinema" 63
Enlightenment 55-7
Erndl, Kathleen M. viii, 16, 69, 167
Evil Dead II (US film) 36
evil spirits 102-3
exorcism 17, 79, 83, 87, 169
Exorcist, The (US film) 87
Expression of the Emotions in Man and Animals, The (Darwin) 11

Fall of the House of Usher, The (US film) 51
Famous Monsters of Filmland (Ackerman) 51
Fanon, Frantz 17, 116, 129-30, 137
Fernandes, Leela 155-6, 158
Film Threat (magazine) 31

Final Girl (US film) 62
Fisher, Terrence 45
Foley, James 32
Forbidden Zone, The (film) 32
Freud, Sigmund 17, 116, 134-8
Friday the 13th (US film) 12, 26, 34
Fright Night (US film) 64

Gabriel, Karen 146
Gandhi, Indira 47, 63, 110, 120
Gandhi, M.K. 47, 53, 58, 119, 125, 153
Gandhi, Rajiv 120
Gaṇeśa (god) 93
Gang of Ghosts (film) 162
Garam Hawa (film) 130
Gator Bait (US film) 31
Gayboy (magazine) 35
Geel, Catherine 23, 43
Gehlawat, Ajay 109
Gehrayee (film) 17, 79, 82, 86
Get Out (US film) 4
ghosts 103-4, 137, 202n.33, 38
Ghoul (TV series) 4
Giardia lamblia (parasite) 35
Gitomer, David 12
Glengarry Glen Ross (US film) 32
Go Goa Gone (film) 3
Godhra train riots (2002) 120-1
Goga 86
Goldberg, Ellen viii, 17, 69
Golden Temple 110
Golwalkar, Madhav Sadashiv 118-20
Gond tribe 54
goondas 7
Gopal, Sangita 97, 107
Gopalan, Lalitha 142-3, 145-6, 151, 171, 173
"Gothic Criticism" (Baldick/Mighall) 56-7
Gothic Flame, The (Varma) 44-5, 48, 51, 58
Gothic Studies 55
Great Andamanese tribe 54
Grixti, Joseph 123
Gujarat riots 133
Gunga Din (US film) 89
Gyalmo Hope Nyagmal, Queen Consort 61

Index

Haggard, Stephen 22, 27
Haitian Vodou 79
Haiwan (film) 40
Halbfass, Wilhelm 81
Hasan, Kamal 2
Hashim, Hikmat 48
Hastar (god) 3
Hastings, Warren 101
Haunted House (film) 1
Haunting Bollywood (Sen) 4
Haveli (film) 27, 31, 35
Haveli ke Peeche (film) 30
Hay, Simon 101
Hedgewar, Keshav Baliram 118
Heller-Nicholas, Alexandra 143, 148, 150–1
Help! (film) 89
Henry, Claire 143
Highgate Cemetery 59
Hilarious House of Frightenstein, The (variety show) 52
Himalayas 60–1
Hindi Cinema: Ghosts and Ideologies (Mubarki) 4–5
Hindu Rashtra 116
Hinduism
 and *bhakti* theology 43
 common blood 116–17, 203–4n.6
 and female characters in films 179
 and India 137
 modern 91–3
 muscular 133
 and Muslim violence 119
 and nationalism 120–1, 128–9, 135
 particular theology 8
 and "Protestant presuppositions" 57–8
 and sanctity of marriage 111
 and *Tantra* 78–82
 and universalism 86
Hindutva (Hindu-ness) 117–18, 121, 126, 128–34, 137–8
Hindutva: Who is a Hindu? (Savarkar) 116
Hitler, Adolf 131, 133, 207n.52
Hobsbawm, Eric 149–50
Holden, Phillip 55
Holocaust 131

Holy Mountain, The (film) 32
Horror of Dracula (UK film) 45–6, 50, 191n.5
House That Dripped Blood, The (film) 51
Hughes, William 55

I Spit on Your Grave (US film) 144–5, 151, 214n.64
Illustrated Weekly of India 48
INC (Indian National Congress) 119–20
Indian Censor Board 95, 200n.5
Indian Demonology: The Inverted Pantheon (Bhattacharyya) 9
Indian Horror Cinema Dhusiya 5
Indiana Jones and the Temple of Doom (US film) 87–9
India's Bandit Queen (Sen) 156
Insaf Ka Tarazu (film) 146, 171–3, 213n.34, 217–18n.22
Irréversible (film) 151
It (King) 9
Iyer, Usha 63
izzat 171

Jaadugar (film) 17, 79, 84–7, 92
Jaani Dushman (film) 1, 45
Jackson, Peter 11–12
Jagganath festival 41
jagrata 75, 196nn.4,5
Jains 78, 80
James, M.R. 47
jangli cult 54
Jaws (US film) 6, 40
Jha, Prakash 74
Jharkhand state 8
Jodorowsky, Alejandro 32

Kaal (film) 3
Kādambarī (Banabhatta) 81
Kahaani (film) 174
Kakkar, Sudhir 109
Kālī (goddess) 42, 74, 77, 127, 149
Kālikā Purāṇa 89
Kalyan Khajina (film) 21
Kāpālikas 81–2
Kapoor, Kareena 3
Kapoor, Shatki 64
Kapur, Shekhar 18, 142, 148, 150, 154–8

Karloff, Boris 11
Kashmir śaivites 80
Kastel, Roger 40, 189–90n.37
Kaśyapa Saṃhitā 63
Kauffman, Stanley 156–8
Kaun Hai? (TV show) xiii
Kern, Richard 32
Khan, Aamir 3
Khan, Abdul Ghaffar Khan 125
Khatarnak Raat (film) 27, 36
Khooni Murdaa (film) 40
Khooni Panja (Talwar) 2
Khooni Tantrik (film) 79
King Kong vs. Godzilla (US film) 39
King, Stephen 7, 9, 11
Kipling, Rudyard 56
Kishwar, Madhu 142, 145, 158, 210n.3, 216n.96
Kohli, Rajkumar 45
Kohraa (film) 1
Kristeva, Julia 79
Kṛṣṇa-*bhakti* 41, 60, 128, 190n.40
Kṛṣṇamiśra 81
kṛtyā 38, 41–2
Krueger, Freddy 9
Kudrat (film) 56
Kulinism 104
Kung Fu films 7
Kurtz, Stanley M. 41
Kurukṣetra (battle) 26

Laaga Chunari Mein Daag 170–1
Lady Killer (film) 27, 36–7
Lajmi, Kalpana 74
Lapekas, Jenny 145
Last House on the Left, The (US film) 144–5, 212nn.22-3
Laughing Screaming: Modern Hollywood Horror and Comedy (Paul) 12
Law of the Threshold, The (Steel) 82
Laycock, Joseph P. 9
Leák (film) 29
Lee, Christopher 16, 46, 50, 192n.23
Lee, Spike 32
Lemos, T. M. 137
Lévy, Catherine 23
Lewis, Matthew 50, 51
Lipstick (film) 146
Longfellow, Brenda 156

Lord Rama 120
Lost Horizon (Hilton) 58, 60, 64
Lovecraft, H.P. 7
Ludden, David 121
Lugosi, Bela 63
Lunch, Lydia 32
Lutgendorf, Philip 70

Macbeth (play) 49, 53
Magic and Mystery in Tibet (David-Néel) 60, 194n.61
Mahā Kālī (goddess) 83
Mahābhārata (film) 26, 69, 71, 74, 94, 128
Mahal (film) 1, 182
Maharashtra Prevention Act (2013) 8
Mahendra Bir Bikram Shah Dev, King 48
Mahiṣa (buffalo demon) 72
Mālatīmādhava (Bhāvabhūti) 12, 25
Malayalam (film) 89
Malda district, West Bengal 8
Manchester, "Bishop" Seán 59
Mangalsutra (film) 97, 108, 111, 200n.9
Mansoori, Shahid and Wahid 31–5
Manto, Sadaat Hasan 14
māntrik 83–4
Manu Smṛti 154, 156, 215n.76
Mardaani 2 (film) 164
Mardaani (film)
 an ordinary monster 175–7
 beyond avenging women 171–5
 children and vulnerability 178–9, 218n.34
 conclusion 183–4
 horror tropes and appetites 164–6
 introduction 18, 161–2
 little religious imagery in 71
 maximum city horror 180–3, 218n.38
 plot summary 163–4
 a woman hero 166–71, 217n.14
market forces 24–5, 188n.13
Marlina Si Pembunuh Dalam Empat Babak (film) 159
masala (spicy) 21–2, 27, 30, 38–40, 71–2, 97, 158
material intertextuality 25–7
Maturin, Charles 53
Maut ki Haveli (film) 30

medievalism 57
Mehbooba (film) 56
Melmoth the Wanderer 53, 192n.33
Melmoth the Wanderer (Maturin) 53–4
Merchant of Venice, The (play) 49
methodological fetishism 24
"Metzengerstein: A Tale in Imitation of the German" (Poe) 56
Mighall, Robert 56–8, 64
Mikles, Natasha 9
Minh-ha, Trinh T. 154
Mishra, Vijay 56, 69, 79–80
Mittal, B. 95–6
Modi, Narendra 120–1, 133
Moghul rule 120
Monk, The (Lewis) 51
Monster on the Campus (US film) 36
Morrison, Toni 55
Mother India (film) 73–4
movie posters 21–44
Mrityudand (film) 74
"Ms. Ann Radcliffe Award" (Count Dracula Society) 51
Mubarki, Meraj Ahmed xii, 5, 178
Mukerji, Rani 3, 71, 167, 169–70, 217n.11
Muṇḍamāla Tantra 89
mūrtis 8, 186n.10
Muslims xii, 116, 118–19, 133–4, 136–8, 204n.12
Mysteries of Udolpho, The (Radcliffe) 51
mysterium tremendum (Otto) 59

Naan Kadavul (film) 79, 90
Nair, Kartik 165
Nasser, Gamal Abdel 46, 48–9
Nāṭyaśāstra Bharata xiii, 10–11
nautch girls 102–3
Naya Daur (film) 102
Necromancer, The 61
Neel Kamal (film) 56
Nehru, Jawaharlal 16, 44, 46, 49, 125, 134, 182–3
Nepali Cultural Centre 61
Nightmare on Elm Street, A (US film) 9
Nihalani, Govind xiii, 17, 115, 124, 128, 136
1920 (film) 107
Nityānanda, Dvija 12

Northanger Abbey (Austen) 49–50
nudity 2, 38, 158–9

Oakman, Daniel 48
Oddie, Morgan 18
Om Shanti (film) 69
Oṃ symbol 2
Omen, The (US film) 6
"On Possibilities of Gothic Romances on the Silver Screen" (Varma) 51
Once Upon a Time in Hollywood (Tarantino) 5
"Operation Dracula" (1945) 46
Othello (play) 48–9
Other, the 92, 154, 157
Otto, Rudolf 59

Palladino, Tony 30, 34
Pañcatantra 64, 195–6n.81
Paranormal Activity (US film) 3
Paraśurāma 26
Parosi (film) 64
Partition 116, 126, 129, 134, 136–8, 210n.85
Pārvatī 41
Pasolini, Pier Paolo 14
pativrata stree (loyal wife) 108
Paul, William 12
Penny, F.E.F. 82
Pennywise (clown-creature) 9
Perrin, Alice 102
petni (spirit) 103–4
"Phantom Rickshaw, The" (Kipling) 56
Pinch, William 149, 155
Pink Flamingos (film) 32
Pitt, Brad 5
"pizza effect" 45–6
Poe, Edgar Allan 50, 56
Porky's (US film) 12
Prabhakar, V. 36
Prabhodacandrodaya (Kṛṣṇamiśra) 81
Pratighat (film) 16, 71–2, 74
Praz, Mario 53
Price, Harry 59
Price, Vincent 16, 36, 46, 50–2, 59
Psycho (US film) 30–1, 34–5, 46
Psychotronic Video (magazine) 31
pujari ki shaitan 28
punyabhumi (Hindu holy land) 116

Purana Haveli (film) 30
Purana Mandir (film) 1, 62
purāṇas 29, 71
Pyaasa (film) 53
Pyasaa Shaitan (Shelly) 2

qawwali (devotional song) 37
The Queen's Journal 52

Raagini (film) 3
Raaz (film) 17, 94–102, 104–11, 200nn.3, 14, 16, 202n.39
Radcliffe, Anne 50
Radhakrishnan, Sarvepalli 60
Raimi, Sam 11–12, 36
Raja Harishchandra (film) 21
Rajan, Rajeswari Sunder 149
Raje, Aruna 82
Rajneesh, Bhagwan Shree 85
Ram Janmabhoomi Mandir Movement 120
Ramakrishna, Kodi 90
Ramanujan, Anuradha 150, 154
Rāmāyaṇa 69, 71
Ramsay brothers 1–2, 8, 62–3, 96–8, 107, 110, 162, 165, 185n.1
rape
 circuits of power 156–60
 and communalism 115
 and *Dev* 127, 132, 135, 138
 divine horror 73–4, 77
 Indian rape revenge 145–8
 introduction 15, 18
 in *Mardaani* 163–4
 and *Raaz* 95
 rape, revenge, banditry 148–53, 210nn.4–7
 revenge 140–2
 revenge as horror 142–5
 truth and testimony 154–5
 of vulnerable persons 161
rasas (aesthetics) xii–xiii, 10, 13, 69–72, 128
Read, Jacinda 143–4, 153, 211n.16
Reed, Donald A. 51, 53–4
"Refining the Repulsive" (Chakrabarti) 14
Reservoir Dogs (US film) 32
Revati-Jatahārini 63
Revival (King) 7

Rollin, Jean 32
Roman Catholicism 57–9
Romero, George A. 31
Routray, Bibhu Prasad 152
Roy, Arundhati 148–52, 155, 160
Roy, Rammohun 86
RSS (Rashtriya Swayamsevak Sangh) 118–20, 131
rūh 37

sādhu 81
Sadleir, Michael 50
Sākta lineages 80
śākti 71, 76
Salò, or the 120 Days of Sodom (Pasolini) 14
"Samri" (monster) 2
sanatana dharma 121
Sanderson, Alexis 80
Sangarsh (film) 17, 79, 87–9, 92
saṃnyāsins (ascetic warriors) 118
Sanskritic culture 9
Sarkar, Bhaskar 17, 116–18, 121, 133–8, 171, 205n.20, 208–9n.34
Sarkar, Pradeep 169–70
Sarkar, Sumit 112
Sarkar, Tanika 116–17
al-Sarraj, Abdel Hamid 48–9
Sathya Sai Baba 85
Sattvik food 104
Satyavān, Sāvitri 17
śava sādhana 82
Savarkar, Vinayak Damodar 116–17
Savini, Tom 29
Scarry, Elaine 137
Schauerromantik 61
Schopen, Gregory 57
Scream for Help (UK film) 39
"Scream Queens" 10
Scream (US film) 62
SEBC (Socially and Educationally Backward Castes) 121
Secrets of the Kaula Circle (Sharpe) 82
Sen, Aditi 17, 69
Sen, Mala 150, 155–6
Sen, Meheli xii, 4, 30, 56, 135, 162, 166, 178, 180–1, 183
sex xiv, 102–8, 151
 see also rape
Shah, Kanti 95–6

Shaitaan 107
Shaitaani Badla 95
Shaitan Tantrik (film) 70, 79, 87
Shangri-La 58
Sharma, Meenakshi 124, 206n.33
Sharpe, Elizabeth 82
She (Rider Haggard) 54
Shelly, Joginder 2, 95–6
Sholay (film) 30
Siddiqui, Gohar 152
Sikh riots 110, 120
Sikkim 61
Silence of the Lambs, The (US film) 87–8
Singh, Harinam 95–6
Singh, Man 152
Singh, Teerath 95–6
Singham (film) 168
"sinister yogī" 17, 79
Śitalā-maṅgala 12
Śiva (god) 2, 8, 28, 41–2
Slenderman mythology 9
Smith, Andrew 55
Smith, R.V. 101
song booklets 22–3
Specters of Marx (Derrida) 137
Spielberg, Stephen 87
stāyibhāvas (stable moods) 70
Steel, Flora Annie 82
Stoker, Bram 46, 65, 101, 201n.21
Straw Dogs (film) 144–5
Stree (film) 3–4, 162, 165
strīdharma 17, 94, 108–9
Suez Crisis 48
Summers, Montague 50
Sunday Searchlight Magazine 48
Supreme Court of India 124
Swami's Curse, The (Penny) 82
Syria 48–9

Talaash: The Answer Lies Within (film) 3
Talwar, Vinod 2
Tamas (film) 130
tāntriks
　and American Hollywood productions 87
　and *Darawani Haveli* 27–30
　horrifying and sinister 76–80, 89–93
　introduction 7–8, 17
　malicious and fraudulent 84–7
　in South Asian narrative 80–2, 197–8n.16
　stereotyping of 54
　and vampire man Varma 60–6
　varieties of experience 82–4
Tarantino, Quentin 5, 32
Taylor, Jeannine 26
Telugu (film) 89
Thakur family 54
Thapar, Romila 118
Theater of Blood (US film) 51–2
"Theorizing Horror in Bollywood" (Hinduism Group) xii
Thompkins, J. M. S. 58
Times of India 94, 97, 199n.1
Tombs, Pete 29
Toronto International Film Festival (TIFF) 155
Train to Pakistan (film) 130
"Transylvania Weekends"(Varma) 16
Treatise on Drama (Nāṭyaśāstra) see *Nāṭyaśāstra*
trimūrti 60
triśūl 28
tulpa (thought-form) 9
Tumbbad (film) 3–4, 165

Udan Khatola (film) 54, 64
unheimlich (Freud) 136
United Arab Republic (UAR) 48–9
Urban, Hugh viii, 16–17
Urban Legend (US film) 62

Vāc (goddess) 41
Vaiṣṇava Sahajiyā 41
Vajpayee, Atal Bihari 120
vamachara (also *vāmācāra*) 92
Vámbéry, Arminius 65
vampire legends 61–2
Van, Billy 52
van Vogt, A.E. 51
Varma, Devendra Prasad
　death of and legacy 53–5
　early life 47–9, 191–2n.12–3, 20
　gothic revivals 50–2, 192n.24, 30
　"Hindu mystic" 57
　ideas of 59–65, 195–6n.81
　introduction 11, 16

significant role in horror films 46
and spiritual-mystical wisdom 58-9,
 193-4n.51-2
vampire man 44-5
Varma, Eileen Florence (née Sircar)
 47, 57
Varney the Vampire 50
Vedas xiii, 92
Vedic demonology 26
Veerana (film) 1, 8, 13, 46, 54, 62, 64,
 185n.9
Verma, Ram Gopal 110, 203n.52
Vetālapañcaviṃśati 5
vīra rasa 28
Virdi, Jyotika 142-3
Vitali, Valentina 45, 110
Vivekananda, Swami 86, 92, 198-9nn.33,
 49
Voices from the Vaults (Varma) 51-2

Walker, Johnny 53
Walpole, Horace 50

Warren, Ed and Lorraine 59
Waters, John 32
Watkins, Beth 18
What Lies Beneath (US film) 97, 109
White, David Gordon 9, 17, 80, 186n.13
Williams, Linda 143-4
Woh Kaun Thi (film) 1, 102
Wohi Bhayakar Raat (film) 2, 64
Woman in White, The (Collins) 101-2
Wood, Ed Jr. 31
Wood, Robin 143
wuxia films 7

Yash Raj Films 162, 181
Yoginī Tantra 89
yogīs 78-80, 83, 92-3

Zakmi Aurat (film) 144, 146, 148, 151,
 213n.35
Zedd, Nick 32
Zee Horror Show (TV show) 2
Zombie High (US film) 31

CPSIA information can be obtained
at www.ICGtesting.com
Printed in the USA
LVHW081923111122
732936LV00004B/205